THE TREASURES OF ALEXANDER THE GREAT

Onassis Series in Hellenic Culture

The Age of Titans: The Rise and Fall of the Great Hellenistic Navies
William M. Murray

Sophocles and the Language of Tragedy
Simon Goldhill

Nectar and Illusion: Nature in Byzantine Art and Literature
Henry Maguire

*Adventures with Iphigenia at Tauris: A Cultural History
of Euripides' Black Sea Tragedy*
Edith Hall

Beauty: The Fortunes of an Ancient Greek Idea
David Konstan

Euripides and the Gods
Mary Lefkowitz

*Brother-Making in Late Antiquity and Byzantium: Monks,
Laymen and Christian Ritual*
Claudia Rapp

*The Treasures of Alexander the Great: How One Man's Wealth
Shaped the World*
Frank L. Holt

Onassis
Foundation (USA)

THE TREASURES
OF ALEXANDER THE GREAT

How One Man's Wealth Shaped the World

Frank L. Holt

OXFORD
UNIVERSITY PRESS

OXFORD
UNIVERSITY PRESS

Oxford University Press is a department of the University of Oxford. It furthers
the University's objective of excellence in research, scholarship, and education
by publishing worldwide.Oxford is a registered trade mark of Oxford University
Press in the UK and certain other countries.

Published in the United States of America by Oxford University Press
198 Madison Avenue, New York, NY 10016, United States of America.

Library of Congress Cataloging-in-Publication Data
Names: Holt, Frank Lee.
Title: The treasures of Alexander the Great : how one man's wealth shaped the world /
Frank L. Holt.
Description: New York, NY : Oxford University Press, 2016. | Series: Onassis
series in Hellenic culture | Includes bibliographical references and index.
Identifiers: LCCN 2015032790 | ISBN 978-0-19-995096-6 (hardback : alkaline paper)
| ISBN 978-0-19-995097-3 | ISBN 978-0-19-046971-9 | ISBN 978-0-19-046970-2
Subjects: LCSH: Alexander, the Great, 356 B.C.–323 B.C.—Influence. |
Greece—History—Macedonian Expansion, 359–323 B.C. |
Wealth—Macedonia—History. | Property—Macedonia—History. |
Pillage—Macedonia—History. | War—Economic aspects—Macedonia—History.
| Imperialism—Economic aspects—Macedonia—History. | Macedonia—Kings
and rulers—Biography. | Macedonia—History—To 168 B.C.
| BISAC: HISTORY / Ancient / Greece.
Classification: LCC DF234.2 .H65 2016 | DDC 938.07092—dc23 LC record
available at http://lccn.loc.gov/2015032790

1 3 5 7 9 8 6 4 2
Printed by Sheridan, USA

The amount of wealth that he plundered was unimaginable.
Diodorus of Sicily

qqqqqqqqqqddddddddtttttttttttttttt
hhnnnnnnnooooooooppoooooooooooo;;;;;;;;;;;;;;;\\\\\\\\\\\\\\\\\.,\

For all our cats who have tip-toe-typed messages like
this one across the pages of my manuscript, curious first
readers of every line and mischievous editors of same.

Jedi

Han

Bella

CONTENTS

List of Illustrations *xi*

Preface *xiii*

1. Introduction 1

 Imagining the Unimaginable 4

 Sources and Methods 8

 Exploring a Neglected Past 19

2. Poor Alexander? 23

 Humbled Origins 24

 The Making of a Hero 32

 War and Wealth 39

3. Conquest, Up Close and Costly 44

 Balkan Treasures 46

 Asia Minor 50

 The Middle East and Beyond 54

4. Reciting the Sword's Prayer 68
 The Lord of All Your Former Possessions 69
 Booty beyond Imagining 71
 The Sack of Persepolis 77
 A Historic Haul 85
 Rajas, Riches, Resentments 91

5. A King's Priorities 95
 Personal Gifts and Patronage 96
 Religion and Ceremony 107
 Cities and Other Infrastructure 110
 Armies and Navies 112

6. (Mis)Management 119
 Lucky Thessalian, Weary Macedonian 120
 Debt and Despair 124
 Harpalus the Treasurer 127
 Scams and Schemers 133
 With Harpalus or the King? 137
 The Successors 141

7. Conclusion 146
 The Story of the Moral 147
 A Change of Hearts and Minds 151
 Monetization 157
 Counting Coins 164
 What We Can Say about What We Can See 172

Appendices 179
1. Ancient Measures and Modern Conversions 179
2. Summary of Reported Assets 181

CONTENTS

3. Summary of Reported Debits 187
4. Where Is It Now? 195
Notes 199
Selected Bibliography 263
Index 281

LIST OF ILLUSTRATIONS

Map of Alexander's Campaigns		2
1.1	Bust of Alexander	6
1.2	The Darius Vase (detail)	12
1.3	Athena on Gold Coin of Alexander	21
2.1	Macedonian Palace at Pella	35
2.2	Model of the Royal Tombs at Vergina	36
2.3	Gold Larnax from Vergina	38
3.1	Nontax Revenue	45
3.2	Timocleia before Alexander	49
3.3	The Issus Mosaic	62
4.1	Alexander Entering Babylon	73
4.2	The Burning of Persepolis	78
4.3	Ruins of Persepolis	81
4.4	Tribute Bearers at Persepolis	83
5.1	Incidence of Expenditure	96
5.2	The Triumph of Alexander	100
5.3	Priene Inscription	108
5.4	Ruined Walls at Ai Khanoum	111
6.1	The Issus Mosaic (detail)	129

LIST OF ILLUSTRATIONS

7.1 Tetradrachma of Philip II 160
7.2 Tetradrachma of Alexander 161
7.3 Hoard of Alexander Coins 169

PREFACE

The history of Alexander the Great bedevils us with contradictions. The young king was at once charismatic, cultured, kind, calculating, impetuous, and cruel. He exhibited pure genius alongside puerile bravado. He could marshal as few others have done all the resources needed to command an army triumphantly on three continents, but managed his wealth so erratically that he twice turned over the world's greatest treasure to a hedonistic thief and let his soldiers fall into embarrassing debt. In life he united into a single empire all the lands from the Balkans to the banks of the Hyphasis River in modern India, then in death unleashed one of history's longest territorial disputes, which gave rise to numerous warring states and six Syrian Wars over just one contested border. In some respects Alexander waged war more humanely than others in the ancient world. This is certainly evident in his treatment of Timocleia of Thebes, Darius's family in Persia, and Raja Porus in India. But the young king also mutilated captives, killed his own generals, exterminated whole communities of noncombatants, and carried off more people and property in a shorter time than anyone else in history.

The historian Diodorus of Sicily wrestled in the first century BC, as we still do in the twenty-first century AD, to find words that might somehow express the magnitude of Alexander's war-won wealth. The one he chose ("unimaginable") remains popular today, but it hardly suits the purposes of serious historical analysis. How, how much, where, and why Alexander amassed his treasures impacts our understanding of the king's life and legacy: follow the money, find the man. We therefore need to reach beyond impressionistic adjectives to identify whatever survives of facts and figures. The results cannot yet produce a statistically based economic profile of Alexander's reign, but they can inform us about the conqueror's basic priorities and policies and how these reflected his world at war.

Unfortunately, these are matters poorly represented in the vast enterprise of Alexander studies. Of more than 4,000 books and articles devoted to Alexander's career published in the past sixty-five years, fewer than twenty-five actually have the words "wealth," "money," "budget," "economy," "commerce," "finance," "plunder," "loot," "treasure," "slaves," or "spoils" in their titles. The most useful among these have been written by R. D. Milns (1987), Georges Le Rider (2007), Daniel Franz (2009), and Borja Antela-Bernárdez (2015), all listed in the bibliography. As a whole, however, works about Alexander ignore his wealth, works about the ancient economy ignore Alexander, works about coins ignore other forms of property, and works about military history ignore numismatics. This book is intended to facilitate a conversation among all interested specialists across the disciplines of history, classics, economics, archaeology, and numismatics.

The next step will be to join the larger discussions already underway for later and longer periods, such as Kwasi Kwarteng's *War and Gold: A 500-Year History of Empires, Adventures, and Debt* (New York: Public Affairs, 2014). Alexander plays no part,

of course, in Kwarteng's work, but we may ask if his model for the Hapsburgs holds true for the Macedonians a thousand years earlier. Relevant, too, is the Big History conversation surrounding archaeologist Ian Morris's controversial study *War! What Is It Good For?* (New York: Farrar, Straus and Giroux, 2014). Morris barely mentions Alexander in his book, yet the young conqueror is surely a key subject in any debate about the efficacy of war. Stressing an upside to armed conflict, Morris makes the counterintuitive claim (p. 9) that war has been one of the most civilizing thing we humans do:

> This process has been messy and uneven: the winners of wars regularly go on rampages of rape and plunder, selling thousands of survivors into slavery and stealing their land. The losers may be left impoverished for generations. It is a terrible, ugly business. And yet, with the passage of time—maybe decades, maybe centuries—the creation of a bigger society tends to make *everyone*, the descendants of victors and vanquished alike, better-off. . . . War has enriched the world.

Morris's italicized emphasis on the word "everyone" echoes a statement made 1,900 years earlier by Plutarch of Chaeronea (*Moralia* 343b): "Alexander enriched even his enemies by defeating them." In Plutarch's rhetoric (*Moralia* 328e), the wars of Alexander gave those he conquered richer and happier lives. Are Morris and Plutarch right?

Large conversations based on the sweeping scale of the *longue durée* are meant to negate the extraordinary, to smooth out the bumps in Big History. But the bumps do matter. Consider, for example, that no ancient wars ameliorated slavery, and very few modern ones have done any better. At present there are still an estimated 27 million slaves among us. The persistence of a large population of slaves throughout most of human history seems an uncomfortably

large bump in the big-frame theory that wars have cumulatively made societies safer, richer, and more civilized. In fact, wars have made far more slaves than they have freed. Governments might fight wars to avoid their own enslavement, but almost never to end slavery as an institution. To argue that wars make strong states, and that these have the ability to end abuses such as slavery, ignores the fact that this did not happen on any appreciable scale over the first 90% of recorded history.

The pages that follow will not look past the rough edges of history. They will investigate in some detail only a few years in the fourth century BC, but these were years that shook the world. They will focus on war and wealth, on power and plunder. They will seek a better understanding of a phenomenal but frustratingly complex individual who beguiles us still. Young, bold, brilliant, and brutal, Alexander the Great was a winner, but winners require losers—and *pace* Plutarch and Morris, there were many of them. Our aim must be to challenge unfair accusations laid against Alexander while simultaneously questioning cases where he has been given undue credit. Both tasks are essential to maintaining a balanced view of the past. Part of that balance will be to appreciate that while the king is ultimately the owner and arbiter of all in his realm, he is not omniscient or omnipotent. Much of financial importance occurred away from Alexander and was perhaps unknown to him. This study will therefore examine the problem from different viewpoints, whether that of soldiers and women or Persians and Egyptians.

I owe debts to many whose assistance has improved this book beyond my frail powers. I begin with Stefan Vranka, Senior Editor for Classics, and Sarah Pirovitz, Associate Editor, at Oxford University Press. I thank the entire OUP team for excellent advice and skilled management of the publication process, including Project Manager Mary Jo Rhodes of Newgen. The Onassis Foundation has supported me as an Onassis Senior Visiting

Scholar, facilitating the completion of this project through my participation in its University Seminars Program. Under the auspices of this program, I was privileged to present lectures and seminars on my work in progress. I wish to thank my hosts at the University of Chicago; the University of Illinois, Chicago; and the University of Cincinnati. This pleasant experience was quite ably coordinated by Dr. Maria Sereti, Director of Educational Affairs for the Onassis Foundation.

Grants from my own university provided a semester's research leave to complete the manuscript, subventions for illustrations and maps, and funding for a graduate (Frances Joseph) and an undergraduate (Kevin Hartley) assistant. The specific contributions of each are acknowledged elsewhere in the book. Professor Theodore Antikas provided important information on the Vergina tombs. I appreciate a timely reference on Malalas from Professor Benjamin Garstad. My mentor, Stanley Burstein, was kind enough to read through a draft of the entire manuscript, offering sage counsel and critiques wherever needed. Catherine Rubincam offered her expert advice on a draft of my first chapter. I benefited also from the suggestions offered by the press's anonymous outside reader. As always, my wife, Linda, read the manuscript many times and made writing a shared joy. Help of a dubious nature was rendered by the feline members of our family, to whom this book is dedicated nonetheless.

Houston, Texas
April 2015

THE TREASURES OF ALEXANDER THE GREAT

Introduction

When a strong man armed keepeth his palace, his goods are in
peace: But when a man stronger than he shall come upon him,
and overcome him, he taketh from him all his armour wherein he
trusted, and divideth his spoils.

Luke 11.21–22

To the victor belong the spoils of war, and no conqueror ever cap-
tured more people and property in so short a lifespan as Alexander
the Great of Macedonia (356–323 BC).[1] Ambitious and able beyond
his years (see Figure 1.1), Alexander overcame strong men armed
across 2 million square miles of territory stretching from Albania to
India. He reached into three continents (Europe, Asia, and Africa)
with an appetite for conquest constrained only by his ignorance
of the other four. Everywhere he went, he warred; everywhere he
warred, he won; and everywhere he won, he amassed more wealth.
Eventually, Alexander assumed control of the vast resources cov-
eted in earlier times by the princes of Troy, the pharaohs of Egypt,
the kings of Assyria, and the rajas of the Indus valley. Most lucrative
of all, Alexander stormed the palaces of the Achaemenid Persian
Empire and stripped their treasures with epic consequences. Claims
have been made that the sudden redistribution of so much wealth
changed the world forever, ending the era of Classical civilization

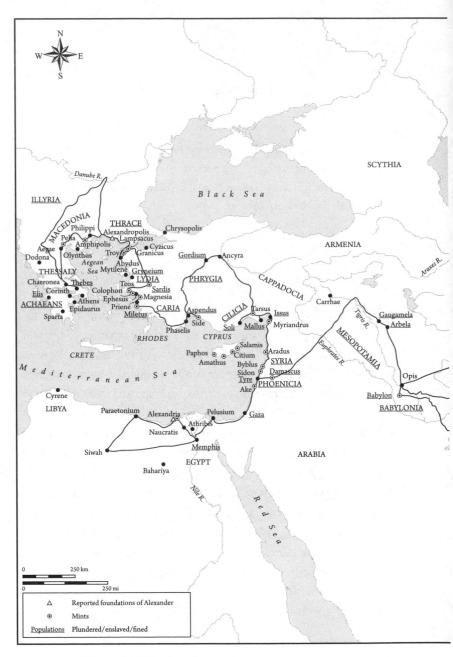

Map 1. Map of Alexander's Campaigns.

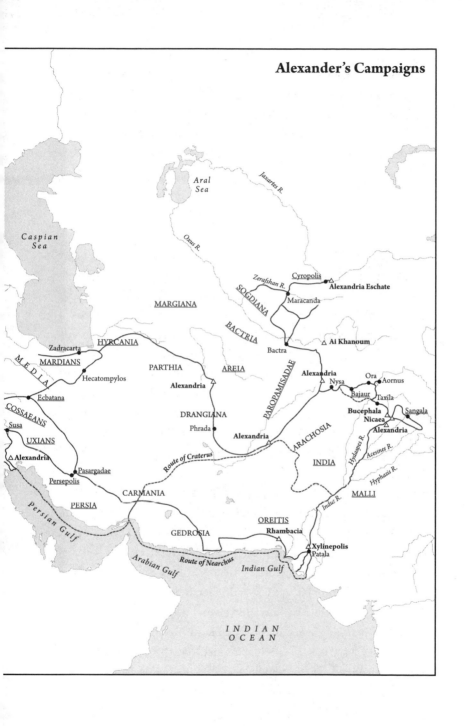

Alexander's Campaigns

and financing a new epoch called the Hellenistic Age (330–30 BC).[2] Whatever remained in the hands of the Hellenistic kingdoms of Macedonia, Syria, and Egypt eventually fell to the Romans, who used part of Alexander's residual fortune to found an empire of their own. It may be argued that Alexander's military dominated the Near East for years, but his money dominated Eurasia for centuries.

IMAGINING THE UNIMAGINABLE

Coming to terms with Alexander's reported wealth has never been an easy prospect. Modern historians generally use such adjectives as "enormous," "colossal," and "fabulous"; one scholar describes the king's loot as "enough to stagger the imagination."[3] Ancient writers similarly expressed their awe by labeling the king's wealth "incredible" or "unimaginable." The historian Diodorus of Sicily said of the first city captured and destroyed by the young king: "More than 6,000 Thebans were killed, more than 30,000 souls were enslaved, and the amount of wealth that he plundered was unimaginable."[4] Regarding the treasures Alexander looted in Persia, the historian Quintus Curtius Rufus wrote, "The reports of captured wealth are so enormous that the amounts strain credulity."[5] In the end, however, Curtius did believe the figures.[6] Should we?

To accept the scatter of surviving numbers that lie behind the loose descriptors "unimaginable" and "colossal" would mean that Alexander captured in just four months of fighting a full quarter of the riches removed from the Americas by Spain during the 140 years between 1520 and 1660.[7] In fact, it has become commonplace to insist that the discovery and despoliation of the New World by the Old is the only event comparable to Alexander's plunder of Persia.[8] Can we trust the ancient report that the conqueror actually requisitioned 5,000 camels and 20,000 mules to haul away his spoils from one Persian city?[9] This caravan would stretch over

70 miles (113 kilometers) from end to end, forming a vast treasure train whose length equals the distance from New York to New Haven or London to Southampton. Wherever it lumbered, it would literally cover the streets with gold.

According to Sitta von Reden, by the age of twenty-five, Alexander possessed enough treasure to mint three centuries' worth of the annual supply of coins produced by Athens at the height of its power.[10] François de Callataÿ calculates that this would be "enough to pay 100,000 men one drachma a day for 20 years."[11] Sophia Kremydi-Sicilianou considers Alexander richer than all of the previous kings of Macedonia combined.[12] The king's estimated total wealth would mean that if every person alive in 323 BC owned a drachma's worth of silver, Alexander would be eleven times richer than all of them together.[13] All told, Alexander's wealth would exceed what a contemporary fourth-century mason could earn by laying one brick per second without a moment's pause for 60,000 years; a well-paid contemporary stone cutter who earned a drachma for every fifty letters he chiseled would have to carve into stone the entire *Encyclopedia Britannica* 352 times.[14] Such resources concentrated into the hands of a single person do stagger the imagination.

It is little wonder, then, that Alexander tapped into the legends of Midas and other golden heroes.[15] The author of *Maccabees* knew him as the man who "advanced to the ends of the earth and plundered innumerable nations."[16] Chroniclers in the sixth century AD presumed that Chrysopolis ("City of Gold") on the Bosporus Strait got its name from Alexander, who allegedly paused there to dole out massive quantities of treasure to his troops.[17] Sundiata Keita founded the Mali Empire in thirteenth-century Africa inspired by the legendary fortune of Alexander the Great, whom he knew as "the mighty King of Gold and Silver."[18] A century later in India, the rich sultan Mubarak I issued large silver coins appropriate to carry his title *Sikandar al-zaman*, "the Alexander of his time."[19] Central

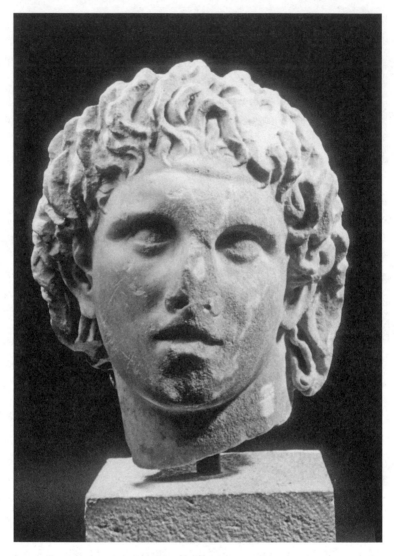

Figure 1.1. Bust of Alexander (Pella). © *Heritage Images/Corbis.*

Asian legend still holds that the "gold-strewing" Zerafshan River in Uzbekistan and Tajikistan takes its name from a golden dam built upstream by Alexander.[20]

In modern pulp fiction, L. Ron Hubbard's *Tomb of the Ten Thousand Dead* describes a murderous search for the dazzling treasures buried by Alexander in the deserts of Pakistan.[21] Similar adventures shape the plots of Steve Berry's novel *The Venetian Betrayal,* the 1947 film *Sinbad the Sailor,* and an episode of George Lucas's *Young Indiana Jones* TV series titled "Treasure of the Peacock's Eye."[22] Players of the popular video game *Samantha Swift and the Golden Touch* must help a young archaeologist gather clues to the location of Alexander's "most prized golden treasures."[23] A similarly rapacious game called *Pack'n Plunder* accompanied the recent archaeological exhibit "Alexander the Great: 2000 Years of Treasures" in Sydney, Australia. In the wildest imaginations of some people, shameless hucksters have truly discovered the lost riches of Alexander the Great. One case alleges that $60 million of ancient gold has been found buried in an Illinois cave, along with the bodies of Alexander (and Cleopatra!), all guarded by a garrulous ghost named Charlie.[24] Not to be outdone, a similar claim has been made for a cave in Jordan containing booby-trapped treasures of gold and jewels alongside the bodies of Alexander, Cleopatra, and—for good measure—Marc Antony, this time mysteriously (and conveniently) protected from public scrutiny by "a secret society."[25]

Hidden somewhere on the other side of imagination and exaggeration lies the truth about Alexander's treasures. How much wealth of various kinds did the young king actually acquire, and from what sources? How, and how well, did he manage these revenues? On what did the king choose to spend his fortune, and how does this illuminate his personality and policies? Where is that wealth today? For the most part, these questions have been drowned out by the din of other arguments about Alexander. To

answer these questions, modern scholars must return to the ancient sources with a workable methodology in mind. That approach must take into account several inescapable problems: the incompleteness of our written sources, both documentary and literary; the moralizing tendencies of some interpretive models; the quantification and correlation of extant material evidence, particularly numismatic; and of course, the parameters of what constitutes treasure and wealth as the appropriate focus of such an investigation.

SOURCES AND METHODS

To tackle the last issue first, treasure takes many forms and should not be limited to coins and bullion alone, as some historians and many numismatists tend to do. Any rare, attractive, or useful material might be considered worthy of pursuit and protection. The ancients stockpiled royal and private caches not only of coins but also of artwork, jewelry, drugs, gemstones, furnishings, dyed cloth, wine, exotic waters, and so forth.[26] Alexander's wealth also consisted of many items never to be found tucked away in an ancient treasury or modern museum, such as slaves, livestock, and real estate (see chapter 3).[27] A survey of the kinds of objects that victorious armies sought as plunder reveals what men valued: money, bullion, persons, apparel, cups, art, jewelry, furniture, animals, weapons, and even building materials such as stone and tiles.[28]

The loyalty of soldiers was not cheap, nor that of the gods. Alexander conducted thousands of sacrifices that consumed gold, silver, and vast herds of animals. As bounties, the king distributed villages, spices, estates, and other gifts just as valuable as money. In many cases, our sources suggest that the finest gifts that Alexander could give or receive were nonmonetary objects, such as the spoils of purple cloth he sent to his mother or the elephants he accepted

from Indian rajas. One account of Alexander's reign states flatly that pearls in Asia were more highly valued than anything made of gold.[29] Therefore, the terms "treasure" and "wealth" should be used in the broadest sense of any material goods that enhanced the power, prestige, influence, and/or independence of their owner. Titles and religious claims might do these same things, of course, but they are not physical objects of the sort to be investigated herein as material wealth. The Greeks took a comprehensive view of such matters, and so must we: all coins could be treasure, but not all treasure must be coins.

By concentrating on coinage, most numismatic approaches to Alexander's finances remain trapped in the orbit of the king's royal mints. This is partly because mint studies have been the traditional methodology for cataloguing and analyzing the coins of that era.[30] Even in a recent work that expands in scope well beyond Alexander's coinage to examine also finance and policy, the author follows the king mint by mint and makes no claim to treat the campaign much beyond Babylon, the minting but not the territorial limit of the empire.[31] Half the king's career of plundering and spending is thereby glossed in just a few pages, and of course the nonmetals that made up a considerable portion of the conqueror's wealth go unnoticed.

As for the incompleteness of our surviving written evidence, a proper methodology requires caution but not despair. Somewhere behind the story as we have it lies a stratum of sound information not altogether corrupted by literary conceits and carelessness. There can be little doubt that a trove of reliable archival data once existed detailing the revenues and expenditures of Alexander's reign. Hints of that data may be found in the occasional recovery of stone inscriptions, clay tablets, parchment texts, and other documents. For instance, epigraphic evidence shows that Alexander's chancery concerned itself with the minutiae of land tenure, taxes,

timber revenues, requisitions, and army pay.[32] The king availed himself of the financial and logistical apparatus that he found operating in newly conquered areas. An archive of Aramaic documents from Afghanistan preserves records used to facilitate Alexander's administration of the satrapy (province) of Bactria, including inventories and allocations of goods such as geese, camels, horses, chickens, sheep, flour, vinegar, wine, millet, wheat, barley, and other stores.[33]

Some such documentary material did find its way into the formalized literary tradition about Alexander, although never as much as we might like. A detailed official report of what Alexander's officer Parmenion seized at Damascus in 333 BC was mined by several later authors, who tell us not only how much coin and bullion were found but also how many mules and camels had transported it there, and the precise numbers of royal servants (cooks, weavers, perfumers, concubines, etc.) captured.[34] Another instance is the documentary apparatus visible in Alexander's huge pay-off of his army's debts at Susa in 324 BC. Extant sources reveal a very exact accounting of the cash disbursement, as well as the existence of debt rosters that were double-checked to identify possible cases of fraud among the troops.[35] We may lament that we no longer have access to these primary documents, but at least a shadow of them flickers across the pages of later writers. They survived first in the histories composed by Alexander's contemporaries such as the court propagandist Callisthenes, the general (later king of Egypt) Ptolemy, the engineer Aristobulus, the chamberlain Chares, and the sailors Nearchus and Onesicritus.[36] These accounts were consulted in turn by men working at least 300 to 500 years later, including historians, biographers, geographers, and encyclopedists. The canonical five extant narratives upon which most modern studies of Alexander are based were written by Diodorus of Sicily, Quintus Curtius Rufus of Rome, Plutarch of Chaeronea, Arrian of Nicomedia, and

Pompeius Trogus of Gaul, the latter known only in a condensed version (epitome) compiled by the Roman writer Justin.[37] Outside these basic sources may be gleaned a smattering of useful data preserved in the writings of men such as the geographer Strabo and the encyclopedic symposiast Athenaeus.[38] They collectively present a workable outline of Alexander's campaigns along with some sense of the king's strategy and tactics. We learn with some certainty where Alexander went, what he did, and how he fought.

Unfortunately, these same ancient writers did not balance their enthusiasm for military details with an equal regard for economic matters, in spite of the ancient dictum that "great sums of money are the sinews of war."[39] Arrian's history of Alexander's campaigns includes 225 total quantifications, of which only 23 (10%) may be deemed financial compared to 189 (84%) that are military.[40] Similarly, Curtius offers 243 quantifications, of which only 42 (17%) are monetary, and Diodorus includes 26 financial figures out of a total of 161 (16%). Plutarch's biography of Alexander relates 75 quantifications, including 14 of a financial nature (19%); Justin's epitome of Trogus preserves only 29 quantifications for the reign of Alexander, with 6 of them (21%) financial. Compared to battles, budgets seemed unheroically mundane to ancient writers, who chose their data accordingly.[41]

The relatively small sample of enumerations to be found in the literary sources is vital but notoriously problematical. Generations ago, A. H. M. Jones confessed to the world "the ignominious truth, that there are no ancient statistics."[42] He did not mean that there are no useful numbers.[43] In fact, the culling of numerical data from ancient sources has become an academic enterprise unto itself.[44] We do, after all, encounter fractions in Homer, compound interest in Aristophanes, calculations with an abacus in Polybius, and simple counting on one's fingers in Herodotus.[45] Many ancient societies practiced accounting seriously, if somewhat less complexly

than in our computer-driven age. Accustomed to the technical capabilities of the US Department of the Treasury and its Internal Revenue Service, we may underestimate the tableau painted on the lower register of the so-called Darius Vase, shown in Figure 1.2.[46] Produced in Apulia, probably during Alexander's lifetime or immediately thereafter, it shows an accountant in Greek clothing seated at his counting table. He is assessing the tribute being brought to a Persian king, shown seated above on the royal throne. This scene will be analyzed further in chapter 2, but here it is worth pointing out that one tribute bearer carries a stack of bowls, and another a heavy bag presumably of coins being tabulated by the accountant using pebbles on his counting table. In the fashion of an abacus, the pebbles have been placed in rows corresponding to units marked on the table by Greek letters: 10,000s, 1,000s, 100s, 10s, and 5s. These numbers designate drachmas, with the next rows marked

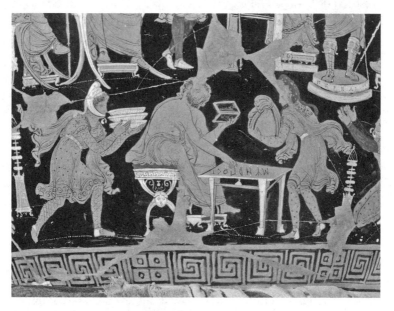

Figure 1.2. The Darius Vase (detail). © *Araldo de Luca/Corbis.*

as Greek fractional denominations: obols, hemiobols, and tetart-emoria.[47] This last unit represents a tiny silver coin weighting about 0.18 grams (0.006 ounces), and it is 240,000 times smaller than the largest unit. The accountant is therefore keeping an extraordinarily precise record. The sum shown is 1,335.83 drachmas.[48] Such running figures were then transferred to the accountant's wax tablet as so many talents of silver, the standard unit for measuring large amounts of treasure. This is a rare glimpse into a process that left few permanent traces as figures formulated on the table passed via the erasable wax tablet to sometimes equally ephemeral media such as papyrus or clay tablets.

The ancient world certainly quantified itself on many levels, but the figures that happen to survive are so scattered, inconsistent, and fragmentary that they cannot function in the same way as we expect of modern statistics. Working out anything as complicated as ancient gross domestic product, inflation rates, unemployment levels, or national debt from such numbers must involve massive guesswork to fill in the gaps. Furthermore, the information we do have often lacks exactitude. Greek authors often show measurable degrees of patterning in which figures for battle casualties and such have been rounded to nodal points, generally multiples of ten. As Catherine Rubincam demonstrates, the result of "typical" or "formulaic" numbers betokens imprecision but not dishonesty.[49] Writers in the Roman period tended also to follow certain literary conventions when using numbers. They habitually favored figures that were stylized as powers of 10 (10/100/1,000), as decupled multiples of 30 (300/3,000/30,000), or as decupled multiples of 40 (400/4,000/40,000).[50] All five major narrative sources for Alexander's campaigns conform to this general pattern of numeracy.[51] Diodorus, for example, tends to describe Macedonian armies around the benchmark of 30,000 infantry. He reports that Philip's infantry at Chaeronea in 338 BC numbered "more than 30,000."[52] Diodorus gives the same number for Alexander's infantry at Thebes

in 335.[53] At the crossing into Asia a year later, Diodorus enumerates the separate infantry contingents in Alexander's force; his own figures add up to 32,000 men, but he nevertheless states that the infantry numbered 30,000.[54] Clearly, the figure 30,000 served as a conventional rather than exact counting of troops.[55] This in no way invalidates the figure as a reasonable estimate for what may have been a fairly standardized infantry force, but the relative frequency of this number invites caution. Elsewhere in Diodorus, for example, there were 30,000 captives at Thebes (17.14.1); a ransom of 30,000 talents was offered to Alexander (17.54.2); Darius fled toward Bactria with 30,000 mercenaries (17.73.2); Cyrus received 30,000 wagonloads of supplies (17.81.1); 30,000 infantry arrived at the Acesines River (17.95.4); and 30,000 Persian boys traveled to Susa (17.108.1). Arrian reports "not much more than 30,000 infantry" in Alexander's army in 334 BC (1.11.3); 30,000 Persian cavalry and 30,000 Greek mercenaries at the Granicus River (2.8.5–6); 30,000 Tyrians sold (2.24.5); a tribute of 30,000 cattle (3.17.6); a force of 30,000 refugees (3.30.10); over 30,000 Indian infantry (4.25.5); another army of 30,000 Indian infantry (5.15.4); and 30,000 Epigoni (7.6.1). In fact, figures of 30,000 are so commonplace in ancient sources that some phantom examples have slipped into the modern literature, serving as salutary warnings of a persistent phenomenon.[56]

We must expect, then, two things from the numbers found in the surviving narratives of Alexander's reign: they will be relatively rare and they will usually be rounded off as ballpark figures. In terms of rarity, for example, our sources mention 295 financial gains or losses incurred by Alexander but attach actual figures to only 55 of them (19%).[57] As for round numbers, simple multiples of ten account for over 86% of Justin/Trogus's total quantifications, 90% of Arrian's, 91% of Diodorus's, and 98% of Curtius's. Indeed, odd numbers seldom appear in these texts. Only 7% of all quantifications in Arrian and Justin/Trogus are odd numbers, just 5% in Diodorus, and a

mere 2% in Curtius's history.[58] The casual rounding of numbers in literary sources reminds us to notice the abnormally specific, a rule useful in many contexts. Observe how one figure stands out sharply in this progression of financial numbers found in Plutarch's biography of Alexander: 1,000 talents (39.10); 1,000 talents (59.5); 2,000 talents (42.5); 3,000 talents (68.7); 9,870 talents (70.3); 10,000 talents (72.5); 10,000 drachmas (23.10); 10,000 talents (29.7); 40,000 talents (36.1). There is something reassuring in the figure 9,870 for the talents paid out by Alexander to retire his soldiers' debts at Susa, mentioned earlier in this chapter, especially given the belabored phrasing necessary to express it in Greek: "short of ten thousand talents by one-hundred-thirty talents." Because Curtius gives the same figure in an equally wordy Latin construction (Alexander set out "x milia talentum" of which only "c et xxx talenta" remained), this number appears relatively unaffected by literary conventions.[59] Diodorus, on the other hand, opts for the inexact wording "just shy of 10,000 talents."[60] Arrian and Justin/Trogus claim the figure to be 20,000 talents.[61] The latter authors may have included some additional largesse in their totals, but all in all we may take the correct figure to be very near 9,870 talents.

Due diligence reminds us that error can affect numbers as easily as literary license. Figures travel perilously through the ages, mutating as they move from manuscript to manuscript and language to language.[62] Without warning, one number can become another. Plutarch's statement that Alexander employed 10,000 pairs of mules to help haul away the spoils of Persepolis passes into the modern Penguin translation as "two thousand pairs of mules," a huge disparity of 16,000 animals.[63] Others have overlooked the reference to "pairs" and quote a figure of only 10,000 mules.[64] Plutarch mentions 5,000 camels in the same passage, but Diodorus 17.71.2 says 3,000. To one modern historian, this somehow means 7,000 camels.[65] These are simple though significant misrepresentations. At other times a problem might stem from the inherent ambiguity

of the Greek language, which has no uncompounded word for any number above 10,000, and even then the same word (*myrios*) might mean "numberless" rather than the actual number. This is akin to the modern habit of claiming, say, "I have told you this a million times" without meaning it statistically.[66]

Every ancient datum need not be held suspect without cause, but even accurate figures faithfully transmitted may be misleading in their selection and presentation. In other words, we have to work with a biased rather than random sample of a larger population of economic figures that no longer exists. For example, our sources are three times more likely to mention expenditures than assets (compare appendices 2 and 3). Having a handful of ancient writers select our sample for us means that we now have no statistical method to eliminate any biases—our data are irremediably nonrandom. There is no way to go back, but this does not mean that we can never move forward. Nonstatistical inferences may yet be made that couple common sense and an awareness of the kinds of biases in the sample. We may infer, for example, that deaths among Alexander's associates occurred throughout his reign, and that some of these occasioned costly funerals at the king's expense. Many of these deaths were caused by battle and assassination, but some unknown percentage resulted from other factors ranging from accidents to illness to old age. Our five main narrative sources give us different nonrandom samples of these latter burials. No single burial appears in all five samples. Cumulatively, the sample provides the names of just eight persons who died nonviolently and were accorded rich burials by the king.[67] Scholars can never precisely calculate from these figures the ratio of battle/non-battle losses, nor the relative burial expenses for each group borne by Alexander.[68] The cost for only one of these funerals is given, and this because it was surely one of the greatest outliers in the king's entire budget, so no sense of an average funereal expenditure can be ascertained.[69] It does seem reasonable to infer, however, that

these expensive burials were more prevalent in the latter part of the reign than in its early years since this distribution is observed in all five nonrandom samples.[70] The chronological assumption cannot be proved with any statistical formula, but it makes sense in the context of the king's growing resources, his mounting sense of the grand gesture, and his need to garner goodwill far from home.[71] Besides, the bias in these nonrandom samples is one of singling out from all cases the ones interesting to particular authors, not of systematically ignoring the early reign. All five samples therefore share a common bias, but one which does not necessarily impact all uses of this data (see chapter 5).

Known motives behind a source's selectivity must be considered when assessing the credence of specific figures. It was Plutarch's goal to contrast Alexander's virtuous poverty with Darius's emasculating riches, making it necessary for the biographer to exaggerate both whenever possible (see chapter 2). Other writers moralized about the conqueror's venality and rapacity (see chapter 7). Numbers that survive solely in these contexts may be less reliable than those carried forward by no obvious agenda. The former are intentional numbers, the latter incidental. In other words, a secondary author who went looking for numbers to support a literary motif may be intentionally misleading in his or her selectivity, whereas a secondary writer who passes on a number ingenuously attached to some event in his or her narration at least preserves that quantification in its original context. The latter is incidental to the author's literary purpose.

In cases where several authors provide quantifications of particular income or expenditure, care must be taken in reconciling any differences among them. Divergent figures should not be casually amalgamated as if the discrepancies do not matter. Some effort must be made to understand why the figures vary, as with Alexander's inheritance from Philip (see chapter 2) or the treasure seized at Susa (see chapter 4). Not just the numbers are at

issue here, but also what they are quantifying. A consistency in the figures must be matched by a consistency in the objects enumerated. If several sources mention a quantity of 40,000 talents, but some attach the figure to one set of things (coined silver) and some to another commodity (unstruck bullion), then we face a clash no less significant than if the data were reversed (same goods, discrepant numbers).

The usual approach to sorting out all such Alexander problems involves a methodology of source criticism (*Quellenforschung*), whereby the researcher studies carefully whence each of the extant works derived its information, how the secondary author(s) reshaped it, and therefore how reliable it might be in its current form. It is known, for example, that certain eyewitness accounts of Alexander's reign were gossipy and sensationalist. These include Chares, Ephippus, and Polycleitus, who wrote about the extravagance of Alexander's court.[72] In addition to Alexander's own interest in publicizing his generosity, the popularity of such works helps to explain why there are more surviving reports of the king's expenses than income. Gossipy versions of events must not be entirely dismissed even if tainted with some hyperbole, for accounts of such public occasions as the Susa weddings were subject to contradiction by thousands of other eyewitnesses and people tend to remember benefactions.[73] As long as we remember that these descriptions were biased in favor of the extreme, and that these extremes do not represent the entire reign but rather the last years, then some controlled use of the material is warranted.

Opportunities to cross-check data, though rare, are fundamentally important. For instance, if a certain quantity of treasure is stated in one place, and the number of animals needed to haul it in another, then it is possible at least to confirm whether these separate data are compatible (see chapter 4).[74] To this type of comparative textual analysis must be triangulated the material evidence drawn

from archaeology and numismatics, where statistical analyses are actually viable. Coins, by virtue of their durability and massive numbers, survive in volumes sufficient to calculate at least one portion of Alexander's wealth. To do so requires some assumptions that may be controversial, such as the quantity of coins that could normally be struck from a single die, but these methods are being refined and tested with encouraging results (see chapter 7). These investigations must be used to help confirm or refute as independently as possible the financial data embedded in the literary tradition.

EXPLORING A NEGLECTED PAST

The ancients took special care to preserve the military side of Alexander's story, passing down to us a detailed accounting of marches, battles, sieges, sorties, and other such operations.[75] This is the past that the past chose for us to know. But that is not enough. Today, we want—indeed, we need—to understand more completely Alexander's wealth and its impact on the world he conquered. This is the past that the past never set out to explain in any direct way, but which we are obligated to seek out. We cannot fault the ancients for having interests other than our own, but neither should we be forever limited in our inquiries to ancient habits of mind. Among other treasures, Alexander captured and coined immense quantities of metals in a brief, convulsive period. Against the clarion call of Eugene Borza that "it is the continuing task of scholars to understand the impact of such a release of gold and silver on the economy of the eastern Mediterranean world" stands the deafening silence on the subject to be found in a recent survey of research devoted to the ancient economy.[76] While our sources offer no comprehensive statistical basis by which to achieve this goal, the best must be done with what exists.

The following pages will show that our sources actually contain far more information than has generally been marshaled by scholars. In his survey of Alexander's known income from conquest, for example, Martin Price referenced only a fraction of the recorded cases.[77] Worse still is the recent tabulation of "Alexander's Plunder, according to the literary sources" published by Andrew Meadows in a study of Hellenistic coinage.[78] While patently drawing his data from Price, including several errors and omissions, Meadows underreports even further the number of known cases.[79] In the most ambitious accounting to date, Daniel Franz provides a source list of both assets and expenses that makes no claims to completeness; it is, in fact, less than 13% complete.[80] A more thorough chronological summary of the available data for assets and expenditures may be found in appendices 2 and 3. By the end of this book, it will be clearer what we can see in the sources, and what we can say about it.

The picture that emerges from this data will not necessarily be heroic or inspiring, for it must be a constant reminder to those Pollyannaish about plunder that war transfers wealth through violence. It is possible, of course, to hold different views about conquest and despoliation. Socrates taught Plato that war—especially against non-Greeks—was a legitimate means of acquiring wealth, and that lesson was apparently passed down to Aristotle and thence to his student Alexander.[81] These men walked about in a world that condoned many reasons to conquer, including revenge, revenue, honor, and even the primal pleasure of killing.[82] Money was certainly one powerful motive, and surely the financial rewards of conquest were not lost on Alexander's generation. As Sir Moses Finley has pointed out, "The hard fact remains that successful ancient wars produced profits, and that ancient leaders were fully aware of that possibility."[83] Significantly, the Greeks used the same word (*opheleia*) for profit and plunder. Finley, among others, prefers the translation "profit" instead of "booty" or "loot" because the

latter meanings are deemed pejorative in our culture but not so in the Greeks', and because "profit" better reflects the nonmonetary gains from war such as slaves and land.[84] So, while the Greeks knew no economic terms for what we mean today by investment, labor market, capital, or entrepreneur, they developed a remarkably rich vocabulary for the act and end results of looting.[85] Athena, goddess of wisdom, was also the patroness of plunder (Athena Leitis).[86] She served as tutelary goddess for Alexander's campaigns and took a conspicuous place on the gold coinage of the conqueror, as shown in Figure 1.3.

Even a statesman such as Cicero, who defended the right of all persons to maintain their property and to live free from harm, could simultaneously espouse the state's imperious right to expand its power and glory by seizing persons and their property as the spoils of war.[87] Cicero could also unselfconsciously condemn Alexander—and yet praise Rome—for doing the latter (see chapter 7), showing

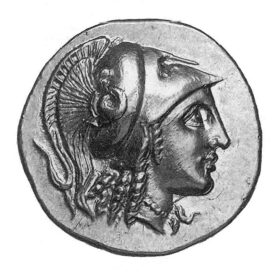

Figure 1.3. Athena on Gold Coin of Alexander (obverse). © *Bpk, Berlin/ Münzkabinett, Staatliche Museen/Art Resource, New York.*

just how contradictory our thoughts on imperialism can be. Was Alexander a grasping despot or a conscientious state builder? Did he conquer for good or evil? Eighty years ago, in the aftermath of the League of Nations and before the specter of World War II, a doting article about the Macedonian king was titled "Alexander the Great and the Unity of Mankind."[88] In it, the author Sir William Tarn passionately lauded Alexander as the first person on earth to dream of a peaceful brotherhood of all peoples. An assessment of the "same" king today is titled "Alexander the Monster" and vilifies the man as "a murderous, rage-filled, paranoid, alcoholic, religious fanatic who, on at least one occasion, showed a fondness for what today might be considered necrophilia."[89]

As fascinating as we may find the many different Alexanders imagined by historians from one generation to the next, it is more instructive to examine the pedestals on which their constructs are made to stand. Early on, the king's contemporaries admired his courage, youth, and generosity, and above all else, his unremitting success. Thanks to Alexander, many Greeks saw, seized, and shared more of the world than had any compatriots before them. They made Alexander the model of royal virtue, standing tall on a pedestal that his successors such as Ptolemy built large enough to share. In time, others climbed on, such as the Roman generals Pompey and Julius Caesar. This crowded podium could not but alarm opponents and iconoclasts, including Cicero and Seneca.[90] They tore down parts of the pedestal by questioning Alexander's motives and even his sanity. Plutarch quickly built it back; St. Augustine chiseled it down again. For many centuries now, veneration has risen and fallen beneath the conqueror's feet. The statue never really changes, only the pedestal on which it stands.

Chapter 2

Poor Alexander?

In such great poverty and tumult, this untested lad dared set his sights on Babylon and Susa.

Plutarch, *Moralia* 327d

He was bankrupt.

W. W. Tarn, *Cambridge Ancient History*

For more than two millennia, the world has marveled at the story of the poor Macedonian boy who became the richest man in the world. There is just enough truth in the reversal of fortunes for Macedonia and Persia to make this exaggeration seem real, and there are just enough financial numbers adduced in the sources to give the whole construct a statistical façade.[1] The figures come to us from a speech by the king and from Plutarch's encomium for the self-made man; it is reinforced by comparisons to other rulers and by stories of Alexander sharing unselfishly his meager inheritance. Each of these matters must be considered in turn. The result will show that young Alexander did face a cyclical cash-flow problem at the outset of his reign and occasionally thereafter, but he was never actually poor or bankrupt. There is no greater injustice to King Philip II than to disparage for literary effect the inheritance handed down to his son. Wealth means far more than cash on hand, and Alexander's

resources were patently sufficient to carry his ambitions beyond the horizons of Greece.

HUMBLED ORIGINS

In 336 BC, Alexander witnessed the assassination of his father in a theater thronged with emissaries shocked to see a genuine Greek tragedy unfolding on the stage before them.[2] Philip II, at the height of his power, fell dead at the hands of a disgruntled bodyguard whose motives may never be fully known.[3] The king and his killer breathed their last breaths within moments of each other, the latter dispatched by the vengeful spears of Philip's other guards. During a relatively long reign of twenty-four years (his immediate predecessors averaged just three years each), Philip had led his struggling realm to primacy among the powers of Greece. He had made Macedonia a great military state and then assumed command of a Pan-Hellenic crusade against Persia, the historic enemy of the Greeks. The crowds that watched Philip die had come to celebrate the launch of that campaign, unaware of how quickly their cheers would be silenced.

In the chaos of that morning, the kingless Macedonians gambled their future on the unproven talents of a twenty-year-old prince. Young Alexander was no one's hero yet, but he was heir to a fine army and his father's plan to lead it east. Twelve years later and half a conquered world away at Opis in Mesopotamia, Alexander summed up that inheritance in a speech designed to highlight how much he had made of his father's bequest.[4] Alexander dutifully praised Philip's transformation of Macedonia from a backward nation of timid herdsmen unable to protect their flocks, to a country in command of all Greece.[5] Macedonia grew to be the envy of the eastern Mediterranean littoral, whence Alexander made it the arbiter of the world. Most dramatically of all, Alexander parlayed

the heavy debts inherited from his father into unprecedented wealth. Curtius's version of the speech quotes Alexander as saying:

> I inherited no more than sixty talents (360,000 drachmas) of royal assets plus a debt of 500 talents (3,000,000 drachmas) with which to make a name for myself.[6]

Arrian provides a similar account, noting also some additional debts incurred by the new king:

> My father left me only a few gold and silver cups, with less than sixty talents in the treasury to offset his debts of nearly 500 talents plus the 800 more I had to borrow to begin the campaign.[7]

Cups aside, these tallies appear to be consistent and precise. Based on the remarks attributed to Alexander at Opis, Philip left 360,000 drachmas in the treasury, but also outstanding debts totaling more than eight times those assets, to which Alexander added a further deficit of 4.8 million drachmas. Macedonia was allegedly broke at the moment of Alexander's dramatic accession.

By Greek standards, Philip did have a reputation for extravagant spending. Listing the festivities hosted by the king in his last hours, Diodorus three times uses the word *megaloprepes* (sumptuous, magnificent) to describe the sacrifices, banquets, and royal trappings contributing to the king's final "dazzling spectacle of riches."[8] The contemporary historian Theopompus paints a particularly unflattering picture of Philip's prodigality:

> Philip really could not throw away his money fast enough. Neither he nor anyone around him had any grasp of management or finance. . . . He was a mere soldier with no inclination to keep track of income or expenditures.[9]

Justin adds that "Philip was better at acquiring wealth than safeguarding it, rendering him perpetually broke amid his daily pillaging."[10] Because his gold was so scarce, poor Philip was said to have kept one small libation bowl tucked away for safekeeping under his pillow.[11] Yet, the king maintained a large army and increased the mining of gold and silver to such an extent that he garnered more than a thousand talents annually from Philippi, the city he founded in eastern Macedonia.[12] Additional revenues are impossible to enumerate, but Macedonia controlled a lucrative trade in timber and other exports. It was said that 150 years after Philip, the Macedonians were paying more than 200 talents a year in royal taxes.[13] Furthermore, according to Justin, Philip was downright frugal when compared to his luxury-loving son.[14] In fact, one modern admirer of Philip's financial acumen has afforded him the kind of misplaced praise usually reserved for Alexander: "If Philip were alive today, he would be in constant demand as an expert consultant on both the economics and the politics of developing nations."[15] So what is to be believed about the state of the Macedonian treasury in 336 BC?[16]

The venerable scholar G. T. Griffith concludes rather harshly that Philip spent so heavily on war, wine, women, boys, and the bribing of politicians that he went broke: "By Greek standards rich, very rich, he still managed to leave an empty Treasury when he died."[17] The numismatist François de Callataÿ accepts the notion that "the treasury of the Macedonian State was empty," while the historian Ernst Badian agrees that Alexander had little choice but to invade Persia because "his treasury was bankrupt."[18] Even those who discredit the Opis speech have reached the same conclusion: "We should not count too much on the evidential value of such a speech, but there is nothing to contradict the common testimony that Philip had used up his money."[19] So, while the speeches found in ancient historical works are notoriously suspect as reliable

guides to what was actually said, the claims attributed to Alexander at Opis are widely believed. The oration is all the more trusted by some because both accounts of it preserve, quite beyond the possibility of coincidence, the same figures for Alexander's initial assets and debits.[20]

Alexander may indeed have cited these very figures on the dais that day at Opis, but this hardly proves that his initial poverty was real rather than rhetorical.[21] He humbled his own origins for political effect. One or two figures may tell a story, but not the full story, and the art of persuasion lies in selection. If we accept the numbers given by the king, we might notice some others that he did not give. For example, the king offered no true inventory of his palaces or their contents, for even the tomb attributed to Philip contained more than the "few gold and silver cups" mentioned in the Opis speech.[22] Nor did Alexander remind his followers that on the day of his accession he owned a horse of legendary expense. In fact, the reported cost of Bucephalus was thirteen talents (78,000 drachmas), a sum Alexander had been willing to forfeit out of his own boyhood resources at a time when that amount alone made you a rich man in Athens.[23] No horse in Greco-Roman antiquity cost as much; in fact, Bucephalus was not double or triple the price of contemporary mounts, but sixty-five times more expensive.[24] These are not the lifestyles of impoverished royals.[25] At Opis it was Alexander's purpose to paint a particular portrait of his past, not to deliver a full accounting of Macedonia's finances. He meant to stress before a crowd of mutinous soldiers just how far a poor boy had come, having built on his father's legacy a far grander record of military and financial success. It was a theme supported by memories of his recent generosity at Susa, where the king paid off the men's heavy debts with boons besides.

This popular "rags to riches" narrative had an interesting corollary. Alexander had to be compared to another king besides Philip,

namely, their contemporary rival Darius III of Persia.[26] In essence, young Alexander was favorably situated between two kings who allegedly squandered their revenues. One leitmotif of that comparison played upon Alexander's initial poverty, starkly contrasted with Darius's excessive wealth. The vast empire of the Achaemenid dynasty stretched from the Aegean to the Indus, and the tribute drawn from those lands was collected annually. For Greeks, Persia's riches were a constant wonder and easily exaggerated. The Great King's luxuriant palaces and treasuries were also imagined to be the source of idleness and dissipation.[27] Chares of Mitylene, Alexander's court chamberlain, gives this account:

> The Persian kings had become so attached to luxury that at the head of their royal couch they kept a room furnished with 5000 talents (142.2 tons) of gold, called the Great King's pillow, and at his feet another room filled with 3000 talents (85.3 tons) of silver, called the Great King's footstool.[28]

The philosophical Plutarch made much of this popular contrast. He claims that Alexander as a child actually hoped to inherit a humble throne to prove his mettle by amassing his own wealth.[29] When the adolescent Alexander met some Persian ambassadors at his father's court, the envoys allegedly said of the precocious prince: "This boy is the great King, ours is merely rich."[30] Allegedly, when the impoverished Alexander set his sights on the realm of that "merely rich" king, he gave away to his companions nearly all that remained of his "petty and insignificant" inheritance, leaving himself (as he famously said) only his hopes.[31] This tradition highlighted the moral distinction between the two kings, and it justified the eventual transfer of Darius's undeserved riches to the virtuous Alexander.

The perceived contrast between the opposing kings was chan-
neled into descriptions of their armies. Curtius penned a famous
story about the day that Charidemus, a Greek exiled from Athens
by Alexander's orders, was asked by Darius to size up the rival
armies during a Persian war council.[32] Charidemus admitted that
the Persian army was unbelievably rich and resplendent, but that
it was unfortunately no match for the grim and unadorned ranks
of the Macedonian phalanx. Like their leader, these Macedonian
troops were not motivated by wealth but rather schooled in pov-
erty so that they were comfortable sleeping on hard ground and
scrounging for meager rations. Charidemus's advice was as simple
as it was unwelcome: send gold and silver to Greece and hire men
like Alexander's. Darius, allegedly blinded by Fortune, ordered the
immediate execution of Charidemus. This may be the scene being
played out on the late fourth-century BC Darius Vase, which shows
a Greek accountant recording the tribute for a Persian king labeled
Darius.[33] Some take the king to be Darius I on the eve of the Persian
War fought in the fifth century, based on an episode described by
Herodotus, but the king may actually be Darius III as depicted by
Curtius.[34] This interpretation puts the painting much closer to the
king being referenced, as an artistic evocation of a nearly contempo-
rary event. The fate of Charidemus increases the pathos of the tab-
leau, as do the supplications of the men below the king, who could
be the three known sons of Charidemus or figures mourning the
failure of their king to heed the proper counsel. Finally, the gather-
ing of tribute largely in the form of Greek coins makes sense of the
story as we have it in Curtius, where Charidemus is urging Darius
to spend his money on Greek mercenaries. This same Charidemus
had furthermore acquired a reputation for extortion and stealing
treasure.[35] In the end, no matter which Darius is meant, the vase
reflects a long tradition of Greek art and literature devoted to the

themes of Persian wealth, war councils, and the failure of both in the face of Greek austerity.

Darius, of course, rejected the strategy of Charidemus and rode off to battle Alexander at Issus. Curtius paints a memorable picture of Darius's forces as they marched from Babylon.[36] Sunlight gleamed on the gold, silver, and gemstones that adorned the thousands of Persian chariots, weapons, and soldiers. All of this luxury imparted to the Persian troops "an almost effeminate refinement" (*muliebriter propemodum culta*) that weakened their capacity for war.[37] In stark juxtaposition, "the Macedonian army shone not with gold, but bronze and steel, ready to fight."[38] This view endured long into the medieval lays of Walter of Châtillon and others, who describe the "lisping catamites" of Persia as no match for the manly Macedonians:

> Behold the weakling throngs flashing with gold,
> Behold how gems gleam in their womanish ranks:
> They offer more of booty than of danger.
> Gold's to be won with iron.[39]

After his victory at Issus, Alexander laid claim to these spoils of war. When at last he gazed upon the opulence of Darius's captured possessions, the Macedonian allegedly remarked, "So this, I suppose, is what it means to be a king."[40] This reaction, according to some commentators, expressed Alexander's pity toward the deluded Darius "for thinking that kingship consisted in wealth alone."[41] Plutarch's account of that wealth gives emphasis to the occasion:

> The treasures found in Darius's camp were astounding, all the more because the Persians were traveling light, having left most of their baggage at Damascus. The tent of Darius overflowed with royal attendants, magnificent trappings,

and much money. . . . Alexander gazed upon the exquisitely wrought golden basins, jars, bathtubs, and containers and he smelled the wondrous fragrance of spices and perfumes.[42]

A similar story was told by Herodotus when the Spartans captured Mardonius's sumptuous tent after the Battle of Plataea in 479 BC, prompting the remark, "Behold how the silly Persians, accustomed to such wealth, have come to Greece to rob us of our poverty."[43] Such moments were Hellenic clichés. When Alexander took possession of Darius's erstwhile property, Plutarch reprised another platitude about requiting the better man:

Saying "Let us wash away the sweat of battle in the bath of Darius," Alexander was reminded by a companion, "Not Darius's anymore, but Alexander's, for ownership passes to the conqueror."[44]

What Alexander prized most among Darius's treasures was a small box in which, according to legend, the victor thereafter kept his annotated copy of the *Iliad*.[45] Reminding us of Philip and his one precious bowl, Alexander allegedly kept this box under his pillow, the gesture of a humble son and the worthy conqueror of a Persian king whose own "pillow" was said to be 142 tons of gold. The exaggerations at both ends of the financial spectrum tapped into a long Greek tradition.

Alexander admired the warriors' world of Homeric epic, with its primordial economy based on gift exchange and the distribution of plunder—customs that helped define his leadership and served as the very crux of the *Iliad* itself. When monetization first came to ancient Macedonia, it did not transform all social relationships into financial ones. Birth, honor, and heroism still mattered to men like Alexander, just as they had to his putative ancestor Achilles.[46]

When the great warriors Glaucus and Diomedes squared off for battle at Troy, they did something quite alien to rational economic exchange. They honored old hereditary bonds of guest-friendship and traded armor, even though that exchange cost one of them dearly: Diomedes's bronze armor was worth only nine oxen, while Glaucus's gold armor was worth a hundred. Zeus, winks Homer, must have stolen the wits of Glaucus.[47]

THE MAKING OF A HERO

Plutarch clearly fashions from popular anecdotes a compelling story of the triumph of the self-made man. "In such great poverty and tumult," he says, "this untested lad dared set his sights on Babylon and Susa."[48] To support this view, Plutarch offers some numbers to enhance his didactic narrative. In his biography of Alexander, Plutarch states:

> To launch his military campaign, the king had no more than seventy talents (420,000 drachmas) according to Aristobulus' history; Duris reports enough to maintain the army for thirty days, while Onesicritus says that Alexander was 200 talents (1,200,000 drachmas) in debt.[49]

In his *Moralia*, Plutarch twice mentions the particulars of the king's early finances:

> Philip left no money in the treasury, and even owed 200 talents as Onesicritus records. . . . The high and mighty resources bequeathed by Fortune to Alexander totaled only seventy talents, as Aristobulus says, while Duris attributes only thirty days' provisions to the king.[50]

Alexander crossed into Asia with enough supplies for thirty days, according to Phylarchus, whereas Aristobulus relates that the king had seventy talents.[51]

Plutarch does us the great favor of citing his sources for the various data he reports, which makes it possible—by a process of elimination—to determine the likely primary source behind some of those contrasting numbers mentioned earlier from the Opis speech in Arrian and Curtius. As a general (though not absolute) rule, material found in Arrian that did not derive from Aristobulus can be traced to his other main source, Ptolemy.[52] Since Plutarch's amounts for debts and assets go back explicitly to Aristobulus and Onesicritus, some of the figures cited in Alexander's speech at Opis can perhaps be traced back to Ptolemy.[53] Together with the month's supply of provisions recorded by Duris and Phylarchus, this collection of financial information from Ptolemy(?), Aristobulus, and Onesicritus seems full and reliably early. Unfortunately, the various calculations do not agree on either side of the ledger:

Assets	Debits
60 talents (Ptolemy?)	500 + 800 talents (Ptolemy?)
70 talents (Aristobulus)	200 talents (Onesicritus)
30 days' provisions (Duris, Phylarchus)	

Several factors may account for the disparities. First, of course, some numbers may be right and others erroneous or exaggerated. Second, the figures surely take into account different things: debts at accession, debts accrued subsequently, mobile provisions, and perhaps money as opposed to wealth in general. The reckoning

given in the Opis speech by Curtius and Arrian is directly related to Alexander's inheritance in 336 BC, but with the obvious addition of debts accrued some time later by Alexander himself. Likewise, Plutarch appears to be conflating diverse estimations across the first years of Alexander's reign using numbers he has sought for just that purpose.[54] In his biography, Plutarch reports his figures in the context of the king's crossing into Persia, with the two references to a single month's military provisions especially appropriate for that circumstance. Some of his other numbers may be a hodge-podge of financial data calculated from the start of the reign and/or the start of the Asian campaign.[55] We are faced with a pastiche of data that does not quite add up for any particular moment, but which agrees in the overall impression of a young king's desperate financial straits.[56] That impression, however, is intended by our sources and has been supported by monetary data selected for that very reason. The details need not be invented out of thin air to be misleading.

In such cases, it is wise to triangulate, to seek other vantage points or independent evidence to test the literary tradition and its intentioned numbers. Material evidence, in fact, provides a different window on Alexander's world, one filled with signs of great wealth. Alexander inherited not one palace, but two (at Aegae and Pella), whose excavated ruins can still be walked with some appreciation of their original grandeur, as shown in Figure 2.1.[57] One of the hallmarks of archaeology over the past fifty years has also been the unexpected quantity and quality of tombs and buried treasure excavated in northern Greece. The history of Macedonia's material culture has been rewritten by stunning discoveries not only at Pella and Aegae (modern Vergina) but also at Derveni, Dion, Philippi, and Aiani.[58] The goods carried to the grave by Macedonians of various ranks belie the old view, stoked by the calumny of Demosthenes, that the region was poor, backward, and barbarian.[59] The elite left tombs that make it clear how sophisticated their tastes and how wealthy

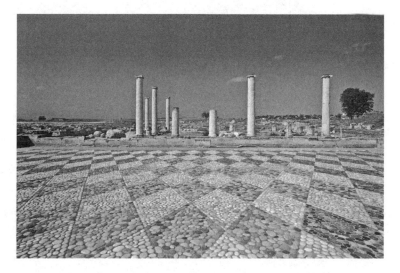

Figure 2.1. Macedonian Palace at Pella. © *Vanni Archive/Art Resource, New York.*

their mourners were. Gifted artists fashioned from a ready supply of gold and silver the finest of jewelry, parade armor, funerary wreaths, and other luxury items. In particular, the Macedonians interred expensive metalware used in the symposium. What Demosthenes's Athenians had fancied and fashioned of clay, the Macedonians one-upped in bronze, silver, and gold, setting a new standard for luxury.[60] Tombs decked out with thrones, walls richly painted, bodies dressed in gold from head to toe, carvings in ivory, textiles woven from golden thread—these examples of disposable wealth do not quite square with penury.[61] Many Macedonians were no doubt poor, but the king and his companions were not among them.[62]

Archaeologists have unearthed more than a dozen fine tombs at Vergina, the palace site where Philip fell dead.[63] One of those graves may well represent the fulfillment of Alexander's first royal duty, the burial of his father in requisite splendor. This commission probably entailed the young king's first major expenditures, for the building of the stone structure, its painted decoration, and the collection of

treasures worthy to stock it. Two of the graves in the so-called Great Tumulus, shown in Figure 2.2, have been identified as the possible resting place of Philip II: Tomb I, a cist burial containing magnificent murals but otherwise robbed in antiquity; or Tomb II, a larger and more elaborate dual-chambered, barrel-vaulted tomb still containing its treasures.[64] Within days of discovering these two tombs in November 1977, their excavator Manolis Andronikos announced his hypothesis that Philip lay in the second tomb.[65] He described the materials in Tomb II with such words as "exquisite," "magnificent," "amazing," "unparalleled," and "wondrous"—items worthy of a monarch such as Philip II.[66] These grave goods continue to be the stars of books and traveling art exhibitions showcasing the antiquities of Macedonia.[67] Meanwhile, scholars worldwide have done what their

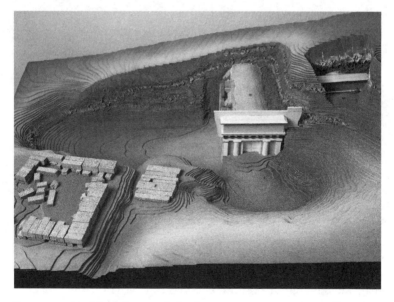

Figure 2.2. Model of the Royal Tombs at Vergina. © *Gianni Dagli Orti/The Archive at Art Resource, New York.*

training requires; in articles, books, and academic conferences, they have tested the arguments of Andronikos, some siding with the discoverer and others proposing alternative theories. For instance, one group favors the view that Philip II was interred in Tomb I, while his son Philip III Arrhidaeus (Alexander's half-brother) was buried in Tomb II.[68] Adding to the controversy has been the relentless pace of archaeological work in and around Vergina, with various tombs now being attributed to other members of the royal family: Alexander's son Alexander IV in Tomb III of the Great Tumulus, Philip II's mother in the so-called Eurydice tomb nearby, Alexander's alleged son Herakles in the precinct of Eukleia, and so forth.[69]

It would be convenient if the chronology and contents of these tombs could be fixed with enough certainty to know which one marks the beginning of Alexander's reign.[70] Even so, this might not matter much to the question of Alexander's wealth. Those who associate Tomb II with Philip II must acknowledge that the new king inherited enough treasure to honor Philip regally, but so might Tomb I if it had not been plundered in antiquity. The only surviving points of comparison are the structure and decoration of the two tombs, Tomb I having the finer interior painting but Tomb II the more elaborate façade. Tomb II is certainly larger and architecturally more complex, but it lacks the above-ground cult shrine (heroon) that was clearly built in conjunction with Tomb I.[71] We cannot say that either burial was meager or in any way indicative of strained finances, although one tentative suggestion has been made in that direction. According to Ian Worthington,

(significantly) no coins have been found in any of the burials at Vergina. Perhaps (and only perhaps) the absence of coins in Tomb II ties in with Alexander's need for all the money he could lay hands on because of his father's cash shortages.[72]

Of course, the first statement negates any need for the second: if none of the other burials at Vergina contained coins, there is no reason to explain their absence from Tomb II, least of all by positing— no matter how tentatively—the extraordinary circumstance of a king having not one coin to spare. Since Worthington accepts Tomb II, with what he calls its "many precious and beautiful grave goods," as the one Alexander prepared for Philip, it is all the more difficult to imagine that had the son wished to include a coin or two, he could not afford the gesture.[73] Just one of the two gold coffers (*larnakes*) in Tomb II, illustrated in Figure 2.3, weighs in at 7.79 kilograms (17.1 pounds), enough to produce over 900 Macedonian gold coins.[74] What remains of the charred gold wreath found inside this coffer, parts of which were consumed in the funeral pyre, weighs enough to

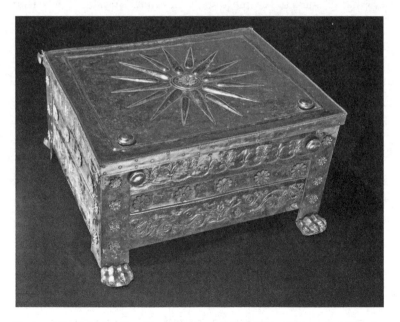

Figure 2.3. Gold Larnax from Vergina. © *DeA Picture Library/Art Resource, New York.*

mint another eighty-four gold coins.[75] Nor was the high value of the silver objects lost on those who placed them in the grave: five pieces of the silver plate abandoned in Tomb II had their exact weights inscribed on them for administrative purposes, the largest marked "94 drachmas and 3 obols."[76] The tomb is a testament to the wealth its builder was willing and able to leave buried beneath the soil.

WAR AND WEALTH

Poor, bankrupt Alexander appears to be the exaggeration of a temporary dearth of currency in the treasury of a powerful and wealthy royal family whose resources were never limited to money alone. To be sure, the young king was *relatively* impoverished at the outset of his reign: he was poorer in 336 BC than he would be in 333, and poorer then by far than he would be in 330 or 323.[77] This does not mean, however, that he was ever poor in the way that Plutarch suggests with the phrases "insignificant inheritance" and "such great poverty." The consistency of the trope (a virtuously poor Alexander makes good on his meager inheritance) and the diversity of the selected figures (from Alexander and/or his contemporaries) may result from feeding the theme a steady diet of accurate but incomplete numbers. It must be remembered that Alexander inherited resources deemed by his father sufficient for the start of his war with Persia, an invasion that was partly underway and soon to begin in earnest.[78] The reported debts probably reflect short-term loans meant to cover the imminent military advance, monies that might in due course be repaid through plunder, requisitions in enemy territory, and tax revenues from conquered lands.

At the moment when Alexander was allegedly broke on the eve of his march into Persia, he was able—like his father—to host lavish celebrations and sacrifices.[79] As before, the banquets, games, and

other entertainments are described as sumptuous. Designed to reverence the gods and rouse his army, these preparations were a necessary investment. It did not hurt that various portents of success were observed or invented at the same time.[80] Most important, Alexander strove to ingratiate his officer corps by every means possible. He therefore made a show of distributing some of his royal patrimony to the companions (*hetairoi*).[81] These lucrative benefactions included farmlands, villages, and the revenues from various harbors and other entities. Although not mentioned, such crown property might also mean timber concessions, vineyards, and tax grants.

Some ancient admirers fashioned from this story a compelling testimonial to Alexander's selfless generosity in the face of poverty, alleging that one companion (Perdiccas) and then perhaps others worried that their king would give away everything and leave nothing for himself.[82] Alexander famously countered that his own hopes lay in Asia, to which Perdiccas replied, "Then we shall share those hopes as well, for it is not just to take your possessions, but rather to wait for those of Darius."[83] Clearly, the thrust of the anecdote is that the plunder of Asia would solve the penury of Europe. Justin, who does not include the Perdiccas vignette, nevertheless makes the same point:

> Alexander gave away to his friends all of his ancestral property in Macedonia and Europe, declaring that Asia would provide enough for him. . . . The Persian Empire, he added, was ripe for harvesting by better stewards, to which his soldiers agreed. Already forgetting their families and the dangers of fighting far from home, the men thought only of Persian gold and the boundless wealth of the East that beckoned as their personal plunder.[84]

While there is surely some romantic exaggeration in the extent of both Alexander's poverty and his generosity, two things are

certain: the king did bestow some such boons upon his close com-
panions, and these grants anticipated the wealth to be won in Asia.
In his discussion of Macedonian royal gifts to *hetairoi*, Miltiades
Hatzopoulos suggests that Alexander borrowed heavily from his
companions to help fund the invasion of Persia, in essence guar-
anteeing the loans by granting his followers future revenues from
his crown holdings.[85] This would give his followers a stake in the
war and cover any temporary arrears of the king until recouped by
Persian treasure. The fact that Antipater could manage Macedonia's
affairs throughout Alexander's absence by drawing primarily on
the state's normal revenues shows that Alexander gave away noth-
ing that harmed the homeland.[86]

Even after he became the wealthiest man in Europe and Asia,
Alexander endured temporary cash-flow problems. These were
matters of liquidity, not outright poverty, as in 326 BC when the
king again needed cash, this time in India. Plutarch preserves the
anecdote wherein the king, too far removed from the resources
he needed, demanded money from his companions to help fund a
naval operation.[87] Alexander sought 300 talents (1.8 million drach-
mas) from Eumenes, who claimed he could only with difficulty lay
hands on a hundred (600,000 drachmas). Aggressively testing his
compatriot, the king set fire to Eumenes's tent to see what else he
might be hiding; the blaze reportedly melted more than a thousand
talents of silver and gold. This solicitation of funds from his *hetai-
roi* suggests a temporary means of subsidizing the campaign, draw-
ing on plunder being carried by his marshals. It will be shown that
these spoils had only recently been accumulated after the king had
destroyed the army's excess baggage, including his own, perhaps
leaving him shortsightedly low on funds. His resources at this point
late in his career were not poor, just perhaps poorly managed.

The periodically flush then cashless soldier was a mainstay
of the ancient military, and a Macedonian king was no different

except in degree.[88] Scholars generally accept that Philip practiced a military economy that cyclically flooded then depleted his ready cash from campaign to campaign.[89] Philip may well have been short of certain liquid assets in 336 BC, but he nonetheless was wealthy by the standards of the day and could expect soon to be far richer from the spoils of war. Those who insist that "Philip never plundered or pillaged conquered lands or their people" have a strange view of history.[90] They have obviously never walked among the ruins of Olynthus or read the ancient sources describing Philip's sack of that city. We are told that "After plundering the city, he sold off the people and property to raise large sums of money for continuing the war."[91] As long as a king was winning wars, his economic security seemed assured and the waste or want elsewhere in his realm seldom troubled his sleep.

Like father, like son. When Alexander was eighteen, Philip summoned him to review the rudiments of war at his side.[92] At the time, Philip was busy setting an example of plundering "like a pirate" (*de piratica*) "to recoup like a businessman the costs of one war by waging another" (*more negotiantium inpensas belli alio bello refecturus*). Note the casual juxtaposition of piracy, business, plunder, and war.[93] Although sometimes cash-strapped, these two kings oversaw a dramatic expansion of Macedonian military power. In 358 BC, Philip commanded an army of 10,600 Macedonian citizen soldiers; under Alexander, that figure rose to 26,800 in 334 BC and then to about 42,000 by 322.[94] Thanks in no small part to looting, campaigning on credit was common in antiquity, and Alexander himself—even when fabulously rich—ran up huge arrears for things like troop pay until it was convenient to settle his accounts.[95] Armies were expensive to equip and maintain; idle armies were prohibitively so. Only conquest paid the bills.[96] For many such rulers, war was all about wealth as a pathway to fund more wars.[97] This

fact explains in part why Philip and his son set their sights so firmly on the East.[98]

To sum up, the words "poverty," "bankrupt," and "broke" do not convey the reality of Alexander's financial status in 336/335 BC. These terms ignore the totality of the king's resources and exaggerate the cyclical cash shortages that often accompanied the onset of new military campaigns within the constraints of Macedonia's war-driven economy. That exaggeration suited Alexander's rhetoric at Opis, and it reinforced a motif known best to us in the works of Plutarch. It enhanced Alexander's reputation for self-made greatness and selfless generosity, but it is not altogether fair to Philip or Darius.

Conquest, Up Close and Costly

The most valuable items of all the plunder realized in Greek warfare were the adult natives of both sexes, hunted down and brought in by the predatory victorious troops to be sold as slaves.

W. K. Pritchett, *Ancient Greek Military Practices*

The laws of mankind are clear on this point: When a city falls, the victors own all that lies within, people and property alike.

Xenophon, *Cyropaedia* 7.7.73

The hell of war has a way of hiding behind higher ideals such as esprit de corps, patriotism, sacrifice, and valor. These virtues make the best of a bad business, but historians must acknowledge both sides. Those who would praise the economic outcome of Alexander's wars are obliged to recognize the inescapable downside of conquest, represented in Figure 3.1. War redistributes wealth violently. Massacres, confiscations, deportations, the sacking of cities, and the selling of survivors into slavery all dispense property with a heavy hand. It is gain for some at great cost to others. Alexander did not just enrich himself with the idle treasures of a rival king; many thousands of nonroyal people also lost their property, freedom, and lives through the harsh and impersonal blunt instrument of war. Most narratives of Alexander's reign that do pay attention to these ravages leap from city to city, siege to siege, and battle to

REPORTED CASES OF NON TAX REVENUE

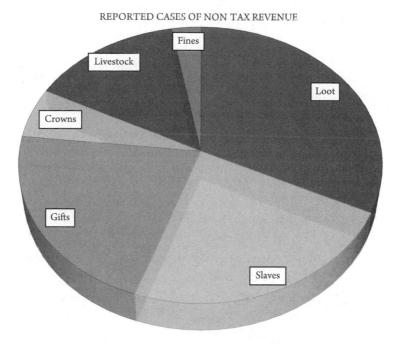

Figure 3.1. Chart Showing Incidence of Nontax Revenue. © *Frank Holt.*

battle without acknowledging how much common people and the agricultural countryside also suffered.[1] So, before examining the more famous caches of royal wealth seized by Alexander and his army in great cities, it is important to consider first the depredations endured by ordinary people along the march of the Macedonians.[2] In doing so, it should be noted that looting was such a normalized byproduct of ancient warfare that it seldom received comment except in extraordinary cases, and even then it was an activity that defied accurate quantification. This is particularly true of the plundering of private rather than royal property in situations that were chaotic and at times undisciplined.

BALKAN TREASURES

After burying his father, Alexander busied himself right way with the monumental task of securing his throne and stabilizing Macedonia. Philip did not leave his son poor, but the rolling economy of military finance was temporarily delayed. The march against Persia had to wait, stranding an advance force of about 10,000 troops in Asia Minor while the main army tarried with Alexander in Europe.³ None of these men could be idled. They had to be employed profitably, which meant at someone else's expense. In Asia Minor, this required eighteen more months of living off the land, requisitioning by force whatever was needed. Meanwhile, Alexander intended to supplement the customary revenues of his realm by seizing as much plunder as possible in the Balkans.

The new king had done this before. In 340 BC, when Alexander was only sixteen, his father had briefly left him in charge of Macedonia.⁴ Making the most of this opportunity, Alexander had led an expedition into Thrace, attacked a local tribe called the Maedi, seized their principal settlement, and founded a new city there named Alexandropolis.⁵ This was Alexander's first taste of real command and its rewards. It is little wonder, then, that just a few years later he began his own reign in much the same way. After asserting his right to succeed Philip as leader (*hegemon*) of the Corinthian League and commander of the Greek war against Persia, Alexander embarked on a lightning campaign into Thrace and Illyria.⁶ Certainly there were good strategic reasons to launch a show of force prior to quitting Europe, but a seizure of wealth was another motivation not lost on Arrian, here our principal source. Twice he notes the collection and speedy transport of loot back to Macedonia.⁷ First, an unspecified amount of Thracian plunder was placed under the command of Lysanias and Philotas. The military escort was not perfunctory; Philip II had previously lost what he

CONQUEST, UP CLOSE AND COSTLY

had plundered in this region when, heavily laden on his way home, he was attacked and wounded by the Triballi.[8] Alexander's booty safely traveled "down to the coastal cities," presumably Maroneia and Abdera, and thence to the treasuries of Macedonia.[9] A second convoy followed when Alexander's men looted and leveled a Getic town near the Danube River. Two prominent Macedonian officers, the battalion commanders Philip and Meleager, took charge of this shipment. Their rank suggests the importance of the treasure.[10]

The quantity and quality of transportable wealth available to the victorious Macedonians may be judged by examining the luxury goods characteristic of Thrace during this period.[11] Excavations and chance finds in modern Bulgaria have yielded a growing list of impressive Thracian troves from the mid- to late fourth century BC, such as the Panagjurishte Treasure, the Lukovit Treasure, the Rogozen Treasure, the Vorovo Treasure, and the Sveshtari Treasure buried by the Getae in tombs rivaling those of the Macedonian royals at Aegae. These objects include exquisite gold and silver bracelets, wreaths, pendants, rings, drinking vessels, and military trappings. The Rogozen Treasure, for example, contained 165 silver and gold objects, while the gold in the Panagjurishte Treasure weighed 8.5 kilograms (18.7 pounds).[12] While it is unlikely that Alexander's army targeted the wealth buried in tombs, they surely took from the living items of similar manufacture.

Yet, more than metals, Arrian stresses the human haul of Alexander's campaigns in Thrace and Illyria. After some 15,000 Thracian warriors were killed, nearly all of their women and children were seized along with their chattels.[13] In Illyria, too, many more were killed and others enslaved.[14] Creating slaves was one of the key aims of ancient warfare.[15] Indeed, imperialism and slavery were both "normal" aspects of violent domination and wealth creation. Prisoners of war had no rights, and the Greeks had no qualms about slaughtering them, usually quite publically and sometimes

47

ritualistically.[16] Captives might be shot down with javelins, stoned, drowned, strangled, hanged, crucified, or beheaded. Enemies spared by ancient armies were sometimes tortured and mutilated.[17] In fact, the horrors of captivity were at times so frightening that people chose to kill themselves and their families rather than be seized. On several occasions, the inhabitants of cities attacked by Alexander committed mass suicide in their homes.[18]

Alexander did not limit to his northern neighbors his drive to enslave for profit; Greeks were also fair game. An attempt at Thebes to defy Alexander's hegemony drew the king quickly south, with tragic consequences. The storied city fell to Alexander's forces late in the summer of 335 BC. It was thoroughly looted and, except for its temples and the house of its famous poet Pindar, leveled to the ground with the complicity of regional allies in the Boeotian League.[19] For this, Alexander bears no more blame than his contemporaries since the nature of ancient warfare legitimized looting and enslaving the losers. With great indifference, war divided the world into victors and victims, the haves and haves-no-longer. It may be argued, in fact, that Thebes was to Europe what Persepolis was to be for Asia—a deliberate and decisive act of policy designed to send a strong message to Alexander's opposition.[20]

Among the treasures claimed by Alexander was an elaborate candelabrum that he dedicated to Apollo at Kyme, plus a famous painting by Aristides that he carried home to Pella.[21] Again, however, the human costs were far higher. One particular outrage in the general plundering of the city involved a troop of Thracian allies whose Macedonian commander raped a prominent woman named Timocleia and then demanded all her property.[22] She lured her abductor to a well in which she claimed all her gold and silver had been hidden.[23] When the greedy officer went down to investigate, Timocleia and her servants rained stones upon him until he died.

Timocleia was arrested and brought before Alexander for punishment. The king instead pardoned her and set her family free, a dispensation for which the king has long been lauded in literature and art (see Figure 3.2). Unfortunately, this notable act of compassion did little to assuage the suffering elsewhere in Thebes. Indiscriminate slaughter inside the city claimed 6,000 lives, and another 30,000 allegedly fell into slavery.[24] In addition to what Diodorus called "the unimaginable amount of plundered wealth" carried out of Thebes, the sale of these prisoners brought the king another 440 talents of silver, equal to 2,640,000 drachmas.[25] The destruction of Thebes was not just a political and military act; it was also very much a calculated economic undertaking. For many unfortunate inhabitants of Thebes, this was the second time in just three years that they had been captured for profit by the Macedonians.[26]

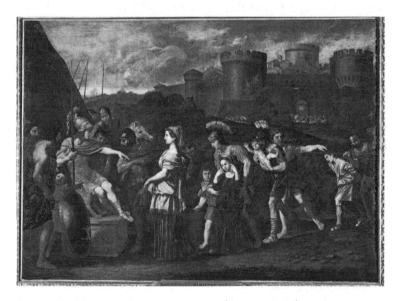

Figure 3.2. Timocleia before Alexander (Domenichino). Musée Bossuet, Meaux, France. © Scala/White Images/Art Resource, New York.

ASIA MINOR

Leaving his general Antipater with 13,500 soldiers to guard Greece, Alexander finally crossed the Hellespont and swept into Asia Minor during the spring of 334 BC with some 37,000 troops and a fleet of about 200 warships.[27] Steeped in ceremony, the occasion warranted more expensive sacrifices, the ritual casting of a spear into enemy territory, and a symbolic visit to the site of Troy.[28] Taken together, these gestures spun the invasion as the justifiable continuation of an age-old war whose winner owned Asia by right of conquest. Now in Persian territory, young Alexander allegedly admonished his men to avoid any unnecessary destruction of prop- erties that they were soon to possess.[29] On their side, the Persians likewise rejected the advice of Memnon to lay waste the lands through which Alexander had to travel.[30] Indeed, not plundering was also a military tactic: Alexander specifically left the personal estates of Memnon untouched just to arouse suspicion among the Persians that this Greek mercenary captain in the Great King's ser- vice might have made a secret deal with the invaders.[31] In any case, fighting and foraging had been depleting this area ever since Philip had sent over his advance force years earlier. For example, Memnon squeezed hard the citizens of Lampsacus to cover his expenses, and even resorted to cutting the pay and rations of his soldiers.[32] Also, at the same time that Memnon in 335 BC was pillaging the country- side around Cyzicus, the Macedonian general Parmenion was sack- ing the city of Gryneium and selling its citizens into slavery.[33] Thus, rival armies had been plundering this land long enough to convince both sides to let matters rest on one great battle, winner take all.

That battle took place along the banks of the Granicus River. Although nearly killed in hand-to-hand fighting, Alexander pre- vailed.[34] It was a victory over satraps and condottieri rather than Darius himself, but a triumph nonetheless that gave the invasion

vital momentum. It also brought captured treasures, most of it presumably rifled from the baggage of the many Persians who fell.[35] The looting of the loser's camp was a regular feature of warfare, and Alexander's men relished this privilege with each great victory over the Persians at the Granicus (334 BC), Issus (333 BC), and Gaugamela (331 BC). Every time, the quantities of treasure grew exponentially. At the Granicus, Alexander sent the lion's share of luxury items (drinking vessels, purple cloth, etc.) to his mother Olympias in Macedonia.[36] The rest was dispersed more symbolically to serve state ends.[37] Prisoners, of course, always formed part of the loot. The king ordered a massacre of Greek mercenaries, showing his greater concern for political rather than economic gain. The survivors, traitors to his Pan-Hellenic cause, were bound in chains and condemned to hard labor in Macedonia.[38] Their suffering sent a powerful message. To Athens he sent 300 Persian panoplies, meant to decorate the Parthenon as payback for the temple of Athena destroyed by Xerxes in 480 BC. The dedication was to read. "Alexander son of Philip and the Greeks, but not the Spartans, took these spoils from the barbarians who dwell in Asia."

To honor those of his soldiers who died in the battle, Alexander bore two notable expenses.[39] First, he commissioned Lysippus to create bronze statues of the Macedonians who had perished in the first surge of battle.[40] In his discussion of this monument, Andrew Stewart calculates its probable cost as 65 to 69.5 talents (390,000 to 417,000 drachmas).[41] This was immediately after Alexander's entire war chest had allegedly totaled just 70 talents (420,000 drachmas), according to Plutarch. Stewart's figure, if correct, means that Alexander had rapidly made up for any shortages of wealth, real or imagined. Alexander already could afford this magnificent gesture, as well as its sequel. He cancelled all rents on the royal lands held by the parents and children of the fallen, as well as their personal liturgies and property taxes. How this bore upon the gifts of crown

revenues and properties already lavished upon his *hetairoi* is not clear, but these grants suggest that the king had not disposed of all his claims to such wealth and still had windfalls to give. Even if this new gesture merely entitled the families of the fallen to inherit the older gifts, it constituted a more or less permanent loss of revenue to the treasury at a time when the king was allegedly not far from broke. These outlays were no doubt carefully engineered to make the very most of the military victory at the Granicus, but there is little reason to believe that Alexander was thereby willing to bleed resources at a perilous rate. Back in Macedonia, Antipater required regular access to revenues sufficient to maintain a standing army that was often called into action as Alexander moved farther and farther away.[42] The muscle of Alexander's military never atrophied for want of wealth.

Victorious, Alexander assumed control of the surrounding Persian territory and dealt with its administrative status. The king's thinking proved remarkably conventional: from satrapy to satrapy, Alexander's first inclination was to continue the local policies and practices already in place. In many ways, the reign of the young monarch followed seamlessly that of Philip in Europe and Darius in Asia. Alexander, of course, had to appoint a new regional governor since the previous one, Arsites, had fled the battle and then committed suicide.[43] Alexander chose Calas, a Macedonian, but retained for him the Persian administrative title of satrap.[44] Significantly, this Calas had gained local experience as a commander in the expeditionary army sent over by Philip II, so he had been serving in this region for some time. Calas was probably the brother of Harpalus, the man who became the notorious treasurer of Alexander's empire. Whether this means that Calas also claimed some interest in financial matters is unclear, but certainly he became responsible for inaugurating Alexander's fiscal authority in Asia. While much of the bureaucracy remains invisible to us, the organization stretching

below the chief treasurer and his staff eventually included satraps (mostly Graeco-Macedonians, such as Calas), some regional trib-ute collectors (all Graeco-Macedonians, such as Nikias in Lydia and Asclepiodorus in Babylonia),[45] treasury wardens in major cities on the model of the Persian system, local tribal leaders and head-men as seen in the Aramaic documents from Bactria, and of course the unit commanders and their clerks traveling with the army, such as Antiphanes (Companion Cavalry), Eugnostus (mercenaries in Egypt), and Evagoras (Hydaspes flotilla).[46]

The Macedonian king ordered the inhabitants of Hellespontine Phrygia to pay the same tribute (*phoros*) as they had previously rendered to Darius.[47] For their part, the local Greek communities instead paid a "contribution" (*syntaxis*) to the Hellenic war effort. It seems likely that the Greeks' *syntaxis* was commensurate with their previous *phoros* in all but name, the nominal distinction being necessary only to reinforce the propaganda of liberating the Greek cities of Asia Minor and enlisting their participation as "free" allies in the overthrow of Persia.[48] Individual cities, or groups within cit-ies, were punished or pardoned according to their levels of coop-eration.[49] Liberation politics made it expedient for Alexander to cancel the *phoros* paid to Persia by many of the Greeks in Aeolis and Ionia, with the exception of Ephesus, Aspendus, and Soli.[50] The king threatened to destroy Lampsacus but treated Zeleia gen-erously.[51] After capturing Miletus, Alexander let the city's Greeks go free while selling into slavery all the Persian inhabitants.[52] The citizens of Priene, including those living in other towns, were declared free and independent while their non-Greek neighbors' lands Alexander decreed to be his own.[53] Later, in southern Asia Minor, Alexander exacted from the city of Aspendus a promise of 50 talents (300,000 drachmas) to support the war, in addition to requisitioning the horses bred there as tribute to the Persian king; when the Aspendians tried to renege on the agreement, Alexander

doubled the amount of money as punishment and also ordered an annual tribute to be paid to Macedonia.[54] In other words, unruly Aspendus paid both a *syntaxis* to the Greek league and a *phoros* to the Macedonian crown. Soon thereafter, the king fined the city of Soli the extraordinary sum of 200 talents (1.2 million drachmas) "because it favored the Persians over the Greeks."[55] The neighboring city of Mallus, on the other hand, fared much better; its *phoros* was cancelled altogether on the specious grounds that the inhabitants share with Alexander an Argive ancestry.[56] This tax exemption for one city was probably meant to augment by comparison the punishment of its neighbor. Alexander could not squeeze more money out of Soli (in fact, he subsequently lowered the fine), so he did the next best thing—he lavished rewards on nearby Mallus. Money had many uses, and Alexander learned to exploit them all.[57]

THE MIDDLE EAST AND BEYOND

During the first phase of Alexander's invasion of Persia, the populations in Asia Minor felt unevenly the ravages of war. Sometimes Greeks suffered most, at other times Persians. It must be remembered, too, that Alexander's army did not pillage alone. The enemy also imposed painful demands on the region's economy. For example, the city of Mytilene turned against Alexander and invited into its walls a Persian garrison, only to have its new protectors wring money from the rich and poor alike.[58] Elsewhere, as some Persian forces retreated, they carried away what they wanted and destroyed the rest—as Memnon had originally urged them to do. Arsames, who governed Cilicia, devastated his own province with fire and sword (*igni ferroque*) so that Alexander might capture no more than a smoldering desert.[59] The citizens of Tarsus, anticipating the plundering and torching of their city by the retreating Persians,

appealed to the Macedonian invaders for rescue. By forced marches, Alexander's army arrived just in time to save the city.[60] Prior to the Battle of Gaugamela, Darius ordered his satrap of Babylonia to pillage and then burn everything in Alexander's path.[61] Later, when Darius had lost the battle and was arrested by his own men, the Persian mutineers were "gluttonous for plunder" (*praedae avidum*) as they marched in disorder toward Bactria.[62]

The anarchy that often accompanies armed conflict allowed other cases of looting by rogue elements. Particularly shocking, a prominent Macedonian named Amyntas son of Antiochus made a career of this behavior.[63] Having deserted to Persia early in Alexander's reign, Amyntas next abandoned the cause of Darius as well following the Battle of Issus, "thinking that the state of affairs entitled every man an undisputed right to seize whatever he could."[64] As "an enemy of both kings," he fled to Cyprus with a large force of Greek mercenaries, then led about 4,000 of them to Egypt. Because Sauaces the satrap of Egypt had perished at Issus, Amyntas pretended to be the new governor there. He was challenged—at first unsuccessfully—by Mazaces, commander of the Persian garrison at Memphis. For a time, Amyntas and his men waged a private war in Egypt for the sole purpose of plundering its riches. As these raiders scattered to seize the finest estates in the countryside, the Persians and Egyptians finally rallied and killed them all.[65] This sort of self-appointed power occurred again in 325 BC, when Alexander released from service thousands of mercenaries who then "wandered around all of Asia sustaining themselves by plundering wherever they went."[66] Unofficial wars and concomitant looting erupted all around the edges of the main conflict.

History tends to see the world through a telescope, one event at a time within a universe of surrounding activity. What appears to us as a single campaign with Alexander at its center was, in reality, a series of conflicts impacting people across a broader time

and space. By chance, we can hear the voice of one of the persons caught up in these larger events. An Egyptian physician named Semtutefnakht has left a stone memorial describing how he navigated many treacherous turns of fortune in the late fourth century BC.[67] This man from a priestly family survived the Achaemenid reconquest of Egypt, endeared himself at the Persian court, and later accompanied Darius III to Issus.[68] He probably served as a noncombatant in the Persian medical corps. During the battle, he records with obvious hyperbole, the Greeks slew millions around him but none raised a weapon against him, for which he thanked his protecting deity Herishef. In a dream, this deity then advised Semtutefnakht to flee back to Egypt. The physician escaped alone to the nearby coast and sailed home "without losing a hair" on his head. This resilient man is a rare eyewitness who reminds us of six Egyptian regime changes in just twelve years—not to mention the additional struggle between Amyntas and Mazaces.[69] Just one of his travails was a miraculous escape, vouchsafed by divine intervention, from the onslaught of the main Macedonian army in Syria. Perhaps most amazing of all, he seems to have escaped financial ruin.

Not everyone was so lucky. After defeating Darius at Issus, Alexander's army pillaged both the temporary baggage camp nearby and the main depot at Damascus. The first supplied the victorious soldiers with

plunder consisting of heavy loads of gold and silver, the stuff of luxury rather than war. Because the pillagers could not carry it all, the roads were littered with the enemy's less valuable packs, which the greedy scorned as less worthy. Then the victors arrived at the women and, the more precious their jewelry, the more violently it was stripped from them. Nor were the captives' bodies spared the brutality of the captors' lust.[70]

Alexander took custody of Darius's family, including his mother and his wife, who retained their privileged lifestyles while also providing valuable leverage as hostages. These captives, queens, and concubines were carried about with the army for years.[71] Arrian reckons the baggage pillaged at Issus as worth "no more than 3000 talents" (18 million drachmas) because the larger part had been left at Damascus.[72] The latter depot Alexander set aside for Parmenion and the Thessalian cavalry to seize as a reward for their valor, "wishing for them to profit accordingly."[73] There Curtius claims that Parmenion's troops found articles wrought of silver weighing 500 talents (over fourteen tons), not including the coined money that amounted to 2,600 talents (15.6 million drachmas).[74] Darius's coins had traveled to Damascus on the backs of 600 mules and 300 camels, escorted by a guard of archers.[75] More than 6,000 additional pack animals and allegedly 30,000 camp followers also fell into the victors' hands. A remarkable inventory of some of these persons survives in the following extract of a letter sent by Parmenion to Alexander, detailing all that was seized at Damascus in very specific numbers:

> I found 329 of the king's musically-trained concubines, 46 of his male wreath-weavers, 277 cooks, 29 pot-men, 13 milk-workers, 17 drink-tenders, 70 wine-workers, and 40 perfumers.[76]

All of this, says Plutarch, was the invading army's first taste of true wealth, and thenceforth Alexander's soldiers "were like hounds on the trail of Persia's treasures."[77]

After the prolonged siege of Tyre, we find in Arrian the conventional figure of 30,000 captives, as at Damascus and Thebes; the actual number is probably nearer 13,000.[78] Most of these were women and children, auctioned away on the slave market. At Gaza a few months later, some 10,000 Persian and Arab defenders perished

and Alexander sold off the women and children.[79] From there he shipped home to Macedonia "great quantities of spoils" to family and friends, including one massive gift of 14.2 tons of frankincense and 2.8 tons of myrrh destined for his stingy old tutor Leonidas.[80]

When Alexander marched south and took control of Egypt unopposed, he proclaimed himself

the ruler of the rulers of all the lands; the mighty lion who seizes possession of the mountains, fields, and deserts; the strong bull who protects Egypt; the master of the sea and all the sun encircles; beloved of Re and chosen of Ammon; the son of Ammon, Alexander.[81]

These titles, carved into a pedestal that once stood before the temple of Alexander at Bahariya Oasis, do not extol the king as a wise and progressive economist. He does not present himself as a liberator of idle wealth; he is not even a builder of cities or promoter of trade. He has chosen from the pharaonic repertoire a series of names that boast of conquest and power, not to mention divine favor and a divine father.[82] Here Alexander is a lion and a bull, not an owl or a lamb. On other Egyptian monuments, we find versions of Alexander's Horus name that describe the king as brave, strong-armed, and "the One who attacks foreign countries."[83] The Greek meaning of the king's name (Ἀλέξανδρος, "Defender of People") has been cleverly rendered in an Egyptian context.[84] This is the world in which Alexander must be understood as a man and a monarch, even when he was annexing territories without a fight.

Combat resumed in earnest once the king left Egypt to face down Darius at Gaugamela. Victory opened the way to dazzling riches from the royal coffers of Babylon and Susa, seizures covered in the following chapter, while the general population felt the

press of the Macedonians as well. Sometimes, for political reasons, Alexander offered protections to the locals; at other times, he did not. A cuneiform tablet tells us that at Sippar (near Babylon) on October 18, 331 BC, the Macedonian king issued a pledge that his troops would not break into the private homes of Persians.[85] This order seems to reflect his worried negotiations in the first days after Gaugamela, but it was a benevolent gesture that did not extend to Persepolis. There, according to Diodorus, Alexander unleashed the full fury of his army:

> Alexander declared Persepolis to be the most onerous city in all Asia, and gave it to his soldiers to plunder, with the exception of the palaces. It was the wealthiest city under the sun and the private homes there had been filled over the years with all sorts of desirable things. The Macedonians rushed in, killing all the men and robbing all the residences since even the common folk owned fine furnishings. Much silver and no small amount of gold were pillaged there, along with very expensive clothing, some of it dyed with purple from the sea and some embroidered in gold. All of this fell into the hands of the conquerors.... The Macedonians indulged themselves in frenzied looting for a full day without satisfying their lust. They were so thoroughly consumed with greed that they fought with each other and killed many comrades who had grabbed a greater share. Certain of the most valuable spoils discovered were hacked apart with swords so that each might have his portion. Some men were so crazed that they chopped off the hands of those grasping for disputed pieces. They forcibly carried off the women and their finery, making these captives their slaves. Inasmuch as Persepolis surpassed all other cities in wealth, so too it exceeded all in its misfortune.[86]

Similarly, Curtius describes soldiers fighting over the spoils, adding that many Persians could do little more than burn themselves and their families to death inside their homes.[87]

Surely the pathos of this episode has been heightened in our sources, but at the core of these accounts lies an ancient reality— plunderers did grapple over their prizes, and victims did burn themselves and their property.[88] Some scholars would prefer to dismiss the destruction of Persepolis altogether, but these accounts cannot be wished away.[89] Nor is it accurate to claim that "Until Persepolis in winter 331-330, nothing explicit is said about looting and booty being permitted to Alexander's men."[90] It has been shown previously, for example, that in 333 BC Alexander allowed Parmenion and the Thessalians to enrich themselves by looting Damascus. At that same time, adds Plutarch, "the rest of Alexander's army was also filled up with wealth, giving the Macedonians their first taste of gold, silver, women, and barbarian luxury."[91] In fact, the penchant for plundering became increasingly difficult for the king to control even in territories that had already surrendered. In Aria, Alexander had to send ahead troops to protect the locals from his own army as it passed.[92] The king's precautions are praiseworthy, but the need for them suggests a culture of rapacious soldiery unconstrained by orders alone.

Silver and gold were not the only prizes of conquest. From the hill tribes of the Uxians, who dared claim independence both from Darius and Alexander, the young king exacted not luxury goods, but something more vital to humble villagers.[93] After killing many of the Uxians asleep in their beds, the Macedonians "gathered great amounts of plunder."[94] In this case, the haul consisted primarily of cattle and horses since these hill-people "were herdsmen who owned no money or croplands." Thereafter, Alexander continued to demand an annual tribute from these villagers of 100 horses, 500 transport animals, and 30,000 cattle.[95]

When counting the costs of ancient warfare, animals such as these must not be overlooked. If horses wrote history, the reign of Alexander would be a dark chapter indeed. Not many of the 4,200 Macedonian cavalry mounts that set out with the king to conquer Persia could survive the long ordeal and thus had to be replaced from local stocks.[96] Alexander himself lost three steeds, including his favorite Bucephalus, and a rare report in Arrian tells us that at Gaugamela over a thousand Macedonian horses died of wounds and exhaustion.[97] A year later, when about 2,000 Thessalian cavalrymen were discharged from service at Ecbatana, they sold their horses before leaving.[98] The reason was not want, for each man had been given all his back wages plus his salary for the trip home, along with a bonus of one talent each (6,000 drachmas). The men might be discharged, but not their trained warhorses; these were needed by those remaining with Alexander. For the losing side, matters were always worse. One is reminded of the famous Alexander mosaic found at Pompeii that shows a mangled Persian warhorse at the very center of the composition, its last breath foaming in blood, one hoof severed and a broken spear embedded in its flank (see Figure 3.3).[99] This creature represents tens of thousands of fallen horses consumed by these cavalry-intensive campaigns. It is little wonder, then, that Alexander frequently requisitioned large numbers of replacements.

Seizing horses and cattle often meant crippling rural populations, sometimes with explosive consequences.[100] This certainly occurred in Bactria and Sogdiana, where desperate indigenous peoples rallied to save their livestock. A long and costly insurgency erupted there soon after Alexander "replenished from the surrounding territory his supply of cavalry horses, since many had perished" in recent marches through mountains and desert.[101] The fighting settled into a devastating series of cattle raids, each side struggling to steal all the region's resources and so to starve out the other.[102]

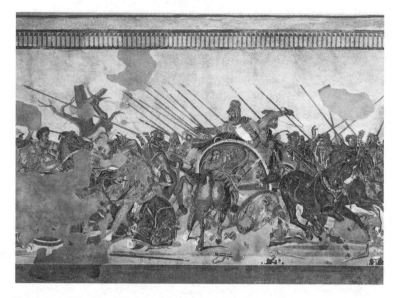

Figure 3.3. The Issus Mosaic. Museo Archeologico Nazionale, Naples, Italy.
© Eric Lessing/Art Resource, New York.

Atrocity followed atrocity as the war of attrition intensified into a war of annihilation.[103] In 329 BC, Alexander ordered that seven Sogdian cities, including Cyropolis and Gaza together with their outlying villages, be pillaged and utterly destroyed.[104] The invaders "slew all the men, as Alexander instructed, and seized the women, children, and other spoils."[105] Then, Alexander sent his army into the Polytimetus (modern Zerafshan) valley with orders to level the villages, burn the crops, and kill the people. Modern estimates of the death toll reach well beyond 100,000 men, women, and children.[106] To repopulate the region, Alexander forcibly settled Greek soldiers in military colonies. These unhappy men were recompensed with the booty plundered from the dead and displaced locals. For instance, at the so-called Rock of Ariamazes, the king accepted the

surrender of the inhabitants, only then to torture and execute the leading families; the survivors were enslaved and distributed, along with the captured money (*pecunia capta*), to the new settlers.[107]

Alexander's treatment of the native peoples in Bactria and Sogdiana was no harsher than his handling of the Greeks he found living among them. The Branchidae in Sogdiana were an expatriate community from Asia Minor that had settled in Central Asia 150 years earlier.[108] They still clung to their Hellenic heritage and surrendered their town with great joy to Alexander, who butchered them to the last man as traitors. The site was then thoroughly looted and every structure razed; finally, the invading Greeks felled all the nearby trees and even burned out the stumps so that no vestige of the Branchidae might remain. The uncomfortable savagery of this incident is no grounds for dismissing it.[109]

As the army pushed on to India, leaving more than 23,000 men behind to resettle and garrison the ravaged lands of Bactria and Sogdiana, the depredations continued.[110] In fact, Plutarch claims that at this point the troops were so hard-pressed to haul their personal accumulations of booty that Alexander ordered them to burn it.[111] The men gave away whatever was needed by others, possibly to the settlers being left behind, and destroyed the rest.[112] Plutarch notes that only a few soldiers showed annoyance at the order since "by this time the king was greatly feared."[113] Another explanation besides logistics may be that an army sated with lucre had little incentive to seek more.[114] The prospects for plunder in India, "a land filled not only with gold but also gems and pearls," were supposed to rival those of Persia.[115] After the Battle of the Hydaspes, Alexander allegedly exhorted his men to think of the spoils from Persia as cheap and ordinary (*vilia et obsoleta*) and to imagine filling their homes with Indian gems, pearls, gold, and ivory.[116] So, "to gain the goodwill of his troops, the king allowed

them to pillage for themselves the enemy's country, which held treasures of every kind."[117] Among his field officers, Ptolemy took the lesson to heart and did the same thing some thirteen years later in Cilicia, letting his troops loot "in order to fire their enthusiasm."[118] Alexander also appeased his men by establishing monthly rations for the wives and children they had acquired on the march, and by distributing 25,000 expensive new panoplies inlaid with gold and silver, plus gold tack for their horses.[119] The royal provisioning of the camp followers may have been necessary because the men no longer had their earlier spoils to provide for their dependents. A second time the loot-laden army, struggling back to Babylon through the Gedrosian Desert in 325 BC, had to "set fire to the spoils for which they had marched to the farthest reaches of the East."[120] The king stepped in again to cover the devastating and demoralizing loss.

Seldom has the world witnessed such an insatiable juggernaut chewing through thousands of miles of conquered territory. Compared to Alexander in India, Sherman's infamous five-week, 300-mile "March to the Sea" in 1864 diminishes in scale. For example, in just about a week, Alexander managed to exterminate nearly all the inhabitants of a large district in the southern Punjab of India.[121] This entailed the deliberate targeting of noncombatants, including the massacre of defenseless refugees caught on the open road or crossing rivers. From the embattled towns and tribes in India that survived, the king demanded more tribute.[122] For those who resisted, the populations were sold into slavery or slaughtered.[123] As a result,

> vast tracts were simultaneously laid waste with fire, devastation, and massive slaughtering. Before long the soldiers had piled up much plunder, and the bodies of those they killed numbered beyond many tens of thousands.[124]

We may find embedded in our sources some rough measures of what this invasion meant for the Indus Valley. First, the general Eumenes alone amassed in India more than a thousand talents of gold and silver.[125] Second, Alexander's companion Onesicritus wrote a highly laudatory account of the kingdom of Musicanus, which he visited and studied.[126] That somewhat idealized report was extracted by Strabo (14.34), who tells us that Musicanus's subjects enjoyed extraordinarily long and healthy lives free of corruption. This utopia and its ruler did not long survive, however, for Musicanus dared revolt against the Macedonians.[127] Alexander razed his cities and rounded up the survivors as slaves; Musicanus and the Brahmans of his nation were summarily crucified.[128]

South Asia did not soon forgive the passage of Alexander's army. Some of those left in charge by Alexander were assassinated by disgruntled natives, others by unhappy settlers.[129] Even Alexander's main naval base in southern India came under attack by emboldened natives determined to drive the Macedonian fleet away.[130] The invader's footprint shrank quickly throughout the region as the king's garrisons emptied. In the judgment of A. B. Bosworth, "For all the ostensible victories and all its dreadful carnage the campaign in India had proved a failure in the end."[131] This is true in terms of Alexander's aspirations to integrate India into his empire, but the king did achieve one goal—he thoroughly looted these exotic lands before leaving.

The enthusiasm with which Alexander's troops sacked the East echoes in a dedication later made to Zeus by the citizens of Thespiae in Boeotia, honoring their avenging soldiers "who destroyed Persian cities with Alexander in barbarian Asia."[132] It is easy to admire Alexander's success and to envy his financial gains, and it is natural to sympathize with those like the Thespians who

followed him loyally through hardships of every kind. Yet, the impact of this war on hapless civilians was immeasurably devastating even though these practices were generally acceptable by ancient conventions. When, for example, Moses answered the call of God to defeat, slaughter, enslave, and plunder the Midianites, the very people who had sheltered Moses while he was exiled from Egypt, the bloody results were apparently not brutal enough. Trying harder to please God, Moses next ordered the execution of "every male among the little ones" and of all the women, too, except young virgin girls to be kept as slaves.[133] The cruel truth is that no ancient place or people escaped the ebb and flow of pain and plunder that marks the tides of war.[134] For this reason, our sources make no effort to hide the importance of looting in the lives of leaders such as Alexander.[135]

From Thrace and Thebes to Persepolis and the Punjab, no accurate accounting is possible of the human and ecological costs of Alexander's conquests. Our sources mention more than two dozen populations enslaved by Alexander, giving the profits in only one case—the 440 talents at Thebes. Without question, the number of civilian casualties—men, women, and children killed or enslaved—far exceeded losses in battle for all sides. Property damage and destruction—whole settlements and cities razed to the ground—defies imagining, as does the wastage of cattle and croplands. In many places, a generation of men disappeared with no slight impact on the economic and social lives of those left behind. In all of this there is no sign that Alexander's policies changed over time. He was as quick to loot and enslave in India as he had been at the beginning in the Balkans. He remained as willing to pardon or punish Greeks as Asians. If anything, it was the king's army that grew fonder of plundering as the campaign continued, their greed manipulated at times by the king and then

his successors. Alexander was born rich and royal; his troops and generals found in war the novel opportunity to become both. Men of little means amassed tons of gold and silver, and some of them became kings in their own right. Such were the deadly attractions of war and wealth in the world of Alexander the Great.

Chapter 4

Reciting the Sword's Prayer

We should pray that our enemies be endowed with all good things except courage, so that their possessions will belong no longer to them, but to us by the sword.

Antisthenes

Alexander had either accepted in surrender or taken by storm many cities crammed with royal treasures, but the wealth from this one city eclipsed all that had come before.

Curtius 5.6.2

Antisthenes, a follower of Socrates, recites without conscience the ancient supplication of looters.[1] Curtius, for his part, names the greatest beneficiary of that prayer. Darius III, of course, was the biggest loser—though not for lack of courage.[2] While many commoners lost their lives and livelihoods as the Macedonian army made its way across the Persian Empire, none forfeited more to Alexander's glory than his royal adversary. The Great King of Kings endured loss after loss among his troops and his treasuries until finally, on a lonely stretch of road near Hecatompylus, ill fortune claimed his life as well.[3] It was a dreadful era for royals. The last three kings of Achaemenid Persia were all assassinated (Artaxerxes III Ochus, Artaxerxes IV Arses, and Darius III), followed by the gruesome dismemberment of Darius's self-proclaimed successor Artaxerxes V (Bessus). Alexander's side fared no better. Although

it is only rumored with little reliability that Alexander himself was assassinated, there is no doubt that most of his family was murdered, including his uncle (Alexander II), father (Philip II), mother (Olympias), sister (Cleopatra), half-brother (Philip III), half-sisters (Cynnane, Thessaloniki, and Europa), stepmother (Cleopatra), wives (Roxane, Stateira, and Parysatis), and sons (Heracles and Alexander IV).[4] The rich and the famous were as ill-fated as anyone else in the fourth century BC.

THE LORD OF ALL YOUR FORMER POSSESSIONS

The Greeks as a whole had dreamt of Persia's royal wealth for many years, awaiting only an opportunity to seize it.[5] Some sense of that longing may be seen in the works of not only Greek historians, playwrights, and pamphleteers but also potters and painters who imagined the Persians as wealthy, womanly, and weak.[6] Achaemenid Persia was luxury personified, the perfect place for plunderers. The series of cities referenced earlier by Curtius, each crammed with royal treasures, began with Sardis in Asia Minor. There Alexander hastened after his first victory at the Granicus River to claim its royal treasury.[7] Although no source indicates how much of the Great King's wealth was found stored at Sardis, its confiscation certainly was a priority for Alexander.[8] The commander of the Persian garrison, Mithrines, unexpectedly surrendered the well-guarded treasure without incident, one of Alexander's luckier moments in the war.[9] The king ordered a Macedonian named Pausanias to take Mithrines's place in Sardis and directed Nikias, a Greek otherwise unknown, to assess and collect the local tribute. It was clearly Alexander's aim to gather up all that the retreating Persians had left behind and to begin collecting the local revenues

now due him as king and conqueror.[10] This pattern of revenue gathering and administration persisted throughout the first years of his invasion.

The next recorded stop along Alexander's route of royal Persian repositories was Gordium, the capital of Phrygia and former home of King Midas (he of the golden touch).[11] From treasures seized there, Alexander was able to send 1,100 talents (6.6 million drachmas) back to the seacoast and thence to Macedonia.[12] Notably, on his best day, Philip had been able to send home "only" 700 talents of plunder.[13] In Cilicia, the king no doubt helped himself to the royal treasures stored at Cyinda.[14] At Damascus, beyond the wealth abandoned by Darius and his army at Issus, the Macedonians discovered 2,600 talents of coined silver worth 15.6 million drachmas, along with over fourteen tons of wrought silver.[15] Having frightened away the Persian porters, Parmenion's men helped themselves:

> Scattered across all the fields lay the treasures of the king, including his money meant to pay the army, the refinements of many noblemen and women, gold vases, gold bridles, tents decked out in royal magnificence, and also abandoned chariots filled with treasures, all creating a sight sad even for the plunderers to the extent their greed allowed, for parts of that wealth accumulated over so many years, incredible and beyond belief, could be seen torn by branches and trampled in the dirt. The hands of the looters were incapable of taking it all.[16]

From this point onward, Alexander's claim on the wealth of Darius was absolute. According to Arrian, the Macedonian wrote the Persian a letter in which he admonished, "Henceforth when you write to me, address me as King of Asia, and not as an equal, asking of me as the lord of all your former possessions whatsoever you may need."[17]

In Memphis, the satrapal capital of Egypt, Alexander received from the Persian governor Mazaces a trove of royal equipment plus an additional 800 talents (4.8 million drachmas).[18] It is uncertain how much the recent fighting between Mazaces and Amyntas, discussed in the previous chapter, may have diminished these revenues. Regardless, in just two years of campaigning, the young king had enriched himself mightily from the provincial stores of his royal adversary. A Babylonian compilation known as the "Dynastic Prophecy" includes an embedded piece of propaganda that censures the invading Macedonians as bent on "plundering and robbing" Darius III, who in turn planned to rebound and bring back to his palaces all the war's booty.[19] This Persian triumph was to be followed by a period of restored happiness and prosperity across the land. That dream, of course, was never realized.

BOOTY BEYOND IMAGINING

The battle of Gaugamela on October 1, 331 BC, marked the military climax of Alexander's war against Persia. A fascinating contemporary Babylonian clay tablet refers to Darius at the outset of this battle as "the King of the World," but afterward transfers that title to Alexander.[20] In victory, Parmenion and his troops seized the Persians' baggage train along with some elephants and camels.[21] Reversing their roles after Issus, Alexander himself hastened to the main depot some seventy miles away at Arbela.[22] There the king confiscated many of his opponent's traveling possessions, although it was said that Darius made off toward Media with 7,000 or 8,000 talents (worth 42 million to 48 million drachmas).[23] Nonetheless, Alexander seized at Arbela the vanquished king's chariot, shield, weapons, clothing, food, and a treasure that included 3,000 to 4,000 talents of silver (worth 18 million to 24 million drachmas).[24]

According to Arrian, Darius had fled secure in his belief that Alexander could not resist the massive booty now awaiting him as "the true stakes of the war."[25] Curtius attributes a speech to Darius that reflects the same thinking; in it, Alexander and his army are described as crazed for treasure and sure to glut themselves on Persian gold.[26] Diodorus mentions Darius's plans in the later context of the surrender of Susa, whose dazzling treasures were hoped to preoccupy the Macedonians.[27] Ironically, the material fortunes of war had reversed poles. Henceforth, Darius allegedly saw himself as virtuously poor while Alexander fell sway to wealth and luxury.

As the Macedonians marched down through Mesopotamia, no capable force stood between the invaders and the grand capitals of the Persian Empire. In Babylon, Susa, Persepolis, and Ecbatana stood palaces and royal treasuries that the Persians could no longer protect. The shocked officials left in charge could do little more than negotiate the handing over of keys to the kingdom.[28] When the satrap Mazaeus surrendered Babylon some three weeks after Gaugamela, it was an event one modern scholar calls more decisive than the battle itself.[29] Not to be outdone by the compliant satrap, Bagophanes the custodian (*ganzabara*) of the Babylonian royal treasury strewed Alexander's path with flowers and welcomed his new king with gifts that were— practically speaking—already Alexander's.[30] Bagophanes then led Alexander on an inspection tour of the treasury.[31]

The young conqueror's triumphal march into Babylon followed age-old Eastern protocols going back to Cyrus and beyond, and it inspired Western visions of opulence for centuries to come, beginning with the Romans. The painting in Figure 4.1 shows how Charles Le Brun imagined the gaudy processional for the pleasure of Louis XIV circa 1665.[32] In the foreground, men muscle the spoils of conquest past the Hanging Gardens far in the distance, while between them lumbers Alexander's chariot pulled by a bejeweled elephant. In 1675, Gérard Audran produced a huge fifteen by

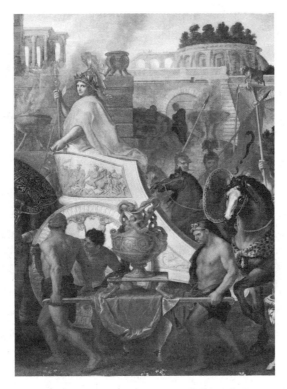

Figure 4.1. Le Brun's *Alexander Entering Babylon* (detail). Musée du Louvre.
© *Erich Lessing/Art Resource, New York.*

twenty-three–foot engraving of Le Brun's work, adding to it an inscription about virtuous heroes that dispels any notion of linking embarrassment with riches.[33] Sébastien Le Clerc sought in 1703 to one-up his fellow French artists by cluttering his scene with many more men staggering under the weight of much more treasure.[34] This preoccupation with pageantry and plunder still finds expression today, such as the lavishly expensive re-enactment of Alexander's entry into Babylon staged by Oliver Stone for his 2004 film *Alexander*.[35]

Unfortunately, no source records the quantity of royal treasure found stored at Babylon, called by Curtius "the richest of cities."[36] This is a strange and vexing lapse among authors who took some note of the treasures later seized at other Persian capitals. We know that Alexander toured the Babylonian treasury and remained in the city long enough to make a thorough inventory, but we have been afforded no insight into what he found. We learn only that Alexander set aside part of those riches to reward his soldiers beyond the booty seized by them at Gaugamela.[37] Both Diodorus and Curtius seem to follow a common source for this disbursement.[38] Diodorus reports his figures in Near Eastern minae, while Curtius converts them to Roman denarii: six minae/600 denarii for each Macedonian cavalryman, five minae/500 denarii for each allied cavalryman, and two minae/200 denarii per Macedonian infantryman. Given the usual equivalence of one Roman denarius to one Greek drachma, these sums tally perfectly. There lingers, however, some confusion about various combat units; for instance, did Alexander's allied Greek and Balkan infantry receive the same payout as the Macedonian phalangites, or some lesser (unstated) amount? This question is important for modern efforts to deduce from these numbers the overall salary structure of Alexander's army.[39] This problem is exacerbated by a further reference in each source to mercenaries' (or other groups') pay by monthly stipends that are difficult to calculate. What were the salary differentials between various mercenary units, such as infantry and cavalry? Do these figures exclude the value of daily rations? Furthermore, most modern translations of Curtius recite the same data as Diodorus regarding the mercenaries ("two months' pay"), even though Curtius's text actually reports "three months' pay."[40] Thus, any reassurance of identical sums regarding mercenary pay comes to us only by way of a modern emendation of one text to match the other.

As might be expected, our knowledge of Alexander's forces at Gaugamela does not match precisely the military units being paid at Babylon a few weeks later.[41] Faced with this dilemma, we can do no better in assessing the payout at Babylon than to include the mercenary cavalry among the allied cavalry, lump the allied Greek and Balkan infantry with the Macedonian infantry, and use the smaller of the two reported mercenary stipends (two months rather than three) with a proposed mercenary pay scale of four obols per day.[42] This rough calculation suggests a total payment of about 10.5 million drachmas (over 1,757 talents). While this is a huge outlay by Greek standards, Alexander had allegedly seized about twice that amount from Darius's traveling purse at Arbela. Given this observation, the distribution at Babylon could not have seriously dipped into his new-found fortune. It required, however, the minting of some bullion into currency. This task fell to old Mazaeus, the first of the Persians to retain administrative power, who became Alexander's satrap of Babylonia with the Greek Asclepiodorus as collector of taxes.[43] Mazaeus struck the coins on the Attic standard but bearing local designs and his own name in Aramaic rather than the Alexander types introduced in Phoenicia.[44]

Flush with cash and feasting on the larders of the Babylonians, Alexander's army spent more than a month enjoying the city.[45] A leisurely march then brought the invaders—augmented along the way by reinforcements from Greece—to the gates of Darius's next imperial capital, Susa.[46] The expected pomp played out again as gift-bearing delegates welcomed the conquerors into their city. This time, the sources offer relatively full accountings of the royal treasures surrendered there, although with a few discrepancies among them:

Diodorus 17.66.1–2: More than 40,000 talents of uncoined gold and silver, plus 9,000 talents of gold darics

Plutarch, *Alexander* **36**: 40,000 talents of coins, and untold other valuables, including 5,000 talents' weight of 190-year-old purple dye[47] and water stored from the Nile and Danube Rivers

Justin 11.14.9: 40,000 talents

Arrian 3.16.7: 50,000 talents of silver, plus all the other royal possessions, including famous plundered artworks

Curtius 5.2.11–15: 50,000 talents of uncoined silver, plus royal furniture

These figures reveal three things about the literary tradition. First, some authors (and their sources) chose to list interesting treasures beyond precious metals, such as dyes, potables, furniture, and artwork.[48] Second, all of the Alexander historians reported one of two base amounts of metals, either 40,000 or 50,000 talents. Finally, three writers make some effort to identify how much of these metals was, or was not, in the form of struck coinage. According to the writer Polycleitus, who may have been with Alexander at Susa, it was the Persians' custom to hoard there the royal tribute of gold and silver in the form of bullion and gift-worthy wares rather than coinage, which was struck only as needed.[49] A preponderance of unstruck metals is consistent with all of the reports listed previously, except that of Plutarch.

There is a general tendency to favor Diodorus's reporting because it appears to be more precise. Taking the talents all to be valued as silver, we can have the one figure of 40,000 and add the darics to get the other of nearly 50,000.[50] In a rather loose way, this brings most of the numbers into some sort of underlying agreement. The problem remains, however, that it brings the numbers into rough alignment by ignoring the commodities that go with them. Obviously, reporting 40,000 talents of uncoined bullion (Diodorus) is not quite the same as 40,000 talents of coins (Plutarch) or 50,000 talents of

uncoined silver (Curtius). This is no great setback when seeking a ballpark valuation, but it raises questions about what these writers found or misrepresented in their sources. At best, we may argue that Alexander's inventory of the Susa treasury revealed precious metals worth about 49,000 talents of silver (equal to 294 million drachmas), some but not all of it coined, in addition to many other luxury items.[51] This amount justifies the remark made by Aristagoras to Sparta's king Cleomenes in Herodotus's history: "If you capture Susa, you may compete with Zeus himself for riches."[52] For Alexander, far greater was yet to come.

THE SACK OF PERSEPOLIS

The Macedonian entry into Persepolis had none of the pomp and ceremony staged previously at Babylon and Susa. Rather, as described in chapter 3, Alexander let his troops ravage everything in the city except the royal quarter, which would itself be destroyed in due course. Instead of the stately processions painted by Le Brun and Le Clerc, for Persepolis we have the fiery and frenetic canvases of Georges-Antoine Rochegrosse's *L'Incindie de Persépolis* and others such as Figure 4.2.[53] The change reflected in these artworks and in the sources that inspired them seems especially dramatic. What compelled such a grim transformation? That question has become one of the most vexing in all of Alexander scholarship.[54] Many have made the burning of Persepolis a "big picture" problem that reflects all the dynamics of Alexander's reign, from geopolitical to personal. Whatever interests us in that world, we inevitably find it illuminated by the flames over Persepolis: Alexander's anxiety about the bickering city-states back home, a sign of the king's growing alcoholism and dementia, a sincere effort to avenge 150 years of Persian interference in Greece, a last warning to Darius, a savage revelation

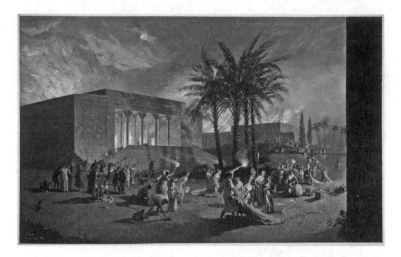

Figure 4.2. The Burning of Persepolis. © *NGS Image Collection/The Archive at Art Resource, New York.*

of the conqueror's true self, a deliberate break between the kingships of Darius and Alexander, and so on.[55] Sir Mortimer Wheeler insisted that "the burning of Persepolis marked a major divide, not merely in the particular history and archaeology of Eurasia, but in the broad history and archaeology of ideas."[56]

We must be careful, however, in our musings over the fate of Persepolis. What happened there was certainly extraordinary in its planning and execution, but it was not a turning point in Alexander's treatment of captured cities. It was not a "new" Alexander who destroyed a city to send a message, but rather the same one who had leveled Thebes and Tyre. When we are surprised that the king ravaged Persepolis after doing nothing similar to Babylon and Susa, we forget the patterning of Alexander's campaigns. The question is not so much why Persepolis, Thebes, Ecbatana, or Sangala, but why not Athens, Babylon, Susa, or the kingdom of Porus. As in the case of Mallus and Soli, the king often paired mercy and revenge,

with pardon serving as a "force multiplier" for punishment. In a sense, Alexander played "good cop, bad cop" on a global scale. So to imagine that Alexander at Babylon was the real king and the one at Persepolis an aberration misses the point: it took both to conquer.

The comparatively mild treatment of Babylon and Susa was patently political. The Macedonian king knew that the treasures at Persepolis far exceeded those of the other sites, and that these riches were in obvious danger. To burn through Babylon and Susa on his way there would only encourage the locals at Persepolis to despoil the treasury before his arrival, a possibility that remained even after Alexander's studied moderation toward Babylon and Susa.[57] In the future, too, Alexander would need Babylon and Susa (as he would also need Athens and Porus), but once the king had his hands on its treasury, Persepolis was as expendable as Thebes or Tyre. Alexander chose to make an example of Persepolis for a number of reasons. He did encounter some stiff resistance in route to the city, led by Ariobarzanes, the satrap of Persis; a pathetic band of old, mutilated Greek prisoners did meet their countrymen outside the city gates, begging sympathy for their plight; and perhaps Alexander did see Persepolis as answerable for past Persian inroads into Greece.[58] Alexander's actions may well have been driven by policy (the original propaganda of Pan-Hellenic revenge), pique (the resistance of Ariobarzanes), and pathos (the Greek invalids).[59]

Months after sacking the city of Persepolis, the burning of its palace complex completed Alexander's mission there. The emptying of the treasury ceremonially broke the connection between the Achaemenid kings and their greatest repository of regal gifts, symbols of generations of loyalty and obeisance to a now-defunct dynasty. There are essentially two versions of how this happened.[60] Arrian offers a perfunctory account that masks just how long Alexander spent at Persepolis.[61] He mentions only that Parmenion opposed the burning of the palace, warning that the Persians would

be less likely to support a vindictive conqueror and reprising that old conceit about recognizing these properties as now belonging to the victor. Alexander, however, was determined to punish the Persians for destroying Athens 150 years earlier. Arrian expresses his own censure of the deed, siding with Parmenion. Even more briefly, other sources state that Alexander burned Persepolis's palaces to avenge the Greeks for Persia's attacks on their temples and cities.[62]

The opposing version does not dispute the motive of revenge but does emphasize the role played by an Athenian prostitute named Thais, who urged Alexander and his drunken guests to torch the palace in a more or less spontaneous frenzy.[63] To whatever extent the moment of final destruction was triggered by these revelries, the narrative makes clear Alexander's intention all along to burn the palaces before leaving. Planning "to utterly destroy Persepolis," the Macedonian king first spent months clearing out valuables from the royal quarter.[64] To do so, he had to embark upon a considerable logistical operation that required sending to Mesopotamia for thousands of pack and harness animals, inventorying and crating a vast and bulky treasure, and transferring loads under guard to Susa and perhaps other repositories. Diodorus recounts this chronology straightforwardly, while Curtius conflates aspects of the two burnings (the city and then the palaces). Nonetheless, Curtius's narrative makes it obvious that the palaces were not fired until months after the Macedonians' arrival, after the treasury had been substantially emptied at great effort by Alexander.[65] There apparently remained a scattering of valuables still in the palace complex that were hastily pillaged by soldiers as the final conflagration spread.[66] These included articles of royal clothing, furniture, and statuary; most notably, Curtius adds the oddly specific report that the troops smashed with pickaxes a cache of fancy vessels.[67] This seemingly random act of senseless destruction is an important chronological clue, as will be argued later.

Archaeological evidence supports this sequence of events lead-
ing to the fiery climax of Alexander's sojourn at Persepolis. In fact,
there is no other moment in Alexander's campaigns that is so well
corroborated by excavation. Modern scientific exploration of the
Persepolis ruins began with the Iranian government's 1924 solici-
tation of a conservation prospectus from noted archaeologist Ernst
Herzfeld.[68] Excavations under the aegis of the Oriental Institute at
the University of Chicago were led by Herzfeld from 1931 to 1934,
and then by Erich Schmidt from 1935 to 1939.[69] These and subse-
quent efforts revealed the elegantly juxtaposed remains of several
palatial structures on the royal terrace, as seen in Figure 4.3. There
are monumental gateways and staircases, public and private rooms,
massive columns, courtyards, a sprawling audience hall (*apadana*),
and a vast ornate treasury.[70] The wares stockpiled in the treasury,
indeed all the buildings themselves, were the accumulated glories
of many kings stretching back through the Achaemenid dynasty to

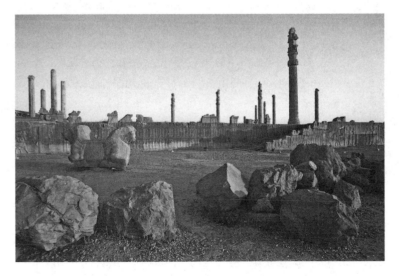

Figure 4.3. Ruins of Persepolis. © *Kazuyoshi Nomachi/Corbis.*

Darius I—the founder of the city. When Alexander ascended the grand stairway to the royal terrace and strode through the soaring Gate of All Nations, the Achaemenid palaces were stunning and secure; when he and his army departed some four months later, all lay desolate. Archaeology affords a rare glimpse into that metamorphosis, illuminating centuries of Persian history that ended with a single infamous day in the life of a strong man armed.

The palace complex at Persepolis served as a museumlike showpiece of Achaemenid power, where splendors reflecting the expansive heritage of the Persian Empire were put on proud display. Like the storage rooms of a modern museum, material not on exhibition in the adjacent Hall of a Hundred Columns and elsewhere rested in the palace treasury. One of the first structures built on the royal terrace, this treasury measured 134 by 78 meters, covering the area of two American football fields.[71] Built of mudbrick with thick outer walls, the self-contained windowless structure comprised some 100 rooms, corridors, and courtyards with its roof supported by over 300 painted wooden columns standing on stone bases. Its flooring showed the wear of constant activity along circuitous, restricted pathways. Above, in a second-story repository, clay tablets were kept as records of special payments disbursed from hoarded silver, but these transfers were small and local in nature rather than major transactions involving the imperial army, taxation, or grandiose construction projects.

Some idea of the luxury items housed inside the treasury may be seen in the *apadana* reliefs carved nearby, which show the annual tribute brought by delegates to the New Year's festival.[72] As in Figure 4.4, we witness the procession of emissaries, arriving from all quarters of the empire, bearing textiles, jewels, ornately formed bowls, ivory, gold, silver, and containers filled with spices. These objects piled up century by century, setting the Persepolis treasury apart from all others in the empire.[73] Scant remains of these

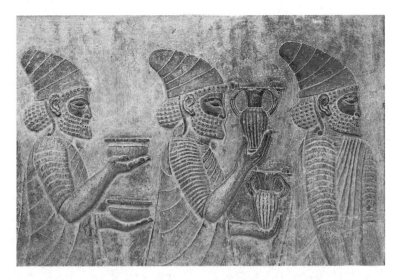

Figure 4.4. Tribute Bearers at Persepolis (Apadana). © *DeA Picture Library/Art Resource, New York.*

treasures were found in the archaeological excavations. Recovered from the debris was a modest scattering of beads, pendants, pins, clasps, buckles, bracelets, rings, sculpture fragments, tools, and weapons. Materials included agate, onyx, lapis lazuli, turquoise, amethyst, amber, coral, alabaster, rock crystal, glass, and quartz, along with metals. Only twenty-one coins were found in the treasury excavations, most of them already old when the place was sacked, and none of them Achaemenid.[74]

Of special note was a concentration in Halls 38 and 41 of inscribed mortars, pestles, plates, trays, and what the archaeologists called finely crafted royal tableware fashioned from stone. During the final destruction of the treasury, about 900 of these objects were methodically smashed by the Macedonians in a deliberate act of "seemingly senseless vandalism."[75] This discovery illuminates the reference made by Curtius (cited earlier) to

just this sort of activity. We can be sure that this smashing was not done during the initial looting of the city when Alexander first arrived in January 330 BC, as Curtius's conflated narrative might seem to suggest. Soldiers would not have bothered wrecking stone tableware, even if some of it had gold or silver trim, while rummaging through Persia's greatest treasury. Nor would this litter of broken stoneware have been left in the way during the four months that Alexander's men paced these floors, packing and hauling off the surrounding wealth. Curtius's narrative, in any case, otherwise supports the clearing of the treasury prior to its burning. Only in the context of that last act, when the king gave his soldiers leave to help themselves to anything left and, perhaps in a frenzy of drink and emotion, also to smash into pieces the royal and ritual wares of the enemy, does the archaeological evidence make sense.[76]

Supporting this view of deliberate, vengeful destruction is the fact that the final incineration did not spread from a single location on the royal terrace, but resulted from simultaneously targeted fires aimed foremost at Xerxes's residential palace (Hadish), the *apadana*, the Hall of a Hundred Columns (Throne Room), and the treasury—all closely associated with the Achaemenid ruler who destroyed Athens.[77] So, whereas there are few traces of fire in the residential palace of Darius (Tachara), that of Xerxes was annihilated beyond reconstruction. The calculated nature of the event is all the more notable if archaeologist Alireza Shahbazi, former director of Persepolis, is correct that stone slabs, removed from the treasury and arranged outside, served as preplanned bleachers for "spectators who were *watching* the fire."[78] The spectacle at Persepolis was meant to be "the funeral pyre of the Hellenic crusade"[79] and a sight never to be forgotten.

To our knowledge, Alexander never built anything anywhere that rivals what he destroyed at Persepolis. He allegedly felt at a

later time some remorse for what he had done, as he did also for Thebes.[80] The parallel to Xerxes at Athens is certainly evocative, for the Persian king first stripped the Acropolis treasures and then burned the temples, only to show some regret for it afterward.[81]

A HISTORIC HAUL

Whatever may have been taken by soldiers or destroyed by fire and axe in the final days of Persepolis, Alexander confiscated and hauled away his largest fortune yet. He had the treasurer Tiridates to thank for safely handing over these riches.[82] The invading king was always fortunate in the compliance of Darius's financial officers, and this one, too, was rewarded.[83] The contents of the treasury received a rudimentary valuation in the literary sources, but one that boggled ancient minds no less than our own. According to Curtius, the wealth (*pecunia*) said to be in the treasury verged on the unbelievable, but he concluded that if other details were to be accepted, then so must the figure he found: 120,000 talents (worth 720 million drachmas).[84] Diodorus reports the same total, but with a little more precision about what was being measured: "gold and silver worth 120,000 talents, reckoning both in terms of silver."[85] A strict reading would suggest that many of the treasures were not included in the appraisal, such as furnishings, artwork, jewelry, gems, spices, and other wares. Plutarch mentions only that as much coined money was discovered at Persepolis as at Susa, which means by his own account 40,000 talents (240 million drachmas).[86] Strabo provides a total for both Susa and Persepolis of 40,000 talents, with an alternative figure of 50,000.[87] Justin/ Trogus merely hints that Alexander was surprised by just how much treasure he commandeered from Persepolis, while Arrian is silent on the matter.[88]

As usual, these numbers are not satisfactory by modern standards, for they give only a rough approximation of a single commodity stored at Persepolis, namely, the precious metals (coins and bullion). The tally ignores all other valuables, including probably the gold and silver inlays and fittings that adorned cups, bowls, furniture, and other items. These appurtenances would be difficult to quantify under any circumstances, and we know only from bits and pieces found in the excavations that "all categories of objects made of precious metals are represented by far more specimens of gold than of silver."[89] Furthermore, the figures for Persepolis, even more than those for Susa, fixate on the formulaic number 40,000 and its multiple 120,000. This does not completely discredit the data, but it raises suspicions that what we are really being told is that the amounts were "huge" and "extremely huge" rather than precisely 40,000 and 120,000 talents, respectively.[90] As George Grote long ago cautiously observed:

> Such overwhelming figures deserve no confidence upon any evidence short of an official return. At the same time, we ought to expect a very great sum, considering the long series of years that had been spent in amassing it.[91]

We may gain some control of these huge figures by two means: first, by comparing the talents to the number of animals used to haul them from Persepolis; and second, by examining the total figures for all Persian treasuries given by some sources for the next stage in Alexander's campaigns. The Macedonian king requisitioned thousands of baggage animals to ferry his wealth away from Persepolis. Diodorus 17.71.2 mentions "a multitude" of mules and other beasts of burden, plus 3,000 camels; Curtius mentions pack animals and camels without numbering them; Plutarch, *Alexander* 37.4, enumerates 20,000 mules and 5,000 camels. These numbers

do not all match, but they invite us here, as at Damascus, to examine the carrying capacity of a given train to see if it was sufficient for all or part of the reported load. One attempt to do this was made in the groundbreaking study of Alexander's logistics published by Donald Engels in 1978.[92] He proposed that:

Parmenio was ordered to transport the 7,290 tons of gold and silver stored at Persepolis, Susa, and Pasargadae to Ecbatana with 20,000 mules and 5,000 camels, an extraordinary problem in logistics.

The problem is indeed extraordinary, but unfortunately Engels rushes past it, and in any case his calculations are amiss. No source reckons these treasures as 7,290 tons of gold and silver, and if they had, these beasts could not possibly have carried it. Engels estimates the carrying capacity of a mule as 200 pounds (90.7 kilograms), and of a camel, 300 pounds (136.1 kilograms).[93] As a result, the largest of the reported baggage trains (in Plutarch) could only manage 2,750 tons, considerably less than Engels's estimate for the treasure. Even if he were to suggest that the burden need not be packed into one load, his reconstruction would necessitate three round trips across the Zagros Plateau from Persepolis to Ecbatana, totaling an incredible 1,572 miles. For more than four months, this caravan would have had to inch-worm along with its own length of over 70 miles, far exceeding the mere 13 to 15 miles it could travel in a day. The head of the line would always be about five days ahead of the rear, so that the last poor beasts would likely find no fodder left along the road. Defending and feeding this long train was indeed "an extraordinary problem in logistics." Ameliorating the challenge somewhat, however, is the fact that the weight it carried was probably much less than what Engels surmises.

To calculate the actual tonnage of treasure, we begin with the valuation of 120,000 talents for precious metals found in the Persepolis treasury. This figure has been taken by many scholars to mean "more than three million kg" of gold and silver, or about 3,400 tons.[94] This burden alone, much less the other contents of the treasury, already exceeds the abilities of the largest reported baggage train by about 650 tons. The recurring mistake of historians is to imagine that 120,000 talents worth of silver must weigh 120,000 talents, when some part of that valuation is gold. This gold has been explicitly assessed as so much silver, and the relative values of these metals will therefore affect the actual weight. For example, at an exchange ratio of ten to one, a valuation of 120,000 talents of silver might actually represent a hoard of 60,000 talents of silver and 6,000 talents of gold, with a total *value* of 3.1 million kilograms of silver but an actual *weight* of only 1.7 million kilograms (about 1,874 tons).[95] This example falls well within the capabilities of 20,000 mules and 5,000 camels, and allows for additional burdens of other treasures. Therefore, the hauling capacity of the highest stated number of beasts does not contradict the ballpark valuation of 120,000 talents for the Persepolis treasure. This remains true when the spoils from Pasargadae are added, amounting to 6,000 talents more (at most, 171 tons).[96] Alexander had traveled to this early Achaemenid palace site located twenty-five miles (forty kilometers) northeast of Persepolis to receive from its governor Gobares the royal wealth kept there.[97]

Another check on these figures comes from the grand total of monetary wealth assembled at Ecbatana during the next phase of the Macedonian campaign.[98] When Alexander finally arrived at Ecbatana after his long layover at Persepolis, he found the last great royal treasury partially depleted. Darius had fled with 7,000 or 8,000 talents (42 million to 48 million drachmas), part of it abandoned along the road, while others had embezzled huge sums during the chaos of the Persian Empire's last days.[99] Alexander seized

21,000 to 26,000 talents (126 million to 156 million drachmas).[100] The king handed 12,000 to 13,000 talents over to his soldiers as a gift, almost seven times the amount distributed at Babylon.[101] This dramatic increase in largesse may be noted, too, in the particulars cited by Diodorus and Curtius for allied forces: one talent per caval- ryman and ten minae for each infantryman, twelve and five times, respectively, the bonuses at Babylon.[102] These sums were over and above all back pay, and the Greek allies choosing to stay with the campaign earned a bounty of three talents.[103] The bonuses paid to the discharged Thessalians alone totaled 2,000 talents.[104]

The palace itself at Ecbatana was lavishly plated with gold and silver, and perhaps because the already plundered treasury was dis- appointing, Alexander and his army stripped some of the precious metals to make up the losses.[105] Over a century and many plunder- ings later, enough gold and silver remained to melt down into nearly 4,000 talents of coins (24 million drachmas).[106] Taken together, the young conqueror's haul from Darius's treasuries and palaces proved astounding. According to Strabo:

> Some say that the treasures found at Susa and in Persis [from Persepolis and Pasargadae] were valued as 40,000 talents, but certain others say 50,000; these figures do not include the wealth in Babylon or in the army camp. Still other writers claim that all of the treasures from everywhere were collected at Ecbatana, and these were valued as 180,000 talents. Beyond this, Darius made off with 8,000 talents from Media, which his treacherous killers then plundered.[107]

Strabo provides data from three sets of lost sources. The first two give figures far below those consulted by Diodorus and Curtius, whose totals for Susa alone equal 40,000 to 50,000 talents (much less the additional 120,000 to 126,000 talents from Persis).

In all likelihood, the numbers 40,000 and 50,000 have been misunderstood by Strabo or an intermediary source as the valuation of two treasuries rather than one. Diodorus also gives a grand total of 180,000 talents, but Justin/Trogus writes 190,000.[108] Curtius offers no final account, but one can be reconstructed from his various subtotals:

Babylon............?
Susa................50,000 talents uncoined
Persepolis.........120,000 talents
Pasargadae.......6,000 talents
Ecbatana...........26,000 talents
 TOTAL..............202,000 talents

On the other hand, Diodorus's subtotals add up to 190,000 talents:
Babylon............?
Susa................49,000 talents coined and uncoined
Persepolis.........120,000 talents
Pasargadae.......?
Ecbatana..........21,000 talents
 TOTAL..............190,000 talents

Unfortunately, Arrian presents no useful check because he or his sources took an interest in only one treasury, that of Susa. The surviving literary tradition reaches, by one way or another, a total valuation of about 180,000 to 200,000 talents. As a ballpark figure for precious metals, this seems as good as we are likely to get. The number may have been inflated, but even so, the contents of the Babylonian treasury are not included. If that first palace site contained wealth commensurate with Susa or Ecbatana, then it would cover any literary exaggeration of the grand total by up to 40,000 talents.

Therefore, a valuation of 180,000 talents (worth 1.08 billion drach mas) for the precious metals seized by Alexander from Darius's royal stores may actually be a low estimate, but it will do. The true amount of wealth plundered by Alexander would, of course, be considerably higher since we cannot ascertain the added value of confiscated lands, slaves, jewelry, gemstones, furnishings, dyed cloth, artwork, spices, and other luxury goods.

RAJAS, RICHES, RESENTMENTS

Alexander and his army would never again enjoy windfalls of such magnitude, even though at Ecbatana in the summer of 330 BC the reign had not yet reached its halfway point. There were still more kings to conquer or co-opt, but not many and none so rich as the Achaemenids.[109] The heady days of plundering palaces gave way to a new phase of fighting in Central and South Asia. Though royal spoils became rarer, there was still no end of profit and plunder in these later campaigns.[110] When, for example, Alexander in 326 BC approached the city of Taxila beyond the Indus, he was received with the same ceremony as when he had entered Babylon and Susa. Indian delegations met the king with pomp and presents as they surrendered their "great and prosperous city."[111] Alexander treated kindly the local raja, Omphis/Taxiles, but laid hands on no sprawling treasury to placate his troops.[112] By the standards set in Persia, the king acquired a pittance: gifts of 80 to 200 talents (worth 480,000 to 1.2 million drachmas), 3,000 cattle, over 10,000 sheep, and 30 to 58 elephants.[113] The pachyderms were, of course, a boon only to Alexander and his later successors, not to the army at large.

Taxiles was cleverly angling for support in his own little border wars, and his fawning so pleased Alexander that the Macedonian gave far more than he got. Taxiles received back all of his money (the

thing that most interested the Macedonians) and was plied with lands and loot besides. Alexander presented Taxiles with portions of his spoils, including gold and silver tableware, thirty horses with royal tack, Persian robes, and 1,000 talents.[114] Their king's liberality upset the Macedonians.[115] One of Alexander's most outspoken critics was the battalion commander Meleager, a man wealthy enough to import dust from Egypt to sprinkle on the floor for his wrestling matches.[116] He nonetheless complained in his cups that only among the barbarians of India had the king found a man worthy of 1,000 talents.[117] Meleager's angry remark, which may well have cost him further promotion, probably reflects his resentment about another recent incident. Upon departing Bactra for India, Alexander had ordered his soldiers to burn all their personal bundles of Persian spoils.[118] Surely this loss made it all the more galling to witness the king's eagerness to dole out spoils to an Indian raja, some of which the king had perhaps held back from the fires at Bactra.

Like Taxiles, the Indian ruler Abisares offered gifts to Alexander on more than one occasion while seeking his best advantage among the rival powers of India.[119] The royal delegation, led by Abisares's brother, presented the Macedonian monarch with an unspecified sum of money and thirty to forty elephants. Other rajas added spectacular presents of their own. Sopeithes dramatically appeared before the invaders dressed in dazzling splendor; wearing pearls of conspicuous beauty, a royal robe embroidered in gold and purple, and a pair of gem-studded golden sandals; and carrying a golden scepter topped with beryl that he handed over to Alexander along with other impressive gifts.[120] Sopeithes's neighbor Phegeus met Alexander with many gifts; the Sibians and Sambastae did likewise.[121] From the territory of the Malli came a hundred envoys (Arrian 6.14.1 says more than 150) robed in gold and purple.[122] These nobles and the surrounding kings were treated by Alexander to a magnificent banquet festooned with golden couches and, not to be

outdone by the local garb, with tapestries woven in gold and purple. Curtius laments that this spectacle "displayed the corrupting influence of ancient Persian luxury" and adds an interesting sequel.[123] A few days later, these same guests returned with gifts of their own for Alexander: 300 cavalrymen for his army, 1,030 chariots, cloth (presumably dyed), 1,000 shields, 100 talents of "white iron" (steel, brass, tin, nickel?), and an assortment of exotica (lions, tigers, lizard skins, and tortoise shells). Competitive gift giving was a special feature of the Indus campaign. More and more, Alexander expected to be plied with treasures worthy of his fame.[124]

Appeasing the conqueror with lucre sometimes served as the last hope of desperate leaders across the ancient East. After the Mardians had foolishly stolen Alexander's horse Bucephalus, the king threatened to exterminate them all.[125] Quickly the thieves returned the horse along with their "most expensive gifts." In India, the panicky raja Musicanus offered Alexander his elephants and all of the other gifts most highly prized in his realm.[126] Back in Persis, drawing from his own patrimony, the frightened Persian nobleman Orxines plied the king and his army with "presents of all kinds."[127] These included fine horses, ornately gilded chariots, furnishings, gems, purple clothing, huge gold vases, and 3,000 talents of coined silver. These gifts were intended to mollify Alexander since Orxines had assumed control of Persis on his own initiative after the death of its satrap.[128] The gambit failed, and the doomed Orxines was furthermore accused of defiling royal tombs and executing innocent Persians. It was alleged by the eunuch Bagoas that the treasures given by Orxines had been looted from the royal tomb of Cyrus the Great.[129]

Greeks, too, sought the king's pardon or preferment. Ambassadors famously brought golden crowns to Alexander in Babylon, honoring him as though a god.[130] The gesture was hardly economic, but it did carry with it material gain. It was said of Alexander's last days that

from nearly all parts of the inhabited world there arrived envoys on missions either to praise his victories, or to offer him crowns, or to make treaties. Many brought magnificent gifts, some of them ready to defend themselves against accusations.[131]

All in all, our sources present a tale of two conquests, each with disparate kinds and quantities of material gain. From 336 to 330 BC, Alexander and his men absorbed the concentrated wealth of teeming cities and large vanquished armies, as well as rural populations. Among these were major windfalls (Thebes, Granicus, Gordium, Issus, Damascus, Tyre, Gaza, Memphis, Gaugamela, Arbela, Babylon, Susa, Persepolis, Pasargadae, and Ecbatana), many of which the ancients attempted to quantify by one means or another. From 329 to 323, however, the spoils of war derived from less urbanized regions and consisted of a greater proportion of perishable goods (slaves, cattle, horses, elephants). Royal gifts from local rulers replaced the luxury items from Persian treasuries, apparently in valuations that drew less notice from ancient writers who quantified few of them. This does not mean that the profits of war were negligible in the latter period, since one of the rare figures we are given (the fortune hidden in Eumenes's tent) suggests otherwise. Nor can we assume that the invaders were any less aggressive in their pursuit of loot once the rich heartland of Persia was behind them. In fact, the plundering of Sogdiana and India was particularly savage. So, to the wealth won from Darius, Alexander added enormous but unquantifiable sums from petty kings, rajas, towns, tribes, and other entities across Eurasia. He became perhaps the richest individual ever to rule an ancient empire. It remains to be seen what he chose to do with so much treasure.

A King's Priorities

Wealth in the hands of a mortal man is widely powerful . . . and
makes him many friends.

Pindar, *Pythian* 5.1

When Alexander the Greatest carried off the treasures of
Asia, then all-conquering wealth—as Pindar says—spread far
and wide.

Athenaeus, Deipnosophistae 6.231e

As a young man, Alexander the Great controlled an incredible
portion of the world's resources. These possessions empowered
the king far beyond the battlefield supremacy for which he is
renowned. It won him favor, bought him loyalty, appeased his gods,
and endowed his every wish—sometimes even beyond the grave.
He allocated funds for bribery and bounties; for banquets and
entertainments; for burials and memorials; for the construction of
temples, cities, harbors, and ships; for prizes and gifts; for religious
offerings and the relief of orphans; and even for the purchase of a
vicious dog.[1] Some of Alexander's wealth did him no good, such as
the huge sums embezzled by underlings or deliberately abandoned
by the king, but the rest was deployed as an extension of his power
and personality.

While in general the king's expenditures are reported anecdot-
ally, the data are still quite useful in the aggregate. Invention and

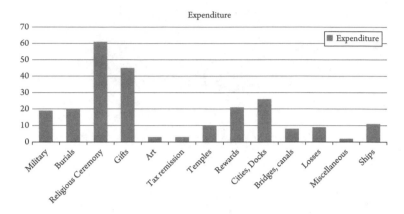

Figure 5.1. Chart Showing Incidence of Expenditures. © *Frank Holt.*

exaggeration are less a danger here than selection bias. For the most part, if a secondary source records a gift to a particular person or group, then such a gesture was likely made.[2] The larger problem is that many if not most grants may have been unreported unless of some special interest to a later author. To some degree, therefore, the list of Alexander's known payouts reflects the king's choices filtered through the concerns of later writers. All in all, however, the distribution of royal treasures paints an interesting picture of at least some of the king's priorities. We cannot always know how much the king allocated for this or that, but the frequency of certain categories of payment does reveal key patterns, as illustrated in Figure 5.1.

PERSONAL GIFTS AND PATRONAGE

Alexander's discretionary spending and gift giving reveal a man "who was by nature exceedingly generous, and ever more so as his successes mounted."[3] The young king's munificence was widely considered one of his better qualities, for an ancient ruler's liberality

(*polydoria*) marked him as great in power, good in spirit.[4] In his summation of Alexander's life, Arrian praises the king by saying: "As for money, Alexander used it very sparingly for his own pleasures, but quite generously for the benefit of his fellow man."[5] Plutarch has Alexander say that "the wealth of Darius is barely enough for my friends."[6]

The real danger for an unselfish king was that some recipients might get jealous of others. As shown in chapter 4, for example, the Macedonians resented any spoils going to foreign rulers such as Taxiles. Distributing wealth naturally aroused strong passions, for the king's gifts represented status, as well as property. Rewards were ritualized as visible bonds between a king and his entourage, from family and intimate friends to diplomats, allies, artists, philosophers, and, not least, his army.[7] Camaraderie was a costly commodity in social and religious settings reminiscent of the heroic age of Homer. There needed to be elaborate gifts, sacrifices, entertainments, and memorials to maintain proper order and morale. Alexander's view of the right use of wealth therefore had as much to do with personal identity as it did with economics. Hence, the king was not to be bested by Taxiles in liberality, Macedonian resentments be damned, because "it put the barbarian under an obligation to him."[8]

These bonds of benefaction and obligation linked Alexander to the entire network of men and women that structured his life. His mother and sister, his *hetairoi*, his personal physician, his royal pages, his teachers, his drinking companions, his soldiers, and even his enemies—all may be found among those he took pains to treat generously from his own purse at one time or another. Quite often, we view these exchanges as purely economic and thereby miss deeper levels of meaning. For example, Alexander sometimes tailored his gifts and rewards in a way that advanced larger interests. In the delicate period when Alexander began to adopt Persian dress

and protocols in the face of Macedonian opposition, the conqueror might simply have bribed his *hetairoi* with royal money. Instead, Alexander cleverly gave his commanders valuable gifts that were themselves Persianizing: purple cloaks, Persian harnesses for their horses, and even Persian estates stocked with expensive native clothing.[9] For Greeks and Macedonians, the color purple had tremendous prestige value going all the way back to the Homeric epics.[10] The Persians, meanwhile, had institutionalized the distribution of purple cloaks and related gifts as a sign of the Great King's special favor.[11] Alexander followed suit: "The vast booty taken by Alexander from the Persians enabled him to continue the practice of the Persian royal court of expanding the scope of purple as a symbol of high status."[12] As Diodorus (17.78.1) observes about Alexander's Orientalizing policies, "Many complained, but he neutralized them through gifts."

Getting was the other ritualized side of giving. It is noteworthy that from Granicus in 334 BC and Gaza in 332, Alexander sent his mother Persian spoils, including expensive purple cloth; then, as he was seizing more great quantities of purple cloth and dye at Susa in 331, Alexander received from Olympias a gift from Macedonia of large supplies of . . . purple cloth.[13] This passing of purple cloth and clothing back and forth across Alexander's growing empire was plainly more symbolic than practical, for well-meaning Olympias was surely "carrying coals to Newcastle." When Alexander in turn gave this Macedonian purple cloth to Darius's mother Sisygambis as a sign that she was, in this gift-giving network, as much his kin as the woman who sent it, the young king accidentally insulted her by suggesting that her offspring—like the women of Alexander's family—should learn to make it.[14] Alexander made amends for the offense, showing how complex were the gifts that bridged the warring states of Greece and Persia.

It seems that Olympias and her circle dominated Alexander's gift giving in Macedonia. She appears by name three times among the king's known expenditures, and her daughter Cleopatra once.[15] Not making the list were any of Alexander's half-siblings from Philip's other wives. Another relative through Olympias was Alexander's stern mentor Leonidas, duly enriched alongside the prince's teacher Aristotle.[16] Alexander's other tutor, Lysimachus, does not appear in the list, although he and other Acarnanians such as the physician Philip (who is in the registry) were likely employed through Olympias's influence.[17]

Although his father's other families were ignored, Alexander bestowed gifts, royal allowances, and special favors upon the captured family of Darius. As Parivash Jamzadeh has pointed out:

A peculiar feature repeated in practically every history of Alexander . . . is Darius' declaration of his debt to him. Although Alexander is the aggressor, who in pursuit of kingship over the Achaemenid empire and further east, has defeated him in successive battles, has sacked and burnt his capital, has captured his treasures and has chased him to every corner of his kingdom, yet there are pathetic speeches ascribed to him praising Alexander's magnanimity, generosity, honour and above all declaring him worthy of Achaemenid kingship.[18]

That reputation long endured, as demonstrated in Figure 5.2, where Bernardo Rosselli's fifteenth-century painting of a triumphant Alexander imagines the women of Darius's family enjoying their part in the procession.

Both alms and arms legitimized Alexander, as when he later extended his largesse beyond Darius's family to include other women in Asia, such as stipends for camp followers, dowries for native

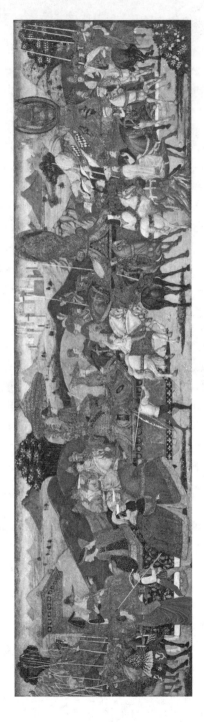

Figure 5.2. The Triumph of Alexander (Rosselli). Digital Image © 2015 Museum Associates/Los Angeles County Museum of Art/Licensed by Art Resource, New York.

wives of Macedonian soldiers, and Cyrus's traditional payment of gold coins to all the women of Persis.[19] Alexander was particularly keen on honoring the memory and precedents of Cyrus, his role model for Asian sovereignty.[20] Alexander made a point to reward groups within Persia (the Ariaspians, the Gedrosians) for their ancient loyalties to King Cyrus.[21] This homage may have been heartfelt, but it also had propaganda value for a king courting both sides in the struggle. Thus, he also made certain to dispatch a share of his spoils to the city of Croton in Italy to honor one of its citizens who, a century and a half earlier, had helped the Greeks in their war against Persia.[22] Wealth made it possible for the king to champion opposing forces, in reference not only to the present but also to the past.

Money carried Alexander's fame far and wide by many means. The purses of rich kings naturally attracted parasites in large numbers, and these in turn tended to attract attention because of their tawdry lifestyles. The Greek term *parasitos* means literally "one who eats at another's table" and denotes freeloaders and flatterers of various kinds.[23] The poet Theocritus of Chios criticized others for growing fond of Macedonian court luxury, yet he was chastised in turn by his rival Theopompus:

Theocritus of all people now drinks from gold and silver goblets, and eats with similar utensils, even though he formerly had no silverware, nor any bronzeware either, just earthenware to drink from—and that all cracked and chipped.[24]

Beyond the prizes given out for competitions, Alexander rewarded artists, athletes, and entertainers with random gifts, often in response to requests or compliments. When the prodigious drinker Proteas asked Alexander to prove his friendship, the king doled out five talents (30,000 drachmas) to humor the man.[25] The comic

actor Lykon inserted into his performance an appeal for money, prompting a bemused Alexander to give him ten talents (60,000 drachmas).[26] At their first meeting, the king allegedly made the philosopher Pyrrhon immensely rich with a gift of 10,000 gold coins, worth 200,000 drachmas.[27] Catching the conqueror in a good mood could pay off handsomely.

A curious and, at face value, discreditable story found in the *Alexander Romance* claims that the king presided over the Isthmian Games at Corinth and promised a victorious athlete any gift he wished if he could win all three combat events (wrestling, pancration, and boxing).[28] When Clitomachus swept all three, Alexander vowed to rebuild Thebes whence the athlete had come. In reality, this famous athlete was active a century after Alexander's reign,[29] but this chronologically impossible anecdote may have arisen from an actual case in which Alexander honored an Olympic victor trying to get his hometown of Thebes rebuilt. Arrian (2.15.2–4) reports that in 332 BC, Alexander captured some Greek envoys to Persia, including the athlete Dionysodorus of Thebes seeking Darius's help in restoring the city destroyed by Alexander. Publically, the Macedonian king pardoned Dionysodorus because the man's hopes were honorable; privately, Alexander's reason was the man's athletic prowess. It is easy enough to see how the two Theban athletes were mixed up, and how even a further version later arose involving a medieval *jongleur* instead of an Olympian.[30]

During his reign, Alexander financed at least twenty-three athletic competitions.[31] These were all, of course, carefully staged and had an important religious dimension; many formed part of larger celebrations involving artistic contests as well. These occasions provided rest and entertainment for the army and navy, celebrated key milestones in the campaign, and showcased the king's prestige. Their quintessential Greek nature also provided a periodic reminder of the king's original Pan-Hellenic propaganda, particularly in the

latter half of the reign when there was growing anxiety in the ranks. No matter how Asian Alexander might become, his devotion to ancestral games and gods kept him visibly grounded in the traditions of faraway Greece.

Naturally, the potential for sycophancy grew with the swelling entourage of entertainers and athletes in Alexander's company. It was allegedly the king's custom to be entertained by athletes and musicians when he dined or rested.[32] Thousands were said to perform, of whom dozens are still known by name.[33] Drawn from throughout the Mediterranean world and beyond, these ancient celebrities included boxers, ball players, jugglers, conjurers, actors, harpists, flutists, poets, singers, dancers, and others who made of Alexander's army not only a traveling city but also a traveling circus. In its day, Alexander's entourage was the greatest show on Earth. The diversity of backgrounds and homelands showcased the vast reach of the king's fame and spendable fortune. Alexander's court chamberlain Chares gives a name-dropping first-hand account of this ensemble in action amid the expensive trappings of the Susa weddings:

The nuptials were celebrated over the course of five days, and large numbers of Greeks and barbarians provided entertainments, with some Indians also. Wonderful conjurers performed: Scymnus from Tarentum, Philistides from Syracuse, and Heraclitus from Mytilene. After them, the rhapsodist Alexis of Tarentum gave a recital. The harpists who performed without singing were Cratinus from Methymna, Aristonymus from Athens, and Athenodorus from Teos; those who sang were Heraclitus of Tarentum and Aristocrates of Thebes. Singing with flute accompaniment were Dionysius from Heraclea and Hyperbolus from Cyzicus. Flutists included Timotheus, Phrynichus, Caphisias, Diophantus, and Evius the Chalcidian.

Previously called the Flatterers of Dionysus, this guild was henceforth known as the Flatterers of Alexander because of their performances, and this gave the king much pleasure. The tragic actors Thessalus, Athenodorus, and Aristocritus entertained, as did the comic actors Lykon, Phormion, and Ariston. The harpist Phrasimelus also appeared.[34]

It was particularly expensive to lure such headliners away from other patrons and venues. Alexander paid the fine imposed by Athens upon the prize-winning tragic actor Athenodorus when the latter broke his contract for the Greater Dionysia festival to perform for the king.[35] Still, the athletes, writers, and performers served practical ends, sometimes in a serious capacity such as war and diplomacy. One famous musician, Aristonicus of Olynthus, volunteered for battle and was posthumously honored by Alexander.[36] The runner Philonides from Crete, an Olympic victor, served Alexander as a courier.[37] It was the responsibility of another of the entourage, Aristotle's kinsman Callisthenes, to embellish the king's glory in history, for which he was lavishly rewarded until he fatally displeased his patron.[38] Some sense of the renown of Alexander's patronage may be found in the regret of later artists who missed out on the king's bounty, one of whom was told: "Had you only been born in Alexander's day, you would have earned a Cyprus or Phoenicia for every line of your poetry."[39]

Because the maintenance of this lot was not cheap, some soldiers complained bitterly about how much the troupe ate and drank. Resentful warriors said of the boxer Dioxippus that while they trained for battle, the useless athlete prepared his belly for feasting.[40] One of the Macedonians eventually challenged Dioxippus to a duel but lost ingloriously to the boxer. The troops got even by framing Dioxippus for stealing a gold banqueting cup; the humiliated athlete killed himself to the great joy of his detractors.[41]

At Susa, the flutist Evius (mentioned earlier) was billeted in a house previously assigned to Eumenes.[42] Offended, Eumenes screamed at Alexander that he might as well throw away his weapons and become a musician or tragic actor. This was, of course, the same Eumenes who hid from Alexander more than a thousand talents of gold and silver while in India.[43]

It was never easy for the king to satisfy his followers. Aristotle taught that humans are naturally governed by their appetites, which increase inexorably: "Give men two obols a day," he said, "and soon they only want more."[44] When Alexander was informed before the Battle of Gaugamela that his greedy soldiers were conspiring to hide their anticipated spoils from the royal treasury, the king allegedly pardoned the offense as he later did for Eumenes.[45] Olympias warned her son often that his generous gifts were inflaming the desires of his companions, affording them the wealth and airs of kings.[46]

The indulgence and greed that had grown within the ranks of Alexander's army can be glimpsed in a sprinkling of surviving anecdotes beyond the ones about Eumenes. These stories must be weighed carefully since they were obviously recorded as the most outlandish of examples, but they seem to represent a consensus about the army's growing love of extravagance. The luxuriant example set by the king filtered down through his court and camp, allegedly reaching even to their slaves. In time, Alexander's gigantic tent was said to rival Darius's in its opulence, with fifty gold pillars, a gold-embroidered roof, and a golden throne at its center.[47] The floor was sprinkled with rare perfumes and fragrant wine.[48] According to Curtius, "All that was corrupt in the ancient luxury of the Persians became the new lifestyle of the Macedonians."[49] Plutarch nevertheless praises the moderation of Alexander's appetites, but notes that the king's dinners grew more lavish over time until he finally capped the expenditure for a single meal at 10,000 drachmas.[50]

This limit was equal to about 5,000 days' wages for a skilled Greek construction worker at the time.[51] Feasts of this sort imitated Persian custom, wherein meals allegedly cost 2.4 million drachmas, including huge quantities of wine, cider, milk, honey, vinegar, almonds, sesame, garlic, dill, mustard, turnips, melons, apples, raisins, venison, cattle, turtles, horses, sheep, goats, pigeons, and gazelles.[52] The sort of staff necessary for such banqueting has already been mentioned in the context of Darius's captured entourage at Damascus, including 277 cooks, 13 milk workers, 17 drink tenders, and 70 wine workers.[53] As if these foods were not enough, it was also claimed that

> whenever Alexander's comrades hosted a dinner, they covered all the desserts in gold so that diners tore off the gold wrapping and tossed it aside along with nutshells and the like, which the slave attendants then gathered up as spoils.[54]

Filling out the ranks of Alexander's army were soldiers fired by new notions of what it meant to be rich and comfortable. Those dining at Alexander's table each learned to consume about 160 drachmas worth of food and drink at a sitting, the equivalent of eighty days' pay for a contemporary mercenary.[55] The Greek Hagnon was said to use gold or silver nails in his boots, and the Macedonian Cleitus the White fancied regal purple rugs in his quarters.[56] Some men carried on the march expensive sporting equipment and camel loads of sand to spread upon their personal exercise areas.[57] Philotas was charged in a highly rhetorical passage with clogging the streets of a city with his personal wagonloads of gold and silver.[58] At the eastern limit of Alexander's march, the ill-fated commander Coenus is made to say to Alexander at the Hyphasis River, "Thanks to you, the troops will return home rich and important rather than poor and humble."[59]

RELIGION AND CEREMONY

Religion played a role in all ceremonies of state, from weddings
and victory celebrations to banquets and burials. In this way the
gods enjoyed their fair share of Alexander's wealth. The quaint
story of Alexander rebuking Leonidas for being stingy toward the
gods is meant to show the king sharing his good fortune piously
and generously.[60] Ephippus of Olynthus even claims to have wit-
nessed Alexander's use of Persian spoils to play the part of the
gods at various events.[61] These charades may be exaggerated, but
the king made a show of his piety by sacrificing every day, calling
forth expenditures that were sometimes modest and sometimes
magnificent.[62] Of the nearly 5,000 offerings made to the gods by
Alexander, only those on about fifty special occasions have been
recorded.[63] These accompanied military and political milestones of
various kinds, including nearly every river crossing. At the Indus,
the raja Taxiles provided Alexander with 3,000 cattle and 10,000
sheep for sacrificing.[64] In many instances, the king hosted expen-
sive banquets and/or competitions in conjunction with these cer-
emonies.[65] He also constructed altars, particularly to mark frontiers
at such places as the Hellespont, Aornus, and Hyphasis. By these
means, Alexander honored a wide array of deities and heroes: Zeus,
Herakles, Athena, Apollo, Artemis, Helios, Poseidon, Dionysus,
Asclepius, the Dioscuri, Amphitrite, Nereus, the Nereids, the
nine Muses, Apis, Ammon, Protesilaus, Priam, Hephaestion, Sun,
Moon, Earth, and Ocean, plus the rivers Danube, Tigris, Jaxartes,
Hydaspes, Acesines, and Indus.[66] The religiosity of the king can
hardly be questioned by any audit of his expenses.

In addition to his altars, votive offerings, and subsidies, at Troy,
Mallus, Siwah, and Epidaurus, for example, Alexander offered
on several occasions to underwrite the considerable expense of
temple construction.[67] At Ephesus, after directing tax revenues

to Artemis, he promised to cover all costs for the reconstruction of her burnt temple, provided he get credit for doing so on the dedicatory inscription; the Ephesians declined his offer.[68] Not so the obliging citizens of Priene, whose temple bore the inscription shown in Figure 5.3: "King Alexander dedicated the temple to Athena Polias."[69] At Sardis, too, he gave orders to build a temple, this one for Zeus.[70] At the site of his Alexandria in Egypt, Alexander laid out plans for temples to the Greek gods, as well as to Isis.[71] At Thebes, the king built a shrine for the sacred barque

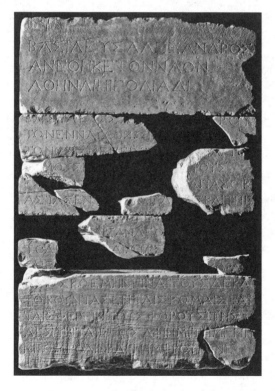

Figure 5.3. Priene Inscription. © *The Trustees of the British Museum/Art Resource, New York.*

of Ammon.[72] Other constructions in Egypt bear his name, for instance, at Hermopolis, Athribis, and the Bahariya Oasis, where an inscription reads: "King Alexander to Ammon, his father."[73] In Babylon, the king took a special interest in the vast temple complex of Baal-Marduk, which was always in need of repair.[74] After his original orders were more or less ignored by slackers during his prolonged absence in the East, Alexander again commanded the temple rebuilt in grand fashion, and other temples repaired.[75] Before his death, Alexander vowed to underwrite temple construction at seven additional sites: Delos, Delphi, Dodona, Dion, Amphipolis, Cyrnus, and Troy. These Greek projects were to cost in excess of 10,000 talents (60 million drachmas), but most of the proposed outlays were cancelled by his successors.[76] It is known that Lysimachus later carried through the plan for Troy, and Philip III Arrhidaeus continued the work started at Babylon.[77]

Our sources notice more than twenty important burials and memorials overseen by Alexander, beginning with his father's and ending with Hephaestion's.[78] Twelve Greeks, Macedonians, Persians, and Indians were so honored individually (Philip II, Darius III and his wife Stateira, Hector, Nicanor, Erigyius, Philip, Demaratus, Aristonicus, Coenus, Calanus, and Hephaestion), not counting the refurbished burials of Cyrus and other Persians whose tombs had been defiled. Mass funerals are recorded after Issus, Tyre, Ecbatana, the Polytimetus (Zerafshan) River, and Sangala, although surely the same occurred after all other major engagements as well. In his speech at Opis, Alexander is made to say, "All who died gloriously received from me a splendid funeral and most also a bronze statue back home."[79] Demonstrations of this type served many ends, from religious to political, and costs could be quite high to meet these aims. Alexander—or at least his chroniclers—showed special concern for his father, close friends, loyal soldiers, and Persian royalty. Ironically, the young king seems

to have grieved most strongly for men who died tragically before their time, including Hector in Egypt and Philip in Sogdiana.[80]

CITIES AND OTHER INFRASTRUCTURE

Alexander also budgeted a great deal of money for the building of cities, although certainly he founded fewer than the seventy or more claimed by Plutarch.[81] That inflated number can only reflect all resettlements, forts, and other outposts substantially smaller than true cities. Collectively, ancient and medieval sources name fifty-seven specific Alexander foundations, of which only six are deemed genuine in P. M. Fraser's important study of the topic: Alexandria in Egypt, Alexandria in Aria, Alexandria Eschate in Sogdiana, Alexandria in Susiana, Alexandria-Bucephala in India, and Alexandria-Rhambacia in Oreitis.[82] Most scholars would add to this list at least seven more cities: Alexandria in Arachosia (modern Kandahar), Alexandria in the Caucasus (modern Begram), Alexandria on the Oxus (modern Ai Khanoum?), Arigaeum, Alexandria-Nicaea (twin city of Bucephala), Alexandria on the Acesines, and Alexandria-Xylinepolis.[83] A few more foundations appear in appendix 3, neglected by and large by scholars because some settlements (along the Indus, for example) probably were not long-lived. This does not mean, however, that Alexander did not invest heavily in them regardless of their fate.

To establish at least a dozen or more true cities plus many other smaller towns and fortresses would be expensive even using local materials worked by army labor, corvées, and slaves. Each site would require walls, public buildings, dwellings, roadways, and the engineering necessary to provide adequate water, sanitation, and other basic services. At some sites this heavy construction had to be recommissioned due to flood damage or other unforeseen setbacks.[84] In only a few cases do sources indicate the size of a new foundation,

such as at Alexandria-Eschate. Built in the face of enemy opposition, Alexander's forces there raised about six miles (ten kilometers) of walls to a defensible height in seventeen to twenty days.[85] For comparison, the excavated city at Ai Khanoum (perhaps Alexandria on the Oxus) has walls about three miles (five kilometers) in length, formed by an estimated 10 million bricks; the completion of these walls, shown in Figure 5.4, would have required a workforce of 3,000 men laboring for six months.[86] Based on a few known cases, it has been taken as something of a rule that the king's new cities held about 10,000 adult male settlers and, with women and children, averaged 50,000 total inhabitants each.[87] If true, the king's building program accommodated at a conservative estimate about 650,000 persons concentrated in thirteen or more new urban centers across the East from Egypt to India. The total costs remain incalculable.

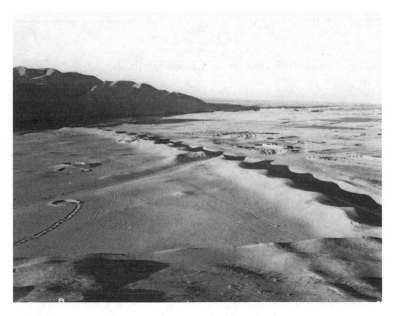

Figure 5.4. Ruined Walls at Ai Khanoum (Afghanistan). © *Courtesy of DAFA*.

For good logistical, military, and commercial reasons, Alexander built most aggressively along rivers and other waterways. Besides new cities, Alexander expended his resources to construct bridges, dockyards, and other structures such as the remarkable mole from the mainland to Tyre. Bridging rivers was, of course, a constant throughout his campaigns. The sources draw attention to these endeavors at the Nile, Euphrates, Araxes, and Indus; other rivers were crossed by means of boats, rafts, and makeshift flotation devices (e.g., goatskins stuffed with straw).[88] The latter means were employed when, for example, there were no building timbers available.[89] Down the Indus Valley and later in Babylonia, the king committed time and money to the construction of a series of dockyards and harbors.[90] These were vulnerable to flood damage and had to be repaired or rebuilt often.

ARMIES AND NAVIES

In conjunction with new docks and shipyards, Alexander naturally authorized massive outlays for ship construction. In India, these expenses taxed the king's available funds and forced him to tap into the traveling wealth of his *hetairoi*. Arrian reports that Alexander appointed thirty-three of his companions as *trierarchs*.[91] The title was more than honorific, for it normally carried with it the obligation to finance the cost of a ship.[92] Eumenes appears on this list of *trierarchs*, suggesting the context of the 300 talents expected of him when Alexander burned his tent to expose his stinginess. If Eumenes's subsidy was typical, then Alexander sought from his followers upwards of 10,000 talents (60 million drachmas) on this occasion.

Expensive craft of all sizes made up fleets destined to ply the Indus River, Indian Ocean, Mediterranean Sea, Caspian Sea, and Mesopotamian rivers. What had been a spotty commitment to

naval matters, using ad hoc requisitions of allied ships, became a near obsession to unite, explore, and expand the empire by sea.[93] In 334 BC, Alexander's operations in the Aegean were supported by about 200 ships until, after the capture of Miletus, he temporarily dismissed most of the allied crews.[94] The ancient sources give various reasons for this decision, including financial exigency, divine omens, and strategic considerations; modern scholars stress concerns over the fleet's ability to confront the Persians and its unsteady loyalty to Alexander.[95] The real reasons, some of them obviously masked by omens and economics, were surely strategic, and when Alexander needed ships again the following year the naval force was reassembled.[96]

At the outset of his reign, Alexander was content with a makeshift seasonal navy; at the end of his reign, the king was fully committed to the seas. The Indus campaign and the success of Nearchus's ocean voyage opened the king's eyes—and his purse—to the economic and military advantages of a future in which waterways were of growing importance. His engineering projects along the Euphrates and Tigris rivers had some agricultural applications, but his primary goals there were strategic.[97] Whereas historians generally see Alexander as a warrior with his feet firmly on the ground, winning his battles on land even if it required building a road to reach an island, the maritime and riverine interests emerging late in his career may have been one of his greatest legacies.[98]

Even so, few would doubt that most of Alexander's wealth went to his land forces in the form of recruitment, wages, bonuses, banquets, gifts, equipment, entertainments, medical care, and—as a final largesse—funerals. The king's army was designed to kill, and it did so more proficiently than its rivals, but it did not do this work cheaply. It is a common misconception that war takes life at bargain prices. The Allies in World War I reportedly spent $36,485.48 for every German soldier killed, considerably more than was spent

to commit most homicides at the time.[99] People were one target, places another. The cost of capturing strongholds such as Tyre, Gaza, and Cyropolis—each operation a siege consuming lives, labor, and materiel—must be reckoned as well.[100] To do their work, Alexander's troops had to be trained, fed, equipped, and paid; it is little wonder, then, that they are mentioned more often as the recipients of royal gifts than the king's family, friends, philosophers, artists, or allied states.

When the king acquired substantial spoils, he shared these both as general donatives and as special rewards to individual soldiers. The former usually followed major military exertions such as sieges (Tyre), battles (Gaugamela, Hydaspes), or prolonged marches (Ecbatana). Gifts of money, luxury goods, and estates could quiet unrest and improve morale, as when Alexander first adopted Persian dress, during the demoralizing monsoons of India, and following the marriages at Susa. Individuals earned extra rewards for such deeds as bringing in an enemy's head, carrying a heavy burden, or volunteering for hazardous duty.[101]

The usual starting point for the study of Alexander's expenditures is the beguiling question of his annual military budget. This, however, is a no-win exercise. Our sources never report the base pay rates for all the various units in Alexander's armies (plural, because the king had to support at least two large land forces, one in Asia under his command and another in Macedonia led by Antipater). Nor can we know the actual numbers of men in service in each of the many units. Some key part of the data is always missing. Thus, for example, we know more about pay scales at the end of the reign, but more about troop numbers at the beginning. Mixing this data gives only the impression of accuracy with perhaps no relation whatsoever to the fiscal reality.[102]

The ancient sources allow only a few deductions about overall expenses. Note that in the case of the king's naval outlays discussed

earlier, we have assessed the relative frequency of certain expenditures, but with no concomitant data about the actual amounts. The present state of evidence suggests that Alexander spent more often on banquets than ships, and more often on ships than temples, but it cannot tell us whether he ultimately devoted more of his actual resources to feasts, fleets, or shrines. We always need more particulars to fill out the financial picture. Did allied troops draw salaries from the Macedonian king or serve at the expense of their home states? Were Macedonian conscripts paid a regular wage from the start of the campaign? Did Alexander provide a supplement for provisions? How many mercenaries did he employ from year to year?

Parts of a poorly preserved inscription found at Athens may refer to Alexander's elite *hypaspists* infantry force along with intriguing but uncertain mentions of money, rations, and periods of time; unfortunately, attempts to make sense of the text have been ingenious but inconclusive.[103] The only other hope of determining precise rates of pay may be found in Arrian. He reports some details for the enrollment of Persians into the Macedonian battalions at Babylon in 323 BC:

A Macedonian *dekarch* was to lead each *dekad*, and next to him a double-pay Macedonian and then a ten-stater man, whose pay was less than that of the double-pay man but more than the regular soldiers. With these there were twelve Persians, and last of the *dekad* a ten-stater Macedonian, so that in a *dekad* there were to be four Macedonians on extra pay, with one in charge, and twelve Persians.[104]

In this file of soldiers, we have a Macedonian leader (*dekarch*) whose pay is not recorded, but which must exceed that of the next Macedonian in line who received double pay. This amount, too, is unstated, but was more than the ten staters given to the third

Macedonian in line and also the fourth Macedonian, who took up the rear, both of whom earned more than regulars. The latter may be the twelve Persians in the middle of the file, whose salary is also unknown. If we *guess* that by "stater" Arrian means an Attic tetradrachma, and that the earnings are monthly, then at best we surmise the following pay structure at the end of Alexander's reign:

Macedonian 1: more than 2X drachmas/month; Macedonian 2: 2X drachmas/month; Macedonians 3 and 4: 40 drachmas/month; Persians 1-12: X (less than 40, more than 20) drachmas/month.

To produce a progressive scale, the figure X must fall between 20 and 40 drachmas. If, for the sake of argument, X is 30 drachmas, then the scale goes up the ranks as 30 drachmas, 40 drachmas, 60 drachmas, and 60-plus drachmas. A minimum of four speculations gets us to about 570 drachmas per file per month. Even then, for the king's entire army, we need also to guess the total number of files, plus the pay rates and numbers for cavalry, sailors, mercenaries, and other military and support personnel.[105]

To extrapolate from such a mishmash of incomplete data an annual military budget obviously requires massive guesswork.[106] To change just one variable (for example, taking Arrian's "stater" to mean a gold stater rather than an Attic silver tetradrachma) considerably changes the calculus. Andreas Andreades nonetheless conjectured that the king's annual war budget was 5,000 to 7,000 talents (30 million to 42 million drachmas) down to 330 BC and 15,000 talents (90 million drachmas) thereafter.[107] This would mean a total expenditure of 150,000 to 162,000 talents (900 million to 972 million drachmas). These figures doubled earlier estimates formulated by historians such as Karl Julius Beloch, and several attempts have been made since then to recalculate these annual costs.[108] Georges Le Rider has posited a combined land and sea force of 89,000 men in 334 BC with a payroll of 89,000 drachmas a day, or about 5,400 talents per year.[109] More recently, Andrew Meadows has tentatively

suggested an annual cost of just over 6,000 talents at the end of the reign, taking us back to much lower figures.[110]

The most closely argued of these studies was produced by Robert Milns in 1987, a cautionary investigation that concluded the following:

> All of this [uncertainty] means that any attempt to estimate how much the armed forces cost Alexander must be regarded as extremely hazardous and unsure; and perhaps the greater the precision claimed in the exercise, the greater our suspicion should be of the result. There are, quite simply, too many unknown—and unknowable—factors and variables.[111]

Although reluctant to propose any budgetary figures of his own, Milns nevertheless deduced that earlier estimates were too low even excluding the costs of food, equipment, baggage animals, and innumerable other expenses. Milns ventured that by 323 BC, Alexander was spending on his army his entire annual income, with a financial crisis looming.[112] This was much the same conclusion, albeit with different numbers, that had been reached by earlier writers.[113]

The impression that another Macedonian king was dying on the edge of insolvency seems, once again, overly dramatic. Certainly, Alexander lived and spent lavishly like there was no tomorrow, but that tomorrow came for the king well ahead of his wealth. It will be shown in the following chapters that at the time of his death, Alexander's treasuries were still well stocked. He was expending funds on numerous big-budget projects, such as the construction of temples. It was reported that he also had plans to complete a Western Mediterranean fleet; roads, ports, and shipyards in North Africa; a pyramid for Philip II; and new cities numerous enough to effect massive population transfers between Europe and Asia.[114] That the dead king's troops voted to cancel these payouts should come as no

surprise.[115] The simple truth is that Alexander's priorities in 323 BC were not shared by his army, nor, more important, by its marshals who had other uses for this money. With the king's death in Babylon, those uses were immediate and almost entirely military, and the claim that spending on armies and navies exhausted the resources amassed by Alexander must take into account the generation that followed him. Poor Alexander in 323 is as much a myth as poor Alexander in 336. His was not a rags-to-riches-to-rags story.

The real conundrum is not the amount of treasure accumulated, which was more than even Alexander could exhaust, but how that wealth was managed. Did Alexander maintain an efficient administrative system for the collection of tribute, the guarding of treasuries, the distribution of funds, and the minting of money? Was there waste and malfeasance? If so, what did the king do about it? The answers to these questions will tell us whether Alexander governed as efficiently as he conquered.

(Mis)Management

In spite of its victories over the richest of peoples, the army had triumphs but no treasure to show for it.

<div align="right">Curtius 10.2.11</div>

I demand money because Alexander has harvested Asia, leaving me only the stubble to glean.

<div align="right">Antigonus One-Eyed</div>

The stewardship of Alexander's resources concerned everyone, from his common soldiers to the kings who succeeded him. All, it would seem, had complaints. It has been demonstrated that men of all stations found reasons to grumble: soldiers about the rewards lavished on entertainers; generals about sharing spoils with foreign dignitaries; common Macedonians about the wagonloads of loot owned by some companions. Alexander's troops were still grousing about unpaid wages long after the king's death.[1] Old Antigonus One-Eyed, the first of Alexander's generals to declare himself king, griped that he only seemed avaricious because Alexander had already taken everything from Asia and nothing of value was left.[2] Peasants fumed that Antigonus was more grasping than Alexander, and in turn that Lysimachus was worse than Antigonus.[3] Historians must naturally be wary of such carping, for it seems a common practice in every place and period. Nonetheless, it must be asked how, and how well, the financial apparatus of Alexander's empire

functioned from the perspective of his contemporaries. A good place to start is among the rank and file. Let us begin, therefore, by examining the experiences of an anonymous Thessalian cavalryman and an anonymous Macedonian infantryman.

LUCKY THESSALIAN, WEARY MACEDONIAN

Our random rider from Thessaly, the rich horse-rearing plains south of Macedonia, would be among the 1,800 or so men whose allied contingent followed the king into Asia and fought with distinction at the battles of Granicus, Issus, and Gaugamela.[4] In addition to his regular pay and/or maintenance, on which our sources give no data, this horseman enjoyed other remunerations that are recorded. For example, he was expressly allowed to enrich himself by looting Darius's baggage depot at Damascus in 333 BC.[5] He was also among the troops who despoiled the Persian baggage camp at Gaugamela, where soldiers had plotted in advance to keep what they looted and not turn it over to the royal treasury.[6] At Babylon in 331, this soldier received from Alexander another boon of 500 drachmas.[7] Shortly thereafter, he joined in the plundering of Persepolis and, at Ecbatana, had the option of returning home to Greece with his wages, travel pay, and another bonus of 6,000 drachmas. Choosing with many others to stay with Alexander, he collected a gratuity of 18,000 drachmas by signing on for another year.[8] At the end of that period, now at the Oxus River in Bactria, he was discharged with a further gift of 12,000 drachmas.[9] What is more, he and his comrades profited by selling their horses before heading home.[10] The value of Alexander's bonuses had risen exponentially in just two years, increasing twenty-four to thirty-six times over the 500 drachmas doled out at Babylon. Thus, in fringe benefits alone, this Thessalian received in two years what a contemporary Greek

architect might earn in forty-two years.[11] By any standard of the day, this Thessalian soldier returned home fabulously rich.

To the rest of his troops, Alexander gave thanks, and presumably money, too, "because they promised to serve zealously for the duration of the war."[12] Among them was our anonymous Macedonian foot soldier serving in the battalion of Meleager.[13] Little did he and his fellow phalangites realize what lay ahead, or how lucky was that loot-laden Thessalian on his way to Greece. The army staying on with Alexander expected soon to arrest Bessus, the self-proclaimed successor of Darius who was hiding nearby in Sogdiana. This was to be the end of major combat operations in the Persian war, but a savage insurgency erupted across the region and dragged the army into its bitterest fighting yet.[14] Our infantryman participated in besieging and sacking the recalcitrant Sogdian cities near the Jaxartes River and fending off deadly cattle raids in Bactria.[15] Gone were the days of palaces to plunder, and the spoils available were for the most part distributed by Alexander to the old and infirm Greeks and Macedonians being settled across the region to recompense these unhappy colonists with lands and loot.[16] Our Macedonian was not among these settlers, and glad of it.

He had come to expect ever richer spoils since invading Asia, but in Bactria and Sogdiana, for the first time, those prospects vanished as the army marched again and again over the same ravaged ground. As rewards dwindled, disaffection grew along with casualty rates, harsh weather conditions, and questions about the leadership of the king and his commanders. The grumbling got one officer killed, speared by Alexander himself.[17] Another high-ranking Macedonian ordered to stay at a garrison refused to do so and was executed by the king.[18] Others revolted on two occasions, "unable to abide living there among the barbarians."[19] Men huddling around their campfires through the three winters of 330, 329–328, and 327 BC, much less those forced to stay permanently,

might remember fondly the warmth and wealth of Persepolis in 331/330 and Egypt in 332/331.

To make matters worse, as shown in chapter 3, when the men lucky enough to leave had loaded their baggage onto wagons at Bactra, the king issued the surprising order to destroy it: "So, all the loot earlier snatched from the flames of fallen cities was set on fire by the soldiers, and no one dared weep for what had been won by their blood and now lost."[20] So the Thessalian had gone west and was now home with his treasures, while the weary Macedonian headed east with none. He had to begin all over in India. At Taxila, the soldier heard that his commander Meleager had openly voiced his displeasure to the king, complaining about the loot given to Taxiles.[21] Alexander in turn criticized Meleager's greed, and the gruff fellow never received another promotion. It was left to him and his soldiers to make good their financial losses by looting India as thoroughly as possible.

Our anonymous Macedonian infantryman never made it all the way down the Indus to see the outer ocean. His battalion, lugging whatever fresh spoils they had accumulated, was among those detached from the main army and sent west through Arachosia and Drangiana under the command of Craterus.[22] These accompanied the men worn out by war, taking the easier route back to Babylon alongside the cumbersome new corps of elephants. These forces dealt with insurrections along their march and rejoined Alexander in Carmania.[23] The reunion with the king's struggling contingent highlighted once again the disparities of wealth within the ranks, for the spoils of the man's compatriots in the main army did not survive their journey through the Gedrosian Desert. When provisions ran out, the starving troops killed and ate the horses and draught animals just as they had done four years earlier in the Hindu Kush. Then, "having nothing to haul their packs, they burned the loot for which they had harassed the farthest reaches of the Orient."[24]

The coup de grace came when a flash flood killed the remaining animals and many of the camp followers, and swept away even the royal baggage.[25]

So it appears that a lot of the army's traveling wealth was lost along the way from Bactria to India and back. This fate did not affect the lucky Thessalian, but it did impact the remaining servicemen in varying degrees. Some of their spoils were destroyed, some of them bartered or spent. When the soldiers had faced privation in their first crossing of the Hindu Kush Mountains, for example, each man apparently fended for himself, buying what he could at inflated prices before eating the baggage animals.[26] Desperate soldiers paid 390 drachmas for an amphora of honey, 300 for wine, and 240 for sesame oil. These rates would cost a skilled Athenian construction worker in that same year 195 days' labor for the honey, 150 for the wine, and 120 for the oil.[27] For the cost of his jar of wine, a soldier could purchase an entire vineyard back in Greece.[28] Significantly, although in peril, the troops wanted the sesame oil not for sustenance but for bathing since they had run out of olive oil.[29] But then, why not pay for essentials and luxuries with wealth soon to be abandoned anyway with the crippled train? This may have happened again in Gedrosia, the troops being eager to spend what they had or to settle debts before ditching the last of their loot. By the end of this two-month desert ordeal, money had become meaningless to these men. The point was driven home when Alexander ordered satraps to send emergency provisions; when one of them dispatched 3,000 talents of coins (worth 18 million drachmas), the king dramatically tossed the money to the starving horses to show just how useless it was.[30]

The survivors of the Gedrosian march may well have envied the anonymous Macedonian in Meleager's battalion, just as he in turn resented the Thessalian cavalryman and his comrades discharged at the Oxus. In Alexander's efforts to ameliorate the

suffering and dissatisfaction endured by those who had survived the long Bactrian and Indian campaigns, our sources disclose a bigger problem in the management of the profits of war. By some means unknown to us, Alexander at Susa was made aware that his army was deep in debt. This information was allegedly news to the king and a cause of shame for his troops, who were as alarmed by Alexander's offer to pay off the loans as the king was surprised of their existence. The situation baffles us as well, for if ever soldiers were in a position to retire personal debts, this would be it. Just before and after this incident, the king lavishly entertained these veterans at huge expense; promised to release many of them from duty with full back pay, traveling expenses, and bonuses of up to fifteen years' salary; granted stipends for the wives and children they were to leave in Asia; and guaranteed that soldiers' orphans would receive their fathers' pay.[31] These same soldiers had seen, seized, and spent more money than could be imagined when they first crossed into Asia. Most had destroyed their traveling wealth on at least two occasions and started all over again. They had marched into battle mocking the silver and gold trappings of the Persian army, only to march away just as lavishly trimmed and armed. Yet, at Susa in 324 BC, they collectively owed the extraordinary sum of 9,870 talents. Our Thessalian horseman departed debt-free, so what had gone wrong in subsequent years for our anonymous Macedonian infantryman and his comrades?

DEBT AND DESPAIR

The total amount of the army's reported debt is staggering; yet, as noted in chapter 1, the figure stands out as a precise quantification in a sea of rounded, conventional numbers. It appears to be a reliable sum that warrants further consideration in the context

of Alexander's financial administration. According to Curtius
(10.2.11), "In spite of its victories over the richest of peoples,
the army had triumphs but no treasure to show for it." The king
responded by generously and laboriously paying off these liabili-
ties in what Joseph Roisman calls "an acute attack of generosity."[32]
Obviously, the creditor was not the king, or else hard cash would
not have needed to be piled on tables by Alexander to pay himself.[33]
The troops owed each other and, more likely, the ubiquitous sutlers.
Diodorus 17.109.2 writes that the affected debtors were the 10,000
old veterans being sent back to Macedonia; Plutarch, *Alexander*
70.3 identifies the lot as the 9,000 wedding guests attending the
mass nuptials at Susa. Putting the event in the same context as the
wedding, Arrian 7.5.3 includes the entire army in Alexander's bene-
faction. Curtius 10.2.9 also includes everyone, but the settlement
occurred prior to choosing which soldiers to discharge from service.
Justin 12.11.1 situates the payout between the wedding celebration
and the retirement of veterans. The number of recipients therefore
ranges from a subset of about 9,000 to the entire military force, pro-
ducing an average indebtedness of up to 6,580 drachmas per man.
This means that after just 10 years of campaigning in Asia, men
owed about 2.7 years' worth of their top earnings using the high-
est possible pay scale for a Macedonian infantryman (assuming
gold ten-stater men), or 13.7 years' worth at the lowest (assuming
silver ten-stater men).[34] At best, taking the entire Macedonian army
into account, the average man's debt would have been less but still
quite substantial.[35]

In a speech attributed to Alexander, the king is made to express
to his men his surprise at the debts they had piled up in light of "the
enormous sums you received in pay and took by plundering."[36] The
troops at first balked at Alexander's offer to help them, partly from
shame and partly from fear that the worst squanderers were being
flushed out for punishment.[37] In time the men complied, making

their declarations and producing witnesses to have the facts duly recorded on official rosters. Then, the king set up tables piled with coinage (essentially banks) throughout the camp, at which the soldiers on the debtor rolls lined up to receive their cash. The process must have been a bureaucratic and logistical challenge, requiring many documents and over 280 tons of coins, not to mention massive security. What was it like on a day when so much cash suddenly pulsed through, and presumably beyond, the throng of soldiers?

Fraud naturally occurred. The case that caught everyone's attention involved Antigenes (or Atarrhias) the One-Eyed, a war hero who had fought both for Alexander and for his father Philip.[38] As a young man, when Antigenes lost his eye in battle, he continued to fight with the arrow still lodged in his face until victory was declared. At Susa, this Antigenes produced a false witness and lied to get himself on the debtor lists. He got the money, but when the fraud was discovered, perhaps by some sort of audit, Antigenes faced the wrath of his king. Alexander summarily relieved him of his command, a disgrace that Antigenes could not bear. To prevent the man's suicide, Alexander pardoned him and let him keep the money. One moral of this story might be the kindness of the Macedonian king, but another is the avarice that compelled a good soldier to commit a crime and, very nearly, suicide.

The amount of debt being carried by the rank and file of Alexander's army seems reliably exact, and it raises serious questions about what had happened to the wealth won from Persia. It is true that military pay had not been regularly issued on campaign, and that some debts may have been owed by soldiers to merchants who followed the army.[39] On the two occasions when the men burned their baggage, however, some debts might have been settled first with the sutlers, if not among themselves. At Susa, these men were issued their back pay and more besides, a considerable boon with which to square accounts. The cumulative interest on any

payday loans should not have amounted to thousands of talents, nor caused such shame if the troops had fallen into trouble only because of Alexander's intermittent paydays. Clearly, pay and pillage had proved no match for the expensive lifestyles adopted in the East, and the destruction of some men's booty had made matters worse. In fact, after the burning of baggage at Bactra, Alexander took upon himself the costs of caring for the wives and children who followed the army into India.[40] No doubt huge gambling debts were also part of the problem in the traveling casino that is almost every marching army. Gambling became troublesome enough that Alexander punished friends whom he caught playing dice for money rather than fun.[41]

Implicit in the number 9,870 is a soldiery spending beyond its means in an army that was never regularly paid. These are the problems of a long campaign carried to the farthest reaches of the known world by men facing danger on a daily basis. The financial troubles of the rank and file reflect to some degree the king's own isolation from the considerable reserves held at the center of his empire, and it must be noted that Alexander lost huge portions of his own treasures as well. In the king's case, however, there is also his grave indifference about how his imperial wealth was being managed by notorious cronies and crooks. If our long-suffering Macedonian infantryman resented the boons enjoyed by the Thessalian cavalryman who had escaped all risks on the eastern frontier, how he must have despised the career of Alexander's chief treasurer.

HARPALUS THE TREASURER

When Alexander invaded Persia, he put a boyhood chum named Harpalus in charge of the royal treasury.[42] The family of Harpalus had connections in the royal Macedonian court, and in fact,

Harpalus's aunt Phila was married to Alexander's father.[43] Harpalus himself was one of the canonical five boyhood friends of Alexander (along with Nearchus, Ptolemy, Erigyius, and Laomedon), although these companions may actually have been slightly older and meant to supervise the prince.[44] In the eyes of Philip, all five failed his son by encouraging him to act contrary to the interests of king and country. Philip banished them in 337 BC, but when Alexander ascended the throne a year later, he recalled all five and made amends for their misfortunes. Each attained high positions, and most proved worthy of them. Harpalus stands out as the grievous exception, a boyhood friend who failed the new king as thoroughly as he had the last.[45]

Because Harpalus was physically unfit for active duty, he could not be rewarded with a military commission such as Alexander bestowed upon the other former exiles; thus, Harpalus became the imperial treasurer.[46] Unfortunately, he fell under the influence of an "evil man" (*aner kakos*) named Tauriscus. Both men fled from Alexander's court shortly before the Battle of Issus in late 333 BC. Thus, while Alexander was riding headlong into battle, as shown in Figure 6.1, Harpalus was running away. What evil he and Tauriscus may have done is unreported, but embezzlement is certainly a possibility. Cowardice, too, may have played a part, since not everyone believed Alexander could win his first face-to-face encounter with Darius. In any case, Harpalus appears as a man of weak character who was induced by a dangerous and perhaps parasitic scoundrel to abandon Alexander at a critical moment. In fact, the king was so shocked by this betrayal that he arrested the two men who brought him the news on the grounds that they must be lying.[47] Tauriscus fled to Italy, while Harpalus found refuge in the Megarid of Greece. Alexander's first major management decision was a fiasco.

His next one proved no better. After defeating Darius at Issus, Alexander seized enormous amounts of treasure at Damascus and in Egypt. In 331 BC, the king entrusted all of this wealth to the care

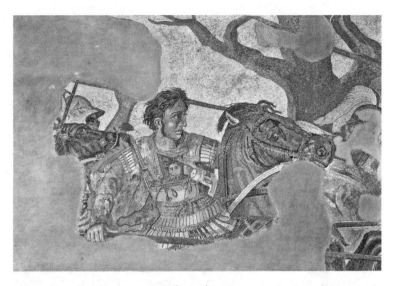

Figure 6.1. The Issus Mosaic (detail). Museo Archeologico Nazionale, Naples, Italy. © *Scala/Art Resource, New York.*

of his newly appointed treasurer—Harpalus.[48] Like a bad lepton, the disgraced man turned up again and was reappointed to his old post with the impressive title "Guardian of the Babylonian Treasury and of the Revenues Accruing Thereto."[49] In fact, Alexander had begged Harpalus to return with assurances that he would suffer no punishment. This is a decision so strange that modern scholars have wrestled valiantly to find a rational explanation for it. According to Bonnie Kingsley, "It is difficult to believe that [Alexander] would have recalled a man who was in fact a deserter to entrust him with access to the treasury," so she supposes that Harpalus actually went to Greece in his official capacity as treasurer; his job was to arrange financing for famine relief.[50] Peter Green has suggested that Harpalus may have been on a secret spy mission to Greece, using the defection story as a cover.[51] Surely Waldemar Heckel is correct that these theories do not adequately account for the role of Tauriscus,

who has no place in the relief mission of Kingsley and whose pretended part in the espionage story should not have survived as a "fact" in Arrian's account.[52] Why, upon completion of his secret assignment, should Harpalus still be said to have absconded with Tauriscus? Indeed, but for Arrian's explicit evidence that Harpalus *fled* to Greece and that he returned *from exile*, there is absolutely no reason to suspect that he was ever gone. If we accept Arrian about that absence, there is no need to counter his explanation for it with made-up missions. The ancient testimony, brief though it may be, plainly states that Harpalus fled with a dastard and then somehow found favor again with his boyhood friend Alexander. There is no saving the administrative reputations of the trusting king and his unreliable treasurer.

No one doubts the sequel to this unsavory business. Harpalus, placed in "potentially the most powerful position assigned to any individual during the expedition," betrayed that trust.[53] At Ecbatana, the treasures scooped up from Persepolis and elsewhere were put into Harpalus's hands along with a temporary guard of 6,000 troops.[54] At some point, while Alexander carried his military campaigns far into Bactria and India, Harpalus went to Babylon, where he adopted a notorious lifestyle. "First," writes Diodorus, "he busied himself violating women and carried on illicit love affairs with natives, spending lavishly much of the treasure to support his uncontrollable appetites."[55] Living like a king, the unrepentant embezzler surrounded himself with an expensive court of his own, including prostitutes, actors, and dancers.[56] Contemporaries criticized Harpalus's luxuriant lifestyle that required the transport of fish all the way from the Red Sea and decorative foliage from faraway Greece.[57] Some of the treasurer's gardening outlays may have been approved by Alexander, but surely not his budget for famous prostitutes.[58] Harpalus summoned from

Athens a courtesan named Pythionice, to whom the treasurer gave gifts "worthy of a queen."[59] When she died, Harpalus erected stunning memorials to her that reportedly cost the imperial treasury 200 talents (1.2 million drachmas).[60] In Babylon, he built a temple dedicated to her worship as Aphrodite Pythionice. This monument, as Theopompus complained to Alexander, shamed all the soldiers who had died without comparable memorials to their valor. On the sacred road to Athens, Harpalus funded an expensive monument worthy, said Dicaearchus, of such great men as Pericles but ignobly celebrating, instead, the life of Harpalus's whore.[61] Many centuries later, the travel writer Pausanias still deemed this "the grandest of all the old Greek tombs," but Plutarch called it "unworthy of the thirty talents demanded by Charicles for its construction."[62] This Charicles, along with others, was duly charged with accepting bribes from Harpalus.[63] The many stories about Harpalus's extravagance may be colored by Greek, and particularly Athenian, political infighting, but possible exaggerations do not cast doubt on the basic facts since men like Pausanias and Plutarch could still see Harpalus's expensive handiwork centuries later.

Whoreless, the unrepentant treasurer sent for an Athenian replacement named Glycera ("Sweetness"). She, too, enjoyed with Harpalus a lifestyle of royal splendor.[64] Their dalliance inspired reports of a statue dedicated to her beauty in Syria, of luxuriating in a palace at Tarsus, and of divine honors and the title of queen. A satyr-play allegedly attended by Alexander publically lampooned Harpalus's besotted intrigues with these women.[65] Indulging himself as de facto king while Alexander and his army toiled through the ravaging campaigns of the East, Harpalus gambled that the real monarch would never return. He hedged that bet by using state funds to bribe various parties in Athens "should the vagaries of fortune"

necessitate another flight.[66] Preparing a refuge suggests some calculation on the part of a man who otherwise appears quite irrational and self-destructive.

Then Harpalus fled again. When Alexander returned from India, he discovered a culture of malfeasance rotting the administrative core of his empire. His strong reaction against this abuse of power cost some subordinates their positions and others their lives.[67] More than anyone else, Harpalus had set the worst example for these miscreants, and he had no intention of paying the price for doing so:

> When Alexander marched back from India and executed many satraps who had been denounced for dereliction of duty, Harpalus feared his own punishment. He therefore packed up 5000 talents of silver (30,000,000 drachmas) and mustered 6000 mercenaries, departing Asia for Athens.[68]

Alexander would never again see the man, the mercenaries, or the money stolen from him. Three embassies demanding the extradition of the runaway treasurer failed, allowing Harpalus time to stir no small amount of trouble. Politicians were bribed, careers ruined, money lost, and a war started.[69] As one result, the implacably anti-Macedonian orator Demosthenes was ten times richer in 323 BC than he had been as a boy.[70] This irony cannot have pleased the king, for the wealth that flooded Athens and emboldened his enemies was stolen from him by a treasonous treasurer. Trusted by no one, Harpalus was murdered on the island of Crete in 324 BC, a year before the death of his childhood friend Alexander.[71]

As might be expected in any such egregious case of embezzlement, there is no way to calculate how much Harpalus may have stolen or wasted over the course of his two careers as chief treasurer. The traveling bundle for his second flight alone approximated the

total value of all lands, livestock, buildings, and other possessions in the whole of wealthy Attica where Harpalus sought asylum.[72] Some may wonder why Harpalus did not take even more of the treasure with him, but we must assume that part of it was dispersed in Susa and other cities, and speed was of the essence. As it was, Harpalus's load of 5,000 talents weighed over 142 tons if silver, and over 14 tons if gold. He more or less lumbered away in flight.

The chaos wrought by Harpalus upon Alexander's empire and its finances must be blamed, in part, on the king himself.[73] Too late, Alexander responded to Harpalus's crimes, and even then the king's concerns were less about the money than the political meddling and the private mercenary army. Appointing Harpalus the first time was a mistake; appointing him a second time was completely reckless.

SCAMS AND SCHEMERS

In the interval between Harpalus's tenures, the king seems to have prudently divided the chief treasurer's responsibilities between Coeranus and Philoxenus, but these men were later reassigned to handle fiscal duties in Phoenicia and Asia Minor once Harpalus was reinstated.[74] In Caria, this Philoxenus later claimed to have run short of money, a situation he corrected by extorting funds from the local population in a liturgy scam.[75] Rich citizens were imposed upon to defray the costs of a Dionysiac festival, the stipulations for which were as troublesome as they were expensive. Each annoyed victim was then permitted secretly to arrange a contribution to escape the liturgy, allowing Philoxenus to keep putting others on the list until his coffers overflowed.

When Harpalus had absconded a second time, Alexander apparently replaced him as treasurer with Antimenes of Rhodes.

Little is known about Antimenes, except that he gained a reputation for oppressive measures.[76] He revived defunct Babylonian laws just in time to trap unsuspecting envoys and tradesmen into paying a 10% tax at Alexander's court, and he even devised a lucrative insurance scheme for slave owners among Alexander's troops.[77] Annual premiums were paid, guaranteeing the master's recovery of property for any slave who escaped. Antimenes kept the premiums, but shifted to satraps all responsibility for capturing the slave or paying the owner. He also ran a lucrative business supplying travelers along the royal highways, again at some expense to the satraps.

In wealthy Egypt, the king had placed a man named Cleomenes of Naucratis in charge of financial and other matters, such as the collection of taxes and the building of Alexandria.[78] This fellow was no childhood friend of the king, but rather a local figure considered by Arrian a "wicked man": the historian twice refers to Cleomenes as an *aner kakos* in the space of a few sentences.[79] The judgment may derive from Ptolemy, one of Arrian's principal sources, since it was Ptolemy who eventually killed Cleomenes following the death of Alexander.[80] Two other contemporaries shared the opinion, however, one in a court case against business associates of Cleomenes and the other the author of the *Economics*, a treatise from the Aristotelian school written no later than circa 320 BC.[81] From the former, a speech found in the corpus of Demosthenes, we learn that two Athenians lent 3,000 drachmas to a certain Dionysodorus and his partner Parmeniscus, expressly to sail to Egypt for a load of grain to be sold in Athens.[82] Instead, in league with Cleomenes, "who did much harm to Greece by buying up all the grain of Egypt and then reselling it at fixed prices," the shippers broke their signed contract and sold it at Rhodes. Why? Because Cleomenes ran a network of agents who tracked grain prices around the Mediterranean in order always to sell at the best markets. When prices at Athens temporarily slumped during the return voyage of the ship, it was diverted to

Rhodes.[83] The lawsuit (whose outcome is unknown) sought damages for breach of contract, citing unscrupulous business practices by the shippers and their partner Cleomenes.

These practices were all the more egregious because they exploited a tragic food shortage gripping the Mediterranean world at the time. Cleomenes was callously price-gouging while many states were facing starvation due to an unprecedented failure of grain harvests between 331 and 324 BC.[84] Emergency measures are widely attested by Greek inscriptions; for example, Alexander's mother and sister appear prominently as individuals among a list of states entitled to purchase grain being rationed from Cyrene.[85] This privilege no doubt owed something to Alexander's influence, yet at the same time the king's finance officer in Egypt was profiteering. How much Cleomenes stood to gain may be calculated from known food prices in Athens. Demosthenes recalls the strict rationing of grain in Athens and the Piraeus, where people were allegedly trampled trying to claim their meager portions as the cost of wheat more than tripled from five to sixteen drachmas per bushel (medimnos).[86] As the famine worsened, Cleomenes doubled it further, charging thirty-two drachmas.[87]

The *Economics* adds to the manipulation of grain prices other schemes in Egypt.[88] Cleomenes threatened to allow crocodile hunting among the sacred basks, prompting the priests to hand over all their gold to protect the beasts. He likewise extorted money from those property owners and priests in Canopus who wished to evade his mandatory order to relocate to Alexandria, only later to enforce the order anyway when additional payments were not forthcoming. Cleomenes further announced that a shortage of funds for the temples of Egypt meant that he must close some and abolish their priesthoods, a threat that brought in an immediate windfall from those paying to have their temples spared. Lastly, he cheated the soldiers under his command of one month's pay per year. One of

Cleomenes's appointees named Ophellas, charged with supervis-
ing the district of Athribis in Upper Egypt, responded to Egyptian
complaints by imposing higher taxes. Among his sources, Arrian
found verification of the complaints filed against Cleomenes and
his staff, for the historian cites a royal letter written on the matter.[89]
In it, Alexander granted Cleomenes a full pardon in exchange
for building shrines to honor his close companion Hephaestion.
Arrian was especially pained to quote Alexander's additional prom-
ise to Cleomenes that "as for your future crimes, no matter how bad
they may be, I shall not punish you." Still reeling from the Harpalus
scandal, Alexander nevertheless handed this powerful comptroller
a perpetual "get out of jail free" card. Cleomenes, infamous for his
profiteering, remained in office until Ptolemy had him killed fol-
lowing the demise of Alexander.[90]

The careers of Harpalus, Philoxenus, Antimenes, Ophellas, and
Cleomenes suggest a pattern of rampant corruption and abuse
quite in keeping with the widespread malfeasance punished by the
king when he returned from India in 325/324 BC.[91] A number of
satraps were executed at the time, but these five financial officers
all escaped disciplinary action—Harpalus by fleeing, Cleomenes
perhaps by pardon, and the rest without notice. It might be argued
that all but Harpalus were merely guilty of being overzealous to
serve the interests of their king by maximizing revenues in every
conceivable way. Yet, even those scholars inclined to see them as
businesslike and efficient concede their ruthlessness.[92] Cleomenes,
after all, controlled 8,000 talents (48 million drachmas) when he
died, the staggering profits of oppressive tactics unprecedented
in satrapal Egypt.[93] This was ten times the sum found there by
Alexander about a decade earlier, the construction of Alexandria
notwithstanding. Whether the king's letter pardoning Cleomenes
is fact or fiction, the aggressive tactics taken by his financial staff
are as much his responsibility as the actions of his military officers.

The only way to save Alexander from seeming hopelessly venal or helplessly uninformed is to plead severe financial exigency on behalf of the king and his minions: in other words, that they had no other choice. This unusual approach has been taken by Georges Le Rider.[94] He concludes that Antimenes and Cleomenes (he does not mention Philoxenus or Ophellas in this regard) were highly skilled financiers forced to be unscrupulous because they never had access to funds sufficient for their assigned tasks: "In order to obey their king, Antimenes and Cleomenes displayed real ingenuity, which was not always compatible with noble sentiments."[95] How was this possible given the enormous wealth captured by Alexander, including the 180,000 talents assembled at Ecbatana in 330 BC? Le Rider's answer is that by late in the reign, this vast treasure was gone, spent except for a residual fund of 50,000 talents needed for new expeditions.[96] To account for the depletion of these Persian treasures, Le Rider claims that Alexander never left the 180,000 talents behind but carried them along from Ecbatana to India so as always to be at the king's "immediate disposal."[97] This left Harpalus, Cleomenes, and Philoxenus to make do only with revenues raised locally, and even Antimenes had little left to work with when the king brought the remainder back from India. The key question, then, is whether the bulk of Alexander's spoils from Persia stayed with Harpalus or followed Alexander to Bactria and India.

WITH HARPALUS OR THE KING?

It may seem incredible that a treasure so large could be obscure enough in its movements as to have its whereabouts disputed by scholars. No one doubts that Alexander had the loot from Persepolis and Pasargadae laboriously transported away, as discussed in chapter 4. Some of it may have been diverted to Susa, but the bulk

of it followed Alexander to Ecbatana as the king pursued Darius.[98] Parmenion was in charge of hauling the treasure and turning it over to Harpalus at Ecbatana, where some 180,000 talents were assembled and kept under guard by 6,000 soldiers.[99] The sources do not explain why so much wealth should be hauled away from Mesopotamia, except to say that Alexander wanted to carry some of it along to cover the expenses of the war.[100] This may be taken to mean that Alexander anticipated a final reckoning with Darius and then, as it transpired, a demobilization and payment of allied forces. Most scholars agree that the remaining treasure next went with its supervisor Harpalus to Babylon, either in late 330 or early 329 BC, as Alexander moved against Bessus in Bactria.[101] Le Rider, however, believes that Harpalus "quickly rid himself" of the job of overseeing the treasure and left for Babylon without it.[102] This seems a strange career move for an embezzler, but even more remarkable would be the king's desire to drag a treasure train of 25,000 baggage animals through what is today eastern Iran, Afghanistan, and Pakistan.

To support his version of events, Le Rider cites the retort attributed to Hermolaus when accused by Alexander of treason in Bactria: "Your soldiers will carry home nothing but scars while for you 30,000 mules haul captured gold."[103] This is taken to mean that the entire Persian treasure was with the army in Bactria, and Le Rider notes that the number of mules mentioned by Hermolaus approximates the last known figure of 20,000 mules and 5,000 camels that had departed Persepolis. This suggests to Le Rider "that between 329 and 327 the quantity of military treasure had remained almost constant" as the invaders traversed mountains and deserts in pursuit of rebels.[104] Citing another speech in Curtius, Le Rider adds that "Philotas's chariots of gold and silver" were still with the army in Arachosia, "implying that the inner circle kept these chariots permanently."[105] Even accepting Curtius at his word about the particulars of these two orations, there is absolutely no

reason to suppose that they refer to immediate circumstances in Arachosia or Bactria. Hermolaus's critique is a generalized one stating only that Alexander owns a vast treasure that his troops do not share; this wealth and the train that carried it need not be in Bactria to make sense of the remark, and Hermolaus does not actually say that it was. The remark is certainly rhetorical, turning as it does the whole treasure into gold, and the similarity in numbers of baggage animals means only that the original train to Ecbatana is being referenced, albeit inflated to the common quantification of 30,000. To take a line from this speech as an informed accounting of Alexander's wealth on hand in Bactria, and to conclude that the quantity of his traveling treasure therefore remained nearly constant, is to misread the evidence in multiple ways.

This is even more obvious when Curtius paraphrases Bolon's speech against Philotas.[106] The supposed indictment is voiced by a coarse old veteran remembering how Philotas's slaves in the past had evicted soldiers from their chosen billets, and how the effete Philotas even barred his comrades from surrounding neighborhoods lest they disturb his sleep. This suggests requisitioned quarters in large, occupied cities. The image is sharpened with Bolon's operative complaint that Philotas's wagonloads of loot had blocked off entire sections of a city. If true at all, the accusation confines itself to a soldier's personal spoils, not the royal treasure, and it seems to recall events in the past—say, at Babylon or Persepolis during the army's long stays in the Persian heartland. The speech certainly does not mention anything so garish and lumbering as chariots made of gold and silver carried along by the companions. There is simply no proof that the Persepolis treasure was ever at Phrada or Bactra. Curtius himself never meant to suggest that it was, for it is his narrative that claims Alexander burned all of his own and the soldiers' traveling loot on the way from Ecbatana to Bactria.[107]

Lacking any reference to the 180,000 talents actually following Alexander beyond Ecbatana, there is ample evidence that they did not. It has been shown in previous chapters, for example, that the baggage train was lost in the first crossing of the Hindu Kush, and that much of whatever remained of the army's mobile wealth was later burned before leaving Bactria. In India, Alexander obviously did not have access to the Persian treasure when he was forced to collect money from his generals to finance the Indus campaign. Then there is the loss of baggage again during the crossing of the Gedrosian Desert. So there is no reason to believe that Alexander had with him at Bactra in 327 BC a train of 30,000 mules carrying around his 180,000 talents, some 50,000 of which he allegedly carried out of India and through Gedrosia back to Babylon. Nor is there any numismatic evidence to account for the depletion of about 130,000 talents (780 million drachmas) during the eastern campaigns. No regular mints operated east of the Tigris, and Alexander's lifetime coinage is conspicuously rare in finds from Central and South Asia.[108] The possibility put forth by Le Rider that the king recycled the coinages of India while in the subcontinent requires no presence of the Persian treasure, and the potential spending of Achaemenid coins while in the East has left no meaningful trace in the archaeological record.[109] Where are the hoards of sigloi and darics to be expected in the East if Alexander expended the bulk of the Persian treasures there? As will be shown in the next chapter, those treasures went west, not east, where hundreds of hoards containing many thousands of coins attest the fate of the main Persian treasure. It had remained with Harpalus.

So, given the massive resources at hand in Mesopotamia, widespread shortages of funds cannot explain the ruthless methods adopted by the king's administrators. There was no honor or sharing among thieves, and the example set at the top by

Harpalus probably encouraged graft, greed, and gross incompetence by others. The apparent indifference of Alexander to these abuses seems hard to explain, much less to excuse. In the case of Harpalus, the king obviously had a history of misplaced trust and friendship. It may well be that, in the end, Alexander was finally willing to hold the treasurer accountable, but the failure of the world's most powerful man to lay hands on Harpalus suggests less than a determined effort. Cleomenes, too, escaped retribution by ingratiating himself with the king, whose personal interest in the honoring of Hephaestion trumped his official responsibilities. The others merely escaped notice, profiting from Alexander's poor oversight and preoccupation with other matters. Managing the managers of his resources was clearly not a top priority for the Macedonian king.

THE SUCCESSORS

Alexander died a phenomenally wealthy man whose empire was nonetheless fragile. The king had no obvious heir. His only legitimate son, yet to be born, was the child of his Bactrian wife Roxane, and Alexander's closest adult male relative was an addled half-brother named Arrhidaeus. Our anonymous Macedonian infantryman saw the looming crisis firsthand in June 323 BC as rifts grew among the generals gathered around their king's deathbed. Into this maelstrom stepped Meleager, the surly commander of our soldier's battalion. Meleager became the spokesman for the rank and file who opposed making Roxane's son Alexander IV the new king, preferring instead the claims of Philip III Arrhidaeus.[110] This was the nationalistic view of a man who publicly disliked Asia and its peoples, the same who had angered Alexander by criticizing the sharing of spoils with Taxiles of India. In fact, Meleager is made

to say in a speech attributed to him at Babylon: "Men, why not go plunder the treasures? Surely, we the people are the rightful heirs of these royal riches!"[111] A group of Meleager's followers, including our infantryman, then stormed off to seize their portion of Alexander's spoils. This greedy rabble was later culled from Meleager's battalion and executed by Perdiccas, who ordered all 300 trampled to death by that most non-Macedonian of weapons—Indian elephants.[112] Meleager himself sought refuge in a temple but was killed nonetheless. Somewhere in Greece, a lucky Thessalian shook his head in disbelief.

Alexander had gone to his grave still promising his soldiers more money.[113] Two years later, they were still demanding payment in a state of near mutiny as their rival commanders each cried poor to safeguard their portions of the treasury.[114] One Alexander had become many; one army had divided against itself. The wistful claims that Alexander's wars unified East and West, and that they created a single political and monetary system, are patently false. His reign inaugurated a brilliant new cultural era, but the first forty years of the Hellenistic Age were consumed by a long and vicious civil war. Rival kings and kingdoms proliferated, chunks of the empire as big as India went their own way, and Egypt almost immediately opted out of the so-called global economy built on the Attic monetary standard, even while Alexander never actually suppressed other currencies.

As Alexander's conquered lands fractured and fought each other in shifting coalitions, his veteran forces kept on looting. Discharged mercenaries roamed Asia as freebooters.[115] Some disgruntled Macedonians turned rogue. For example, in 319 BC, about 3,000 infantrymen serving under Holcias renounced their allegiance to Antigonus One-Eyed and plundered the surrounding territories, much as Amyntas son of Antiochus had done in Egypt back in 332 BC.[116]

Holcias and his soldiers were eventually brought under control and
sent home to Macedonia, but Antigonus still faced opposing fac-
tions led by Alcetas (one of fifty leaders outlawed and condemned
to death at Triparadeisus) and Eumenes.[117] The latter was able to
seize one of Alexander's regional treasuries at Cyinda in Cilicia.[118]
Antigonus had already intercepted in 319 BC a shipment of 600 tal-
ents (3.6 million drachmas) from Cyinda to Macedonia to placate
his mercenaries; in 318, he captured more.[119] Eumenes took 500
talents from Cyinda to recoup his expenses, plus "whatever else he
deemed necessary to wage war against Antigonus."[120] These exac-
tions hardly emptied that treasury, for Antigonus seized Cyinda a
few years later and found 10,000 talents still there. When his son
Demetrius followed in his footsteps in 299, he raided 1,200 talents
more.[121]

We know that Cyinda had served since the seventh century BC
as a royal treasury, when Assyrian armies foreshadowed Alexander's
conquest of the eastern Mediterranean and the gathering there of
plunder.[122] In fact, Alexander saw for himself an Assyrian monu-
ment near Cyinda that celebrated this fact.[123] The Macedonian
king, once again, had merely continued the administrative arrange-
ments he found already in place by maintaining a regional treasury
at Cyinda.[124] This trove was well stocked at the time of Alexander's
death and may lie behind the cryptic charge assigning to Craterus
"custody of the royal money."[125] Even in the throes of continu-
ing warfare among the dead king's generals, it was possible to add
annual revenues.[126] That ongoing conflict, however, eventually
drained the coffers as raid followed raid until the "gold of Cyinda"
became only a memory in the line of one of Menander's plays a gen-
eration later.[127]

The same process played out all across the splintered empire
as Alexander's spoils were themselves despoiled. For years, the

Macedonian veterans raided each other's camps, carried off and reclaimed old spoils, and demonstrated that loot was an indispensable part of their livelihood.[128] Eumenes himself was betrayed to Antigonus by the famous Silver Shields fighting division in return for their lost baggage, which was more important to them than anything else.[129] Antigonus then made his way to the old treasure cities of Ecbatana, Persepolis, and Susa, where he confiscated the residual supplies of silver amounting to some 25,000 talents.[130] Like Alexander, he assembled a large train of wagons and camels to haul it away.[131] Heading to the sea, Antigonus paused at Babylon, no doubt to add more to his caravan of treasures since while there he demanded of Seleucus an accounting of all its wealth. The resulting dispute rattled the nerves of Seleucus, who fled to Egypt, leaving Mesopotamia to Antigonus.[132] These men who would be kings laid waste to the same places and peoples that had been under fire since Alexander's invasion. Their armies were hauling about the same spoils of earlier campaigns. In so doing, were they making the world a better place?

Alexander had set all of this in motion when he carried his father's military ambitions and militarized economy eastward into Persia. It cannot be said that Alexander innovated quickly or comprehensively in his monetary policies, nor that he ever kept close watch on the financial administration of his empire. He assuredly seized far more wealth than had Philip II, but he did not manage it much differently. It is as if the Macedonian army carried its homeland economy wherever it warred, its soldiers temporarily flush or flat broke as circumstances dictated, while all around it Alexander was content to leave in place the Achaemenid administrative system he found. Where these two interacted, there was no end of trouble. For example, twice placing a Macedonian crony in the position of Persian chief treasurer cobbled together the worst

of both worlds—an unreliable man closely bound to the king as a personal *hetairos,* and a highly centralized financial bureaucracy of immense resources. Placing men like Harpalus in unfamiliar positions of great power was like putting old wine into new bottles. Unfortunately, matters did not much improve after Alexander and Harpalus were gone, leaving men like Antigonus One-Eyed to lead old whiners into new battles.

Conclusion

Alexander seemed to be merely the guardian or trustee of the immense riches which he found hoarded up in Persia; and applied them to no other use than the rewarding of merit and courage.

Charles Rollin, *The Life of Alexander the Great*

Alexander was a worthless plunderer.

St. Cyril (?), *Speculum Sapientiae* 2.10

Alexander's phenomenal success has been attributed to many things—the luck of a remarkable father, the learning of a brilliant teacher, the loyalty of a mighty army, the lure of the unknown—but a large part of the young man's legacy was built on the prosperity of plunder. The impact of that looting on the lives of the king and his contemporaries has been documented in earlier chapters, but what now of the larger picture? Is there a silver lining beyond the one sheathing the purses of those on the winning side? Was Alexander a lawless pirate or a high-minded hero? Opinions range from a resoundingly negative assessment of the issue to high praise for Alexander's economic vision and financial acumen, and these views have emerged from all quarters—philosophers, businesspeople, historians, economists, politicians, and moralizing ministers. In the mirror of history, people tend to see more of themselves than of the actual

past. This has given the story of Alexander, king and conqueror, many competing morals.

THE STORY OF THE MORAL

The Greek perception of Alexander's career was naturally colored by political considerations, with some harsh judgments lingering over the looting and leveling of Thebes. Polybius reports a debate late in the third century BC in which one Greek from Aetolia bitterly denounced Alexander's actions, while another from Acarnania defended them.[1] Whatever the king may have done to Thebes, argued the Acarnanian, was counterbalanced by what he had done for the Greeks at large, namely, enslaving the barbarians and taking from them their resources. The question, therefore, was not about plundering per se, but rather how it harmed or helped the Greeks. Persians and others were of no concern.[2]

The earliest ecumenical meditation about Alexander's plundering seems to have hinged upon the pique of an imaginary pirate:

When Alexander the Great captured a certain pirate and scolded him for molesting the seas, the fellow retorted by saying, "We both are in the same business, you and I. But because I do mischief with a little ship, you call me a pirate, while you plunder the world with a giant armada and hail yourself a conqueror!"[3]

The first known iteration of this story can be found in the works of Cicero.[4] Even as the Roman state was stretching its arms around the entire Mediterranean world, opportunists such as Cicero unselfconsciously winced at the imperialism of Alexander.[5] The

young Macedonian seemed a man possessed by the need to possess. Seneca said of him, "What difference does it make how many kingdoms he seized or gave away, or how much of the world paid him tribute? Whatever was left, he wanted that, too."[6] The poet Lucan railed against the greed of Alexander, "the successful plunderer" whose madness caused the world so much misery.[7]

Early in the second century AD, however, the philosophic Plutarch took exception to this view: "For Alexander was neither inclined to despoil Asia like a pirate nor to treat everything as if it were booty and plunder."[8] Countering the aspersions of Cicero, Seneca, and Lucan, Plutarch extolled the conqueror's invasion of Persia as a boon for everybody.[9] Alexander, claimed Plutarch, conquered only to govern well, not to acquire such luxuries as "gold carried away on the backs of countless camels."[10] Elsewhere, however, Plutarch bothered to count those camels, informing his readers that Alexander hauled off the plunder of Persepolis on the backs of 5,000 camels and 20,000 mules.[11] Guided by the gods, generous to a fault, and beloved by all, Plutarch's Alexander carted off these treasures for the Persians' own good: "He made his enemies rich by conquering them."[12] Plutarch's supranational Alexander is the world's first superhero worthy of the genre. Endowed with boundless resources and a benevolent vision, Alexander might appear the avatar of *Iron Man*, the cocky but caring son of a wealthy war profiteer who dedicates himself to building up a military that betters all of mankind.

Although eloquent, Plutarch's spirited defense of Alexander's plundering could not stem the tide of censure. Cicero's tale of the sassy buccaneer animated the heavily moralizing and highly influential work of St. Augustine.[13] It became one of the best known of all anecdotes about Alexander, and its theme was carried forward in the writings of John of Salisbury (who finally provides a name,

Dionides, for the unrepentant pirate), Chaucer, Gower, Boccaccio, Lydgate, Erasmus, and Shakespeare.[14] King Charles I recited the anecdote to onlookers just moments before the executioner removed his head.[15] Milton, moved by Charles's scaffold speech, brought the theme into his *Paradise Lost*, where the pirate reflects not only an avaricious Alexander but also Satan the robber of all mankind.[16] Jewish traditions in the sixth and seventh centuries AD preserve several rebukes of Alexander's avarice.[17] First, while in Africa, the king asks for bread but is served instead a loaf of gold on golden tables because wealth was his true desire. Alexander also receives a human eyeball that he tries to weigh against all of his gold and silver, but his treasures fall short in an echo of Proverbs 27: 20–21: "Hell and destruction are never full; so the eyes of man are never satisfied. As the fining pot for silver, and the furnace for gold; so is a man to his praise."

Around 1200, the Persian poet Nizami described Alexander's arrival at a utopian city that knew no crime or greed.[18] When one of the king's soldiers tried to take some fruit, he was struck dead by a divine force; the same fate befell another who tried to seize a sheep. Alexander therefore ordered his men to cease stealing from the virtuous citizens of this special place. In the thirteenth century, it was said that Alexander's insatiable greed turned an enchanted stream into blood.[19] Later in Dante's *Inferno*, we find Alexander condemned to the seventh circle of Hell, where a river of blood symbolizes the violence of robbers, killers, and tyrants.[20] Petrarch in the fourteenth century could not pardon Alexander's drunken pillage of Persepolis, and Jehan Wauquelin in the fifteenth could not escape the geopolitics of his own century when he listed the tribute brought to the "covetous and grasping" Alexander from the princes of Rome, France, Spain, Germany, England, Sardinia, and Sicily.[21] Predictably, only Machiavelli praised the king's looting

because it allowed Alexander to squander other people's money.[22] Plutarch and Machiavelli aside, however, most ancient and medieval writers fretted mightily over the ethics of Alexander's war-won wealth. Praiseworthy as Alexander might be as a brave and dashing prince, his avarice pained many who saw in it the undoing of the king and the downfall of his empire.

The modern era inherited this negative judgment of Alexander's lust for treasure. The seventeenth-century traveler Jean Chardin met a sect of Zoroastrians who reviled Alexander's memory and cursed the conqueror as a pirate lacking justice and intelligence, a man bent on disrupting world order and murdering the human race.[23] The sentiment was shared in other religious circles. In 1665, the puritanical minister Samuel Clarke wrote a biography of Alexander in which God punished the king for his looting and lavish lifestyle, leaving his rotting corpse as "A notable Embleme of the Vanity of all earthly things."[24] In 1749, the Abbé Mably described Alexander as a brave king who was corrupted by his first glimpse of Persian wealth.[25] John Gast, the Archdeacon of Glandelagh, argued in 1782 that Alexander's spoils, calculated as "upwards of thirty millions sterling," tainted Alexander and his followers with "a relish for Asiatic luxuries." He lamented, "This excessive opulence had been a source of corruption and ruin to the Persians, and it now proved fatal also to the Greeks."[26] For these clergymen, the evangelist Matthew (16:26) might just as well have invoked the name of Alexander in his famous admonition, "For what is a man profited, if he shall gain the whole world, and lose his own soul?" This theme echoes through the 1949 play *Adventure Story* by Terence Rattigan.[27]

In 1848, pastor, educator, and author Jacob Abbott penned a history of Alexander that heaped scorn upon his subject. He accused Alexander of

the most gigantic case of murder and robbery which was ever committed by man; so that, in performing these deeds, the great hero attained at last to the glory of having perpetrated the grandest and most imposing of all human crimes. That these deeds were really crimes there can be no doubt, when we consider that Alexander did not pretend to have any other motive in this invasion than love of conquest, which is, in other words, love of violence and plunder. They are only technically shielded from being called crimes by the fact that the earth has no laws and no tribunals high enough to condemn such enormous burglaries as that of one quarter of the globe breaking violently and murderously in upon and robbing the other.[28]

Abbott clearly echoes the sentiments of Cicero's sassy pirate and takes issue with Plutarch's benign estimation of Alexander's motives. If love of money is the root of all evil, then Abbott's Alexander is the towering tree sprung from it.

A CHANGE OF HEARTS AND MINDS

Ancient, medieval, and early modern criticisms of Alexander might seem perfectly suited to the current orthodoxy about the staggering defects of the king. Many scholars today describe Alexander as a reckless alcoholic, a vicious psychopath, and a destructive barbarian.[29] According to A. B. Bosworth, "The history of Alexander is the history of waste—of money, of forests stripped for siege works and navies, and above all of lives."[30] Alexander has become a man whose life seems aptly summarized in the famous phrase of Thomas Hobbes: "nasty, brutish, and short."[31] Yet, of all the king's alleged offenses, the one most likely to be excused today is the

plundering of Persia. This stunning reversal gathered momentum in the context of Europe's idealization of the Greeks as the founders of Western civilization, plus modern colonialist designs on the areas conquered by Alexander. Writers such as the French philosopher Montesquieu saw the Macedonian conquest of the East as a positive commercial venture that transformed the sagging economic potential of an underdeveloped region of the world.[32] Professor Charles Rollin, a contemporary of Montesquieu, could therefore catalog Alexander's many faults and yet extol his "right use" of Persian treasures.[33]

The success of this positive view of Alexander's plundering can largely be attributed to the prominence of Johann Gustav Droysen, whose work bolstered Plutarch's ancient encomium with a modern economic argument based on monetization. Droysen in the nineteenth century supported the notion that Alexander's pillaging released the pent-up potential of Persia's vast but moribund resources.[34] Droysen likened this liberation of Persian wealth to a surge of blood into previously weak and withered limbs, stimulating new energy and growth. The Persian kings, on the other hand, were vampires who sucked the lifeblood from their empire. In sum, Alexander monetized the idle treasures of his rival, Darius III, and thus transformed the economy of the world in a way that no single person would ever do again. Putting tons of coinage into circulation, Alexander did exactly what Plutarch claimed; he enriched his enemies by defeating them.

Droysen's influential work was quickly absorbed into the mainstream of modern scholarship. The French historian Victor Duruy cited Droysen when writing that the sterile and inactive riches in Persia's treasuries became an energizing force once thrown into circulation by Alexander's generous hand.[35] With only a few exceptions, this interpretation has come to dominate modern judgments

about Alexander's plunder of Persia. The king ceased to be a greedy pirate and became a one-man economic miracle. In 1916, for example, one historian wrote:

> The change for the better which Alexander's conquests made in Asia can hardly be exaggerated. Order took the place of disorder. The vast accumulations of the Persian kings, lying idle in their coffers, were once more brought into circulation, and at last tended to stimulate energy and commercial activity.[36]

These sentiments continued right through the historical literature of the twentieth and twenty-first centuries, from the magisterial works of Ulrich Wilcken and Michael Rostovtzeff to those of Nicholas Hammond and Peter Green. Wilcken praised in Alexander "an economist who knew what he was aiming at" by coining the hoarded treasures of Persia.[37] According to Rostovtzeff, "Alexander's method of dealing with the booty, his lavish expenditure of the Persian hoards of gold and silver, which to a large extent were transformed into coined money, had the effect of enriching a number of men" and thereby relieving widespread poverty, unifying the economies of Greece and Persia, stimulating markets, and creating a sound and lasting monetary policy.[38] Hammond wrote that Alexander's rare genius can be seen in his overnight introduction of capitalism into Asia.[39] While acknowledging that Alexander merely pursued "Homeric raiding on a grand scale," Green identifies a familiar silver lining:

> Alexander's violent disruption of the static Persian economy had at least provided a strong, indeed a frenetic, stimulus for trade. Whereas the Achaemenid rulers had, by their fiscal policies, drained the Near East of gold and silver as tribute, which

they then melted down and kept as bullion, out of circulation except for the darics used to pay mercenaries, or for similar noncommercial purposes, Alexander released the accumulated specie of centuries onto the market in a matter of months.[40]

As noted in chapter 1, the comparison of Alexander's liberation of Persian riches with the opening of the New World to European soldiers and settlers has become commonplace.[41] According to Christopher Howgego, "No such sum [as Alexander's Persian booty] changed hands again through conquest until the Spanish exploitation of the New World in the sixteenth and seventeenth centuries."[42] Economist John Maynard Keynes invariably linked Alexander with Pizzaro.[43] He calculated that Alexander's spoils dwarfed those drained from the Americas, and he wondered how far these unchained treasures served as the mainspring of ancient economic progress.[44] In these paeans for Alexander's commercial impact lies a modern pardon after two millennia of recrimination for gutting the Persian Empire. The egotist has become an economist.

By a long journey, the pirate has also become an entrepreneur. What some positivists might characterize as a beneficial if unintentional byproduct of Persia's fall, others now credit to Alexander's head for business. A present-day industry of books, articles, seminars, and lectures touts Alexander as a model venture capitalist. In a world where poverty, not money, is the root of all evil, Alexander is a hero again. He has escaped the hand-wringing of the history department to be the wunderkind of the business school. No longer restricted to journals about ancient war and society, Alexander today appears in the pages of *Investor's Business Daily, Sales and Marketing Management, The Wall Street Journal,* and *The Economist.* The praises therein often border on the Plutarchan. *Newsweek* international business editor Michael Meyer describes an Alexander

the Great for our modern age whose company, called "Alexander, Inc.," would corner all global markets, pioneer new technologies, lead NASA to Mars, and fund public-spirited philanthropy on an unbelievable scale.[45] Steve Forbes, editor-in-chief of *Forbes* magazine, somehow knows how Alexander would fare with a briefcase:

> As a CEO, Alexander would have been effective, successful, and comfortable in today's multinational business world. He would have been sure to make headlines in business journals, dazzle Wall Street with his hostile takeovers, and instill a combination of admiration and fear in the heads of his investors, managers, allies, and adversaries with his tolerance for risk and in-your-face management style.[46]

Of course, "hostile takeover" meant something altogether different in Alexander's day, and the king's "in-your-face management style" was at times fatal to those who served him, such as Cleitus, Parmenion, Callisthenes, and many of his satraps. Modern CEOs demote, fine, and fire—few of them freely execute their subordinates or command armies on foreign soil.

Corporate Alexander is a modern invention, a hero for a world he could not possibly have imagined. More than two centuries ago, Baron de Sainte-Croix scoffed at attempts to make the Macedonian warrior into a business manager.[47] Today, the king is a veritable CEO. As a charismatic, get-it-done kind of leader, Alexander may certainly inspire the modern executive, but it would be as unwise to run a business the way Alexander ran his empire as it would be to learn from him how to behave like a Catholic saint.[48] His world was a preindustrial, pre-Christian, pre-Keynesian collection of warring states in which his own Homeric values and martial skills found rich opportunities to express themselves through conquest and plunder. Ancient wealth, notes historian Michel Austin, derived largely from

military force and "was not a matter of invisible bank accounts and the like" but of "good land, agricultural stores, flocks and cattle, human beings, and precious metals stored in one form or another, all of which were there for the taking by an aggressor."[49] Not everything in this list would sit comfortably in a modern investor's portfolio.

Those who would imagine Alexander in the modern role of a CEO must in fairness complete the analogy by examining the careers of his CFOs Harpalus and Antimenes, and of his managers Cleomenes and Philoxenus. Yet, typically, none of these financial officers is anywhere to be found in a book about Alexander's leadership written by Partha Bose and much admired by modern CEOs and praised in the pages of *The Wall Street Journal*, *The Economist*, *Business Life*, and *Management Today*.[50] The dust jacket of Bose's advice book heralds it "a gripping biography with compelling analyses of contemporary case studies of successful corporations that have applied Alexander's lessons to their businesses, including Dell, General Electric, Wal-Mart, and the Washington Post Company." Perhaps overlooking Harpalus explains the absence of Enron from this list.[51] Alexander was a fighter, not a financier; he was a skilled manager of generals, but a hapless general manager.

The moral of Alexander's story has changed dramatically over the past few millennia, each "modern" era finding in its own ethos a rationale for blaming or acclaiming the king. Working backward, it should be clear that the present esteem for successful corporations and their CEOs has anachronistically thrust Alexander into that role. It should be plain to any competent student of Alexander's life that he and his treasurers offer no constructive guidance for exemplary business practices, except perhaps as a cautionary tale. Alexander was a charismatic military leader but not a conscientious caretaker of his spear-won wealth.

Prior to becoming a popular captain of industry in the twentieth and twenty-first centuries, Alexander was imagined as an

enlightened leader whose army liberated by way of conquest the idle treasures of Persia. This view likened Alexander's wars to the bloody but necessary exploitation of the New World, whose riches the conquistadors could put to better use than had the natives of the Americas. The moral here seems to be that unmonetized wealth is undeserved wealth, and should rightly pass to the mercantile hands of others. Those endorsing this moral might notice that in Homer's *Iliad*, it is the Asiatic Glaucus who loses his gold armor to the Greek Diomedes. Not appreciating the value of what he had, Glaucus apparently deserved the loss and Diomedes the gain.[52]

Another step back in time takes us to the pre-Droysen lament that money mattered too much to Alexander. Corrupted by greed, the king sinned against a god he never knew and fell short of the ideals of an era in which he never lived. This Alexander disappointed all who agreed with Cicero's saucy pirate that conquest was merely crime writ large. Therefore, no good could come of the king's plunder of Persia. This mantra drowned out the lonely voice of Plutarch, who believed that the moral of Alexander's story was an uplifting one of humanitarian conquest. Plutarch anticipated philosophically what Droysen argued economically. Could their assessment, a common view even today, possibly be correct? Was Alexander's monetary policy a bold new contribution to the world's economic history, and a commendable outcome of plundering Persia?

MONETIZATION

To do what he wanted it to do, at least some of Alexander's wealth had to be converted into currency. In amounts greater than anything else manufactured to sustain the king's career—more than helmets, harnesses, boots, or blankets—craftsmen had to make coins in prodigious numbers to meet the conqueror's needs. Tons of

assayed bullion had to be transported to mints and apportioned to workshops where carved dies were hammered against preweighed blanks to strike millions of coins one at a time. This money represented only a portion of the wealth garnered in the East, but many accounts could hardly be settled efficiently through the barter of slaves, bullion, garments, lands, tableware, and spices.

Kings therefore needed coins, a responsibility that young Alexander learned from both his father Philip and his tutor Aristotle.[53] The one taught by example, the other by instruction. During Alexander's reign, the treatise titled *Economics* was written down by another of Aristotle's students, perhaps Theophrastus, as a guide to financial management.[54] It curiously states that a king had obligations simpler than those of his satraps, a polis, or even private citizens; royal attention was limited to coinage, imports, exports, and expenditures.[55] By modern standards, this is a shallow list of economic responsibilities for the leader of a major state, and we have seen that Alexander may have been lax in his supervision of three of them. What about coinage? The *Economics* advises, "With regard to coinage, the king determines what kinds should be minted and when." This apparently means that monarchs must determine when to strike coins of which denominations, and how much of each. It was presumably the king's prerogative also to choose or approve the designs on currency as a useful extension of policy and propaganda.[56]

Alexander had been responsible for these decisions since the day of his father's death in 336 BC, but it seems that for quite some time the young king merely continued minting the coinage already being struck by Philip. This perhaps reflects Alexander's first pledge as king: to govern as though nothing had changed.[57] Piety may have played its part, but there were other considerations as well.[58] Philip had minted a great deal of what he mined in gold and silver, enough, in fact, to make his currency a new economic force in Greece: "From

these mines Philip quickly amassed a fortune, and from this great supply of money he was able to elevate the Macedonian kingdom ever higher using his gold coins called *Philippeioi* (Philips)."[59] Persia had its gold darics, named for King Darius I, and likewise Macedonia produced its Philips, the first significant gold coinage in Greece.[60] These Philips were gold staters struck on the Attic weight standard (8.60 grams). Die studies confirm a huge output of these coins after 348 BC, adding to the silver tetradrachmas long issued by Philip on the lighter Thraco-Macedonian standard (weighing 14.45 grams each) plus their fractional denominations.[61] The principal design of the staters featured the laureate head of Apollo on the obverse and a two-horse chariot (biga) on the reverse. Philip's silver tetradrachmas showed the laureate head of Zeus on the obverse with a horse and rider (perhaps the king himself, shown in Figure 7.1, and later a victorious jockey) on the reverse. These designs punned the king's name Φίλιππος (Philippos, meaning "Lover of Horses") and alluded to Philip's winning stable.[62]

Under Philip, Macedonia pioneered for the Balkan states a bimetallic currency struck at multiple mints on an unprecedented scale. Alexander inherited and employed those resources in a seamless transition quite unlike anything suggested by Plutarch's biography, where the ambitious prince grew up desperate to eclipse his father and to put his own mark on the monarchy as soon as possible. Plutarch gives us the bravura boy of myth who deigned only to compete against kings at the Olympic games, who wished his father would stop winning battles and save some glory for his impatient son, who wanted ennobling struggles instead of luxury and wealth, who showed up Philip in a bet about handling a valuable horse, and who inspired the Macedonians to call Philip their general but Alexander their king.[63] Thus, for Persians and Macedonians alike, Plutarch's Alexander was allegedly the one true king before his reign even began. This sort of literary presaging masks just how little the

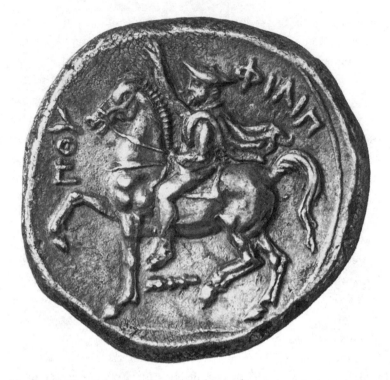

Figure 7.1. Tetradrachma of Philip II (reverse). © *bpk, Berlin/Münzkabinett, Staatliche Museen, Berlin/Art Resource, New York.*

new king can be differentiated from his father in matters such as monetary policy. Since Philip himself had delayed the striking of his first royal coins until he had accumulated some notable successes, it is possible that Alexander also waited dutifully for his first victory over Darius (at Issus in 333) to introduce a currency with his own name and designs.[64] This means that for several years, the son continued to monetize Macedonia's treasures as though they were still Philip's.[65] When Alexander finally began striking gold and silver denominations stamped ΑΛΕΞΑΝΔΡΟΥ (Alexandrou, meaning "Alexander's money," as illustrated in Figure 7.2), he used the Attic

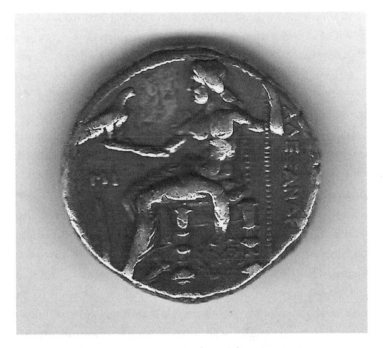

Figure 7.2. Tetradrachma of Alexander (reverse). © Frank Holt.

weight standard for both personal types.[66] His new gold staters featured the head of Athena on the obverse and Nike on the reverse, while the silver tetradrachmas depicted the head of Herakles and the figure of Zeus enthroned.

The possibility that Alexander did not introduce his own distinctive currency from the outset of his reign was suspected as long ago as 1831, based on stylistic arguments and coin hoards.[67] Though still controversial, this point of view has gained enough adherents to become the default position today.[68] On the whole, however, exactly when this transition took place matters less to the economic historian than to the numismatist, for the appearance of the money is secondary to its employment: it was Alexander's gold and silver to

spend whether he fashioned it into one currency or another. We are left with the conclusion that many of the Philips now extant were either produced late in that king's reign, surely to defray some of the costs of the Persian invasion and used to that same purpose by Alexander, or minted by Alexander himself. The same is true at the other end of Alexander's reign, when his immediate successors all continued to mint the dead king's coinage. Even when Hellenistic monarchs such as Seleucus and Ptolemy began striking currency in their own names, the money was being made from bullion taken from Alexander's treasures.

In many ways, Alexander was not nearly as impatient or innovative as the myth of the self-made man purports. He transitioned slowly between the monetary policies of a Macedonian king and an Asian conqueror, including the designs on his coins.[69] The somewhat laissez-faire striking of local coinages was allowed to continue as it had under the Achaemenids. At Tarsus, for example, the royal mint produced Alexander's so-called imperial coinage (Attic standard with Herakles/Zeus) alongside local issues in the name of the Macedonian satrap Balacrus (Persian standard with local types).[70] The mint at Tarsus was one of about two dozen mints eventually striking coins for Alexander during his lifetime: Pella and Amphipolis in Macedonia; Lampsacus and Abydus at the Hellespont; Colophon, Magnesia, Miletus, Teos, Sardis, Side, and Tarsus in Asia Minor; Salamis, Citium, Amathus, and Paphos on Cyprus; Myriandrus, Aradus, Byblus, Sidon, and Ake (or Tyre) along the eastern Mediterranean coast; Alexandria in Egypt; and inland at Damascus and Babylon.[71] With the obvious exception of Alexandria, these were mints with substantial histories of coin production prior to Alexander's arrival.[72] They were not, of course, equally active throughout the new king's reign, and some of them specialized in the manufacture of small denominations such as drachmas (in Asia Minor), while others turned out larger

denominations such as tetradrachmas (e.g., in Macedonia and the Levant).[73]

Overall, numismatic evidence suggests that Alexander introduced his own iconic coinage much more slowly than once believed, allowing the currencies of Philip, Darius, and individual cities to circulate freely. After his victory at Issus in late 333 BC, the conqueror finally ordered mints in Macedonia, Cilicia, and Phoenicia to begin striking his personal types in silver.[74] Fortunately, the Sidonian issues are numbered and securely dated; they commenced between October 333 and September 332, at about the same time as at Tarsus.[75] Alexander's personal gold issues began after his first major success on the seas, namely, the capture of Tyre in July 332. Perhaps not until Alexander returned from India was his personal type produced at new mints in western Asia Minor.[76] Georges Le Rider has argued that Alexander simply had no policy to unify his empire monetarily until, at best, the very end of the reign.[77] It is therefore somewhat hyperbolic to suggest, "We thank him for the first world currency in history."[78] These facts indicate that Alexander took the *Economics* at its word and limited his financial thinking to basic decisions, without grand economic visions.

That the Persian kings were extraordinarily rich, particularly in the eyes of the Greeks, and that Alexander laid hands on those riches, minting some of them, is not in dispute. The problem remains, however, that this process has been distorted to heroize Alexander at the expense of his adversaries. The very notion that Persia's economy needed saving is, of course, quite wrong. What we know of the satrapies and their well-being comes to us in a narrative of war, refugees, and confiscations, yet even then Alexander did not find emptied coffers and impoverished peoples in places sucked dry by the Achaemenids. The continuous looting of nonroyal wealth was detailed earlier in chapter 3, and in chapter 4 the regional Achaemenid treasuries in places such as Memphis appeared

impressive even though recently degraded ahead of Alexander's arrival. Furthermore, Alexander showed no inclination to change the tributary system he found in place, which was clearly functioning well. Nor did he invade an empire that had no experience with coinage, not that coined money had been a prerequisite for economic prosperity for millennia. As will be shown, those satrapies exhibiting little or no reliance on coinage under the Achaemenids, such as Bactria, Sogdiana, and Paropamisadae, were slow to change even under the Greeks.[79] The terms "moribund" and "stagnant" are pejorative relics of colonialism that bear little relation to the realities known to us from documentary, archaeological, and numismatic evidence.[80]

COUNTING COINS

The assumption that Alexander quickly brought immobilized riches into productive circulation seems deceptively self-evident. Although silver and gold formed only a part of Alexander's accumulated assets, the amount of coinage bearing his name that still exists today creates the impression that he must have converted most of his metals into money.[81] But can this inference be quantified and analyzed in a meaningful way? The acclaimed numismatist François de Callataÿ thinks it possible to assess the volume of Alexander's coinage, while other experts remain skeptical.[82] The methodology is essentially twofold: estimate how many obverse dies were originally used to strike a given mintage based on the number of dies represented in the extant sample, and then multiply this figure by the average number of coins an obverse die could produce before it had to be replaced.[83] The first variable depends on the availability of rigorous die studies, which are notoriously laborious to compile. The second variable is a best guess governed in part

by comparative data, most of it medieval, as well as some modern experimentation. Although controversial, these procedures aim only "to circumscribe the uncertainty to an acceptable level."[84]

In 1989, this approach produced a very interesting outcome that closely matched the volume of Alexander-type coinage minted circa 332–290 BC to the amount of gold and silver seized from Persia.[85] The putative balance of treasure captured (reported in the literary tradition as about 180,000 talents) and Alexander coinage minted therefrom (extrapolated as some 200,000 talents by assuming 30,000 coins per obverse die) seemed meaningful to de Callataÿ, but numismatist Martin Price immediately dismissed it as merely coincidental.[86] Indeed, the correlation was too good to be true. Subsequently, de Callataÿ has himself walked back from his original calculations, preferring now to reduce the estimate of manufactured coins per obverse die from 30,000 to 20,000 for silver and 10,000 for gold.[87] As a result, he concludes that "instead of 200,000 talents, the coinages in the name of Alexander are now reduced to c. 90,000 talents and the general equivalence with the Persian booties is gone."[88] Yet, in other analyses, de Callataÿ uses the same numbers of dies but posits an average of 20,000 coins per die for both silver and gold, giving a figure of "no less than 131,000 Attic talents."[89] From such changeable assumptions, he nevertheless endorses the main lines of Droysen's vampire scenario: "Alexander's principal achievement was to put into circulation these gigantic masses of precious metal that were kept immobilized for generations, in part by the Achaemenid tributary system."[90] He quantifies this additionally by suggesting that a quarter-century after Alexander's death, mintages bearing his name represented half or more of all Greek money in circulation.[91] So, while repeatedly cautioning about the uncertainties attending his calculations, de Callataÿ offers support to the monetization theory. In fact, his numbers would mean that there once existed some 24 million Alexander gold coins and 126 million

Alexander silver coins.[92] If we should add to these the bronze mintages of the king, then there would have been more Alexander coins on the planet than there were people.[93]

As impressive as these figures are, they must not obscure an essential fact: all recent projections of Alexander coinage show a considerable gap between the volume of precious metals seized from Persia and the amount of money produced. If accepted, the various calculations of de Callataÿ would mean that Alexander and his successors monetized at best only 50% to 75% of the bullion taken from Susa and Persepolis. This range is a bit misleading since Alexander captured more than just 180,000 talents from Persia as a whole, and furthermore a considerable share of the Alexander coinage was minted in Macedonia, presumably from local rather than Persian stocks.[94] Nor does this take into account the Philip coinage struck by Alexander prior to his victory at Issus and thus ahead of the great hauls of Persian bullion. We must assume, therefore, that the extent to which Alexander circulated the Achaemenids' gold and silver has been overestimated. In fact, de Callataÿ concludes that the Hellenistic world as a whole converted only about a tenth of its precious metals into coinage.[95] The extraordinary volume of wealth unleashed by Alexander is not in question, and the sums still stagger the imagination. Yet, this must be detached from the theory that most, if not all, of Persia's "useless" bullion was put into circulation as part of an enlightened economic policy that somehow justifies for later sensibilities the means by which it was done. The amount converted into productive currency simply does not balance with assets seized. This conclusion is supported by references in the sources to large reserves of unstruck Persian bullion still in Alexander's treasuries years after his death.[96]

In fact, if Alexander had listened to his old general Parmenion and accepted Darius's offer of a negotiated settlement prior to the Battle of Gaugamela in 331 BC, an interesting calculation can be

made. Darius offered to cede all lands west of the Euphrates River plus a reported ransom of 30,000 talents for his family.[97] Adding to this ransom the plunder already won by Alexander and the revenues accruing from his current holdings in Europe, Africa, and Asia, Alexander's wealth by 323 would have approximated the 90,000 talents that de Callataÿ estimates he and his successors ultimately minted.[98] In other words, any goal by Alexander to monetize that amount of wealth could have substantially been achieved without the eight more years of costly, devastating warfare that occasioned the deaths of many thousands in battle, the destruction of Persepolis, the abandonment of baggage trains, the razing of villages, the extermination of tribes, and the unfettered malfeasance of Harpalus. On strictly economic grounds without moral overtones, the ancient world would have been better served had Alexander compromised in 331 BC, although this is counterfactual history in the context of Alexander's own ethos. The king's business was not business.

Scholars nevertheless persist in the search for a silver lining. Besides the projections of coin production based on dies, some have adduced other proxy data for the beneficial seizure and monetization of Persian treasure. For example, studies of lead concentrations in the Greenland ice core have identified periods of heavy pollution linked to the mining and smelting of lead and silver in ancient times.[99] This interesting data has been interpreted by de Callataÿ as follows: "It will surprise no one that the smelting of lead ore (to extract the silver) was high (1.64) in 370 B.C. (2360 BP) and greater still in the 3rd c. (c. 2.2)—i.e., during the massive striking of the silver reserves accumulated by the Persian kings."[100] His chronology is actually amiss by about forty years (in scientific terms, 2360 BP measures the present as 1950, giving a date nearer to 410 BC), but the real problem is that the striking of coin from the Persian reserves involved silver already mined and smelted. Any connection

of atmospheric lead to Alexander's activities should mainly lie in the extraction of ores from his own Macedonian mines.

Another trove of proxy data for monetization derives from coin hoards. For instance, just a few years after Alexander's death, some anonymous person at Hermopolis Parva (modern Damanhur) in Egypt put more than 8,000 Alexander tetradrachmas into a jar for safekeeping—a hoard sufficient to support a contemporary Athenian for over 263 years.[101] We cannot know why this was done, whether to safeguard this money in the face of some imminent threat or to hold it as a savings cache, nor why the owner never managed to retrieve his wealth. Such enormous accumulations only show that ample money was available for hoarding, perhaps lending support to the idea of an actual overproduction of currency. According to Xenophon, "No one has ever possessed so much silver that he does not desire more, and if a man finds himself with a huge amount of it, he takes as much pleasure in burying the surplus as in using it."[102] It seems noteworthy, therefore, that the coins of Alexander have so far been found in 653 buried hoards, more than the combined total of the next three ancient kings on the list: Lysimachus (236 hoards), Philip II (221), and Philip III (175).[103] Figure 7.3 shows a typical hoard of Alexander drachmas retrieved from a pot in Israel.

By their very existence, coin hoards offer some evidence of monetization, but can this association be reliably quantified in a way that tells us the degree of monetization? Historian J. K. Davies has argued:

Through them [Alexander's mints] must have passed some part at least of the captured Achaemenid treasures of 170,000–£[sic]190,000 talents, not to mention the revenues which each successor was clearly at pains to maximize and to monetize. In consequence the early Hellenistic period saw a major quali-tative shift towards the use of coined metal as a medium for

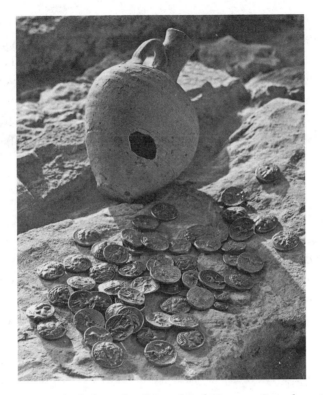

Figure 7.3. Hoard of Alexander Coins. Israel Museum, Jerusalem. © *Eric Lessing/Art Resource, New York.*

exchange or transfer of revenues: that no fewer than 1,900 or 79.6% of the 2,387 Greek coin hoards known in 1973 were buried in the three centuries from 330 to 31 B.C. is a rough but fair reflection of the change in this respect from the Classical period.[104]

Unfortunately, the exact statistic calculated here as "rough but fair" is demonstrably wrong and misleading.[105] The raw data have been compared improperly, exaggerating in every way possible a surge in hoard numbers during the early Hellenistic period, which in any case is not

the same thing as a shift toward the use of coined metal as a medium of exchange. So, beyond basic problems of mathematics and methodology, there stands the dilemma of quantifying the wrong phenomenon. Davies is simply counting how many times we know of that ancient persons did not retrieve caches of buried Greek coins. This tells us nothing about how many hoards were actually buried, and nothing about the amount of coinage buried in them. Since the nonrecovery of hoarded wealth is not a constant, we cannot use the number of known hoards to determine the number of unknown hoards (i.e., those that were buried but retrieved in antiquity). The operative factor in the nonrecovery of buried coins is not the volume of money in circulation, but the crises that prevented owners and their kin from retrieving their hidden valuables. So any increase in the incidence of known hoards, even if correctly computed, cannot be used to prove an increase or overabundance in coin supply.

As a rule, counting hoards unrecovered by their owners provides a quantitative index of immiseration rather than of monetization. In large numbers, they reflect the widespread inability of persons to retrieve hidden wealth due to adverse conditions such as families facing invaders, soldiers not returning from war, the spread of civil unrest, economic disruption, dislocation, disease, disaster, and death. When modern people celebrate the discovery of a hoard as evidence of ancient affluence and good fortune, they often forget that they have actually uncovered tangible proof of some grave personal tragedy. The question is not "Why is this hoard here?" but instead "Why is this hoard *still* here?" Thus, numismatists and historians normally do not find in large hoard numbers a sign of economic prosperity, but rather of difficult and dangerous times. Counterbalancing a profusion of hoards as proxy evidence for monetization is the evidence it provides for peril, and it is the latter undesirable phenomenon that Davies and others have so fervently quantified.

Broadly speaking, hoard *count* reflects surrounding circum-
stances of a military or political nature, whereas hoard *compo-
sition* reveals circulation patterns and relative money supply.
Therefore, the link between hoards and monetization might
be explored more effectively by quantifying the contents of the
known caches, assuming a representative cross-section of rich
and poor unfortunates who left their wealth behind. For example,
if we ask what coin hoards can tell us about the monetization of
the eastern two-thirds of Alexander's empire, from Syria to India,
the answer does nothing to support Droysen's or Davies's argu-
ments.[106] It can be shown that from 332 to 300 BC, the percent-
age of Alexander coins found in hoards is inversely proportional
to the distance from the Mediterranean Sea.[107] In this period,
not only do Mesopotamian hoards have a lower proportion of
Alexander coins than those along the seaboard, but also hoards
from the interior are on average ten times smaller and betray no
circulation of gold and bronze alongside silver. Further east, in
Bactria, Sogdiana, Paropamisadae, and India, hoards indicate
no impact whatsoever from the monetization of Persia's trea-
sures. Using the same *Inventory of Greek Coin Hoards* database
employed by Davies, for example, we find only four Greek coins
(two Alexander, one Philip III, and one Antiochus II) buried in
hoards there during the first 140 years following Alexander's con-
quest, far fewer than were hoarded there before Alexander was
born.[108] For these territories where Alexander invested so much
time, treasure, and blood, there exists no meaningful trace of his
conversion of Persia's idle wealth into coinage.[109] Monetization
came to the region late as the work of Hellenistic kings such as the
Seleucids and Diodotids.

In the contents of many hoards, the high ratio of coins minted
in Macedonia suggests that bullion from the Balkans was as impor-
tant to the ancient economy as currency struck at mints supplied

primarily from Persian stores. In the huge Damanhur hoard from Egypt, for instance, 2,005 of the 5,951 Alexander coins attributable to specific mints came all the way from Amphipolis.[110] In the British Museum's collection of Alexander coins, considered to be representative of the overall corpus, Martin Price catalogued 352 gold and silver specimens from eastern mints (Babylon, Seleucia, Carrhae, Susa, and Ecbatana) struck down to about 290 BC, considerably fewer than the 915 comparable pieces from Macedonian mints.[111]

WHAT WE CAN SAY ABOUT WHAT WE CAN SEE

The numismatic information we can reasonably quantify all points to one conclusion: Alexander and his successors did mint an incredible number of coins, but these were not equal to the stockpiles of precious metals plundered in Persia, and they circulated unevenly across a world riven by conflict and danger. Monetization based on Alexander's plundered wealth lagged in regions such as Bactria and India and varied significantly between rural and urban populations. We might say that the surge of blood heralded by Droysen did not circulate widely but pooled on one side of the empire and bled out in hoards. Meanwhile, we observe that some local mintages continued in production, which kept transaction costs high and the reviled money changers happy. In the breakaway kingdom of Egypt, participation in the larger Hellenistic monetary system was rejected in favor of a closed circulation of coins struck on a different weight standard. Within a hundred years, silver in Egypt was so scarce that the Ptolemies relied primarily on a bronze coinage. Drawing upon one of Alexander's greatest spoils, both the Ptolemies and Seleucids used land in lieu of cash to lure military colonists.

Some unknown portion of all these currencies was hoarded, thus draining it from circulation either for a time if retrieved or permanently if disaster intervened. Only the latter cases can be seen, a quantity that ironically accounts for nearly all existing gold and silver coins from antiquity. What we can detect is idled wealth that could never achieve the things imagined for it by many scholars, for it was as moribund as the Achaemenid treasures "liberated" by Alexander. These buried coins built no businesses, educated no sons, endowed no daughters, freed no slaves, and improved no farms. This does not mean that hoarding itself was always bad, because as savings this strategy could shield the owner from economic shocks.[112] It was, for its day, money in the (blood)bank, albeit without the possibility of increase, as Jesus said of the unprofitable servant who hid his master's money in the ground rather than investing it.[113] In the end, any such buried surplus was ineffectual wealth until, if ever, retrieved.

Other circulation sumps pulled currency out of the economy. Some riches were immobilized, even if just temporarily, as offerings in temples and tombs. Commoners sharing in the spoils of war sometimes lived like royalty and took to their graves the kinds and quantities of treasure once reserved for the tombs of kings.[114] Precious metals in the form of jewelry, cups, bowls, wreaths, and so forth went underground in acts of pious abandonment. Some unknown part of this buried treasure was no doubt recovered and recirculated through grave robbing, a phenomenon that helped redistribute wealth from the rich to the poor. Only what the looters missed, however, can we now observe, such as the grave goods interred inside Tombs II and III at Vergina.[115] Surely the increase of luxury evident in Macedonian tombs is some indication of greater prosperity among the living, but what we can actually measure is what remained underground.[116] Naturally, too, the growing market for silverware and jewelry—buried or not—competed for precious

metals as commodities, to the detriment of coinage.[117] While met-
alware could be used as money, even without converting it to coin,
this practice was cumbersome and did nothing to lower transaction
costs as a stimulus to economic activity.

It must not be forgotten that precious metals, the obsession of
most economic analyses, made up only part of the spoils, taxes,
gifts, and tribute that empowered Alexander the Great. Some signs
of economic growth besides monetization may be sought in other
varieties of material evidence. These proxies include Hellenistic
pottery, house sizes, animal bones from feasting, human skel-
etal dimensions, shipwrecks, temple construction, and so forth.[118]
Nearly all of this data indicates growing prosperity over the long
course of the Hellenistic Age, but in most cases as a continuation
of earlier trends. This evidence is notoriously difficult to quantify
and compare, especially for those seeking a demonstrable change
attributable to Alexander.[119] Fortunately, in Babylon, the survival of
documentary evidence for commodity prices (barley, dates, sesame,
wool, etc.) provides a unique view of economic life during and soon
after Alexander's reign.[120] We learn that barter remained a common
practice, and barley continued to function as money and very often
served as payment for wages. Prices remained extremely volatile
but inflation low over the long run, except for the period 330–300
BC when prices spiked with devastating effect. In May of 325 BC, for
example, grain and other goods were at first completely unattain-
able, and later attainable only at erratic prices.[121] Analysis of these
data has led Robert van der Spek to question the very notion that
Alexander "brought wealth and prosperity" by monetizing Persia's
treasures.[122] A quantitative analysis of the Seleucid economy under-
taken by G. G. Aperghis supports the conclusion that inflation in
Babylon was the result of political and military turmoil rather than
the release of Alexander's coinage into the market.[123] At Amphipolis
in Greece, an inscription records two sales of the same property

in different years of the late fourth century BC, both times for the same price, showing no signs of inflation in that region's housing market.[124] No literary sources describe for Alexander, as they do for Augustus, a rise in real estate prices due to an influx of plunder.[125] The attractive old theory that Alexander endeavored to promote economic expansion through a calculated increase in the money supply is slowly but surely dying.[126] In what regions did Alexander create mints where none had existed before? In what areas do we find hoards where none were previously known?

There is little evidence that Alexander thought deeply about the financial apparatus of his empire as a whole or in part. He dealt with matters without a clear monetary policy at least until the last months of his life. He was, after all, generally far removed from the scattered administrative centers of his realm, whether in Europe or in Asia. His officials maintained various records, some of them meticulously, but how much Alexander really knew about or contributed to fiscal operations and decisions we cannot guess. The malfeasance reported to us suggests little or no real supervision by the king, especially during his long absence in the East. Alexander bears final responsibility, but notably in a world with limited communications and with priorities other than our own. There were simply too many economies for Alexander to manage or merge effectively: international, imperial, satrapal, city, temple. The king's army on the march was itself an epiphenomenon in the larger scope of the new empire, a cumbersome traveling city, circus, government, and economy. Even it alone was sometimes more than the king could handle. It was sometimes flush with cash, sometimes reduced to privation, sometimes awash with heavy loot and wealth in kind, sometimes emptied of disposable riches, sometimes united with the markets of a city or region, and sometimes isolated from all outside emporia. It cast the shifting shadows of wealth and want wherever it went. In its wake were regions that had to rebuild

and restock, new settlements that reallocated the resources of now weakened or abandoned ones, and old economies and institutions that refused to change. Fiscally, Alexander's vision and decision making seem adjuncts of his military purpose, nothing less but certainly nothing more.

Of the two main economic modes by which value was transferred in the ancient world, Alexander depended almost entirely on constraint, meaning plunder, taxation, tribute, and forced labor, rather than on the market, which relied on free exchanges of goods and services. Did Alexander at least use the one mode to stimulate the other? Incidentally, perhaps, but not as a detectable policy, and only in certain areas. Any economic growth was largely a byproduct of an otherwise destructive process.[127] When Alexander looted the treasuries of the East, the economic engine he primed was military. As Carla Sinopoli has written, "The engine of imperial conquest, once started, may be difficult to turn off especially as systems of economic and social rewards and privileges become associated with expansion and with military success."[128] As a result, Alexander's newly won stocks of silver and gold booty were relentlessly recirculated as just that, replundered plunder, with all the attendant miseries of a Persepolis or Thebes recycled through the centuries. The lives this improved must be weighed against the lives it ruined and the lands it wrecked.[129]

CEO, sinner, or saint—which Alexander controlled much of the world's treasure by right of conquest? The answer is straightforward: none of the above. A closer examination of the king's finances shows that he acted true to his own times and temperament. In a relentless cycle, wealthy Alexander unapologetically waged war to acquire the means necessary to wage more war. Had he lived longer, Alexander may have treated his treasures more maturely with an eye toward economic growth and political stability.[130] He might have taken a more obvious and measurable interest in improving

the living standards of his civilian subjects in terms of better wages, health, housing, and—for lack of a more scientific term—happiness. To the degree that Alexander monetized his treasures, however, he did so largely to weaponize his wealth, to add silver and gold to his arsenal of iron. Of all the things that money could buy, most of them were essentially military as far as Alexander the Great was concerned: recruitment, loyalty, self-promotion, materiel, morale, alliances, land and naval bases, divine protection, and even the strategic engineering works along the Tigris and Euphrates. The man at the end of history's most extraordinary money trail carried a sarissa and a copy of the *Iliad*, not a briefcase and *The Wall Street Journal*.

Ancient Measures and Modern Conversions

The following ancient units and their conversions to modern equivalents have been employed throughout this study. For Greek coinage, the Attic standard adopted by Alexander has been used except where noted otherwise. To express large amounts, the short ton (2,000 lbs = 907 kg) is used rather than the long ton (2,240 lbs = 1,016 kg).

Tetartemorion	a tiny silver coin worth one-quarter obol, weighing approximately 0.18 grams
Hemiobol	a silver coin worth half an obol, weighing approximately 0.36 grams
Obol	a silver coin worth one-sixth a drachma, weighing approximately 0.72 grams
Drachma	a silver coin weighing approximately 4.3 grams
Tetradrachma	a silver coin equal to four drachmas, weighing about 17.3 grams
Stater	any principal denomination of a state's currency, especially of gold; on the Attic standard a gold stater weighed about 8.6 grams
Mina	a unit of weight amounting to 100 drachmas
Talent	a unit of weight equivalent to 25.8 kilograms (56.88 pounds); as an accounting term it generally refers to silver worth 60 minae = 1,500 tetradrachmas = 6,000 drachmas = 36,000 obols
Medimnos	a unit of dry measure equal to about 52 liters (nearly 14 gallons)

Commentary:

It is not always plainly stated in our sources whether talents are expressing a valuation in silver or the actual weight of whatever is being quantified. It nevertheless seems clear that common practice was to use talents as a means of accounting on the basis of silver, whether the commodities were silver or not. Diodorus provides an interesting example of how this was done. An incident occurring in Greece during the reign of Philip II involved the melting down of gold objects to mint coinage.[1] Diodorus carefully enumerates the gold items by weight: 120 gold bricks weighing 2 talents each; 360 golden vessels weighing two minae each; and gold statues weighing all together 30 talents. These 282 talents (eight tons) of gold were made into coinage, which Diodorus reformulates as 4,000 talents of silver (at an obvious ratio of one to fourteen).

Diodorus does not provide this same computational detail for the riches acquired by Alexander at Persepolis, but he does provide a valuation in talents of the gold and silver with the explanation "reckoning the gold as silver."[2] It is clear that he means the same thing when enumerating the treasure captured by Alexander at Susa, namely, a valuation in terms of silver.[3] He mentions 40,000 talents of uncoined gold and silver, plus 9,000 talents of gold darics. The weight of uncoined gold and silver would be a useless bit of information unless we knew the relative amounts of the two metals. Surely, then, the author means here (as in the other cases) the silver value of the lot. As for the darics, it makes sense to continue the practice of reporting their worth as silver talents rather than switch to an actual weight of 9,000 talents, equaling about 256 tons. Besides, that tonnage of gold would be worth from 90,000 to 108,000 talents of silver depending on the chosen exchange ratio.[4] Since all other sources for the Susa treasure use the figures 40,000 talents or 50,000 talents for the total value of the precious metals (see chapter 4), it would stretch credulity that one kind of treasure alone (the darics) would be worth about twice those "total" figures, whereas 9,000 silver talents' worth of darics explains the figure of 40,000 for those authors who ignored the darics and about 50,000 for those who included them. This also supports the claim of Polycleitus that most of the metals hoarded at Susa were not in the form of coinage.[5]

APPENDIX 2

Summary of Reported Assets

In this tabulation of wealth acquired by Alexander, amounts are listed as X if unknown, and X + a figure when only part of the total is known.

A. *From Inheritance and Homeland Revenues*[1]

60–70 Talents in royal treasury
1,000 Talents/year from Philippi mines
X + 200 Talents/year from taxes, rents, estates, and other mines

B. *From War and Diplomacy*

When: Where/Who	Type	Amount
335: Thessaly	Taxes, Revenues	X Talents[2]
335: Thrace	Plunder, Slaves	X Talents[3]
335: Thrace	Plunder, Slaves	X Talents[4]
335: Illyria	Slaves	X Talents[5]
335: Thebes	Plunder, Slaves (30,000)	X + 440 Talents[6]
335: Gryneium	Plunder, Slaves	X Talents[7]

(*continued*)

When: Where/Who	Type	Amount
335: Ilium (Troy)	Gold Crown	X Talents[8]
334: Granicus	Plunder, Slaves	X Talents[9]
334: Sardis	Plunder	X Talents[10]
334: Miletus	Slaves	X Talents[11]
334: Caria	Gifts of Food	X Talents[12]
334: Phrygia	Gold Crown	X Talents[13]
333: Gordium	Plunder	X + 1,100 Talents[14]
333: Aspendus	Fine, Horses	X + 100 Talents[15]
333: Soli	Fine	150 Talents[16]
333: Issus	Plunder, Slaves	X + 3,000 Talents[17]
333: Damascus	Plunder, Slaves (30,000)	X + 3,100 Talents[18]
332: Aradus	Gold Crown	X Talents[19]
332: Tyre	Plunder, Slaves	X Talents[20]
332: Gaza	Plunder, Slaves	X Talents[21]
332: Memphis	Plunder	X + 800 Talents[22]
331: Cyrene	Gifts	X Talents[23]
331: Siwah	Gift of Salt Crystals	X Talents[24]
331: Tyre	Two Gold Crowns	X Talents[25]
331: Gaugamela	Plunder	X Talents[26]
331: Arbela	Plunder	X + 3,000–4,000 Talents[27]
331: Babylon	Plunder, Gifts	X Talents[28]
331: Susa	Plunder	X + 40,000–50,000 Talents[29]
330: Persepolis city	Plunder, Slaves	X Talents[30]
330: Persepolis palaces	Plunder	X + 120,000 Talents[31]
330: Pasargadae	Plunder	6,000 Talents[32]
330: Uxians	Plunder	X Talents[33]
330: Elis, Achaea	Fine	120 Talents[34]
330: Ecbatana	Plunder	21,000–26,000 Talents[35]
330: Mardians	Gifts	X Talents[36]
330: Aria	Slaves	X Talents[37]
329: Nabarzanes	Gifts	X Talents[38]
329: Branchidae	Plunder	X Talents[39]
329: Sogdiana	Horses	X Talents[40]
329: Seven Sogdian cities	Plunder, Slaves	X Talents[41]
329: Scythian King	Gifts	X Talents[42]
329: Zerafshan Valley	Plunder, Slaves	X Talents[43]
328: Ariamazes	Plunder, Slaves	X Talents[44]

(continued)

When: Where/Who	Type	Amount
327: Sisimithres	Cattle, Provisions	X Talents[45]
327: Bajaur	Cattle (230,000), Slaves (+40,000)	X Talents[46]
327: Ora	Elephants	X Talents[47]
327: Taxiles	Gifts	X Talents[48]
326: Taxila	Gifts	X Talents[49]
326: Hydaspes River	Elephants, Horses	X Talents[50]
326: Abisares	More Gifts, Elephants	X Talents[51]
326: Porus	Elephants	X Talents[52]
326: Sangala	Horses, Slaves (+70,000)	X Talents[53]
326: Beas	Plunder	X Talents[54]
325: Agalasseis	Slaves	X Talents[55]
325: Sopeithes	Gifts	X Talents[56]
325: Phegeus	Gifts	X Talents[57]
325: Sibians	Gifts	X Talents[58]
325: Acesines	Slaves	X Talents[59]
325: Sambastae	Gifts	X Talents[60]
325: Porticauns	Plunder, Slaves	X Talents[61]
325: Malli/Sudracae	Gifts	X Talents[62]
325: Malli/Sudracae	Plunder, Slaves	X Talents[63]
325: Musicanus	Gifts, Elephants	X Talents[64]
325: Oxycanus	Plunder, Elephants	X Talents[65]
325: Sambus	Slaves, Plunder, Elephants	X Talents[66]
325: Musicanus	Plunder, Slaves	X Talents[67]
325: Oreitae	Plunder	X Talents[68]
325: Patali	Herds, Grain	X Talents[69]
324: Orxines	Gifts	X + 3,000 Talents[70]
324: Susa	Gifts of Crowns	15,000 Talents[71]
324: Nesaean Plain	50,000 Horses	X Talents[72]
324: Ecbatana	Gifts	X + 10 Talents[73]
323: Babylon	Gifts, Gold Crowns	X Talents[74]
Uncertain	Purple Cloth	X Talents[75]

C. From Tribute in Conquered Territories[76]

333: 1,474 Talents
332: 3,288 Talents
331: 3,288 Talents

330: 5,335 Talents[77]
329: 6,271 Talents
328: 6,564 Talents
327: 7,453 Talents
326: 9,161 Talents
325: 9,161 Talents[78]
324: 13,841 Talents
323: 13,841 Talents

Summary

Alexander inherited the relatively small but not inconsequential revenues of Macedonia. Over the course of his reign, reported by Arrian as twelve years and eight months, Alexander accrued as an estimate: $60 + 12.67(1000) + 12.67(X + 200) = 15,264 + 12.67(X)$ talents. War and diplomacy brought the king plunder and gifts that we may only glimpse in our sources, remembering as we must that many incidents probably went unnoticed and most that are mentioned have no figures attached to them.[79] Of twenty-four reported instances of populations enslaved, ranging up to 70,000 souls per incident, only the profits from Thebes are recorded.[80] From available data (using the lower of any disputed figures), we may calculate the amount from plunder and gifts to be $69(X) + 216,820$ talents. Annual tribute from conquered territories added considerably to these assets. Taking the figures for Persian revenues provided by Herodotus in the fifth century BC, we may calculate the annual tribute collectible by Alexander as his army gained control of various satrapies. Making allowances for wartime conditions during Alexander's march, these estimated amounts intentionally fall short of those received by Darius I in Herodotus's ledger. Taking this cautious approach, Alexander may have accrued in tribute an estimated 79,677 talents, not counting livestock and other such revenues as the "satrap's table" and supply requisitions that remained in the satrapies. This is more likely a very low rather than high estimate. According to Justin 13.1.9, for example, Alexander's annual tribute by 323 BC amounted to 30,000 talents ("in annuo vectigali tributo tricena milia"). This is more than double the 13,841 listed previously. Because Justin's figure includes European and other revenues not accounted for in the lower estimate, Georges Le Rider argues in its favor.[81] Helmut Berve and others have been more guarded about Justin's statement.[82] Since 30,000 is one of those formulaic enumerations, and because it is safer to underestimate than to sensationalize, the lower figure is preferable.

In sum, the information passed down to us may be quite conservatively expressed as $311,761 + 81.67(X)$ talents, where some Xs may have been as high

as 40,000 talents (Babylon). It seems, therefore, a reasonable guess that Alexander's conquests enriched the king by at least 300,000 talents (1.8 billion drachmas) and perhaps as much as 400,000 talents (2.4 billion drachmas). The lower figure will be assumed here, remembering that it reflects more than just precious metals.

APPENDIX 3

Summary of Reported Debits

In this tabulation of debits borne by Alexander, amounts are listed as X if unknown, and X + a figure when only part of the total is known. Figures derived from calculations based on partial data are preceded by "ca." Amounts refused, cancelled, certainly legendary, or likely reduced are marked with an asterisk. In some cases the chronology followed here can only be approximate; events with no identifiable context are gathered at the end as "uncertain."

A. Inherited Debts

200–500 Talents[1]

B. Specific Losses and Expenditures

When: Where/Who	Type	Amount
336: Macedonia	Burial of Philip II	X Talents
336: Macedonia	Borrowed for Military Expenses	800 Talents[2]
335: Danube River	Sacrifices	X Talents[3]
335: Langarus	Great Gifts	X Talents[4]

(*continued*)

When: Where/Who	Type	Amount
335: Dion/Aegae	Banquet, Sacrifices, Games	X Talents[5]
335: Macedonia	Gifts to *Hetairoi*	X Talents[6]
334: Chrysopolis	Gold Donatives to Army	*X Talents[7]
334: Hellespont	Sacrifices, Two Altars	X Talents[8]
334: Ilium (Troy)	Votive Offerings, Sacrifices	X Talents[9]
334: Lysippus	Statues, Burials	X Talents[10]
334: Athens	Spoils from Granicus	X Talents[11]
334: Olympias	Spoils from Granicus	X Talents[12]
334: Macedonia	Taxes Remitted	X Talents[13]
334: Sardis	Temple Construction	X Talents[14]
334: Ionia, Aeolis	Tribute Remitted	X Talents[15]
334: Priene	Temple Construction	X Talents[16]
334: Ephesus	Sacrifices, Temple Revenues	X Talents[17]
333: Peloponnesus	Hiring of 4,000 Mercenaries	X Talents[18]
333: Hellespont	For Military Operations	500 Talents[19]
333: Antipater	For Military Expenses	600 Talents[20]
333: Gordium	Sacrifices	X Talents[21]
333: Soli	Rewards for Physician Philip	X Talents[22]
333: Soli	Sacrifices, Games	X Talents[23]
333: Magarsus	Sacrifices	X Talents[24]
333: Mallus	Offerings, Remission of Tribute	X Talents[25]
333: Issus	Sacrifices	X Talents[26]
333: Issus	Lavish Burials, Rewards	X Talents[27]
333: Darius's Family	Allowances, Burial of Persians	X Talents[28]
332: Sidon	Gifts from Persian Spoils	X Talents[29]
332: Darius's Wife	Sumptuous Funeral	X Talents[30]
332: Tyre	Construction of Mole, Engines	X Talents[31]
332: Tyre	Sacrifices, Games, Funerals	X Talents[32]
332: Pnytagoras	Reward of Territory, Fortress	X + 50 Talents[33]
332: Gaza	Sacrifices	X Talents[34]
332: Olympias et al.	Spoils Sent from Gaza	X Talents[35]
332: Leonidas	Gift of Frankincense, Myrrh	X Talents[36]
331: Memphis	Games, Sacrifices	X Talents[37]
331: Alexandria	Sacrifices	X Talents[38]
331: Alexandria	Foundation of City	X Talents[39]
331: Alexandria	Greek/Egyptian Temples	X Talents[40]
331: Athribis	Temple Construction	X Talents[41]
331: Bahariya Oasis	Temple Construction	X Talents[42]
331: Siwah	Rich Gifts to Ammon and Priests	X Talents[43]
331: Memphis	Games, Sacrifices	X Talents[44]

(*continued*)

When: Where/Who	Type	Amount
331: Memphis	Bridges Built	X Talents[45]
331: Egypt	Magnificent Funeral for Hector	X Talents[46]
331: Mytilene	Reimbursed for Expenses	X Talents[47]
331: Tyre	Release of Athenian Prisoners	X Talents[48]
331: Tyre	Games, Dedications to Herakles	X Talents[49]
331: Tyre	Pays Fine for Athenodorus	X Talents[50]
331: Tyre	Gift to Lycon, a Comic Actor	10 Talents[51]
331: "Alexander"	Prize of 12 Villages	X Talents[52]
331: Euphrates River	Two Bridges Built	X Talents[53]
331: Tigris River	Sacrifices during Eclipse	X Talents[54]
331: Ariston	Gold Cup for Enemy's Head	X Talents[55]
331: Companions	Sacrifices, Rewards	X Talents[56]
331: Plataeans	Pledge to Rebuild City	X Talents[57]
331: Croton	Portion of Spoils	X Talents[58]
331: Babylon	Rebuilding of Temple, Sacrifices	X Talents[59]
331: Babylon	Rewards to Soldiers	ca. 1,757 Talents[60]
331: Susa	Sacrifices, Games	X Talents[61]
331: Susa	Return of Spoils to Athens	X Talents[62]
331: Susa	Money to Levy More Troops	1,000–3,000 Talents[63]
331: Araxes River	Bridge Built	X Talents[64]
330: Persepolis	Gifts to Mutilated Greeks	X + 400 Talents[65]
330: Persepolis	Sacrifices, Games, Gifts	X Talents[66]
330: Lycian Guide	Reward for Service	30 Talents[67]
330: Soldier	Gift of Gold	X Talents[68]
330: Parmenion	Gift of Susa Estate	X + 1,000 Talents[69]
330: Olympias	Many Gifts	X Talents[70]
330: Persepolis	Expensive Burial of Darius III	X Talents[71]
330: Persian Nobles	Property Restored	X Talents[72]
330: Ecbatana	Expensive Burials	X Talents[73]
330: Ecbatana	Back Pay and Bonuses	12,000–13,000 Talents[74]
330: Ecbatana	Embezzled	12,000 Talents[75]
330: Zadracarta	Sacrifices, Games	X Talents[76]
330: Hyrcania	Ransom of Bucephalus	X Talents[77]
330: Amazon Queen	Gifts	*X Talents[78]
330: Companions	Cloaks and Persian Harness	X Talents[79]
330: Macedonian Army	Gifts	X Talents[80]
330: Aria	Burial of Nicanor	X Talents[81]
330: Aria	Restored Property to Artacana	X Talents[82]

(*continued*)

When: Where/Who	Type	Amount
330: Aria	Foundation of City	X Talents[83]
330: Ariaspians	Gifts of Much Money, Territory	X Talents[84]
330: Ariaspians	Sacrifices	X Talents[85]
330: Arachosia	Foundation of City	X Talents[86]
330: Gedrosians	Gifts, Territory	X Talents[87]
330: Hindu Kush	Foundation of Cities, Sacrifices	X Talents[88]
329: Oxus River	Discharges for 900 Veterans	ca. 1,000 Talents[89]
329: Sogdiana	Bounty to Surrender Bessus	X Talents[90]
329: Jaxartes River	Foundation of Alexandria	X Talents[91]
329: Polytimetus River	Sacrifices, Burials	X Talents[92]
329: Jaxartes River	Sacrifices, Games	X Talents[93]
329: Jaxartes River	Multiple Sacrifices for Crossing	X Talents[94]
328: Margiana	Foundation of Six Towns	X Talents[95]
328: Bactria/Sogdiana	Foundation of More Cities	X Talents[96]
328: Maracanda	Sacrifices	X Talents[97]
328: Oxus River	Sacrifices	X Talents[98]
328: Bactra	Plundered by Spitamenes	X Talents[99]
328: Delphi	Statue Honoring Aristonicus	X Talents[100]
328: Maracanda	Opulent Banquet	X Talents[101]
327: Sogdian Rock	Bounties for Scaling Cliffs	55–362 Talents[102]
327: Sogdiana	Burials of Erigyius and Philip	X Talents[103]
327: Sogdiana	Recompense to Ravaged Army	X Talents[104]
327: Sogdiana	Gift of 30,000 Cattle	X Talents[105]
327: Sogdiana	Gifts to Anaxarchus	X Talents[106]
327: Royal Pages	Bonus for Service	0.02 Talent[107]
327: Eurylochus	Reward for Exposed Conspiracy	X + 50 Talents[108]
327: Demaratus	Magnificent Funeral	X Talents[109]
327: Bactria	Destroyed All Baggage	X Talents[110]
327: Nicaea	Sacrifices	X Talents[111]
327: Arigaeum	City Foundation	X Talents[112]
326: Nysa	10-Day Bacchanal, Sacrifices	X Talents[113]
326: Aornus	Sacrifices, Altars	X Talents[114]
326: Aornus	Bribe to Local Guides	80 Talents[115]
326: Indus River	Some Ships Built	X Talents[116]
326: Indus River	Bridge Built, More Ships	X Talents[117]
326: Indus River	Sacrifices, Games	X Talents[118]
326: Indus River	Sacrifices	X Talents[119]
326: Taxila	Gifts to Taxiles	X + 1,080 Talents[120]
326: Taxila	Sacrifices, Games	X Talents[121]
326: Hydaspes River	Foundation of Two Cities	X Talents[122]

(continued)

When: Where/Who	Type	Amount
326: Hydaspes	Sacrifices, Games	X Talents[123]
326: Hydaspes	Rewards to Army	X Talents[124]
326: Sangala	Siege Engines Built	X Talents[125]
326: Sangala	Burials	X Talents[126]
326: Hyphasis River	Sacrifices	X Talents[127]
326: Hyphasis River	Altars, Sacrifices, Games	X Talents[128]
326: Hyphasis River	Stipends for Camp Followers	X Talents[129]
326: Acesines River	Foundation of City	X Talents[130]
326: Acesines River	Gold and Silver Panoplies	X Talents[131]
326: Acesines River	Medical Supplies	X Talents[132]
326: Acesines River	Sacrifices	X Talents[133]
326: Hydaspes River	Repairs to Two New Cities	X Talents[134]
326: Hydaspes River	Construction of Indus Flotilla	X Talents[135]
326: Hydaspes River	Funeral for Coenus	X Talents[136]
326: Hydaspes River	Sacrifices, Games	X Talents[137]
326: India	Purchase of Dog	1.67 Talents[138]
326: India	Gifts to Gymnosophists	X Talents[139]
326: India	Gifts to Enemy Archer	X Talents[140]
325: Indus River	Repairs to Ships	X Talents[141]
325: Xathrians	Construction of More Ships	X Talents[142]
325: Malli/Sudracae	Elaborate Feast	X Talents[143]
325: Indus River	Foundation of City, Dockyards	X Talents[144]
325: Indus River	Foundation of City, Dockyards	X Talents[145]
325: Indus River	Repairs to Ships	X Talents[146]
325: Patala	Dockyards Constructed	X Talents[147]
325: Patala	Repairs, Replacement of Ships	X Talents[148]
325: Patala	More Dockyards Constructed	X Talents[149]
325: Xylinepolis	City Foundation	X Talents[150]
325: Indian Ocean	Sacrifices	X Talents[151]
325: Indian Ocean	Sacrifices, Gifts to Poseidon	X Talents[152]
325: Indian Ocean	Games, Sacrifices to Zeus	X Talents[153]
325: Indian Ocean	Repairs to Nearchus's Fleet	X Talents[154]
325: Arbis	Foundation of City	X Talents[155]
325: Rhambacia	Foundation of City	X Talents[156]
325: Gedrosia	Losses in Desert, Flash Flood	X Talents[157]
325: Central Empire	Temples, Tombs Robbed	X Talents[158]
324: Carmania	Money Thrown to Horses	*3,000 Talents[159]
325: Carmania	7-Day Bacchanal	X Talents[160]
325: Carmania	Sacrifices, Games	X Talents[161]
325: Carmania	Sacrifices, Games	X Talents[162]

(continued)

When: Where/Who	Type	Amount
325: Carmania	Sacrifices, Games	X Talents[163]
325: Syria etc.	Construction of Fleet	X Talents[164]
325: Asia	Looting by Mercenaries	X Talents[165]
324: Pasargadae	Restoration of Cyrus's Tomb	X Talents[166]
324: Persian Women	Gifts of Gold Coins	X Talents[167]
324: Persia	Funeral for Calanus	X Talents[168]
324: Persia	Prizes for Drinking Bout	1.67 Talents[169]
324: Babylon	Harpalus's Malfeasance	X + 5,000 Talents[170]
324: Susa	Wedding Ceremonies, Dowries	X Talents[171]
324: Susa	Payment of Soldiers' Debts	9,870 Talents[172]
324: Tigris River	Sacrifices, Games	X Talents[173]
324: Susa	Sacrifices, Games, Gifts	X Talents[174]
324: Susiana	City Foundation	X Talents[175]
324: Opis	Sacrifices, Banquet for 9,000	X Talents[176]
324: Opis	Bonus for Veterans	X + 10,000 Talents[177]
324: Opis	Benefits for Orphans, Wives	X Talents[178]
324: Nesaean Plain	Royal Herd Plundered	X Talents[179]
324: Ecbatana	Sacrifices, Games	X Talents[180]
324: Cossaea	Foundation of Cities	X Talents[181]
324: Babylon	Funeral Pyre of Hephaestion	X + 10,000–12,000 Talents[182]
324: Babylon	Obsequies for Hephaestion	X Talents[183]
323: Hyrcania	Construction of Caspian Fleet	X Talents[184]
323: Macedonia	Money Convoyed to Antipater	X Talents[185]
323: Babylon	Temples	X Talents[186]
323: Epidaurus	Votive Offering to Asclepius	X Talents[187]
323: Babylon	Return of Persian Spoils	X Talents[188]
323: Babylon	Recruitment of Sailors	500 Talents[189]
323: Babylon	Harbor, Dockyard, Ships	X Talents[190]
323: Mesopotamia	Hydrological Projects	X Talents[191]
323: Pallacotta Canal	Foundation of City	X Talents[192]
323: Babylon	Reward for Recovered Diadem	1 Talent[193]
323: Babylon	Reorganization of Army Pay	X Talents[194]
323: Babylon	Rewards for Fleet Trials	X Talents[195]
323: Alexandria	Hephaestion Shrine	X Talents[196]
323: Babylon	Sacrifices, Feast	X Talents[197]
323: Babylon	Daily Sacrifices	X Talents[198]
323: Greece	Construction of Temples	*10,000 Talents[199]
Uncertain	Failed Attempt to Dig Canal	X Talents[200]

(continued)

When: Where/Who	Type	Amount
Uncertain	Canals to Drain Lake Copais	X Talents[201]
Uncertain	Foundation of City (Peritas)	X Talents[202]
Uncertain	Gold-Wrapped Desserts	X Talents[203]
Uncertain	Cost of Large Meals	1.67 Talents[204]
Uncertain	Gold and Silver Furnishings	X Talents[205]
Uncertain	Sacred Vestments	X Talents[206]
Uncertain	Commissioned Apelles Painting	200 Talents[207]
Uncertain	Incense, Fragrant Wines, Myrrh	X Talents[208]
Uncertain	Gift to Companion Proteas	5 Talents[209]
Uncertain	Gift to Philosopher Pyrrhon	33 Talents[210]
Uncertain	Gift to Philosopher Xenocrates	0.5 Talent[211]
Uncertain	Gift to Philosopher Anaxarchus	100 Talents[212]
Uncertain	Gift to Philosopher Aristotle	800 Talents[213]
Uncertain	Gift to Poet Choerilus	X Talents[214]
Uncertain	Gift to Phocion	*X + 100 Talents[215]
Uncertain	Gifts to Ballplayer Serapion	X Talents[216]
Uncertain	Gift to Children of Brahman	X Talents[217]
Uncertain	Dowries for Family of Perilaus	50 Talents[218]
Uncertain	Rebuilding of Thebes	X Talents[219]
Uncertain	Rebuilding of Stagira	X Talents[220]

Summary

Alexander's expenditures and losses have been more frequently reported than his assets (220 cases compared to 75), but with a similar percentage of unknown amounts (X). This disparity reflects in part our sources' interests in lavish occasions and the king's liberality, both perhaps more public and memorable in any case. Taking the lower of any disputed figures, the reported data on debits may be expressed as 192(X) + 82,276.53 [minus 3(*X) and *13,100 talents] = 189(X) + 69,176.53 talents. Significantly, this total includes only a small portion of Alexander's military expenses as discussed in chapter 5.

APPENDIX 4

Where Is It Now?

Visible remains of Alexander's wealth, or of things financed from it, may yet be seen in our modern world. People can walk among the ruins of his palaces at Vergina and Pella; they may glimpse the ground plan of the great city he began building at Alexandria, Egypt. The remnants of Hephaestion's funeral pyre have been found in Babylon.[1] Even from space, what had been the island of Tyre can be seen as part of the mainland because Alexander's men and money made it so. Travelers may observe smaller artifacts associated with the king and his conquests displayed in the fine archaeological museums of Thessaloniki, Pella, Kavalla, Ioannina, and Vergina; at the Oriental Institute in Chicago; in the Metropolitan Museum of Art in New York; and elsewhere across the globe. The patient may wait for such treasures to come to them in the steady parade of block-buster exhibitions begun in 1978. In most of those 36 years, there has been at least one major museum exhibition of Alexander's treasures somewhere in the world.[2] The most recent have appeared in Amsterdam ("The Immortal Alexander the Great"), Oxford ("Herakles to Alexander the Great"), Sydney ("Alexander the Great: 2000 Years of Treasures"), and Montreal/Ottawa/Chicago/Washington, DC ("The Greeks: Agamemnon to Alexander the Great"). The splendid arrays of silverware, jewelry, armaments, and more give a hint of what happened to the spoils of war.

For the most part, however, the king's treasures survive today as coins. The oft-repeated claim that Alexander is no better attested as a historical figure than, say, Jesus of Nazareth betrays an extraordinary ignorance of this numismatic

evidence. Every modern resident and visitor to Lower Manhattan stands within a short walk of more than 9,000 coins minted in Alexander's name; in Bloomsbury the number tops 2,500. Today there are more than 600 Alexander coins in Vienna, more than 500 in Utrecht, nearly 1,000 in Athens, about 400 in Copenhagen, more than 600 in Oxford, and more than 100 each at the universities of Glasgow, Cambridge, and Harvard. The libraries of other colleges and universities sometimes hold Alexander coins long since forgotten until brought to light by inquisitive students and faculty.[3] In its bid to be named European Capital of Culture for 2019, the city of Burgas, Bulgaria, has mounted a local exhibition featuring gold coins of Alexander found nearby.[4] Other collections lie scattered worldwide, hidden in houses like the one burglarized in suburban Everett, Washington, or held in museums, some of them targeted by professional thieves, as at the National Gallery in Athens, the National Commercial Bank of Benghazi, and the local museum in Veliko Trnovo (Bulgaria).[5] In Greece, hard times have led many to take up the looters' trade, driven by dreams of digging up Alexander's ubiquitous coinage.[6]

At any given moment, there may be hundreds of Alexander coins for sale online, not to mention the volume sold by major dealers and auction houses worldwide. A single auction in 2010 disposed of nearly 100 Alexander coins struck in gold and silver, realizing over $33,000 for these lots.[7] Just six months later, the same auctioneers sold a dozen more Alexander coins for $61,900.[8] Market studies of the coin trade have concluded that "the volume of contemporary sales of Alexander coins exceeds that of any other ancient coin variety."[9] In March 2015, spelunkers in Israel stumbled upon some Alexander tetradrachmas left in the corner of a cave, a reminder that the king's treasures still languish underfoot in the many lands he conquered.

The listings that follow of precious metal coins held in some public collections is not meant to be exhaustive. It is a representative sample compiled from published catalogs and personal correspondence. I am grateful to those curators who responded to queries, and to my research assistant Frances M. Joseph, who ably facilitated this survey. Reported holdings in each case may naturally have changed through new acquisitions or de-acquisitions. The point is obvious: from ancient mints operating between present-day Greece and Iraq, Alexander's coinage has since spread across the globe like the glittering ashfall of a great conflagration.

*Some Numismatic Collections Containing Gold and Silver Coins in the
Name of Alexander III*

Where	Gold	Silver	Total
Afghanistan National Museum, Kabul		3	3
Alpha Bank Collection, Athens	10	226	236
American Numismatic Association, Colorado Springs	2	11	13
American Numismatic Society, New York	499	8,723	9,222
Archaeological Museum, Miletus	1	34	35
Austin College, Sherman, Texas		1	1
Bibliothèque Nationale, Paris	8	79	87
Blackburn Museum, Blackburn	13	81	94
British Museum, London	404	2,160	2,564
Cambridge University, Cambridge	9	120	129
Civiche Raccolte Numismatiche, Milan	6	122	128
Cleveland Museum of Art, Cleveland	1	2	3
Danish National Museum, Copenhagen	36	363	399
Erkki Keckman Collection, Helsinki	1	43	44
Geldmuseum, Utrecht	46	488	534
Hamburg Art Gallery, Hamburg	1	2	3
Harvard University, Cambridge, Massachusetts	21	89	110
Indiana University, Bloomington	1	2	3
Israel Museum, Jerusalem	4	23	27
Kunsthistorisches Museum, Vienna	60	565	625
Leipzig University, Leipzig		17	17
Money Museum, Zurich	2	2	4
Museum of Fine Arts, Boston	6	39	45
Museum of Fine Arts, Houston	1	1	2
National Historical Museum, Rio de Janeiro	1	22	23
Numismatic Museum, Athens	92	654	746
Oxford University, Oxford	28	641	669
Royal Coin Cabinet, Stockholm	3	21	24
Royal Library of Belgium, Brussels	2	2	4
Royal Scottish Museum, Edinburgh	1	9	10
Royal Ontario Museum, Toronto	1	77	78
Society of Antiquaries, Newcastle upon Tyne	1	11	12
Smithsonian Institution, Washington, DC		375	375

(*continued*)

Where	Gold	Silver	Total
State Collection of Coins, Munich	23	570	593
University of Aberdeen, Aberdeen	3	9	12
University of California, Berkeley		17	17
University of Calgary, Calgary		1	1
University of Fribourg, Fribourg	1	4	5
University of Glasgow, Glasgow	33	252	285
University of Graz, Graz		10	10
University of Houston, Houston		1	1
University of Manchester, Manchester	5	62	67
University of Missouri, Columbia		10	10
University of Pennsylvania, Philadelphia		4	4
University of Texas, Austin		8	8
University of Tübingen, Tübingen	6	26	32
University of Virginia, Charlottesville		1	1
University of Wisconsin, Madison		20	20
Walters Art Museum, Baltimore		2	2
Washington University, St. Louis	1	11	12
Wheaton College, Norton, Massachusetts		43	43
Yale University, New Haven, Connecticut		24	24

NOTES

Chapter 1

1. The Mongolian ruler Genghis Khan, Alexander's closest rival, lived twice as long (ca. 1162–1227 AD) as the Macedonian king.

2. François de Callataÿ, "Royal Hellenistic Coinages: From Alexander to Mithradates," in *The Oxford Handbook of Greek and Roman Coinage*, ed. William Metcalf (Oxford: Oxford University Press, 2012), 175–76.

3. Gustave Glotz, *Ancient Greece at Work* (1920; repr., New York: Norton, 1967), 325. A. B. Bosworth favors the word "colossal": *Conquest and Empire: The Reign of Alexander the Great* (Cambridge: Cambridge University Press, 1988), 92 and 242; he adds (88) that the king's wealth was "probably unique in history."

4. Diodorus 17.14.1 (quoted in the epigraph of this book).

5. Curtius 5.6.9. See also Diodorus 17.71.1; Plutarch, *Alexander* 37.4; Strabo 15.3.9; Justin/Trogus 11.14.10.

6. Curtius 5.6.9.

7. See, for example, the pioneering archival research of Earl Hamilton, "Imports of American Gold and Silver into Spain, 1503-1660," *Quarterly Journal of Economics* 43 (1929): 468, and "American Treasure and the Rise of Capitalism (1500-1700)," *Economica* 27 (1929): 345. Alexander's plunder between October 331 BC and January 330 BC, later deposited at Ecbatana, is reported by Diodorus 17.80.3; Strabo 15.3.9; Justin 12.1.3.

8. On this popular analogy, see Frank Holt, "Alexander the Great and the Spoils of War," *Ancient Macedonia* 6 (1999): 499–506.

9. Plutarch, *Alexander* 37.4.

10. Sitta von Reden, *Money in Classical Antiquity* (Cambridge: Cambridge University Press, 2010), 82.

11. François de Callataÿ, "The Fabulous Wealth of the Hellenistic Kings: Coinage and Weltmachtpolitik," in *Words and Coins from Ancient Greece to Byzantium*, ed. Vasiliki Penna (Gent: MER, 2012), 92.

12. Sophia Kremydi-Sicilianou, "The Financing of Alexander's Asian Campaign," *Nomismatika Chronika* 18 (1999): 66–67.

13. Based on world population estimates of the US Census Bureau (around 162 million people).

14. Based on wage statistics collected in William Loomis, *Wages, Welfare Costs and Inflation in Classical Athens* (Ann Arbor: University of Michigan Press, 1998), 116 and 158–59.

15. Daniel Ogden, *Alexander the Great: Myth, Genesis and Sexuality* (Exeter: University of Exeter Press, 2011), 63–76.

16. 1 Maccabees 1:1–3.

17. John Malalas, *Chronographia* 8.1.

18. D. T. Niane, ed., *Sundiata: An Epic of Old Mali* (Harlow: Longman, 1965), 23; see also Adrian Tronson, "The 'Life of Alexander' and West Africa," *History Today* 32 (1982): 38–41.

19. Stan Goron and J. P. Goenka, *The Coins of the Indian Sultanates* (New Delhi: Munshiram Manoharlal Publishers, 2001), 40–41.

20. Eugene Schuyler, *Turkistan: Notes of a Journey in Russian Turkistan, Khokand, Bukhara, and Kuldja* (New York: Scribner, Armstrong and Company, 1876), 277–78 and 281–83.

21. This story is now featured in Hubbard, *Tomb of the Ten Thousand Dead* (Hollywood: Galaxy Press, 2008), 1–38.

22. Berry, *The Venetian Betrayal* (New York: Ballantine Books, 2007); the *Sinbad* film by RKO Radio Pictures stars Douglas Fairbanks and Maureen O'Hara; the TV show aired in 1995 starring Sean Patrick Flanery in the title role.

23. Released by Alawar Entertainment (2010).

24. See Wes Smith, "Cleopatra's Tomb? A 'Snowball's Chance' in Egypt," *Chicago Tribune*, April 14, 1996, and Joseph Wilson, "The Cave That Never Was: Outsider Archaeology and Failed Collaboration in the USA," *Public Archaeology* 11 (2012): 73–95.

25. Reported by Aloula News as the substance of a lecture before the Arab World Institute in Paris, October 7, 2013.

26. For example, see Strabo 15.3.21 for what a contemporary of Alexander listed in the treasury at Susa.

27. For a rare consideration of slaves as part of Alexander's spoils, see Borja Antela-Bernárdez, "La Campāna de Alejandro: Esclavismo y dependencia en el espacio de conquista," in *Los espacios de la esclavitud y la dependencia*

desde la antigüedad, ed. Alejandro Beltrán, Inés Sastre, and Miriam Valdés (Besançon: Presses Universitaires de Franche-Comté, 2015), 281–96.

28. W. K. Pritchett, *The Greek State at War, Part 5* (Berkeley: University of California Press, 1991), 168–203.

29. Chares of Mitylene, quoted in Athenaeus 3.93D.

30. See, for examples, Margaret Thompson, *Alexander's Drachm Mints I: Sardes and Miletus* (New York: American Numismatic Society, 1983); Martin J. Price, *The Coinage in the Name of Alexander the Great and Philip Arrhidaeus,* 2 vols. (London: British Museum, 1991); Margaret Thompson, *Alexander's Drachm Mints II: Lampsacus and Abydus* (New York: American Numismatic Society, 1991); and Hyla Troxell, *Studies in the Macedonian Coinage of Alexander the Great* (New York: American Numismatic Society, 1997).

31. Georges Le Rider, *Alexander the Great: Coinage, Finances, and Policy,* trans. W. E. Higgins (Philadelphia: American Philosophical Society, 2007), originally published in French (2003).

32. For examples, see N. G. L. Hammond, "The King and the Land in the Macedonian Kingdom," *Classical Quarterly* 38 (1988): 382–91; A. J. Heisserer, *Alexander the Great and the Greeks: The Epigraphic Evidence* (Norman: University of Oklahoma Press, 1980); and Miltiades Hatzopoulos, *Macedonian Institutions Under the Kings: A Historical and Epigraphic Study,* 2 vols. (Athens: Research Centre for Greek and Roman Antiquity, 1995).

33. Joseph Naveh and Shaul Shaked, eds., *Aramaic Documents from Ancient Bactria (Fourth century BCE.) from Khalili Collections* (London: Khalili Family Trust, 2012), updating Shaul Shaked, *Le satrape de Bactriane et son gouverneur: Documents araméens du IVe s. avant notre ère provenant de Bactriane* (Paris: Diffusion De Boccard, 2004).

34. Plutarch, *Alexander* 24.1–2; Curtius 3.13.1–17; Athenaeus 13.607f.

35. Plutarch, *Alexander* 70.3–6 and *Moralia* 339c–d; Curtius 10.2.9–11; Diodorus 17.109.2. Arrian 7.5.3 and Justin 12.11.3 give a less exact figure. See further discussion in chapter 6.

36. For the lost works of Alexander's contemporaries, consult Lionel Pearson, *The Lost Histories of Alexander the Great* (London: American Philological Association, 1960).

37. On the available sources, see Elizabeth Baynham, "The Ancient Evidence for Alexander the Great," in *Brill's Companion to Alexander the Great,* ed. Joseph Roisman (Leiden: Brill, 2003), 3–29.

38. While interesting in itself, the fictionalized *Alexander Romance* is generally excluded from these analyses.

39. Cicero, *Philippics* 5.5. Plutarch knew this aphorism too: *Cleomenes* 27.1 and 4, as did Diodorus 29.6.1.

40. By "quantifications" are meant specific numbers, not vague references such as "many," "a few," or "some." Also excluded are figures for such things as time spans (one day, two days, etc.), age (e.g., "when Alexander was twenty years old"), and distances. The latter provide a case study unto themselves, for Alexander nurtured a keen interest in measuring distances as attested by his instructions to his bematists (surveyors) on land and to Nearchus by sea. Even so, most of the bematists' figures are round numbers, and Nearchus's data are also numerically problematic. Arrian, *Indika* 37 offers an example in his extract from Nearchus's records, giving the following series of distances in stades: 300; 800; 200; 40; 300; 400; 300; 300. These figures are clearly rounded approximations. They are not inventions, but they are not as precise as we might want them to be. See also Pearson, *Lost Histories*, 144–45.

41. Elizabeth Rubincam, who kindly read and commented on a draft of this chapter, informs me that her studies confirm that every Greek historian on whom she has compiled data (Herodotus, Thucydides, Xenophon, Polybius, and Diodorus) gives military figures more frequently than financial. This trend continues today. In his fine twenty-five-page survey of Alexander's military campaigns, Barry Strauss offers more than fifty quantifications of troops, casualties, ships, and so forth, but not one financial figure. He states simply, "Alexander paid his men generously." See Strauss, "Alexander: The Military Campaign," in *Brill's Companion to Alexander the Great*, ed. Joseph Roisman (Leiden: Brill, 2003), 136.

42. Jones, *Ancient Economic History: An Inaugural Lecture Delivered at University College, London* (London: H. K. Lewis, 1948).

43. See, for example, William Richardson, *Numbering and Measuring in the Classical World*, 2nd ed. (Bristol: Bristol Phoenix Press, 2004).

44. See, for example, Loomis, *Wages, Welfare Costs and Inflation in Classical Athens*. Catherine Rubincam has been compiling a database of numbers in Greek historians, including Diodorus. Her analytical monograph is eagerly awaited; meanwhile, interesting results may be found in her articles, including "Numbers in Greek Poetry and Historiography: Quantifying Fehling," *Classical Quarterly* 53 (2003): 448–63, and "The 'Rationality' of Herodotus and Thucydides as Evidenced by Their Respective Use of Numbers," in *Thucydides and Herodotus: Connections, Divergences, and Later Reception*, ed. Edith Foster and Donald Lateiner (Oxford: Oxford University Press, 2012), 97–122. Another such endeavor, launched in 2007, aims to assemble a comprehensive *Kriegskostendatenbank* for the study of how ancient wars were financed, available online at http://www2.uni-erfurt.de/kriegskosten/kriegskosten_db/ and discussed in Friedrich Burrer and Holger Müller, eds., *Kriegskosten und Kriegsfinanzierung in der Antike* (Darmstadt: WGB, 2008). See especially Daniel Franz, "Kriegsfinanzierung Alexanders des

Grossen," in *1001 & 1 Talente: Visualisierung antiker Kriegskosten*, ed. Holger Müller (Gutenberg: Computus Druck Satz, 2009), 115–50.

45. Homer, *Iliad* 23.751; Aristophanes, *Clouds* 1156; Polybius 5.26.13; Herodotus 6.63.2.

46. Archaeological Museum of Naples, inventory 81947.

47. On these and other measures, see appendix 1.

48. Erroneously reported as 1,235 drachmas and five obols in Claude Pouzadoux, "Un Béotien à Tarente?" in *Artisanats antiques d'Italie et de Gaule*, ed. Jean-Paul Brun (Naples: Centre Jean Bérard, 2009), 259.

49. Rubincam, "Numbers in Greek Poetry and Historiography," 462.

50. For the background of this phenomenon, see Richard Duncan-Jones, *Money and Government in the Roman Empire* (Cambridge: Cambridge University Press, 1994), 16–19, and Walter Scheidel, "Finances, Figures and Fiction," *Classical Quarterly* 46 (1996): 222–38.

51. The author wishes to thank Mr. William Kevin Hartley, holder of a University of Houston Summer Undergraduate Research Fellowship, for valuable assistance in analyzing the quantifications extant in these texts.

52. Diodorus 16.85.5.

53. Diodorus 17.9.3.

54. Diodorus 17.17.3–4. Translations that give the total figure as 32,000 do so only by emending the text to correct the discrepancy.

55. Arrian 1.11.3 also gives the figure as 30,000.

56. See Paul Millett, "The Political Economy of Macedonia," in *A Companion to Ancient Macedonia*, ed. Joseph Roisman and Ian Worthington (Malden, MA: Wiley-Blackwell, 2010), 498, note 99, where the 30,000 Gazans and the 30,000 Gaugamela prisoners are not actually enumerated in Arrian 2.27.7 and 3.15.6.

57. See appendices 2 and 3 for details.

58. Including among Curtius's four odd numbers one gold bowl (4.8.16), a problematic reference to three months' pay (5.1.45), and 365 concubines to provide the king one for each night of the year (6.6.8).

59. Curtius 10.2.10–11.

60. Diodorus 17.109.2.

61. Arrian 7.5.3 and Justin 12.11.3.

62. Scholars must be vigilant about incongruous numbers, even if this means that the same datum might be considered too low by some and too high by others. See, for example, Jacek Rzepka, "How Many Companions Did Philip II Have?" *Electrum* 19 (2012): 131–35.

63. Plutarch, *Alexander* 37.4: μυρίοις ὀρικοῖς ζεύγεσι. Ian Scott-Kilvert, trans., *The Age of Alexander: Nine Greek Lives by Plutarch* (New York: Penguin, 1973), 294. Diodorus 17.71.2 reports 3,000 pack camels and "a multitude" of mules.

64. Examples: Nicholas Cahill, "The Treasury of Persepolis: Gift-Giving at the City of the Persians," *American Journal of Archaeology* 89 (1985): 374; François de Callataÿ, "Le Transport des monnaies dans le monde grec," *Revue Belge de Numismatique et de Sigillographie* 152 (2006): 9, even though he got the number correct in his earlier work, "Les Trésors achéménides et les monnayages d'Alexandre: Espèces immobilisées et espèces circulantes?" *Revue des Études Anciennes* 91 (1989): 263 ("10 000 mulets attelés").

65. Ian Worthington, *Alexander the Great: Man and God* (London: Pearson, 2004), 109.

66. Similarly, the Persian name for the "Palace of Forty Columns" (*chehel sotun*) in Isfahan does not mean the number literally, but rather in terms of "many columns."

67. These are Darius's wife, Hector, Nicanor, Erigyius, Demaratus, Coenus, Calanus, and Hephaestion (see appendix 3). Philip the son of Agathocles fainted and died in Alexander's arms, perhaps of a heart attack, after an exhausting run and military engagement, but this case was certainly battle related: Curtius 8.2.35–40. The noncombat deaths of others are recorded (e.g., Arybbas and Menon), but their actual burials are not mentioned and thus not included.

68. See, for example, J. R. Ruffin, "The Efficacy of Medicine during the Campaigns of Alexander the Great," *Military Medicine* 157 (1992): 467–75.

69. The cost of Hephaestion's obsequies topped 10,000 talents (60 million drachmas). See appendix 3.

70. Plutarch, *Alexander* 39.1 makes the same general observation that Alexander became increasingly generous over time.

71. There is, too, the archaeological evidence for more lavish nonroyal tombs in Macedonia as a result of Alexander's reign: Demetrius Lazarides, Katerina Romiopoulou, and Iannis Touratsaglou, Ὁ Τύμβος τῆς Νικήσιανης (Athens: Athenian Archaeological Service, 1992); Tsimbidou-Avloniti, Μακεδονικοί τάφοι στον Φοίνικα και στον Ἅγιο Ἀθανάσιο Θεσσαλονίκης (Athens: TAPA, 2005).

72. Pearson, *Lost Histories of Alexander the Great*, 50–77.

73. As happened in other instances: Curtius 9.5.21, where Ptolemy contradicts Cleitarchus and Timagenes; Plutarch, *Alexander* 46, where Lysimachus refutes Onesicritus; and Lucian, *How to Write History*, 12, where Alexander scolds Aristobulus.

74. A methodology employed by the Roman historian Livy to check his source, the annalist Valerius Antias: Livy 45.40.1.

75. For a favorable view of the reliability of troop numbers in our sources, particularly Arrian, see N. G. L. Hammond, "Casualties and Reinforcements of Citizen Soldiers in Greece and Macedonia," *Journal of Hellenic Studies* 109 (1989): 56–68.

76. Eugene Borza, "Alexander at Persepolis," in *The Landmark Arrian*, ed. James Romm (New York: Pantheon Books, 2010), 368; Sitta von Reden, "Money in the Ancient Economy: A Survey of Recent Research," *Klio* 84 (2002): 141–74.

77. Price, *Coinage in the Name of Alexander the Great and Philip Arrhidaeus*, vol. I, 25–26, compared to appendix 2.

78. Meadows, "The Spread of Coins in the Hellenistic World," in *Explaining Monetary and Financial Innovation: A Historical Analysis*, ed. Peter Bernholz and Roland Vaubel (New York: Springer International Publishing, 2014), 172.

79. Both authors fail to note the partial remission of Soli's fine; both misrepresent the figure for slaves at Tyre/Gaza. Meadows does, however, correct Price's entry for Damascus.

80. Franz, "Kriegsfinanzierung Alexanders des Grossen," 136–40. This work is nonetheless quite commendable.

81. Plato, *Republic* 2.373d and 5.470c, *Phaedo* 66c; Aristotle, *Politics* 1256b. See further Louis Rawlings, "War and Warfare in Ancient Greece," in *The Oxford Handbook of Warfare in the Classical World*, ed. Brian Campbell and Lawrence Tritle (Oxford: Oxford University Press, 2013), 58, note 7.

82. Rawlings, "War and Warfare in Ancient Greece," 4–5.

83. Finley, *Ancient History: Evidence and Models* (New York: Viking Penguin, 1985), 76.

84. Finley, *Ancient History*, 120, note 19.

85. Diodorus, for instance, is the most concerned with booty of all the Alexander historians; he uses the noun λάφυρα fifty-two times, σκῦλα ten times, ὠφέλεια fifty-three times, and λεία fifteen times as synonyms for plundered wealth. On the broader history of this vocabulary, see Pritchett, *The Greek State at War, Part 5*, 68–152.

86. Homer, *Iliad* 10.460 and Pausanias 5.14.5.

87. For example, Cicero, *De Officiis* 1.38 and 2.85.

88. W. W. Tarn, "Alexander the Great and the Unity of Mankind," *Proceedings of the British Academy* 19 (1933): 123–66.

89. Richard Gabriel, "Alexander the Monster," *Quarterly Journal of Military History* 25 (2013): 38–45.

90. For context, see Laurent Pernot, *Alexandre le Grand: Les risques du pouvoir*, *Textes philosophiques et rhétoriques* (Paris: Les Belles Lettres, 2013).

Chapter 2

1. This stunning reversal of fortune was a motif plied as early as Polybius 29.21.3–7.

2. The circumstances surrounding Philip's murder are described by Diodorus 16.92.3–94.4, Justin 9.6.3–7.10, and Aristotle, *Politics* 1311b1.

3. The assassin Pausanias had a personal grudge against the king, but suspicion also fell on others: Plutarch, *Alexander* 10.6–7 and Arrian 2.14.5.

4. Arrian 7.8–10; Curtius 10.2.15–29. Other sources mention the speech but give few details about its content. For background, see A. B. Bosworth, *From Arrian to Alexander: Studies in Historical Interpretation* (Oxford: Clarendon Press, 1988), 94–113, and Marek Jan Olbrycht, "Curtius Rufus, the Macedonian Mutiny at Opis and Alexander's Iranian Policy in 324 BC," in *The Children of Herodotus*, ed. Jakub Pigon (Newcastle upon Tyne: Cambridge Scholars Publishing, 2008), 231–52.

5. On these claims, see Hugo Montgomery, "The Economic Revolution of Philip II—Myth or Reality?" *Symbolae Osloenses* 60 (1985): 37–47, and a response by N. G. L. Hammond, "Philip's Innovations in Macedonian Economy," *Symbolae Osloenses* 70 (1995): 22–29.

6. Curtius 10.2.24.

7. Arrian 7.9.6.

8. Diodorus 16.91.4 and 5; 16.92.5.

9. As cited by Athenaeus 4.166f–167c; see also 6.260d–e. Robin Lane Fox justly comes to Philip's defense against Theopompus in "Philip's and Alexander's Macedon," in *Brill's Companion to Ancient Macedonia*, ed. Robin Lane Fox (Leiden: Brill, 2011), 367.

10. Justin 9.8.15.

11. Athenaeus 4.155d and 6.231b, citing Duris each time. The cup was said to weigh fifty drachmas.

12. Diodorus 16.8.6. Every positive is someone else's negative. Philip's effort to acquire mining resources has been considered by some to be "more or less equivalent to Hitler's chase after oil-wells": Adela Adam, "Philip *Alias* Hitler," *Greece and Rome* 10 (1941): 106.

13. Plutarch, *Aemilius Paulus* 28.3.

14. Justin 9.8.20.

15. Peter Bernstein, *The Power of Gold: The History of an Obsession* (New York: Wiley, 2000), 40–41. On Alexander as a modernized business guru, see chapter 7.

16. Any possible distinction between the state treasury and the king's personal wealth seems impossible to sort out: Georges Le Rider, *Alexander the Great: Coinage, Finances, and Policy*, trans. W. E. Higgins (Philadelphia: American Philosophical Society, 2007), 23–24.

17. N. G. L. Hammond and G. T. Griffith, *A History of Macedonia, Volume II: 550–336 B.C.* (Oxford: Clarendon Press, 1979), 442.

18. de Callataÿ, "The Fabulous Wealth of the Hellenistic Kings: Coinage and Weltmachtpolitik," in *Words and Coins from Ancient Greece to*

NOTES

Byzantium, ed. Vasiliki Penna (Gent: MER, 2012), 91; Badian, "Alexander in Iran," in *The Cambridge History of Iran*, vol. 7, ed. Ilya Gershevitch (Cambridge: Cambridge University Press, 1985), 423. Among others, one may add Frank Adcock, *The Greek and Macedonian Art of War* (Berkeley: University of California Press, 1957), 67, citing in turn W. W. Tarn, "Alexander: The Conquest of Persia," in *The Cambridge Ancient History VI*, ed. J. B. Bury et al. (Cambridge: Cambridge University Press, 1927), 360 (quoted in the epigraph of this chapter).

19. Alfred Bellinger, *Essays on the Coinage of Alexander the Great* (New York: American Numismatic Society, 1963), 37.

20. Bosworth, *From Arrian to Alexander*, 102–3. W. W. Tarn, *Alexander the Great*, vol. 2 (Cambridge: Cambridge University Press, 1948), 296, accepts this common detail but insists that the speeches are otherwise independent creations; D. B. Nagle, "The Cultural Context of Alexander's Speech at Opis," *Transactions of the American Philological Association* 126 (1996): 151–72, conversely finds much in common between the speeches as a whole.

21. For example, George Cawkwell, *Philip of Macedon* (Boston: Faber and Faber, 1978), 17–18, considers the speech quite genuine. Even so, this does not exclude the possibility that the king made up or exaggerated the figures for effect. As noted by Lionel Pearson, *The Lost Histories of Alexander the Great* (London: American Philological Association, 1960), 156: "his financial resources were naturally not known to the general public. . . . No one was obliged to believe him."

22. On the tomb of Philip, see the discussion later.

23. For the story of purchasing Bucephalus, see Plutarch, *Alexander* 6, and Gellius, *Attic Nights* 5.2.1–5, citing Chares. For the level of wealth in contemporary Athens, note that Demosthenes's inheritance of slightly less than fifteen talents made him rich: Plutarch, *Demosthenes* 4.3.

24. J. R. Hamilton, *Plutarch, Alexander: A Commentary* (Oxford: Clarendon Press, 1969), 15.

25. This is true even if the price of Bucephalus has been inflated. For example, Alexander later heard the story of an island in the Red Sea whose inhabitants were so incredibly rich that they would pay a talent of gold for a horse: Pliny, *Natural History* 6.198. This real or imagined benchmark for wealth was less than the alleged cost of Bucephalus.

26. In his speeches *On Kingship*, especially the second and fourth, Dio Chrysostom manages to contrast not only the kings but also Alexander and the determinedly unmaterialistic philosopher Diogenes.

27. On the complex history of Greek attitudes toward luxury, see Rainer Bernhardt, *Luxuskritik und Aufwandsbeschränkungen in der griechischen Welt* (Stuttgart: Franz Steiner, 2003).

28. As quoted in Athenaeus 12.514e–f.

29. Plutarch, *Alexander* 5.5–6 and *Moralia* 179d.
30. Plutarch, *Moralia* 342c.
31. Plutarch, *Alexander* 15.3–4 and *Moralia* 342d–e. Philip's 800 companions were already allegedly as rich as any 10,000 of the wealthiest men in Greece: Athenaeus 6.261a.
32. Curtius 3.2.10–18; cf. Diodorus 17.30.2–6. For discussion of this episode, see Elizabeth Baynham, *Alexander the Great: The Unique History of Quintus Curtius* (Ann Arbor: University of Michigan Press, 2004), 136–40.
33. See chapter 1.
34. Herodotus 7.101–105, a story involving the exiled Spartan king Demaratus that has a happier ending for the advisor.
35. Aristotle, *Economics* 2.1351b.
36. Curtius 3.3.9–25.
37. Curtius 3.3.14.
38. Curtius 3.3.26. The theme is reprised in Livy 9.17.16–17.
39. From the translation of David Townsend, *The "Alexandreis" of Walter of Châtillon: A Twelfth-Century Epic* (Philadelphia: University of Pennsylvania Press, 1996), 37 (bk. 2, lines 533–536). As late as 1876, the middling poet Joseph Mead was echoing the same lines in *Alexander the Great, A Poem* (London: Elliot Stock, 1876), 146:
 The tinsel bright of Persia's tawdry dress,
 Their gold and gems with all they now possess
 But spoils present to brave rapaciousness.
 Assume your fortitude and wrest them then
 From dastards such, effeminate, not men.
40. Plutarch, *Alexander* 20.13.
41. See Hamilton, *Plutarch, Alexander: A Commentary*, 53.
42. Plutarch, *Alexander* 20.13.
43. Herodotus 9.82.
44. Plutarch, *Alexander* 20.12; cf. Justin 11.6.1. For the long history of the cliché, see Herodotus 1.88.
45. Plutarch, *Alexander* 8.2 and 26.1–2: legendary because it would take a magic box and a massive pillow to accommodate the requisite bundle of papyrus scrolls.
46. For a fascinating approach to the history of money and monetization, see Felix Martin, *Money: The Unauthorized Biography* (New York: Knopf, 2014). Some arguments therein are clearly overstated, but useful to ponder.
47. *Iliad* 6.119–236.
48. Plutarch, *Moralia* 327d.
49. Plutarch, *Alexander* 15.2.
50. Plutarch, *Moralia* 327e.
51. Plutarch, *Moralia* 342d.

52. As for Curtius's familiarity with Ptolemy's history, see Curtius 9.5.21.

53. Hamilton, *Plutarch, Alexander: A Commentary*, 36–37. On the other hand, F. R. Wüst, "Die Rede Alexanders des Grossen in Opis," *Historia* 2 (1953/54): 177–88, traces the speech in Arrian back through Aristobulus to Cleitarchus.

54. Plutarch's cumulative figures render Alexander much less in arrears than do Arrian's and Curtius's (3.8 times less, or 9.5 adding the extra debt of 800 talents). This does not require that Plutarch deliberately chose the less dramatic data, since he may not have known Ptolemy's numbers from the Opis speech: N. G. L. Hammond, *Sources for Alexander the Great: An Analysis of Plutarch's Life and Arrian's Anabasis Alexandrou* (Cambridge: Cambridge University Press, 1993), 30. Plutarch's greater reliance on Aristobulus and Onesicritus rather than upon Ptolemy is well documented: Hamilton, *Plutarch, Alexander: A Commentary*, xlix–lvii.

55. Bellinger, *Essays on the Coinage of Alexander the Great*, 36–37, note 15, argues that all of Plutarch's amounts "cannot be made to coincide" because the seventy talents (much less sixty) reportedly in the treasury could never have supported the army for thirty days.

56. Le Rider, *Alexander the Great*, 24–26, struggles to reconcile the numbers, as does François Rebuffat, "Alexandre le Grand et les problèmes financiers au début de son régne," *Revue Numismatique* 25 (1983): 43–52.

57. These royal structures are nicely presented in Robin Lane Fox, ed., *Brill's Companion to Ancient Macedon* (Leiden: Brill, 2011): by Angeliki Kottaridi, "The Palace of Aegae," 298–333; and by Ioannis Akamatis, "Pella," 393–408.

58. Eugene Borza, *In the Shadow of Olympus: The Emergence of Macedon* (Princeton, NJ: Princeton University Press, 1990), 253–76.

59. Demosthenes, *Third Philippic* 31 calls Philip "a barbarian from Macedonia, where you cannot even buy a decent slave."

60. See, for example, Beryl Barr-Sharrar, "Macedonian Metal Vases in Perspective: Some Observations on Context and Tradition," in *Macedonia and Greece in Late Classical and Early Hellenistic Times*, ed. Beryl Barr-Sharrar and Eugene Borza (Washington, DC: National Gallery of Art, 1982), 123–39; Beryl Barr-Sharrar, *The Derveni Krater: Masterpiece of Classical Greek Metalwork* (Princeton, NJ: American School of Classical Studies at Athens, 2008); and Susan Rotroff, *The Missing Krater and the Hellenistic Symposium: Drinking in the Age of Alexander the Great* (Broadhead Classical Lecture, University of Canterbury, Christchurch, August 7, 1996).

61. Nowhere more evident than in the exhibition hosted by the Onassis Cultural Center, New York: Dimitrios Pandermalis, *Alexander the Great: Treasures from an Epic Era of Hellenism* (New York: Alexander S. Onassis Public Benefit Foundation, 2004).

62. Homer's epithet for Mycenae ("rich in gold") was likewise based on the lives of the elite, not the entire population.

63. Stella Drougou, "Vergina—The Ancient City of Aegae," in *Brill's Companion to Ancient Macedon: Studies in the Archaeology and History of Macedon, 650 BC-300 AD*, ed. Robin Lane Fox (Leiden: Brill, 2011), 253.

64. For good illustrations of these tombs, consult Manolis Andronikos, *Vergina: The Royal Tombs* (Athens: Ekdotike Athenon, 1994), and Stella Drougou and Chryssoula Saatsoglou-Paliadeli, *Vergina: The Land and Its History* (Athens: Ephesus Publishing, 2005).

65. Nicholas Gage, "Tomb of Philip of Macedon Found in Greece," *New York Times*, November 25, 1977.

66. Manolis Andronikos, "Regal Treasures from a Macedonian Tomb," *National Geographic*, July 1978, 54–77.

67. Jane McIntosh, *Treasure Seekers: The World's Great Fortunes Lost and Found* (London: Carlton Books, 2000), 97–101; see also appendix 4.

68. Eugene Borza and Olga Palagia, "The Chronology of the Macedonian Royal Tombs at Vergina," *Jahrbuch des Deutschen Archäologischen Instituts* 122 (2007): 81–125, in turn critiqued by Robin Lane Fox, "Introduction: Dating the Royal Tombs at Vergina," in *Brill's Companion to Ancient Macedonia*, ed. Robin Lane Fox (Leiden: Brill, 2011), 1–34.

69. See Angeliki Kottaridi and Susan Walker, eds., *Heracles to Alexander the Great: Treasures from the Royal Capital of Macedon, a Hellenic Kingdom in the Age of Democracy* (Oxford: Ashmolean Museum, 2011).

70. The most recent analyses of the human remains in Tombs I and II arrive at opposite conclusions: Theodore Antikas et al., "New Finds on the Skeletons in Tomb II at the Great Tumulus of Aegae: Morphological and Pathological Changes" (paper presented at Archaeological Works in Macedonia and Thrace conference, Thessaloniki, March 13, 2014); Antonis Bartsiokas et al., "The Lameness of King Philip and Royal Tomb I at Vergina, Macedonia," *Proceedings of the National Academy of Sciences* (2015): 1–5 (early electronic edition with appendix).

71. There are different opinions about which tomb should be associated with the heroon (e.g., Robin Lane Fox, "Introduction: Dating the Royal Tombs at Vergina," 7), but Tomb I lies between the shrine and Tomb II. Indeed, the heroon's foundation stones nearly touch the roof of Tomb I and clearly align with it, making the two structures closely interconnected. See the photo and plan in Manolis Andronikos, *The Royal Graves at Vergina* (Athens: Archaeological Receipts Fund, 1980), 6–7.

72. Worthington, *Philip II of Macedonia*, 240.

73. Ibid., 235, for Worthington's description of the grave goods.

74. Andronikos, *Vergina: The Royal Tombs*, 168; a much heavier weight (10.8 kilograms) is given in Andronikos, *The Royal Graves at Vergina*, 41.

75. Andronikos, *Vergina: The Royal Tombs*, 171.
76. David Gill, "Inscribed Silver Plate from Tomb II at Vergina," *Hesperia* 77 (2008): 336; and, more generally, Catharine Lorber, "Weight Standards of Thracian Toreutics and Thraco-Macedonian Coinages," *Revue Belge de Numismatique et Sigillographie* 154 (2008): 1–29.
77. See appendix 2.
78. Polyaenus 5.44.4. See also Edmund Bloedow, "Why Did Philip and Alexander Launch a War against the Persian Empire?" *L'Antiquité Classique* 72 (2003): 261–74.
79. Diodorus 17.16.1–4; Arrian 1.11.1–2. For Alexander's expenses, see appendix 3.
80. Plutarch, *Alexander* 14.8–9; Arrian 1.11.2.
81. Plutarch, *Alexander* 15 and *Moralia* 342d; Justin 11.5.5.
82. Justin omits this story, and in *Moralia* 342e, Plutarch writes that only Perdiccas declined the gifts. The source may be Cleitarchus.
83. Cashing in on the trope as king, Perdiccas's rival Ptolemy later allegedly said that it was better to make his friend rich than to be rich himself: Aelian, *Varia Historia* 13.13.
84. Justin 11.5.5–9; cf. Thucydides 4.59 for the common notion that men do not fear war if there is profit in it.
85. Hatzopoulos, *Macedonian Institutions under the Kings: A Historical and Epigraphic Study*, vol. 1 (Athens: Research Centre for Greek and Roman Antiquity, 1996), 436.
86. Alexander sent money to help Antipater on just two occasions (Curtius 3.1.20; Diodorus 18.12.2), even though the homeland was engaged in numerous military operations.
87. Plutarch, *Eumenes* 2.
88. Demosthenes, *First Olynthiac* 22–23, reports a cash-flow crisis for Philip, and Polyaenus 4.2.6 preserves an anecdote about Philip's soldiers clamoring for their back pay.
89. For example, Ian Worthington, *Philip II of Macedonia* (New Haven, CT: Yale University Press, 2008), 168–69, following closely Hammond and Griffith, *A History of Macedonia, Volume II: 550-336 B.C.*, 670–71.
90. Bose, *Alexander the Great's Art of Strategy: The Timeless Leadership Lessons of History's Greatest Empire Builder* (New York: Gotham Books, 2003), 16.
91. Diodorus 16.53.3, cf. Strabo 10.1.8.
92. The story is told in Justin 9.1.
93. See also chapter 7.
94. N. G. L. Hammond, "Casualties and Reinforcements of Citizen Soldiers in Greece and Macedonia," *Journal of Hellenic Studies* 109 (1989): 65.
95. The practice was "a rather unchanging rule" according to François de Callataÿ, "Armies Poorly Paid in Coins (The Anabasis of the

Ten-Thousands) and Coins for Soldiers Poorly Transformed by the Markets (The Hellenistic Thasian-Type Tetradrachms) in Ancient Greece," *Revue Belge de Numismatique et de Sigillographie* 155 (2009): 59.

96. Justin 9.1–2 provides one example, perhaps drawn from Theopompus, and Plutarch, *Pyrrhus* 26.2, provides another.

97. Michel Austin, "Hellenistic Kings, War and the Economy," *Classical Quarterly* 36 (1986): 454.

98. On Persia as "a suitable target for profitable aggression" in the eyes of Philip, Alexander, and their Macedonians, see Michel Austin, "Alexander and the Macedonian Invasion of Asia: Aspects of the Historiography of War and Empire in Antiquity," in *War and Society in the Greek World*, ed. John Rich and Graham Shipley (New York: Routledge, 1993), 197–223.

Chapter 3

1. On this and other aspects of ancient warfare, see Angelos Chaniotis, *War in the Hellenistic World* (Oxford: Blackwell, 2005), 122.

2. For the long history of this phenomenon, see Davide Nadali and Jordi Vidal, eds., *The Other Face of the Battle: The Impact of War on Civilians in the Ancient Near East* (Münster: Ugarit-Verlag, 2014).

3. Polyaenus 5.44.4.

4. Plutarch, *Alexander* 9.1, while Philip was in the field campaigning near Byzantium.

5. This may be the "plundering lesson" referred to by Justin 9.1, though Alexander's age is reported differently.

6. In the spring and summer of 335 BC. Polyaenus 4.3.23 reports Alexander's earlier march through Thessaly, apparently uneventful except for outmaneuvering a blocking force at Tempe. Alexander, like his father, claimed the taxes and other revenues of the Thessalians: Justin 11.3.2.

7. Arrian 1.2.1 and 1.4.5.

8. Justin 9.3.1.

9. A. B. Bosworth, *A Historical Commentary on Arrian's History of Macedonia*, vol. I (Oxford: Clarendon, 1980), 56, identifies the cities.

10. François Rebuffat, "Alexandre le Grand et les problémes financiers au début de son régne," *Revue numismatique* 25 (1983): 46–47, connects this booty with early mintages by Alexander.

11. Zofia Archibald, *The Odrysian Kingdom of Thrace: Orpheus Unmasked* (Oxford: Clarendon Press, 1998). The region remained quite wealthy, and Alexander's successor Lysimachus maintained a royal treasury there: Peter Delev, "Lysimachus, the Getae, and Archaeology," *Classical Quarterly* 50 (2000): 384–401.

12. Ivan Marazov, *The Rogozen Treasure* (Sofia: Svyat Publishers, 1989), 10–12.
13. Arrian 1.1.13, and more among the Triballi: 1.2.7. These cases are not included in the "Catalogue of Enslavement after Battles and Sieges" in *The Greek State at War*, Part 5, ed. W. K. Pritchett (Berkeley: University of California Press, 1991), 226–34, because Pritchett chooses not to cite examples from Arrian. His reliance on Diodorus renders only six instances of enslavement by Alexander's forces, whereas appendix 2 records twenty-three cases.
14. Arrian 1.6.10.
15. For a useful recent treatment, see Borja Antela-Bernárdez, "La Campāna de Alejandro: Esclavismo y dependencia en el espacio de conquista," in *Los espacios de la esclavitud y la dependencia desde la antigüedad*, ed. Alejandro Beltrán, Inés Sastre, and Miriam Valdés (Besançon: Presses Universitaires de Franche-Comté, 2015), 281–96.
16. On the treatment of captives, see the extensive discussion in Pritchett, *The Greek State at War*, Part 5, 203–312.
17. Persian torturing Greeks: Arrian 2.7.1 and Curtius 5.5.5–7. Alexander practicing crucifixion/hanging and torture: Arrian 6.29.11 and 7.24.3; Diodorus 17.46.4.
18. Diodorus 17.28.3–5 (Lycia in 334 BC); Curtius 4.4.12 (Tyre in 332 BC); Curtius 5.6.7 (Persepolis in 330 BC).
19. Arrian 1.7–10; Diodorus 17.8–13; Plutarch, *Alexander* 11–12; Justin 11.3.6–4.8; Polybius 38.2.13–14 and 5.10.6-8. Aelian, *Varia Historia* 13.7, mentions Alexander's kindness to the former hosts of his father Philip.
20. In Polybius 9.34.1–3, we may find a parallel drawn between the fates of Thebes and Persepolis in a speech attributed to Lyciscus.
21. Pliny, *Natural History* 35.98 and 34.14. These treasures were later plundered, in turn, by Rome.
22. Polyaenus 8.40; Plutarch, *Alexander* 12 and most fully in *Moralia* 259d–260d. The story derives from Aristobulus.
23. Wells were obvious places to hide wealth quickly, but other creative solutions were also sought. Apparently, one Theban fugitive managed to conceal his gold in a bronze statue, which then became famous: Pliny, *Natural History* 34.59.
24. Diodorus 17.14.1 and 4; Aelian, *Varia Historia* 13.7. The figure 30,000 is surely a conventional one meaning "a great many" but probably fewer than stated. The auction numbers given by Diodorus (30,000 slaves sold for 440 talents) suggest the low average price of eighty-eight drachmas per prisoner, yet Justin 11.4.8 claims that the auction prices were high. Accepting a lower number of slaves would correct the equation.
25. Diodorus 17.14.1. According to Athenaeus 148e, Cleitarchus in his lost history of Alexander disparaged the *entire* wealth of Thebes as only 440 talents. This seems unlikely for such a large city.

26. In 338, after the Battle of Chaeronea, Philip held the Theban prisoners for ransom: Justin 9.4.6.
27. Diodorus 17.17.5 enumerates Antipater's army; the major sources disagree on the size and composition of Alexander's expeditionary force. See A. B. Bosworth, *Conquest and Empire: The Reign of Alexander the Great* (Cambridge: Cambridge University Press, 1988), 259–66.
28. Arrian 1.11.5–12.1; Diodorus 17.17.1–18.1; Plutarch, *Alexander* 15.7–9; Justin 11.5.10–12. Strabo 13.1.27 mentions benefactions of an undisclosed nature granted to Ilium by Alexander.
29. Justin 11.6.1.
30. Arrian 1.12.8–10; Diodorus 17.18.2–3.
31. Polyaenus 4.3.15.
32. Aristotle, *Economics* 2.1351b.
33. Diodorus 17.7.8–9.
34. Arrian 1.13–16; Diodorus 17.19–21; Plutarch, *Alexander* 16; Justin 11.6.
35. Alexander had allegedly anticipated the looting with pleasure: Plutarch, *Moralia* 179f. Arrian 1.16.3 lists the most prominent among them, including some of Darius's kinsmen.
36. Plutarch, *Alexander* 16.19.
37. Arrian 1.16.6–7; Plutarch, *Alexander* 16.17–18.
38. Arrian 1.16.2; Plutarch, *Alexander* 16.13–14.
39. Arrian 1.16.4–5; Plutarch, *Alexander* 16.15–16; Justin 11.6.12–13. These authors give different details regarding the fallen heroes.
40. These statues were set up at Dion in Macedonia, whence they were looted by the Romans in 146 BC: Pliny, *Natural History* 34.64, and Velleius Paterculus, *Roman History* 1.11.3–4.
41. Stewart, *Faces of Power: Alexander's Image and Hellenistic Politics* (Berkeley: University of California Press, 1993), 123–30.
42. Georges Le Rider, *Alexander the Great: Coinage, Finances, and Policy*, trans. W. E. Higgins (Philadelphia: American Philosophical Society, 2007), 45–47.
43. Arrian 1.16.3, explaining that Arsites, who had rejected Memnon's advice of a scorched-earth tactical retreat, was held responsible for losing the Battle of the Granicus River.
44. Arrian 1.17.1. See also Waldemar Heckel, *Who's Who in the Age of Alexander the Great* (Malden, MA: Blackwell, 2006), 74–75.
45. Arrian 1.17.7 and 3.16.4.
46. Curtius 7.1.15; Arrian 3.5.3 and *Indika* 18.9. See Helmut Berve, *Das Alexanderreich auf prosopographischer Grundlage*, vol. 1 (1926; repr. Salem: Ayer, 1988), 304.
47. Arrian 1.17.1. Alexander's tendency to collect the same revenues as had been paid to the Persian king is reflected in appendix 2.

48. Maxim Kholod, "On the Financial Relations of Alexander the Great and the Greek Cities in Asia Minor: The Case of *Syntaxis*," in *Ruthenia Classica Aetatis Novae*, ed. Andreas Mehl, Alexander Makhlayuk, and Oleg Gabelko (Stuttgart: Franz Steiner, 2013), 83–92. On the epigraphic evidence, see A. J. Heisserer, *Alexander the Great and the Greeks: The Epigraphic Evidence* (Norman: University of Oklahoma Press, 1980).

49. On financing this phase of the invasion, see François de Callataÿ, "Les statères de Pergame et les réquisitions d'Alexandre le Grand," *Revue Numismatique* 169 (2012): 179–96.

50. Arrian 1.18.2.

51. Arrian 1.17.2; Pausanias 6.18.3–4.

52. Arrian 1.19.6; Diodorus 17.22.5.

53. Heisserer, *Alexander the Great and the Greeks*, 146.

54. Arrian 1.26.3 and 27.4.

55. Arrian 2.5.5; Curtius 3.7.2.

56. Arrian 2.5.9.

57. The king continued to impose large fines on Greek states, such as the 120 talents exacted from the Achaeans and Elis in 330 BC for their role in Agis's Revolt: Curtius 6.1.20.

58. Arrian 2.1.4–5. Alexander later in 331 BC reimbursed the Mitylenians for their financial losses: Curtius 4.8.13.

59. Curtius 3.4.3.

60. Curtius 3.4.14–15; Arrian 2.4.5–6.

61. Curtius 4.9.8 and 14.

62. Curtius 5.13.11.

63. Heckel, *Who's Who in the Age of Alexander*, 23–24.

64. Curtius 4.1.27.

65. Arrian 2.13.2–3; Diodorus 17.48.2–5; Curtius 4.1.27–33.

66. Diodorus 17.111.1.

67. Now in the Naples Museum, inventory 1035. Translation available in Miriam Lichtheim, *Ancient Egyptian Literature*, vol. III: *The Late Period* (Berkeley: University of California Press, 1980), 41–44, further discussion by Olivier Perdu, "Le monument de Samtoutefnakht à Naples," *Revue d'Égyptologie* 36 (1985): 99–113.

68. While there is some dispute about which battle Semtutefnakht survived, Issus or Gaugamela, his escape by sea (unless highly rhetorical) favors Issus.

69. For context and chronology, see Stanley Burstein, "Prelude to Alexander: The Reign of Khababash," *Ancient History Bulletin* 14 (2000): 149–54, and Alan Lloyd, "From Satrapy to Hellenistic Kingdom: The Case of Egypt," in *Creating a Hellenistic World*, ed. Andrew Erskine and Lloyd Llewellyn-Jones (Swansea: Classical Press of Wales, 2010), 83–105.

70. Curtius 3.11.20–21.

NOTES

71. Diodorus 17.59.7.
72. Arrian 2.11.9–10. See also Plutarch, *Alexander* 20.11; Curtius 3.8.12; Diodorus 17.32.3 and 35.1–36.5. The royal properties that were looted are discussed in chapter 4.
73. Plutarch, *Alexander* 24.1–2.
74. Curtius 3.13.16. At one point, Curtius 3.13.5 actually uses the Persian word *gaza* for the royal treasure.
75. Curtius 3.3.24. Given the carrying capacity of these animals (over 100 tons), the 74 tons of coinage does not seem an exaggeration. This is a case where two figures for different things (coins and convoy animals) reported at different points in Curtius's narrative provide a useful cross-check.
76. Athenaeus 13.607f.
77. Plutarch, *Alexander* 24.3.
78. Arrian 2.24.4–5 with another 8,000 dead; Diodorus 17.46.3–4 lists 13,000 prisoners sold plus 2,000 crucified; Curtius 4.4.16–17 agrees with Diodorus.
79. Arrian 2.27.7; Curtius 4.6.30.
80. Plutarch, *Alexander* 25.5–8 and *Moralia* 179e–f; Pliny, *Natural History* 12.32.
81. Francisco Bosch-Puche, "L' 'Autel' du temple d'Alexandre le Grand à Bahariya retrouvé," *Bulletin de l'Institut Français d'Archéologie Orientale* 108 (2008): 33.
82. On the same pedestal, a Greek inscription states simply (but significantly): "King Alexander to Ammon, his father."
83. Francisco Bosch-Puche, "The Egyptian Royal Titulary of Alexander the Great, I: Horus, Two Ladies, Golden Horus, and Throne Names," *Journal of Egyptian Archaeology* 99 (2013): 131–54, and "Alexander the Great's Names in the Barque Shrine at Luxor Temple," in *Alexander the Great and Egypt: History, Art, Tradition*, ed. Volker Grieb, Krzysztof Nawotka, and Agnieszka Wojciechowska (Wiesbaden: Harrassowitz, 2014), 55–87.
84. Ivan Ladynin, "Ἀλέξανδρος—'Defender of Egypt?' On the Semantics of Some Denotations of Alexander the Great on the Ancient Egyptian Monuments," *Vestnik Novosibirskogo Gosudarstvennogo Universiteta* 13 (2014): 14–20 (in Russian).
85. For the tablet, see Pierre Briant, *From Cyrus to Alexander: A History of the Persian Empire* (Winona Lake, IN: Eisenbraums, 2003), 862.
86. Diodorus 17.70.
87. Curtius 5.6.4–8. Plutarch, *Alexander* 37.3 mentions the slaughtering of Persians, citing a letter about it allegedly written by Alexander.
88. For example, thousands of Sidonians immolated themselves when their city fell to the Persians in 351 bc: Diodorus 16.45.4–6. Diodorus notes that these fires did not prevent the despoliation of the homes, for the Persian king simply sold the salvage rights to those keen on recovering the

melted silver and gold. For another example of salvaging plunder from a
burned city, see Diodorus 18.22.4–8 (Perdiccas in 322 bc).

89. For the argument that the plundering of the city did not occur, see
 N. G. L. Hammond, "The Archaeological and Literary Evidence for the
 Burning of Persepolis," *Classical Quarterly* 42 (1992): 358–64, refuted by
 Edmund Bloedow and Heather Loube, "Alexander the Great 'Under Fire' in
 Persepolis," *Klio* 79 (1997): 341–53. More recently, Robin Lane Fox, "Aspects
 of Warfare: Alexander and the Early Successors," *Revue des Études Militaires
 Anciennes* 6 (2013): 132, expresses reservations about the plunder of
 Persepolis because it is reported in the so-called Vulgate sources (Diodorus
 and Curtius) yet finds credible the plundering in India recounted by these
 same authors.

90. Lane Fox, "Aspects of Warfare," 132.

91. Plutarch, *Alexander* 24.3. One is reminded of Aristagoras's speech in
 Herodotus 5.49, where the speaker promises that the inhabitants of Persia
 "are wealthier than all the rest of the world combined, owning much gold,
 silver, bronze, fine clothes, cattle, and slaves easy for the taking."

92. Arrian 3.25.2 (Anaxippus in Aria).

93. Variant accounts are given in Arrian 3.17, Diodorus 17.67, and Curtius 5.3.

94. Arrian 3.17.3.

95. Arrian 3.17.6. The conventional number 30,000 is suspicious.

96. For this figure, which he admits to be low, see N. G. L. Hammond, "Cavalry
 Recruited in Macedonia Down to 322 B.C.," *Historia* 47 (1998): 425.

97. Arrian 3.15.6.

98. Arrian 3.19.6.

99. See, for example, Paolo Moreno, *Apelles: The Alexander Mosaic*
 (Milan: Skira, 2001), plate XI and commentary, 23–24.

100. The largest single case allegedly took place on the march from Bactria
 to India, where Ptolemy reports the seizure of over 230,000 cattle in one
 raid: Arrian 4.25.4. This is likely a self-serving exaggeration, but there can
 be little doubt that herds were seized: cf. Curtius 9.8.29. Some herds were
 reportedly sent back to Macedonia by the king.

101. Arrian 3.30.6.

102. Frank Holt, "Spitamenes against Alexander," *Historikogeographika* 4
 (1994): 51–58.

103. Frank Holt, *Into the Land of Bones*, 2nd ed. (Berkeley: University of
 California Press, 2012), 45–84, with sources. See also chapter 6 for the
 effects on Alexander's army.

104. Arrian 4.2.1–4.3.5; Curtius 7.6.10 and 7.6.16–23.

105. Arrian 4.2.4.

106. Holt, *Into the Land of Bones*, 58–60.

107. Curtius 7.11.28–29.
108. Curtius 7.5.28–35; Plutarch, *Moralia* 557b; Ammianus Marcellinus 29.1.31; Strabo 11.11.4.
109. The brutality of this assault has inclined some scholars to reject it; for more information, see Frank Holt, *Alexander the Great and Bactria* (Leiden: Brill, 1988), 74–75.
110. These miserable settlers soon revolted twice in an effort to return home to Greece. See Holt, *Into the Land of Bones*, 96–124.
111. Plutarch, *Alexander* 57.1–2; Polyaenus 4.3.10; cf. Curtius 6.6.14–17, who puts the incident earlier in the campaign. Donald Engels agrees with Curtius in *Alexander the Great and the Logistics of the Macedonian Army* (Berkeley: University of California Press, 1978), 86, but all circumstances point to Bactra instead. See the arguments in Frank Holt, "Alexander the Great at Bactra: A Burning Question," *Electrum* 22 (2015): 9–15.
112. Giving away spoils to comrades bypassed the booty sellers (*laphyropoliai*) who normally followed armies on campaign and suggests that the departing soldiers may have hoped to retrieve some of their loot if they returned home through Bactria. This never happened but see Diodorus 18.7.9.
113. Plutarch, *Alexander* 57.2–3.
114. Polyaenus 4.3.10: "Depriving the Macedonians of their treasures made them anxious to win more." See also Curtius 9.2.10 and 27.
115. Curtius 8.5.3.
116. Curtius 9.1.2.
117. Diodorus 17.94.3–5; cf. Arrian 6.16.2.
118. Diodorus 19.79.6–7.
119. Diodorus 17.94.4; Curtius 8.5.4 and 9.3.21–22; Diodorus 17.95.4. The alimentary measures had Achaemenid precedents.
120. Curtius 9.10.12 and 9.10.22–23; Strabo 15.2.5.
121. Recounted vividly by Arrian 6.5.4–6.11.8. For analysis, see A. B. Bosworth, *Alexander and the East: The Tragedy of Triumph* (Oxford: Oxford University Press, 1996), 133–65.
122. For example, Curtius 9.1.14 and 9.7.14; Arrian 5.29.5 and 6.14.2.
123. For example, Arrian 6.17.1; Curtius 9.4.5–6, 9.8.13, 9.8.15 (cf. Arrian 6.16.4 on money and elephants), and 9.8.29; Diodorus 17.96.3 and 17.99.4.
124. Diodorus 17.104.4–7; cf. Curtius 9.10.7; Strabo 15.2.4–8.
125. Plutarch, *Eumenes* 2.
126. See Lionel Pearson, *The Lost Histories of Alexander the Great* (London: American Philological Association, 1960), 83–111.
127. Arrian 6.17.1–2.
128. Curtius 9.8.16. In India more than anywhere else, the comparison of Alexander to the Spanish conquistadors is apt: Bosworth, *Alexander and the East: The Tragedy of Triumph*, and Bosworth, "A Tale of Two Empires: Hernán Cortés and Alexander the Great," in *Alexander the Great*

NOTES

in Fact and Fiction, ed. A. B. Bosworth and E. J. Baynham (Oxford: Oxford University Press, 2000), 23–49.
129. For instance, Arrian 5.20.7 and 6.27.2; Curtius 10.1.20; Diodorus 19.14.8.
130. Strabo 15.2.5.
131. A. B. Bosworth, "The Indian Satrapies under Alexander the Great," *Antichthon* 17 (1983): 45.
132. *Palatine Anthology* 6.344.
133. Numbers 31:7–54, including a tally of all the plunder and God's rules for distributing it.
134. For example, II Chronicles 36:7 and Ezra 1:7–11.
135. So, too, modern accounts based on those sources. Marek Olbrycht states simply, "Alexander arrived in Asia as king of Macedonia desiring fame, conquest, and booty." See his study, "'An Admirer of Persian Ways': Alexander the Great's Reforms in Parthia-Hyrcania and the Iranian Heritage," in *Excavating an Empire: Achaemenid Persia in Longue Durée*, ed. Touraj Daryaee, Ali Mousavi, and Khodadad Rezakhani (Costa Mesa: Mazda Publishers, 2015), 37.

Chapter 4

1. Quoted in Plutarch, *Moralia* 336a.
2. For an up-to-date, balanced assessment of Darius, see Pierre Briant, *Darius in the Shadow of Alexander*, trans. Jane Marie Todd (Cambridge, MA: Harvard University Press, 2015).
3. Arrian 3.21.10–3.22.6; Plutarch, *Alexander* 43.3–4; Diodorus 17.73.3; Curtius 5.13.23–25; Justin 11.15.5.
4. The essential reference for the women in this list with a useful family tree is Elizabeth Carney, *Women and Monarchy in Macedonia* (Norman: University of Oklahoma Press, 2000).
5. Isocrates, *Panegyrics* 187; cf. Herodotus 5.49.
6. Lloyd Llewellyn-Jones, "The Great Kings of the Fourth Century and the Greek Memory of the Persian Past," in *Greek Notions of the Past in the Archaic and Classical Eras*, ed. John Marincola, Lloyd Llewellyn-Jones, and Calum Maciver (Edinburgh: Edinburgh University Press, 2012), 317–46; and on the writing of *Persica*, see Dominique Lenfant, "Greek Monographs on the Persian World," in *Between Thucydides and Polybius: The Golden Age of Greek Historiography*, ed. Giovanni Parmeggiani (Washington, DC: Center for Hellenic Studies, 2014), 197–210.
7. Arrian 1.17.3–8; Diodorus 17.21.7; cf. Curtius 3.12.6; Plutarch, *Alexander* 17.1.
8. As it had been for Cyrus when he captured the city from Croesus: Xenophon, *Cyropaedia* 7.4.12.

9. The actions of Mithrines require some explanation, so see Pierre Briant, *Histoire de l'empire perse de Cyrus à Alexandre*, vol. 1 (Paris: Fayard, 1996), 862–63.

10. Later, Alexander subordinated Nikias to a regional finance officer named Philoxenus, in charge of all Asia Minor, and appointed Coeranus the superintendent of revenues for Phoenicia: Arrian 3.6.4. See chapter 6.

11. Strabo 14.1.22 passes along the information that there was no treasure kept at that time in Ephesus.

12. Curtius 3.1.20.

13. For the sources and their acceptance, see N. G. L. Hammond and G. T. Griffith, *A History of Macedonia*, vol. II: *550–336 B.C.* (Oxford: Clarendon Press, 1979), 576.

14. For the history of this site, see chapter 6.

15. Curtius 3.13.16: *Summa pecuniae signatae fuit talentum II milia et sescenta, facti argenti pondus quigenta aeqabat* (i.e., 500 talents of wrought silver rather than the 500 pounds given in the Loeb translation).

16. Curtius 3.13.9–11.

17. Arrian 2.14.9, in response to Darius's first offer of a negotiated truce. On the efforts of Darius to bargain with Alexander, see Edmund Bloedow, "Diplomatic Negotiations between Darius and Alexander: Historical Implications of the First Phase at Marathus in Phoenicia in 333/332 B.C.," *Ancient History Bulletin* 9 (1995): 93–110. The talents allegedly offered at various times are all conventional amounts of 10,000 and 30,000.

18. Curtius 4.7.4. Alexander also received "magnificent gifts" from Cyrene: Curtius 4.7.9; Diodorus 17.49.2.

19. On this fascinating document (British Museum n. 40623, see Matthew Neujahr, "When Darius Defeated Alexander: Composition and Redaction in the Dynastic Prophecy," *Journal of Near Eastern Studies* 64 (2005): 101–7. For the larger context of hostility toward Alexander expressed in Iranian sources, see A. S. Shahbazi, "Iranians and Alexander," *American Journal of Ancient History* 2 (2003): 5–38.

20. Paul Bernard, "Nouvelle contribution de l'épigraphie cunéiforme à l'histoire hellénistique," *Bulletin de Correspondance Hellénique* 114 (1990): 528. The document is in the British Museum (n. 36761).

21. Arrian 3.15.4; cf. Plutarch, *Moralia* 180c.

22. Arrian 3.15.5; Diodorus 17.64.3; Curtius 5.1.10, cf. 4.9.9. After Issus, Parmenion had rushed to capture the main depot at Damascus (see chapter 3).

23. Strabo 15.3.9 (8,000); Arrian 3.19.5 (7,000).

24. Diodorus 17.64.3 gives the smaller figure, Curtius 5.1.10 the larger.

25. Arrian 3.16.2–3.

26. Curtius 5.1.4–6.

27. Diodorus 17.65.5. The theory that Darius had ordered his satraps to surrender to distract Alexander with treasure has been effectively refuted by Pierre Briant, *From Cyrus to Alexander: A History of the Persian Empire* (Winona Lake, IN: Eisenbrauns, 2003), 840–42.

28. Some hint of these negotiations may be discerned in the Babylonian document referenced earlier: Bernard, "Nouvelle contribution de l'épigraphie cunéiforme à l'histoire hellénistique," 525–28.

29. Briant, *From Cyrus to Alexander*, 842. On the surrender, see Curtius 5.1.17–19; Arrian 3.16.3; Diodorus 17.64.3.

30. Curtius 5.1.20–23, followed by a lavish description of the city.

31. Curtius 5.1.23. Like Mithrines, Bagophanes did not keep his post: Curtius 5.1.43–44.

32. Now in the Louvre (inv. 2898). For context, see Donald Posner, "Charles LeBrun's Triumphs of Alexander," *Art Bulletin* 41 (1959): 237–48.

33. Ibid., 243.

34. Copies in, for example, the New York Metropolitan Museum of Art (acc. 61.130.3) and Museum of Fine Arts, Boston (acc. P 4813).

35. On the filming and sets, see Robin Lane Fox, *The Making of Alexander* (Oxford: R & L, 2004), 79–88; see also Elizabeth Baynham, "Power, Passion, and Patrons: Alexander, Charles Le Brun, and Oliver Stone," in *Alexander the Great: A New History*, ed. Waldemar Heckel and Lawrence Tritle (Malden, MA: Wiley-Blackwell, 2009), 294–310.

36. Curtius 5.1.7: "Babylona urbem opulentissimum."

37. Diodorus 17.64.6; Curtius 5.1.45. Some of the spoils were shipped to Croton in Italy in a grand gesture of Hellenic unity: Plutarch, *Alexander* 34.2.

38. N. G. L. Hammond argues, for example, that the common source is Diyllus of Athens: *Three Historians of Alexander the Great* (Cambridge: Cambridge University Press, 1983), 161.

39. See, for example, R. D. Milns, "Army Pay and the Military Budget of Alexander the Great," in *Zu Alexander dem Grossen*, vol. 1, ed. Wolfgang Will and Johannes Heinrichs (Amsterdam: Hakkert, 1987), 233–56, esp. 240–44.

40. J. E. Atkinson, *A Commentary on Q. Curtius Rufus' Historiae Alexandri Magni Books 5 to 7.2* (Amsterdam: Hakkert, 1994), 54–55.

41. For Alexander's troop contingents at Gaugamela (minus losses in the battle), see E. W. Marsden, *The Campaign of Gaugamela* (Liverpool: Liverpool University Press, 1964), 24–39.

42. The pay rate for mercenary infantry is based on the consensus of H. W. Parke, *Greek Mercenary Soldiers from the Earliest Times to the Battle of Ipsus* (Oxford: Clarendon Press, 1933), 233; Alfred Bellinger, *Essays on the Coinage of Alexander the Great* (New York: American Numismatic Society, 1963), 37, note 15; and Milns, "Army Pay and the Military Budget of Alexander the Great," 249.

43. Arrian 3.16.4; Curtius 5.1.44.

44. On the range of Babylonian mintages in this period, see Hélène Nicolet-Pierre, "Argent et or frappes en Babylone entre 331 et 311 ou de Mazdai à Séleucos," in *Travaux de numismatique grecque offerts à Georges Le Rider*, ed. Michel Amandry and Silvia Hurter (London: Spink, 1999), 285–305.

45. Diodorus 17.64.4; Curtius 5.1.36–39, commenting on the corrupting influences of the city. Billeting from city to city was no doubt a hardship on the locals, and a source of disputes among the Greeks and Macedonians: Curtius 6.11.3; Plutarch, *Eumenes* 2.1–3.

46. Diodorus 17.65.1–4; Curtius 5.2.1–7; Arrian 3.16.6–7.

47. These 142 tons of dye came from the town of Hermione in Greece.

48. Strabo 15.3.21 repeats the claim of Polycleitus, a possible eyewitness, that at Susa the Persians stockpiled such tribute as dyes, drugs, hair, and wool. It may well have been in Susa that Polycleitus saw an extraordinary chandelier: Athenaeus 5.206e. On Polycleitus, see Lionel Pearson, *The Lost Histories of Alexander the Great* (London: American Philological Association, 1960), 70–77.

49. Cited in Strabo 15.3.21. Herodotus makes a similar observation, although his meaning has been interpreted differently by Antigoni Zournatzi, "The Processing of Gold and Silver Tax in the Achaemenid Empire: Herodotus 3.96.2 and the Archaeological Realities," *Studia Iranica* 29 (2000): 241–72.

50. A. B. Bosworth, *A Historical Commentary on Arrian's History of Macedonia*, vol. 1 (Oxford: Clarendon, 1980), 316; Martin Price, *The Coinage in the Name of Alexander the Great and Philip Arrhidaeus*, vol. 1 (Zurich: Swiss Numismatic Society, 1991), 26.

51. See appendix 2.

52. Herodotus 5.49.

53. Rochegrosse's painting was exhibited by the artist in 1913 and most recently on auction at Christie's in 2011; others include a well-known tableau rendered in *National Geographic* magazine.

54. Ernst Badian singled it out as "the most puzzling incident of Alexander's campaign." See "Alexander in Iran," in *The Cambridge History of Iran*, vol. 7, ed. Ilya Gershevitch (Cambridge: Cambridge University Press, 1985), 443.

55. For a convenient summary of views, see Ali Mousavi, *Persepolis: Discovery and Afterlife of a World Wonder* (Berlin: De Gruyter, 2012), 63–70.

56. Wheeler, *Flames over Persepolis: Turning Point in History* (New York: William Morrow, 1968), 14.

57. Arrian 3.18.10; Curtius 5.5.2; Diodorus 17.69.1.

58. Diodorus 17.69–70 and Curtius 5.2.16–6.8, both highly rhetorical; Arrian 3.17–18.

59. Modern scholars also debate whether events in Greece, specifically the war led by Agis of Sparta, influenced Alexander's decisions at Persepolis: Ernst

Badian, *Collected Papers on Alexander the Great* (London: Routledge, 2012), 338–64; Eugene Borza, "Fire from Heaven: Alexander at Persepolis," *Classical Philology* 67 (1972): 233–45.

60. For recent discussions of the long debate over Alexander's decision to burn Persepolis, see Maria Brosius, "Alexander and the Persians," in *Brill's Companion to Alexander the Great*, ed. Joseph Roisman (Leiden: Brill, 2003), 181–85; and Krzysztof Nawotka, "Alexander the Great in Persepolis," *Acta Antiqua Academiae Scientiarum Hungaricae* 43 (2003): 67–76.

61. Arrian 3.18.10–12.

62. Strabo 15.3.6 and *Itinerarium Alexandri* 67.

63. Diodorus 17.71–72, Curtius 5.7.2–11, and Plutarch, *Alexander* 38, drawing their information from Cleitarchus: Athenaeus 13.576d. On the consistency of the revenge motif, see Michael Flower, "Alexander and Panhellenism," in *Alexander the Great in Fact and Fiction*, ed. A. B. Bosworth and E. J. Baynham (Oxford: Oxford University Press, 2000), 113–15.

64. Diodorus 17.71.

65. Nawotka, "Alexander the Great in Persepolis," 68. He concludes, however, that the deliberate destruction of Persepolis was not so much a matter of Pan-Hellenic retribution as it was aimed at terrorizing the Persian nobility, breaking their spirit and defiling the site by using sacred fire (75).

66. Reported in the conflated lines from Curtius 5.6.5–6. It is plausible that this group of pillagers was being placated by Alexander: Gary Morrison, "Alexander, Combat Psychology, and Persepolis," *Antichthon* 35 (2001): 30–44.

67. Curtius 5.6.5: *dolabris pretiosae artis vasa caedebant.*

68. Published as Herzfeld, "Rapport sur l'état actuel des ruines de Persépolis et propositions pour leur conservation," *Archäologische Mitteilungen aus Iran* 1 (1929): 17–64.

69. These efforts did not extend to the city itself, looted by Alexander's army, but rather focused on the palace complex.

70. For a vivid impression of these structures, see the film and companion book produced by Farzin Rezaeian, *Persepolis Revealed* (Toronto: Sunrise Visual Innovations, 2004).

71. On the excavations, see Erich Schmidt, *The Treasury of Persepolis and Other Discoveries in the Homeland of the Achaemenians* (Chicago: University of Chicago Press, 1939); Schmidt, *Persepolis II: Contents of the Treasury and Other Discoveries* (Chicago: University of Chicago Press, 1957); Nicholas Cahill, "The Treasury of Persepolis: Gift-Giving at the City of the Persians," *American Journal of Archaeology* 89 (1985): 373–89; and Heleen Sancisi-Weerdenburg, "Alexander and Persepolis," in *Alexander the Great: Reality and Myth*, ed. Jesper Carlsen et al. (Rome: "L'Erma" di Bretschneider, 1993), 177–88.

72. Confirmed by Theopompus, a contemporary of Alexander, in Longinus, *On the Sublime* 43.2.
73. Strabo 15.3.6.
74. Schmidt, *Persepolis II*, 110–14. This figure excludes the few numismatic finds from other areas of Persepolis.
75. Ibid., 81. The first set of objects (mortars and pestles) may have been used in the ritualistic preparation of the drug *haoma*: 55.
76. The final looters lost or abandoned some of their cargo as they scurried about the treasury: Schmidt, *Persepolis II*, 5, 55, and 76.
77. Sancisi-Weerdenburg, "Alexander and Persepolis," 182.
78. Shahbazi, "Iranians and Alexander," 19–20, note 71 (his italics). This suggests that the intention was to witness more than just the burning of any remaining contents inside the buildings.
79. Badian, "Alexander in Iran," 447.
80. Persepolis: Arrian 6.30.1. Alexander revisited the ruins, blanketed by debris, on his return from India in 324. A few decades after the fire, the depth of that debris measured about 1.4 meters (4.6 feet): Schmidt, *Persepolis II*, 110. Thebes: Plutarch, *Alexander* 13.3–5.
81. Herodotus 8.53–5.
82. Curtius 5.5.2; Diodorus 17.69.1.
83. Curtius 5.6.11. Treasurers by and large seem to have been bureaucrats rather than soldiers, men inclined to calculate the costs of resistance as a matter of self-interest.
84. Curtius 5.6.9. His credulity has its defenders: Atkinson, *A Commentary on Q. Curtius Rufus*, 115–16.
85. Diodorus 17.71.1. Inexplicably, Ian Worthington, *Alexander the Great: Man and God* (London: Pearson, 2004), 109, states that "120,000 talents of gold coins as well as treasure" was seized.
86. Plutarch, *Alexander* 37.4 (Persepolis) and 36.1 (Susa).
87. Strabo 15.3.9, without naming his discrepant sources.
88. Justin/Trogus 11.14.10.
89. Schmidt, *Persepolis II*, 73.
90. The imprecision is notable in the comment of Diodorus 16.56.7 that some historians had reckoned the treasures plundered from Delphi by the Phocians as not less than what Alexander looted from the Persian treasuries when, by Diodorus's own calculations, the Delphic trove was valued around 10,000 talents.
91. Grote, *History of Greece*, vol. 12 (London: John Murray, 1856), 237–38, note 3.
92. Engels, *Alexander the Great and the Logistics of the Macedonian Army* (Berkeley: University of California Press, 1978), 79. He adds in a note that the weight is only approximate.

93. Ibid., 14. These figures may seem low, but anecdotally, a Macedonian was able with some difficulty to carry one mule's burden of royal gold: Plutarch, *Alexander* 39.3.

94. Cahill, "The Treasury of Persepolis," 374; Edmund Bloedow and Heather Loube, "Alexander the Great 'under Fire' in Persepolis," *Klio* 79 (1997): 344.

95. Taking the ratio established by Alfred Bellinger, *Essays on the Coinage of Alexander the Great*, 31. A higher ratio would correspondingly lower the actual weight of the imagined hoard. In the fifth century BC, the ratio was thirteen to one according to Herodotus 3.95.

96. Curtius 5.6.10.

97. Arrian 3.18.10 refers to the treasure stored at Pasargadae but gives no details.

98. According to Diodorus 17.71.2, Alexander sent part of the Persepolis treasure first to Susa.

99. Darius's withdrawals: Strabo 15.3.9 (8,000); Arrian 3.19.5 (7,000). Abandonment: Plutarch, *Alexander* 43.2. Embezzlements: Curtius 6.2.10; Diodorus 17.74.5.

100. Curtius 6.2.10 (26,000); Diodorus 17.74.5 (21,000).

101. Curtius 6.2.10 (12,000); Diodorus 17.74.5 (13,000).

102. Curtius 6.2.17; Diodorus 17.74.3–5. When Alexander discharged 900 veterans at the Oxus River in 329, the rates were much higher still.

103. Diodorus 17.74.4.

104. Arrian 3.19.5; Plutarch, *Alexander* 42.5.

105. Polybius 10.27.11; Aelian, *Varia Historia* 7.8.

106. Polybius 10.27.12–13.

107. Strabo 15.3.9.

108. Diodorus 17.80.3; Justin/Trogus 12.1.3.

109. For example, the Scythian king who sent Alexander unspecified gifts: Arrian 4.15.2.

110. As shown in chapter 3, *pace* Peter Green, *Alexander of Macedon, 356–323 B.C.* (Berkeley: University of California Press, 1991), 413.

111. Arrian 5.3.5–6 and 5.8.2. Alexander had already received impressive gifts, and promises of more, from Taxiles and his neighbors: Arrian 4.22.6.

112. Taxiles was Omphis's throne name, conferred upon him by Alexander: Curtius 8.12.11–14.

113. Arrian 5.3.5 (200 talents, 3,000 cattle, more than 10,000 sheep, 30 elephants); Curtius 8.12.11 (80 talents, 3,000 bulls, many sheep, 56 elephants); Diodorus 17.86.4–7; Plutarch, *Alexander* 59.1–5; *Metz Epitome* 52 (600 talents, 58 elephants).

114. Arrian 5.8.2; Curtius 8.12.16; Plutarch, *Alexander* 59.5; Strabo 15.1.28.

115. Ibid.

116. Pliny, *Natural History* 35.167–168. It was he who had helped escort Alexander's Getic spoils back to Macedonia in the first months of the king's reign: Arrian 1.4.5.
117. Curtius 8.12.17–18.
118. Plutarch, *Alexander* 57.1–2 and Polyaenus 4.3.10, discussed in chapter 3.
119. Arrian 5.8.3, 20.5, and 29.4.
120. Diodorus 17.92.1; Curtius 9.1.27–30. The gifts included a famous breed of ferocious fighting dogs.
121. Diodorus 17.93.1, 96.2, and 102.4.
122. Curtius 9.7.12.
123. Curtius 9.8.1–2.
124. Arrian 6.15.5.
125. Diodorus 17.76.5–8; Curtius 6.5.18–21.
126. Arrian 6.15.6. This Musicanus later rebelled and was crucified, as noted in chapter 3.
127. Curtius 10.1.22–24.
128. Arrian 6.29.2–30.2; Curtius 10.1.25–38.
129. Curtius 10.1.34–35 reports this allegation but defends Orxines's innocence, in part, it seems, because the benefaction/bribe was 3,000 talents of coined silver while the tomb was supposedly filled with 3,000 talents of gold. There may be some confusion here with the 3,000 talents of coins sent to Alexander by the equally ill-fated satrap Abulites: Plutarch, *Alexander* 68.7.
130. Arrian 7.23.2.
131. Diodorus 17.113.1.

Chapter 5

1. See appendix 3 for a catalog of Alexander's known expenditures.
2. Exceptions include the alleged donatives at Chrysopolis and Alexander's gifts to the Amazon queen.
3. Plutarch, *Alexander* 39.1; cf. Rutilius Lupus 1.18.
4. See, for example, Heleen Sancisi-Weerdenburg, "Gifts in the Persian Empire," in *Le tribute dans l'Empire Perse*, ed. Pierre Briant and Clarisse Herrenschmidt (Paris: Peeters, 1989), 129–46.
5. Arrian 7.28.3.
6. Plutarch, *Moralia* 181e.
7. For a broad treatment, see Lynette Mitchell, *Greeks Bearing Gifts: The Public Use of Private Relationships in the Greek World, 435–323* BC (Cambridge: Cambridge University Press, 1997), especially 167–77.

8. Curtius 8.12.17; cf. Plutarch, *Moralia* 181c.
9. Diodorus 17.77.4–5; Plutarch, *Alexander* 39.10.
10. Meyer Reinhold, *History of Purple as a Status Symbol in Antiquity* (Brussels: Latomus, 1970), 16.
11. Xenophon, *Cyropaedia* 8.2.8.
12. Reinhold, *History of Purple*, 29–30.
13. Plutarch, *Alexander* 16.19 (Granicus) and 25.6–8 (Gaza); Curtius 5.2.18 (Susa). Alexander's adopted mother, Queen Ada of Caria, sent him more practical gifts of fine foods and delicacies, some of which he declined as a lapse of military discipline: Plutarch, *Alexander* 22.7. Plutarch adds that Olympias had tried to do the same thing when Alexander was a boy.
14. Curtius 5.2.18–22. Pierre Briant, *Darius in the Shadow of Alexander*, trans. Jane Marie Todd (Cambridge, MA: Harvard University Press, 2105), 331–34, does not accept the ethnological truth of the tale but sees in it an effort to establish Alexander's sensitivity to other cultures.
15. Plutarch, *Alexander* 16.19, 25.6–8, and 39.12.
16. Plutarch, *Alexander* 25.6–8 and *Moralia* 179e–f; Pliny, *Natural History* 12.62; Athenaeus 9.398e.
17. Diodorus 17.31.6. See Waldemar Heckel, *Who's Who in the Age of Alexander the Great* (Malden, MA: Blackwell, 2006), 153.
18. Jamzadeh, *Alexander Histories and Iranian Reflections: Remnants of Propaganda and Resistance* (Leiden: Brill, 2012), 7.
19. Arrian 7.4.8; Plutarch, *Alexander* 69.1 and *Moralia* 246a–b; Justin 1.6.13; Polyaenus 7.45.2.
20. Marek Olbrycht, "'An Admirer of Persian Ways': Alexander the Great's Reforms in Parthia-Hyrcania and the Iranian Heritage," in *Excavating an Empire: Achaemenid Persia in Longue Durée*, ed. Touraj Daryaee, Ali Mousavi, and Khodadad Rezakhani (Costa Mesa: Mazda Publishers, 2015), 52–54.
21. For example, Diodorus 17.81.
22. Plutarch, *Alexander* 34.3–4. The valor of the hero Phayllus is told in Herodotus 8.47.
23. Athenaeus 6.234–262 writes about infamous parasites and flatterers, including those attached to Philip and Alexander.
24. Athenaeus 6.230f; cf. Plutarch, *Moralia* 603c.
25. Plutarch, *Alexander* 39.6.
26. Plutarch, *Alexander* 29.6 and *Moralia* 334e.
27. Plutarch, *Moralia* 331e.
28. Ps.-Callisthenes, *Alexander Romance* (Armenian), 134.
29. Pausanias 6.15.3; cf. Polybius 27.9.3–13.
30. George Cary, *The Medieval Alexander* (Cambridge: Cambridge University Press, 1956), 364.

31. In a useful examination of this topic, Lindsay Adams reports on fifteen cases: "The Games of Alexander the Great," in *Alexander's Empire: Formulation to Decay*, ed. Waldemar Heckel, Lawrence Tritle, and Pat Wheatley (Claremont, CA: Regina Books, 2007), 125–38. The lower number results largely from his ignoring sources other than Arrian's *Anabasis*. The *Indika*, for example, adds two more games put on by Alexander plus three hosted by Nearchus. This shows that games could be held by detached parts of the king's forces.

32. Athenaeus 12.537d and 539a; cf. the anecdote opening Dio Chrysostom's *On Kingship* 1.

33. Lawrence Tritle, "Alexander and the Greeks: Artists and Soldiers, Friends and Enemies," in *Alexander the Great: A New History*, ed. Waldemar Heckel and Lawrence Tritle (Malden, MA: Wiley-Blackwell, 2009), 121–40.

34. Athenaeus 12.539a.

35. Plutarch, *Alexander* 29.5.

36. See Frank Holt, *Into the Land of Bones: Alexander the Great in Afghanistan*, 2nd ed. (Berkeley: University of California Press, 2012), 72–73.

37. Pausanias 6.16.5.

38. Diogenes Laertius 6.45; *Gnomologium Vaticanum* 367.

39. Plutarch, *Moralia* 333b.

40. Curtius 9.7.16.

41. Curtius 9.7.17–26.

42. Plutarch, *Eumenes* 2.1–3.

43. Plutarch, *Eumenes* 2.

44. Aristotle, *Politics* 1267b. Much the same thing is said by Chremylus in Aristophanes, *Wealth*.

45. Plutarch, *Moralia* 180c.

46. Plutarch, *Alexander* 39.7–8.

47. Aelian, *Varia Historia* 9.3.

48. Athenaeus 12.537d.

49. Curtius 9.7.15.

50. Plutarch, *Alexander* 23.10.

51. William Loomis, *Wages, Welfare Costs and Inflation in Classical Athens* (Ann Arbor: University of Michigan Press, 1998), 177.

52. Reported by Athenaeus 4.146c (citing Ephippus) and more fully in Polyaenus 4.3.32, a passage that perpetuates the cliché of Persian dissipation, but which is nonetheless credited by Pierre Briant, *From Cyrus to Alexander: A History of the Persian Empire* (Winona Lake, IN: Eisenbrauns, 2002), 286–92. A hint of Alexander's own expensive food chain may be found in Athenaeus 9.393.

53. Athenaeus 13.607f.

54. Athenaues 4.155d, citing Agatharchides as the source.

55. Based on the per-person expense that Alexander borrowed from the Persians: Athenaeus 4.146c (citing Ephippus).

56. Athenaeus 12.539c (silver); Aelian, *Varia Historia* 9.3 (gold). Alexander was allegedly unhappy with these types of vulgar luxuries: Plutarch, *Alexander* 40.1.

57. Aelian, *Varia Historia* 9.3.

58. Curtius 6.11.2, during his treason trial.

59. Arrian 5.27.6, at the Hyphasis River shortly before Coenus succumbed to disease.

60. Plutarch, *Alexander* 25.8 and *Moralia* 179e–f; Pliny, *Natural History* 12.62.

61. Reported in Athenaeus 12.537e. Curiously, it bothered the ancients more that Alexander dressed like a Persian than like a god.

62. Arrian 7.25–7.26.3; Plutarch, *Alexander* 76.

63. See appendix 3.

64. Arrian 5.3.5; Curtius 8.12.11. Such numbers are not unheard of: years earlier in Greece, Jason of Pherae collected a thousand cattle and more than 10,000 sheep, goats, and pigs for sacrificing at the Pythian games, according to Xenophon, *Hellenica* 6.4.29, with a crown of gold for providing the best bull. For more on the numbers of sacrificial cattle, see Jeremy McInerney, *The Cattle of the Sun: Cows and Culture in the World of the Ancient Greeks* (Princeton, NJ: Princeton University Press, 2010).

65. See, for examples, Arrian, *Indika* 18.12 and Diodorus 17.16.3–4.

66. In most cases, Alexander sacrificed "to the customary gods" rather than specific deities. At rivers, he sacrificed to the water itself before crossing.

67. Ilium: Strabo 13.1.26; Mallus: Arrian 2.5.9 and Strabo 14.5.16; Siwah: Curtius 4.7.28 and Plutarch, *Alexander* 27.7; Epidaurus: Arrian 7.14.6.

68. Arrian 1.17.10; Strabo 14.1.22.

69. A. J. Heisserer, *Alexander the Great and the Greeks: The Epigraphic Evidence* (Norman: University of Oklahoma Press, 1980), 143. This is a good example of a major expenditure that did not enter the literary record.

70. Arrian 1.17.5–6.

71. Arrian 3.1.5.

72. Mahmud Abd el-Raziq, *Die Darstellungen und Texte des Sanktuars Alexanders des Grossen im Tempel von Luxor* (Mainz am Rhein: Philipp von Zebern, 1984).

73. Ivan Ladynin, "The Argeadai Building Program in Egypt in the Framework of Dynasties' XXIX-XXX Temple Building," in *Alexander the Great and Egypt: History, Art, Tradition*, ed. Volker Grieb, Krzysztof Nawotka, and Agnieszka Wojciechowska (Wiesbaden: Harrassowitz, 2014), 55–87; Dieter Arnold, *Temples of the Last Pharaohs* (Oxford: Oxford University Press, 1999),

138, cf. 133 for a possible case at Edfu; Francisco Bosch-Puche, "L' 'Autel' du temple d'Alexandre le Grand à Bahariya retrouvé," *Bulletin de l'Institut Français d'Archéologie Orientale* 108 (2008): 29–44. Whatever Alexander's role in initiating such works, they were carried out in his name and with his resources.

74. Arrian 3.16.4 (331 BC) and 7.17.1–4 (323 BC), laying blame on Xerxes for the problem.

75. Slackers: Arrian 7.17.3.

76. Plutarch, *Moralia* 343d; Diodorus 18.4.4–5, giving the cost at 1,500 talents per temple.

77. Ilium: Strabo 13.1.26; Babylon: R. J. van der Spek, "The Astronomical Diaries as a Source for Achaemenid and Seleucid History," *Bibliotheca Orientalis* 50 (1993): 96. A reference to a month's wages paid to five of these workers by Philip Arrhidaeus in early 321 BC has been found on a Babylonian clay tablet: Michael Jursa, "Florilegium babyloniacum: Neue Texte aus hellenistischer und spätachämenischer Zeit," in *Mining the Archives*, ed. Cornelia Wunsch (Dresden: ISLET, 2002), 120–21.

78. See appendix 3. A more lavish reburial of Philip may have been planned, and Hephaestion was honored with more than one memorial.

79. Arrian 7.10.4.

80. Hector: Curtius 4.8.9; Philip: Curtius 8.2.40; cf. another Alexander in India: Plutarch, *Alexander* 58.5.

81. Plutarch, *Moralia* 328e.

82. Fraser, *Cities of Alexander the Great* (Oxford: Clarendon Press, 1996), 201 and 240–43. For a compendium of the evidence for all of the Alexandrias and related cities, see Getzel Cohen, *The Hellenistic Settlements*, 3 vols. (Berkeley: University of California Press, 2013).

83. See, for example, A. B. Bosworth, *Conquest and Empire: The Reign of Alexander the Great* (Cambridge: Cambridge University Press, 1988), 245–50. Very rarely has a scholar accepted a total of seventy or so cities, among them N. G. L. Hammond, "Alexander's Newly-Founded Cities," *Greek, Roman and Byzantine Studies* 39 (1998): 243–69.

84. Arrian 5.29.5, where monsoon rains washed away Bucephala and Nicaea.

85. Arrian 4.4.1; Justin 12.5.12; Curtius 7.6.25–27; *Itinerarium Alexandri* 58.

86. Pierre Leriche, "Bactria, Land of a Thousand Cities," in *After Alexander: Central Asia before Islam*, ed. Joe Cribb and Georgina Herrmann (Oxford: Oxford University Press, 2007), 142, note 47.

87. For example, Hammond, "Alexander's Newly-Founded Cities," 257; Marek Jan Olbrycht, "Ethnicity of Settlers in the Colonies of Alexander the Great in Iran and Central Asia," *Bulletin of the International Institute of Central Asian Studies* 14 (2011): 22–35.

88. See appendix 3 for bridges. On flotation skins, see Edmund Bloedow, "On the Crossing of Rivers: Alexander's διφθέραι," *Klio* 84 (2002): 57–75.

89. Arrian 3.29.4; Curtius 7.5.17. Arrian 5.7.1–2 and 5.8.1 comments further on Alexander's likely bridging methods.
90. See appendix 3 for the years 326–323 BC.
91. Arrian, *Indika* 18.3–8. The *trierarchs* are conveniently listed in Waldemar Heckel, *Who's Who in the Age of Alexander the Great* (Malden, MA: Blackwell, 2006), 345–46 (omitting, however, Archias son of Anaxidotus).
92. Had the title been merely honorific, it is hard to explain why Onesicritus, the helmsman of Alexander's own vessel, was excluded. Also absent among the *trierarchs* is Evagoras, secretary of the entire flotilla.
93. For background, see Hans Hauben, "The Expansion of Macedonian Sea-Power under Alexander the Great," *Ancient Society* 7 (1976): 79–105.
94. Arrian 1.20.1; Diodorus 17.22.5, noting that Alexander retained the Athenian squadron of twenty ships to haul his siege equipment.
95. A. B. Bosworth, *A Historical Commentary on Arrian's History of Alexander*, vol. I (Oxford: Clarendon Press, 1980), 141–43.
96. Arrian 2.2.3; Curtius 3.1.19.
97. On the river constructions, see R. J. van der Spek, "Palace, Temple and Market in Seleucid Babylonia," in *Le roi et l'économie*, ed. Véronique Chankowski and Frédérique Duyrat (Paris: De Boccard, 2004), 303–32.
98. Although he does not link this trend back to Alexander, it is nonetheless pointed out by Robin Lane Fox, "Aspects of Warfare: Alexander and the Early Successors," *Revue des Études Militaires Anciennes* 6 (2013): 130, that 323–303 BC represented a new era of intensive naval warfare.
99. For the calculation, see Ian Morris, *War! What Is It Good For?* (New York: Farrar, Straus and Giroux, 2014), 250.
100. On the construction of siege machines, see Arrian 2.21.1, 2.26.2–4, 4.2.2, and 5.24.4.
101. Enumerated in appendix 3.
102. This methodology has been attempted, for example, by Georges Le Rider, *Alexander the Great: Coinage, Finances, and Policy*, trans. W. E. Higgins (Philadelphia: American Philosophical Society, 2007), 74–76.
103. Heisserer, *Alexander the Great and the Greeks: The Epigraphic Evidence*, 3–26; Ian Worthington, "Alexander the Great and the Greeks in 336? Another Reading of IG ii² 329," *Zeitschrift für Papyrologie und Epigraphik* 147 (2004): 59–71. The inscription may mean that *hypaspists* were paid one drachma per day, but this is conjectural.
104. Arrian 7.23.3–4.
105. By comparison, there is greater hope of reconstructing this kind of data for the Roman imperial army: Michel Reddé, ed., *De l'or pour les braves! Soldes, armées et circulation monétaire dans le monde romain* (Bordeaux: Ausonius, 2014).
106. As shown in chapter 4 for the military bonuses disbursed at Babylon.

NOTES

107. Andreades, "Les Finances de guerre d'Alexandre le Grand," *Annales d'Histoire Économique et Sociale* 1 (1929): 321–34.
108. Beloch, *Griechische Geschichte*, vol. 4, part 1 (Berlin: Walter de Gruyter, 1925), 42–43. Beloch's estimate has influenced many historians, for example, G. T. Griffith, "The Macedonian Background," *Greece and Rome* 12 (1965): 127.
109. Le Rider, *Alexander the Great: Coinage, Finances, and Policy*, trans. W. E. Higgins (Philadelphia: American Philosophical Society, 2007), 76.
110. Meadows, "The Spread of Coins in the Hellenistic World," in *Explaining Monetary and Financial Innovation: A Historical Analysis*, ed. Peter Bernholz and Roland Vaubel (New York: Springer International Publishing, 2014), 171.
111. Milns, "Army Pay and the Military Budget of Alexander the Great," in *Zu Alexander dem Grossen*, vol. 1, ed. Wolfgang Will and Johannes Heinrichs (Amsterdam: Hakkert, 1987), 249. He builds upon the work of Roch Knapowski, "Die Finanzen Alexanders des Grossen," in *Geschichte Mittelasiens in Altertum*, ed. Franz Altheim and Ruth Stiehl (Berlin: de Gruyter, 1970), 235–47.
112. Milns, "Army Pay," 254–56.
113. See, for example, Wilson Bevan, *The World's Leading Conquerors* (New York: Henry Holt, 1913), 54.
114. On these much-debated last plans, see Ernst Badian, *Collected Papers on Alexander the Great* (London: Routledge, 2012), 174–92.
115. Diodorus 18.4.4–5.

Chapter 6

1. N. G. L. Hammond, "An Unfulfilled Promise by Alexander the Great," in *Zu Alexander dem Grossen*, vol. 1, ed. Wolfgang Will and Johannes Heinrichs (Amsterdam: Hakkert, 1987), 627–34.
2. Plutarch, *Moralia* 182a.
3. Plutarch, *Phocion* 29.1.
4. On these troops, see Rolf Strootman, "Alexander's Thessalian Cavalry," *TALANTA* 42/43 (2010–2011): 51–67.
5. Plutarch, *Alexander* 24.1–2. Strootman, "Alexander's Thessalian Cavalry," 63, states that the Thessalians had been led on a similar pillaging expedition after Granicus, but this is only an assumption based on Arrian 1.17.8.
6. The Thessalians were brigaded with Parmenion, who seized the baggage camp: Arrian 3.11.10 and 3.15.4. On the soldiers' plot, see Plutarch, *Moralia* 180c.
7. Diodorus 17.64.6; Curtius 5.1.45. See discussion in chapter 4.
8. Curtius 6.2.10 and 17; Diodorus 17.74.3–5.

9. Arrian 3.29.5; Curtius 7.5.27.
10. Arrian 3.19.6, discussed in chapter 3.
11. Loomis, *Wages, Welfare Costs and Inflation in Classical Athens* (Ann Arbor: University of Michigan Press, 1998), 279, for an Eleusinian architect in 329/328 BC.
12. Curtius 7.5.27.
13. On Meleager and his command, see Waldemar Heckel, *The Marshals of Alexander's Empire* (New York: Routledge, 1992), 165–70.
14. For further details, see chapter 4 and Frank Holt, *Into the Land of Bones*, 2nd ed. (Berkeley: University of California Press, 2012).
15. Curtius 7.6.19 and 21; Arrian 4.16.1 and 4–7.
16. For example, Curtius 7.11.28–29.
17. Holt, *Into the Land of Bones*, 75–79 (the murder of Cleitus).
18. Plutarch, *Alexander* 57.3.
19. Diodorus 17.99.5–6; Curtius 9.7.1–11.
20. Curtius 6.6.14–17, who resituates the incident earlier in the context of a digression on Alexander's growing autocracy. The correct chronology is evident in Plutarch, *Alexander* 57.1–2 and Polyaenus 4.3.10, which matches the circumstances at Bactra.
21. Curtius 8.12.17–18.
22. Arrian 6.17.3; Strabo 15.2.4.
23. Arrian 6.27.3.
24. Curtius 9.10.12; cf. Arrian 6.25.1–3.
25. Arrian 6.25.4–5.
26. Arrian 3.28.5–10; Strabo 15.2.10; and Curtius 7.4.22–25.
27. Curtius 7.4.23 gives the prices; for the Athenian wages, see Loomis, *Wages, Welfare Costs and Inflation in Classical Athens*, 177.
28. Miltiades Hatzopoulos, *Actes du ventes d'Amphipolis* (Athens: Boccard, 1991), 33–38 and 81, discusses an inscription now in the Kavala Museum recording the sale of a vineyard near Amphipolis for the relatively high price of 320 drachmas for six plethra (1.38 acres). Thus, for the cost of one amphora of wine, a contemporary could acquire a vineyard producing about eighty-six amphorae every year.
29. As noted by Curtius 7.4.23.
30. Plutarch, *Alexander* 68.7.
31. Pay and bonuses: Arrian 7.12.1, cf. 7.10.3; Plutarch, *Alexander* 71.8. Stipends: Arrian 7.12.2; Plutarch, *Alexander* 71.9; Justin 12.4.8–9; Diodorus 17.110.3 (claiming there were 10,000 children on the dole).
32. Roisman, *Alexander's Veterans and the Early Wars of the Successors* (Austin: University of Texas Press, 2012), 40.
33. Justin 12.11.2 notes that the creditors were as pleased as the debtors by Alexander's settlement.

34. On which kind of stater, see R. D. Milns, "Army Pay and the Military Budget of Alexander the Great," in *Zu Alexander dem Grossen*, vol. 1, ed. Wolfgang Will and Johannes Heinrichs (Amsterdam: Hakkert, 1987), 246–47.

35. The average would be much higher using the figure chosen by Robin Lane Fox, "Aspects of Warfare: Alexander and the Early Successors," *Revue des Études Militaires Anciennes* 6 (2013): 132, who believes that the debts totaled 20,000 talents.

36. Arrian 7.10.3 (at Opis).

37. Roisman, *Alexander's Veterans and the Early Wars of the Successors*, 43, blames Alexander for the suspicions exhibited by his soldiers. Not to be overlooked is the strong sense of guilt felt among the debtors.

38. Plutarch, *Alexander* 70.4–6 and *Moralia* 339c–d. This man is not to be confused with the more famous Antigonus One-Eyed, quoted at the beginning of this chapter. See Waldemar Heckel, *Who's Who in the Age of Alexander the Great* (Malden, MA: Blackwell, 2006), 31.

39. Arrian 6.22.4 and 6.23.6.

40. Diodorus 17.94.4; Justin 12.4.2–11.

41. Plutarch, *Moralia* 181c. Alexander's father had been known for excessive gambling (and drinking): Athenaeus 6.260 provides some anecdotes.

42. Arrian 3.6.6.

43. The sources are conveniently assembled by Heckel, *Who's Who in the Age of Alexander the Great*, 129–31.

44. Heckel, *The Marshals of Alexander's Empire*, 205–33.

45. Plutarch, *Alexander* 10 and Arrian 3.6.4–7.

46. Arrian 3.6.6: "because his body was unfit for war." The nature of Harpalus's infirmity is not disclosed, but it was not severe enough to inhibit his traveling or penchant for prostitutes.

47. Plutarch, *Alexander* 41.8. See Ernst Badian, "The First Flight of Harpalus," *Historia* 9 (1960): 245–46.

48. Arrian 3.6.4.

49. Diodorus 17.108.4: Ἅρπαλος δὲ τῶν ἐν Βαβυλῶνι θησαυρῶν καὶ τῶν προσόδων τὴν φυλακὴν πεπιστευμένος. In one anecdote, Plutarch, *Moralia* 179f speaks of a *dioiketes* receiving the king's instructions in the matter of a large personal gift.

50. Kingsley, "Harpalos in the Megarid (333–331 B.C.) and the Grain Shipments from Cyrene," *Zeitschrift für Papyrologie und Epigraphik* 66 (1986): 165–77.

51. Green, *Alexander of Macedon* (Berkeley: University of California Press, 1991), 222.

52. Heckel, *Marshals of Alexander's Empire*, 215–17.

53. Kingsley, "Harpalos in the Megarid," 165.

54. Arrian 3.19.7–8.

55. Diodorus 17.108.4–5.

56. For example, see Hyperides 5, col. 9 on the dancer Mnesitheus.

57. Plutarch, *Alexander* 35.15; Theophrastus, *History of Plants* 4.4; Pliny, *Natural History* 16.144; Diodorus 17.108.4.

58. Plutarch, *Moralia* 648c–d attributes the gardening to Alexander's orders.

59. Diodorus 17.108.5; cf. Athenaeus 595c, quoting Philomenon.

60. The figure comes from Theopompus, cited by Athenaeus 595b.

61. Cited by Athenaeus 594e–f; cf. Diodorus 17.108.5.

62. Pausanias, *Description of Greece* 1.37.5; Plutarch, *Phocion* 22.

63. Plutarch, *Phocion* 22. Charicles became the guardian of a daughter left by Harpalus and Pythionice.

64. Diodorus 17.108.6; Athenaeus 586c–d and 595d.

65. Athenaeus 595e–596b.

66. Diodorus 17.108.6.

67. Called a "reign of terror" by Ernst Badian, who conveniently lists those punished but argues that the real motivation was an unhinged Alexander's bloody reassertion of authority after the humiliation of his retreat from India: *Collected Papers on Alexander the Great* (London: Routledge, 2012), 58–95.

68. Diodorus 17.108.6. There is mention of a paymaster with Harpalus at the time of his murder in Crete: Pausanias 2.33.4.

69. Christopher Blackwell, *In the Absence of Alexander: Harpalus and the Failure of Macedonian Authority* (New York: Peter Lang, 1999); Christian Habicht, *Athens from Alexander to Antony* (Cambridge, MA: Harvard University Press, 1997), 30–35.

70. Demosthenes had inherited slightly less than 15 talents (Plutarch, *Demosthenes* 4.3), but was worth perhaps 150 talents when charged with taking payoffs from Harpalus: Jonathan Goldstein, "Demosthenes' Fine and Its Payment, 323–322 B.C.," *Classical Journal* 67 (1971): 20–21.

71. Pausanias 2.33.4.

72. Polybius 2.62 supplies the figure (5,750 talents) for Attica in a tax valuation for 378 BC.

73. On the culture of financial corruption, see also Curtius 6.2.10 (12,000 of 26,000 talents embezzled at Ecbatana).

74. Arrian 3.6.4, with commentary: A. B. Bosworth, *A Historical Commentary on Arrian's History of Macedonia*, vol. 1 (Oxford: Clarendon, 1980), 280–82.

75. Aristotle, *Economics* 1352a.

76. Aristotle, *Economics* 1352b and 1353a. Even less is known about the enigmatic treasurer Xenocles/Xenophilus: Heckel, *Who's Who in the Age of Alexander the Great*, 272.

77. Alexander troubled himself to write a letter on behalf of *hetairoi* who were seeking runaway slaves: Plutarch, *Alexander* 42.1.

78. Arrian 3.5.4; Curtius 4.8.5; Justin 13.4.11. For discussion, see Georges Le Rider, *Alexander the Great: Coinage, Finances, and Policy*, trans. W. E. Higgins (Philadelphia: American Philosophical Society, 2007), 179–200.

79. Arrian 7.23.6–8.

NOTES

80. Pausanias 1.6.3.
81. These works are conventionally cited as Demosthenes, *Against Dionysodorus*, and Aristotle, *Economics*, even though authorship is disputed.
82. Demosthenes, *Against Dionysodorus* 56.9 and 45. It was, in fact, illegal for an Athenian to ship (or make loans to ship) grain to any port other than Athens: Demosthenes, *Against Lacritus* 35.50.
83. Demosthenes, *Against Dionysodorus* 56.8–9.
84. The data have been compiled in Peter Garnsey, *Famine and Food Supply in the Graeco-Roman World* (Cambridge: Cambridge University Press, 1988), 154–66.
85. Discussed in Blackwell, *In the Absence of Alexander*, 89–92.
86. Demosthenes, *Against Phormio* 34.37–39. See appendix 1.
87. Aristotle, *Economics* 1352b.
88. Aristotle, *Economics* 1352a–1353b.
89. Arrian 7.23.6–8. Some scholars dispute the authenticity of the letter, but Arrian found it credible even though he expressly disliked its contents and would rather not have reported it. He actually censures Alexander three times for writing it.
90. Cleomenes is called a racketeer by Alan Lloyd, "From Satrapy to Hellenistic Kingdom: The Case of Egypt," in *Creating a Hellenistic World*, ed. Andrew Erskine and Lloyd Llewellyn-Jones (Swansea: Classical Press of Wales, 2010), 87.
91. Arrian 6.27.4–5; Curtius 10.1.1–9.
92. For example, on Cleomenes, see Stanley Burstein, "Alexander's Administration of Egypt: A Note on the Career of Cleomenes of Naucratis," in *Macedonian Legacies: Studies in Ancient Macedonian History and Culture in Honor of Eugene N. Borza*, ed. Timothy Howe and Jean Reames (Claremont, CA: Regina Books, 2008), 187, and Daniel Ogden, "Alexander in Africa (332–331 BC and Beyond): The Facts, the Traditions and the Problems," in *Alexander in Africa*, ed. Philip Bosman (Pretoria: Classical Association of South Africa, 2014), 16–17.
93. Diodorus 18.14.1, who stresses the fairness of Ptolemy and his philanthropy toward the Egyptians when taking over these treasures, clearly in contrast to Cleomenes.
94. Le Rider, *Alexander the Great: Coinage, Finances, and Policy*, 233–38.
95. Le Rider, *Alexander the Great: Coinage, Finances, and Policy*, 233.
96. Le Rider, *Alexander the Great: Coinage, Finances, and Policy*, 237, citing Justin 13.1.9 for the money remaining at Alexander's death.
97. Le Rider, *Alexander the Great: Coinage, Finances, and Policy*, 234.
98. Susa: Diodorus 17.71.2; cf. Strabo 15.3.9.
99. Arrian 3.19.7; see also chapter 4.

100. Diodorus 17.71.2.
101. For example, Ernst Badian, "The Administration of the Empire," *Greece and Rome* 12 (1965): 180, states categorically, "The King, obviously, could not have his main treasure follow him through Bactria and India."
102. Le Rider, *Alexander the Great: Coinage, Finances, and Policy*, 204. Following a scenario sketched out by Paul Goukowsky, Le Rider argues (234) that Parmenion allegedly replaced Harpalus as custodian of the 180,000 talents at Ecbatana until Alexander had the old general assassinated. The treasure was then allegedly conveyed to Alexander in Arachosia.
103. Curtius 8.7.11.
104. Le Rider, *Alexander the Great: Coinage, Finances, and Policy*, 234.
105. Citing Curtius 6.11.3 at the time of Philotas's treason trial: Le Rider, *Alexander the Great: Coinage, Finances, and Policy*, 234. Le Rider mistranslates the Latin text, which mentions wagonloads of gold and silver rather than heavy chariots made of gold and silver.
106. Waldemar Heckel, *Who's Who in the Age of Alexander the Great*, 73, writes of Bolon: "He is, however, mentioned only by Curtius, who may have invented the individual and the sentiments expressed for dramatic effect."
107. Frank Holt, "Alexander the Great at Bactra: A Burning Question," *Electrum* 22 (2015): 9–15.
108. As acknowledged by Le Rider, *Alexander the Great: Coinage, Finances, and Policy*, 240–41.
109. Le Rider, *Alexander the Great: Coinage, Finances, and Policy*, 243–46, noting the discovery of only fifteen (!) darics east of the Tigris, most of them from the problematic Oxus Hoard.
110. Curtius 10.6.20–21; Justin 13.2.6–8; Arrian, *Successors* 1.2.
111. Curtius 10.6.23–24; cf. Justin 13.1.8: "The ranking officers set their sights on power, but the common soldiers eyed the treasury and its heaps of gold as suddenly available for plunder."
112. Curtius 10.9.11–21.
113. Arrian 7.8.1 and 7.12.1. See also Hammond, "An Unfulfilled Promise by Alexander the Great."
114. Arrian, *Successors* 32; Diodorus 18.39.3–4.
115. Diodorus 17.111.1.
116. Polyaenus 4.6.6.
117. Diodorus 18.37.1–2, 39.7, 40.1–47.3; Justin 13.8.10; Plutarch, *Eumenes* 8.7–8.
118. Diodorus 18.62.2; Strabo 14.5.10. Eager attempts to identify this ancient site with the impressive ruins atop Mount Karasis have been dashed: Timm Radt, "The Ruins on Mount Karasis in Cilicia," in *From Pella to Gandhara: Hybridisation and Identity in the Art and Architecture of*

NOTES

the Hellenistic East, ed. Anna Kouremenos, Sujatha Chandrasekaran, and Roberto Rossi (Oxford: Archaeopress, 2011), 49–64.

119. Diodorus 18.52.7 and Polyaenus 4.6.9, discussed in R. H. Simpson, "A Note on Cyinda," *Historia* 6 (1957): 503–4.
120. Diodorus 18.58.1; Plutarch, *Eumenes* 13. Eumenes was empowered to take these funds by King Philip III Arrhidaeus in Macedonia.
121. Plutarch, *Demetrius* 32.
122. J. D. Bing, "A Further Note on Cyinda/Kundi," *Historia* 22 (1973): 346–50.
123. Arrian 2.5.2–4.
124. Bing, "A Further Note on Cyinda/Kundi," 350.
125. Justin 13.4.5, discussed in Alexander Meeus, "Some Institutional Problems Concerning the Succession to Alexander the Great: *Prostasia* and Chiliarchy," *Historia* 58 (2009): 295.
126. Diodorus 19.56.5.
127. Quoted in Athenaeus 11.484c.
128. Roisman, *Alexander's Veterans and the Early Wars of the Successors,* provides a cogent account of these matters.
129. Ibid., 221–36.
130. Diodorus 19.46.5–48.8.
131. Diodorus 19.55.1.
132. Diodorus 19.55.1–9.

Chapter 7

1. Polybius 9.28.1–39.7.
2. On the Greek view of Alexander's legacy, see Andrew Erskine, "The View from the Old World: Contemporary Perspectives on Hellenistic Culture," in *Shifting Social Imaginaries in the Hellenistic Period,* ed. Eftychia Stavrianopoulou (Leiden: Brill, 2013), 339–63, and specifically for Polybius, Nikolaus Overtoom, "Six Polybian Themes Concerning Alexander the Great," *Classical World* 106 (2013): 571–93.
3. St. Augustine, *City of God* 4.4. For a Roman context to this tale, see Brian Harding, "The Use of Alexander the Great in Augustine's *City of God,*" *Augustinian Studies* 39 (2008): 113–28. For the similar notion that modern state building is merely organized crime on a larger scale, see Charles Tilly, "War Making and State Making as Organized Crime," in *Bringing the State Back In,* ed. Peter Evans, Dietrich Rueschemeyer, and Theda Skocpol (Cambridge: Cambridge University Press, 1985), 169–91.
4. The tale survives as a fragment of Cicero's *De Republica* 3.12. Cicero's source remains entirely conjectural, although Alexander did occasionally encounter captured pirates (Arrian 3.2.4–5; Curtius 4.5.19–21, 4.8.11 and 15) and a similar rebuke is recorded by Curtius 7.8.19. The possibility remains open,

of course, that Cicero was really chastising Pompey, hero of the Pirate War, in the guise of Pompey's hero Alexander.

5. Cicero hardly seems in a position to criticize Alexander. As governor of Cilicia, Cicero's above-board profits totaled more than three times the standard he set for a life of luxury: Moses Finley, *The Ancient Economy* (London: Chatto and Windus, 1975), 55. For some background on Cicero and plunder, see Margaret Miles, *Art as Plunder* (Cambridge: Cambridge University Press, 2008).

6. Seneca, *De Beneficiis* 7.2. On mankind's insatiability, see Aristotle, *Politics* 2.1267b.

7. Lucan, *Pharsalia* 10, lines 20–45. When Robin Lane Fox says of Alexander, "Nobody applied the old stereotype to him, that luxury caused a ruling power to go soft," he notably does not add "or corrupt." See Lane Fox, "The First Hellenistic Man," in *Creating a Hellenistic World*, ed. Andrew Erskine and Lloyd Llewellyn-Jones (Swansea: Classical Press of Wales, 2010), 7.

8. Plutarch, *Moralia* 330d.

9. For Seneca's attitude, see his *De Beneficiis* 7.3; cf. 2.16.

10. Plutarch, *Moralia* 342a; cf. 328e.

11. Plutarch, *Alexander* 37.4. Since the mules are mentioned in pairs, it is possible that they pulled heavy carts laden with booty.

12. Plutarch, *Moralia* 343b.

13. See also Orosius, *Seven Books of History against the Pagans* 3.18.10, who used Alexander's bloodlust to prove that pagan history was just as horrible as the Christian centuries that saw the sack of Rome by Goths and Vandals. For background, see David Ashurst, "Alexander the Great," in *Heroes and Anti-Heroes in Medieval Romance*, ed. Neil Cartlidge (Cambridge: DS Brewer, 2012), 31–32.

14. George Cary, *The Medieval Alexander* (Cambridge: Cambridge University Press, 1956), 95–98 and 156; Janet Spencer, "Princes, Pirates, and Pigs: Criminalizing Wars of Conquest in *Henry V*," *Shakespeare Quarterly* 47 (1996): 160–77.

15. *King Charls His Speech Made upon the Scaffold* (London: Peter Cole, 1649), 8.

16. Su Fang Ng, "Pirating Paradise: Alexander the Great, the Dutch East Indies, and Satanic Empire in *Paradise Lost*," *Milton Studies* 52 (2011): 59–91.

17. Translated and discussed in Ory Amitay, "Alexander in *Bavli Tamid*: In Search for a Meaning," in *The Alexander Romance in Persia and the East*, ed. Richard Stoneman (Groningen: Barkhuis Publishing, 2012), 349–65.

18. For what follows, see Cyrus Masroori, "Alexander in the City of the Excellent: A Persian Tradition of Utopia," *Utopian Studies* 24 (2013): 60–62.

19. Cary, *The Medieval Alexander*, 175–76. In Lucan's *Pharsalia*, 10, line 33, Alexander filled the rivers Euphrates and Ganges with Persian and Indian blood.

NOTES

20. Canto 12.107.
21. Petrarch, *De Viris Illustribus*; Wauquelin, *The Deeds and Conquests of Alexander the Great*, 86.
22. Machiavelli, *The Prince*, 16.
23. Chardin, *Voyages du Chevalier de Chardin en Perse et autres lieux de l'Orient*, vol. 2 (Amsterdam: La Compagnie, 1735), 184–86. For context, see Pierre Briant, *Darius in the Shadow of Alexander*, trans. Jane Marie Todd (Cambridge, MA: Harvard University Press, 2015), 363–70.
24. Clarke, *The Life and Death of Alexander the Great* (London: Wm. Miller, 1665), 61.
25. Abbé de Mabry, *Observations sur les Grecs* (Geneva: Compagnie des Libraires, 1749), 201. He added, "Ce germe de corruption se développa dans la prospérité. Mâitre de tout il voulut enfin jouir."
26. Gast, *The History of Greece, from the Accession of Alexander of Macedon, till Its Final Subjection to the Roman Power*, vol. I (London: J. Murray, 1782), 58–59.
27. I owe this interesting reference to the press's anonymous reader.
28. Abbott, *The History of Alexander the Great* (New York: Harper and Brothers, 1848), 208–9.
29. On the new orthodoxy of a crazed and cruel Alexander, see the debate of Ian Worthington, "How 'Great' Was Alexander?" *Ancient History Bulletin* 13 (1999): 39–55; Frank Holt, "Alexander the Great Today: In the Interests of Historical Accuracy?" *Ancient History Bulletin* 13 (1999): 111–17; Worthington, "Alexander and 'the Interests of Historical Accuracy': A Reply," *Ancient History Bulletin* 13 (1999): 136–40; and Holt, "The Death of Coenus: Another Study in Method," *Ancient History Bulletin* 14 (2000): 49–55.
30. Bosworth, *Alexander and the East: The Tragedy of Triumph* (Oxford: Oxford University Press, 1996), 30.
31. Hobbes, *Leviathan* 13.9.
32. On the background of this historiography, see Pierre Briant, "Alexander and the Persian Empire, between 'Decline' and 'Renovation,'" in *Alexander the Great: A New History*, ed. Waldemar Heckel and Lawrence Tritle (Malden, MA: Wiley-Blackwell, 2009), 171–88.
33. Rollin, *The Life of Alexander the Great, King of Macedon* (Providence, RI: B. Wheeler, 1796), 142. Rollin borrows the sentiments of Plutarch, *Moralia* 333b.
34. Droysen, *Geschichte des Hellenismus*, vol. 1 (1877; repr., Tübingen: Tübingen Wissenschaftliche Buchgemeinschaft, 1952), 436–38.
35. Duruy, *Histoire des Grecs*, vol. 3 (1889; repr., Graz: Akademische Druck, 1968), 314: "L'industrie vivement sollicité par les immenses richesses autrefois inactives et stériles dans les trésors royaux, maintenant jetés dans la circulation par la main prodigue du conquérant."

36. Arthur Curteis, *Rise of the Macedonian Empire* (New York: Scribners, 1916), 214. This same quotation appeared earlier in Curteis's introduction to Rev. John Williams, *The Life of Alexander the Great* (New York: A. L. Burt, 1902), ix.

37. Wilcken, *Alexander the Great* (1931; repr., New York: Norton, 1967), 255–56.

38. Rostovtzeff, *The Social and Economic History of the Hellenistic World*, vol. 1 (Oxford: Clarendon Press, 1941), 129–35. See also Keith Roberts, *The Origins of Business, Money, and Markets* (New York: Columbia University Press, 2011), 88.

39. Hammond, *Alexander the Great: King, Commander and Statesman* (Park Ridge, NJ: Noyes Press, 1980), 263.

40. Green, *Alexander to Actium: The Historical Evolution of the Hellenistic Age* (Berkeley: University of California Press, 1990), 366. He estimates the value as $285 billion in 1978 currency.

41. For examples: John Mahaffy, *Alexander's Empire* (London: T. Fisher Unwin, 1887), 27; Ulrich Wilcken, *Alexander the Great*, 284 and 291; Pierre Jouguet, *Macedonian Imperialism and the Hellenization of the East* (London: Kegan Paul, 1928), 173; Richard Billows, *Kings and Colonists: Aspects of Macedonian Imperialism* (Leiden: Brill, 1995), 215; and R. J. van der Spek, "The 'Silverization' of the Economy of the Achaemenid and Seleukid Empires and Early Modern China," in *The Economies of Hellenistic Societies, Third to First Centuries*, ed. Zofia Archibald, John Davies, and Vincent Gabrielsen (Oxford: Oxford University Press, 2011), 409–10.

42. Howgego, *Ancient History from Coins* (London: Routledge, 1995), 50.

43. Keynes, *A Treatise on Money*, vol. 2 (New York: Harcourt, Brace and Company, 1930), 152 and 291.

44. Ibid., 150–51.

45. Michael Meyer, *The Alexander Complex: The Dreams that Drive the Great Businessmen* (New York: Times, 1989), 4. For a similar encomium on Alexander's father, King Philip II, see chapter 3.

46. Steve Forbes and John Prevas, *Power Ambition Glory: The Stunning Parallels between Great Leaders of the Ancient World and Today . . . and What Lessons You Can Learn* (New York: Three Rivers Press, 2009), 101.

47. Guillaume Emmanuel Joseph de Sainte-Croix, *Examen critique des anciens historiens d'Alexandre le Grand*, 2nd ed. (Paris: Delance et Lesueur, 1804), 415.

48. In a way, these modern advice books about how to succeed like Alexander rely on a form of ancient and medieval historiography wherein anecdotal exempla are taken out of context to illustrate some life lesson for a prince or CEO.

49. Michel Austin, "Alexander and the Macedonian Invasion of Asia: Aspects of the Historiography of War and Empire in Antiquity," in *War and Society in*

the Greek World, ed. John Rich and Graham Shipley (New York: Routledge, 1993), 219.

50. Partha Bose, *Alexander the Great's Art of Strategy: The Timeless Leadership Lessons of History's Greatest Empire Builder* (New York: Gotham Books, 2003).

51. There is, however, the opposing viewpoint that a sense of corporate moral responsibility has no practical application even in cases such as Enron, "the poster child for corporate corruption": John Hasnas, "Reflections on Corporate Moral Responsibility and the Problem Solving Technique of Alexander the Great," *Journal of Business Ethics* 107 (2012): 183–95. Unobserved by the author is the deeper irony that the technique he advocates (Alexander's cutting of the Gordian Knot) was, even in antiquity, considered cheating.

52. *Iliad* 6.119–236. See chapter 2.

53. For excellent background surveys, see Michele Faraguna, "Aspetti amministrativi e finanziari della monarchia macedone fra IV e III secolo a.C.," *Athenaeum* 86 (1998): 349–95, and Paul Millett, "The Political Economy of Macedonia," in *A Companion to Ancient Macedonia*, ed. Joseph Roisman and Ian Worthington (Malden, MA: Wiley-Blackwell, 2010), 472–504.

54. Aeneas Tacticus also wrote a treatise available in Alexander's day about financing wars: *Siegecraft* 14.2.

55. Aristotle, *Economics* 1345b.

56. Alain Bresson, "Coinage and Money Supply in the Hellenistic Age," in *Making, Moving and Managing: The New World of Ancient Economies, 323–31 BC*, ed. Zofia Archibald, John Davies, and Vincent Gabrielsen (Oxford: Oxbow Books, 2005), 44–72.

57. Diodorus 17.2.2; cf. Justin 11.1.8.

58. Some have theorized that Alexander was obligated by formal agreements to pay Philip's debts in Philip's coins, thus delaying the institution of a new royal currency: Martin J. Price, "Alexander's Reform of the Macedonian Regal Coinage," *Numismatic Chronicle* (1982): 180–90, disputed by Thomas R. Martin, *Sovereignty and Coinage in Classical Greece* (Princeton, NJ: Princeton University Press, 1985), 292, note 63. Delaying an Attic weight silver coinage would also allow Alexander to service Philip's contracts using lighter coins.

59. Diodorus 16.8.7.

60. Because of the king with his bow commonly stamped on darics, Agesilaus once remarked that he was being driven from Asia by 10,000 archers, a quaint correlation of money with military power: Plutarch, *Artaxerxes* 15.6.

61. The standard treatments of Philip's coinages are Georges Le Rider, *Le Monnayage d'argent et d'or de Philippe II* (Paris: Bourgey, 1977), and his follow-up *Monnayage et finances de Philippe II: Un état de la question* (Paris: Diffusion de Boccard, 1996).

62. Plutarch, *Alexander* 3.8 and 4.9; cf. *Moralia* 105a.

63. Plutarch, *Alexander* 4.8–9.4.

64. On Philip's delayed mintage, see Le Rider, *Alexander the Great: Coinage, Finances, and Policy*, trans. W. E. Higgins (Philadelphia: American Philosophical Society, 2007), 89–90. A small, enigmatic series of "Eagle" coins bearing Alexander's name but struck on the Thraco-Macedonian standard may have been issued early in Alexander's reign; this remains uncertain: Le Rider, *Monnayage et finances*, 91–94.

65. There is some epigraphic and literary evidence to suggest that Philips were still the currency early in Alexander's reign: François de Callataÿ, "La Date des premiers tétradrachmes de poids attique émis par Alexandre le Grand," *Revue Belge de Numismatique et de Sigillographie* 128 (1982): 22.

66. It is generally doubted that Alexander put the royal title on his coinage: Emiliano Arena, "L'Introduzione della leggenda ΒΑΣΙΛΕΩΣ ΑΛΕΞΑΝΔΡΟΥ nella monetazione di Alessandro Magno," *Revue Belge de Numismatique et de Sigillographie* 157 (2011): 135–70.

67. Esprit Marie Cousinéry, *Voyage dans la Macédoine* (Paris: Imprimerie Royale, 1831), 230–31.

68. Giants have stood on both sides of the issue. Those inclined to date Alexander's imperial coinage from his accession include Edward Newell, *Reattribution of Certain Tetradrachms of Alexander the Great* (New York: American Numismatic Society, 1912); Alfred Bellinger, *Essays on the Coinage of Alexander the Great* (New York: American Numismatic Society, 1963), 7–12; and Martin J. Price, *The Coinage in the Name of Alexander the Great and Philip Arrhidaeus*, vol. 1 (London: British Museum, 1991), 27–29. Those who favor a lower date of circa 333 BC include Gerhard Kleiner, Orestes Zervos, François de Callataÿ, Carmen Arnold-Biucchi, Hyla Troxell, and Georges Le Rider. For an overview of the problem with citations to the literature, see the excellent treatment by Le Rider, *Alexander the Great: Coinage, Finances, and Policy*, 8–14 and 38–43.

69. For the appearance of Iranian royal iconography on Alexander's coins, see Marek Jan Olbrycht, " 'An Admirer of Persian Ways,' " 43–44.

70. Le Rider, *Alexander the Great: Coinage, Finances, and Policy*, 152–59.

71. Margaret Thompson, "The Coinage of Philip II and Alexander III," in *Macedonia and Greece in Late Classical and Early Hellenistic Times*, ed. Beryl Barr-Sharrar and Eugene Borza (Washington, DC: National Gallery of Art, 1982), 113–14. For a slightly different list of mints, and studies of each one, consult Price, *The Coinage in the Name of Alexander the Great and Philip Arrhidaeus*. For possibly relocating the Ake mint to Tyre, see Andre Lemaire, "Le monnayage de Tyr et celui dit d'Akko dans la deuxième moité du IVe siècle avant J.-C.," *Revue Numismatique* 18 (1976): 11–24. For a possible early mintage at Pergamon, see François de Callataÿ, "Les statères de

Pergame et les réquisitions d'Alexandre le Grand," *Revue Numismatique* 169 (2012): 179–96.

72. The output at Alexandria (and possibly at Memphis, too) was small: Sitta von Reden, *Money in Ptolemaic Egypt* (Cambridge: Cambridge University Press, 2007), 33.

73. A traveling mint may have been responsible for the production of special medallions: Frank Holt, *Alexander the Great and the Mystery of the Elephant Medallions* (Berkeley: University of California Press, 2003).

74. It is interesting to note that Harpalus was not in office when these changes were made, nor when Alexander opened many new mints at the end of his reign.

75. The pioneering work on these coinages was done by Edward Newell, *The Dated Alexander Coinage of Sidon and Ake* (New Haven, CT: Yale University Press, 1916).

76. Le Rider, *Alexander the Great: Coinage, Finances, and Policy*, 85–105 and 109–110, who sees Alexander adhering to Achaemenid precedents.

77. Le Rider, *Alexander the Great: Coinage, Finances, and Policy*, 255–56; see also 60–72 and Margaret Thompson, "Paying the Mercenaries," in *Studies in Honor of Leo Mildenberg*, ed. Arthur Houghton et al. (Wetteren: NR Editions, 1984), 241–47, based largely on mint studies. See Thompson, *Alexander's Drachm Mints I: Sardes and Miletus* (New York: ANS, 1983), and *Alexander's Drachm Mints II: Lampsacus and Abydus* (New York: ANS, 1991). For the view that Alexander intended a universal currency from the outset, see Sophia Kremydi-Sicilianou, "The Financing of Alexander's Asian Campaign," *Nomismatika Chronika* 18 (1999): 61–68.

78. Michael Alram, "The Coinage of the Persian Empire," in *The Oxford Handbook of Greek and Roman Coinage*, ed. Willaim Metcalf (Oxford: Oxford University Press, 2012), 80. It is common to overstate the universality of Alexander's coinage: Andrew Meadows, "The Spread of Coins in the Hellenistic World," 174.

79. Strabo 15.3.21 points out that the Persian kings mainly used coinage in their western satrapies and minted it as needed.

80. Pierre Briant, *From Cyrus to Alexander: A History of the Persian Empire* (Winona Lake, IN: Eisenbrauns, 2002), 800–809.

81. On the survival of Alexander's coinage, see appendix 4.

82. François de Callataÿ, "Quantifying Monetary Production in Greco-Roman Times: A General Frame," *Pragmateiai* 19 (2011): 7–29. For the skeptical side of this debate, see T. V. Buttrey, "Calculating Ancient Coin Production: Facts and Fantasies," *Numismatic Chronicle* 153 (1993): 335–51, and "Calculating Ancient Coin Production II: Why It Cannot Be Done," *Numismatic Chronicle* 154 (1994): 341–52.

83. Because obverse and reverse dies wear out at different rates in the hammering process, the former (which must be replaced less frequently than the latter) are selected for these calculations.
84. de Callataÿ, "Quantifying Monetary Production in Greco-Roman Times," 9.
85. François de Callataÿ, "Les trésors achéménides et les monnayages d'Alexandre: Espèces immobilisées et espèces circulantes?" *Revue des Études Anciennes* 91 (1989): 259–74.
86. Ibid., 272, and for Price's comment, 274.
87. de Callataÿ, "Quantifying Monetary Production in Greco-Roman Times," 23.
88. Ibid.
89. de Callataÿ, "Royal Hellenistic Coinages: From Alexander to Mithradates," in *The Oxford Handbook of Greek and Roman Coinage*, ed. William Metcalf (Oxford: Oxford University Press, 2012), 179.
90. Ibid., 178. It must be noted that the assumption that Achaemenid Persia immobilized much of its revenues is not universal, and some experts put the hoarding of its annual tribute at no more than 5%: Matthew Stolper, *Entrepreneurs and Empire: The Murasu Archive, the Murasu Firm, and Persian Rule in Babylonia* (Leiden: Nederlands Instituut voor het Nabije Oosten, 1985), 143–46.
91. de Callataÿ, "Royal Hellenistic Coinages: From Alexander to Mithradates," 179. His estimate is based on the value of the coins.
92. Using de Callataÿ's suggested formula of 20,000 coins per obverse die.
93. Based on estimates compiled by the US Census Bureau, which put the figure in 400 BC at 162 million and in 200 BC at 150 million to 231 million: https://www.census.gov/population/international/data/worldpop/table_history.php.
94. Alexander sent a relatively small portion of the Persian bullion to Macedonia: Curtius 3.1.20 and Diodorus 18.12.2.
95. de Callataÿ, "Quantifying Monetary Production in Greco-Roman Times," 22.
96. Diodorus 19.46.6, for instance, mentions 5,000 talents of uncoined silver still at Ecbatana in 316 BC.
97. Diodorus 17.54.1–5; Curtius 4.11.1–22; Plutarch, *Alexander* 29.7–8; Justin 11.12.9–15. Too much weight cannot be put on the conventionalized figure of 30,000 talents, but a huge ransom is likely.
98. Beyond the lucrative sharing of power and the likelihood in 331 BC of Alexander outliving Darius, the Macedonian's assets would have exceeded 80,000 talents and his military expenditures would have been significantly less.
99. Sungmin Hong, Jean-Pierre Candelone, Clair Patterson, and Claude Boutron, "Greenland Ice Evidence of Hemispheric Lead Pollution

NOTES

Two Millennia Ago by Greek and Roman Civilizations," *Science* 265 (1994): 1841–43.

100. de Callataÿ, "The Graeco-Roman Economy in the Super Long-Run: Lead, Copper, and Shipwrecks," *Journal of Roman Archaeology* 18 (2005): 365.

101. Based on the calculation of one drachma for three days' expenses, derived from Alfred Bellinger, *Essays on the Coinage of Alexander the Great* (New York: American Numismatic Society, 1963), 30. For the Egyptian hoard, see Margaret Thompson, Otto Mørkholm, and Colin Kraay, eds., *An Inventory of Greek Coin Hoards* [hereafter simply *IGCH*] (New York: American Numismatic Society, 1973), no. 1664, along with Orestes Zervos, "Additions to the Demanhur Hoard of Alexander Tetradrachms," *Numismatic Chronicle* 140 (1980): 185–88.

102. Xenophon, *Ways and Means* 4.7. For examples of currency that soldiers did not put into circulation, see François de Callataÿ, "Armies Poorly Paid (the Anabasis of the Ten-Thousands) and Coins for Soldiers Poorly Transformed by the Markets (the Hellenistic Thasian-Type Tetradrachms) in Ancient Greece," *Revue Belge de Numismatique et de Sigillographie* 155 (2009): 51–70.

103. Figures calculated from *IGCH* and the nine supplemental volumes of *Coin Hoards* published thus far. The next three kings are Alexander's general Lysimachus (236), Alexander's father Philip II (221), and Alexander's successor Philip III (175).

104. Davies, "Cultural, Social and Economic Features of the Hellenistic World," in *The Cambridge Ancient History*, 2nd ed., vol. 7, part 1: *The Hellenistic World*, ed. Frank Walbank et al. (Cambridge: Cambridge University Press, 1984), 277.

105. On this, see the full discussion in Frank Holt, "Alexander the Great and the Spoils of War," *Ancient Macedonia* 6 (1999): 499–506.

106. *Pace* David MacDowall, "Der Einfluss Alexanders des Grossen auf das Münzwesen Afghanistans und Nordwest-Indiens," in *Aus dem Osten des Alexanderreiches*, ed. Jakob Ozols and Volker Thewalt (Cologne: Du Mont, 1984), 66–73.

107. Based on the informative study by Frédérique Duyrat, "La circulation monétaire dans l'Orient séleucide (Syrie, Phénicie, Mésopotamie, Iran)," *Topoi* 6 (2004): 381–424.

108. Compare *IGCH* nos. 1820 and 1830 (before Alexander) to nos. 1831 and 1832 (after Alexander down to about 200 BC), and Frank Holt, "Alexander the Great and the Spoils of War," 505–506. The old view of rapid monetization remains potent in spite of the evidence: see Robin Waterfield, *Dividing the Spoils: The War for Alexander the Great's Empire* (Oxford: Oxford University Press, 2011), 166, 169, and 198.

NOTES

109. Frank Holt, *Thundering Zeus: The Making of Hellenistic Bactria* (Berkeley: University of California Press, 1999), 29–37. Only three of all *IGCH* hoards known from Bactria, Sogdiana, Paropamisadae, and India have yielded coins minted in Alexander's name, yielding but about 200 altogether, almost all from the Oxus Treasure (*IGCH* 1822).

110. Updated figures derived from Hyla Troxell, *Studies in the Macedonian Coinage of Alexander the Great* (New York: American Numismatic Society, 1997), 75.

111. Price, *The Coinage in the Name of Alexander the Great and Philip Arrhidaeus* (London: British Museum, 1991). Sophia Kremydi-Sicilianou, "The Financing of Alexander's Asian Campaign," *Nomismatika Chronika* 18 (1999): 65, argues that hoards from Amphipolis and Babylon produced half of all Alexander's coins.

112. For hoarding as part of a balanced economy, see Véronique Chankowski, "Richesse et patrimoine dans les cités grecques: De la thésaurisation à la croissance," in *Richesse et Sociétés*, ed. Catherine Baroin and Cécile Michel (Paris: de Boccard, 2013), 163–72.

113. Matthew 25:14–30; Luke 19:12–27.

114. Lindsay Adams, "In the Wake of Alexander the Great: The Impact of Conquest on the Aegean World," *Ancient World* 27 (1996): 34–35.

115. Robbers overlooked a few valuable coins in the two finely painted Macedonian tombs of the late fourth century BC at Phinikas and Ayios Athanasios: Maria Tsimbidou-Avloniti, Μακεδονικοί τάφοι στον Φοίνικα και στον Άγιο Αθανάσιο (Athens: TAPA, 2005).

116. Except, of course, for the tomb structures themselves, which reveal patterns of wealth even when looted. There was an "upsurge of monumental building activity" in the late fourth century BC: Janos Fedak, *Monumental Tombs of the Hellenistic Age: A Study of Selected Tombs from the Pre-Classical to the Early Imperial Era* (Toronto: University of Toronto Press, 1990), 98.

117. On silver in the Hellenistic economy, see the informative study of Katerina Panagopoulou, "Between Necessity and Extravagance: Silver as a Commodity in the Hellenistic Period," *Annual of the British School at Athens* 102 (2007): 315–43.

118. For examples: Athena Tsingarida and Didier Viviers, eds., *Pottery Markets in the Ancient Greek World* (Brussels: CReA-Patrimoine, 2013); Ian Morris, "Archaeology, Standards of Living, and Greek Economic History," in *The Ancient Economy: Evidence and Models*, ed. J. G. Manning and Ian Morris (Stanford: Stanford University Press, 2005), 91–126; Geoffrey Kron, "Comparative Evidence and the Reconstruction of the Ancient Economy: Greco-Roman Housing and the Level and Distribution of

Wealth and Income," in *Quantifying the Greco-Roman Economy and Beyond*, ed. François de Callataÿ (Bari: Edipuglia, 2014), 123–46; G. Kron, "Anthropometry, Physical Anthropology, and the Reconstruction of Ancient Health, Nutrition, and Living Standards," *Historia* 54 (2005): 68–83.

119. On the data's limitations, see Morris, "Archaeology, Standards of Living, and Greek Economic History," 110–25.

120. For data and discussion, see R. J. van der Spek, "Palace, Temple and Market in Seleucid Babylonia," in *Le roi et l'économie*, ed. Véronique Chankowski and Frédérique Duyrat (Paris: de Boccard, 2004), 303–332.

121. R. J. van der Spek, B. van Leeuwen, and J. L. van Zanden, eds., *A History of Market Performance from Ancient Babylonia to the Modern World* (New York: Routledge, 2015), 8. Curtius 10.8.11–12 describes the onset of another famine in 323 BC, caused by the cavalry's confiscation of grain.

122. van der Spek, "Palace, Temple and Market in Seleucid Babylonia," 311–13, and even more forcefully in "How to Measure Prosperity? The Case of Hellenistic Babylonia," in *Approches de l'economie hellénistique*, ed. Raymond Descat (Paris: de Boccard, 2006), 287–310.

123. Aperghis, *The Seleukid Royal Economy: The Finances and Financial Administration of the Seleucid Empire* (Cambridge: Cambridge University Press, 2004), 79–85.

124. Miltiades Hatzopoulos, *Actes de vent d'Amphipolis* (Athens: de Boccard, 1991), 84–85.

125. Suetonius, *Augustus* 41.1–2.

126. Andrew Meadows, "The Spread of Coins in the Hellenistic World," in *Explaining Monetary and Financial Innovation: A Historical Analysis*, ed. Peter Bernholz and Roland Vaubel (New York: Springer International Publishing, 2014), 180–81.

127. For an interesting summary of war's economic impact on the Hellenistic world, see Angelos Chaniotis, *War in the Hellenistic World* (Oxford: Blackwell, 2005), 115–42.

128. Sinopoli, "The Archaeology of Empires," *Annual Review of Anthropology* 23 (1994): 163.

129. This must include Macedonia itself, according to a particularly grim assessment by A. B. Bosworth, "Alexander the Great and the Decline of Macedon," *Journal of Hellenic Studies* 106 (1986): 1–12, an argument reiterated in the face of some efforts to downplay the damage: Bosworth, *The Legacy of Alexander: Politics, Warfare, and Propaganda under the Successors* (Oxford: Oxford University Press, 2002), 64–97.

130. For example, India scarcely remained in Macedonian hands long enough to follow Gorgus's advice to improve the mining of gold and silver there: Strabo 15.1.30.

Appendix 1

1. Diodorus 16.56.6.
2. Diodorus 17.71.1.
3. Diodorus 17.66.1–2.
4. For example, 1:10 (Milns) or 1:12 (Berve). On Cyprus, the exchange rate was 1:13.33 before 333/332 BC and 1:10 thereafter: Evangeline Markou, "Gold and Silver Weight Standards in Fourth-Century Cyprus: A Resume," in *Proceedings of the XIVth International Numismatic Congress*, ed. Nicholas Holmes (Glasgow: International Numismatic Council, 2011), 282.
5. As cited by Strabo 15.3.21.

Appendix 2

1. See chapter 2 for sources and discussion of the amounts in this category.
2. Justin 11.3.2.
3. Arrian 1.1.13–1.2.1.
4. Arrian 1.4.5 and 1.2.7.
5. Arrian 1.6.10.
6. Arrian 1.7–10 and 2.15.3; Diodorus 17.8–14; Plutarch, *Alexander* 11–12; Justin 11.3.6–4.8; Polybius 38.2.13–14 and 5.10.6–8; Athenaeus, *Deipnosophistae* 148e; Aelian, *Varia Historia* 13.7.
7. Diodorus 17.7.8–9.
8. Arrian 1.12.1, from Menoetius.
9. Arrian 1.13–16; Diodorus 17.19–21; Plutarch, *Alexander* 16; Justin 11.6; *Codex Sabbaiticum* 29. Years later, Alexander freed the Athenian prisoners: Arrian 3.6.2; Curtius 3.1.9 and 4.8.12.
10. Arrian 1.17.3–8; Diodorus 17.21.7; cf. Curtius 3.12.6; Plutarch, *Alexander* 17.1.
11. Arrian 1.19.6; Diodorus 17.22.5.
12. Foods and delicacies provided daily by Queen Ada: Plutarch, *Alexander* 22.7–8 and *Moralia* 127b, 180a, 1099c.
13. Arrian 1.24.5, given by envoys from Phaselis.
14. Curtius 3.1.20.
15. Arrian 1.26.3 (50 talents toward the army's wages) and 27.4 (amount raised to 100 talents).
16. Arrian 2.5.5 (200 talents) and 2.12.2 (50 talents remitted); Curtius 3.7.2 (200 talents).
17. Arrian 2.11.9–10; Plutarch, *Alexander* 20.11; Curtius 3.8.12 and 3.11.20–21; Diodorus 17.32.3 and 35.1–36.5; *Papyrus Oxyrhynchus* 1798, fragment 44.
18. Plutarch, *Alexander* 24.1–2; Arrian 2.15.1; Curtius 3.13.1–17; Athenaeus 13.607f.

NOTES

19. Arrian 2.13.8, given by Straton.
20. Arrian 2.24.4–5 reports 30,000 captives; Diodorus 17.46.3–4 lists 13,000 prisoners sold; Curtius 4.4.16–17 agrees with Diodorus.
21. Arrian 2.27.7; Curtius 4.6.30.
22. Curtius 4.7.4.
23. Diodorus 17.49.2; Curtius 4.7.9.
24. Arrian 3.4.3, from the priests of Ammon.
25. Diodorus 17.48.6 and Curtius 4.5.11 mention one crown sent by the Corinthian League; the second is attested from Athens in IG^2 1496.
26. Arrian 3.15.4 and 6, including elephants and camels.
27. Arrian 3.15.5; Diodorus 17.64.3; Curtius 5.1.10, cf. 4.9.9.
28. Diodorus 17.64.3; Curtius 5.1.17–23; Arrian 3.16.3.
29. Diodorus 17.66.1–2; Curtius 5.2.11–15; Plutarch, *Alexander* 36; Arrian 3.16.7; Justin 11.14.9.
30. Diodorus 17.70; Curtius 5.6.4–8; Plutarch, *Alexander* 37.3.
31. Arrian 3.18.10–12; Diodorus 17.71–72; Curtius 5.6.9 and 5.7.1–11; Plutarch, Alexander 37.5–38.8; Strabo 15.3.6 and 9; Justin 11.14.10; Athenaeus 13.576d; *Itenerarium Alexandri* 67.
32. Curtius 5.6.10; Arrian 3.18.10.
33. Arrian 3.17, including an annual tribute of 30,600 animals; Diodorus 17.67; Curtius 5.3.
34. Curtius 6.1.20.
35. Curtius 6.2.10; Diodorus 17.74.5; Polybius 10.27.11; Aelian, *Varia Historia* 7.8.
36. Diodorus 17.76.5–8; Curtius 6.5.18–21.
37. Arrian 3.25.7.
38. Curtius 6.5.22–23.
39. Curtius 7.5.28–35; Plutarch, *Moralia* 557b; Ammianus Marcellinus 29.1.31; Strabo 11.11.4.
40. Arrian 3.30.6.
41. Arrian 4.2.1–4.3.5; Curtius 7.6.10 and 7.6.16–23.
42. Arrian 4.15.2.
43. Arrian 4.6.5–7; Curtius 7.9.22.
44. Curtius 7.11.28–29.
45. Curtius 8.4.19.
46. Arrian 4.25.4.
47. Arrian 4.27.9.
48. Arrian 4.22.6 and 5.3.5 (nearly 200 talents of silver, 3,000 oxen for sacrificing, more than 10,000 cattle, 30 elephants); Curtius 8.12.11 (many sheep, about 3,000 bulls, 56 elephants); Diodorus 17.86.4–7; Plutarch, *Alexander* 59.1–5; *Metz Epitome* 52.
49. Arrian 5.8.3, from Indian rajas such as Abisares and Doxareus.
50. Arrian 5.15.2 and 18.2, captured in battle.

51. Arrian 5.20.5 and 5.29.4.
52. Arrian 5.21.2 and 5.24.4, requisitioned by Alexander to attack Sangala.
53. Arrian 5.24.5, enumerating 17,000 Indians killed, over 70,000 captured, and the confiscation of 300 wagons with 500 horses.
54. Diodorus 17.94.3–5.
55. Diodorus 17.96.3.
56. Diodorus 17.92.1; Curtius 9.1.27–30.
57. Diodorus 17.93.1.
58. Diodorus 17.96.2.
59. Curtius 9.4.5.
60. Diodorus 17.102.4.
61. Curtius 9.8.13; Diodorus 17.102.5.
62. Curtius 9.8.1–2; Arrian 6.14.1.
63. Curtius 9.4.25; Arrian 6.7.3.
64. Arrian 6.15.6.
65. Arrian 6.16.2.
66. Curtius 9.8.15; Arrian 6.16.4.
67. Arrian 6.17.1.
68. Diodorus 17.104.4–7; Curtius 9.10.7; Strabo 15.2.4–8; Arrian 6.21.4–5.
69. Curtius 9.8.28–29.
70. Curtius 10.1.22–38, who lists as gifts to Alexander and the *hetairoi* tamed horses, fancy chariots, furniture, jewels, heavy gold vases, purple clothing, and 3,000 talents of coined silver. Because the eunuch Bagoas was slighted by Orxines, the former accused the latter of looting these valuables from the tomb of Cyrus.
71. Athenaeus 12.539a: crowns bestowed by ambassadors during the wedding feasts.
72. Arrian 7.13.1, following the theft of most of the herd.
73. Athenaeus 12.538b: Gorgus the armorer proclaimed this gift to Alexander of 3,000 gold coins, plus the armor and siege equipment needed to capture Athens.
74. Arrian 7.23.2; Diodorus 17.113.1.
75. Demanded in a letter from Alexander to Chios and other Ionian cities, according to Phylarchus: Athenaeus 12.539f–540a.
76. Herodotus 3.89–98, converting different weight standards and not including unspecified values for spices, horses, or grain.
77. One could add the tribute of 30,600 animals/year imposed on the Uxians: Arrian 3.17.6.
78. One could add references to tribute imposed by Alexander on various tribes and towns in India: Arrian 5.29.5 and 6.14.2; Curtius 9.1.14 and 9.7.14.
79. On the "invisibility" of plunder, see Paul Millett, "The Political Economy of Macedonia," in *A Companion to Ancient Macedonia*, ed. Joseph Roisman and Ian Worthington (Malden, MA: Wiley-Blackwell, 2010), 490.

80. If, for the sake of argument, the average number of slaves per reported incident is taken to be 15,000, then 24(X) would equal 360,000 persons. If we further guess that these are the major incidents, but that a similar number of less notable cases occurred, we might add, say, 24(1,000) for an estimate of 384,000 mostly women and children enslaved. This is likely to be too low rather than too high.

81. Le Rider, *Alexander the Great: Coinage, Finances, and Policy* (Philadelphia: American Philosophical Society, 2007), 80.

82. Berve, *Das Alexanderreich auf prosopographischer Grundlage*, vol. 1 (1926; repr., Salem: Ayer, 1988), 312, note 1, citing also Beloch.

Appendix 3

1. Arrian 7.9.6; Curtius 10.2.24; Plutarch, *Alexander* 15.2 and *Moralia* 327e, 342d. See discussion in chapter 2.

2. Arrian 7.9.6.

3. Arrian 1.4.5.

4. Arrian 1.5.4.

5. Diodorus 17.16.3–4 ("for nine days with great magnificence"); Arrian 1.11.1.

6. Plutarch, *Alexander* 15 and *Moralia* 342d; Justin 11.5.5.

7. Malalas, *Chronographia* 8.1. This report from a sixth-century source erroneously alleges that Alexander crossed the Bosporus at modern Scutari and named the site "City of Gold" in honor of his benefaction. This may be a confused version of the previous entry recorded in Plutarch and Justin, the latter placing the incident after the king's first sight of Asia. I thank Professor Benjamin Garstad for this reference.

8. Arrian 1.11.5–7.

9. Strabo 13.1.26; Arrian 1.11.8.

10. Arrian 1.16.4–7; Plutarch, *Alexander* 16.15–16; Justin 11.6.12–13. For the estimated cost of 65 to 69.5 talents, see chapter 4.

11. Plutarch, *Alexander* 16.17–18; Arrian 1.16.7.

12. Plutarch, *Alexander* 16.19 (drinking vessels, purple clothing, etc.); *Codex Sabbaiticum* 29.

13. Arrian 1.16.5; Justin 11.6.13.

14. Arrian 1.17.5–6.

15. Arrian 1.18.2, with a few cities excepted.

16. A. J. Heisserer, *Alexander the Great and the Greeks: The Epigraphic Evidence* (Norman: University of Oklahoma Press, 1980), 143–66. The promise of payment was probably made in 334 BC, and the dedication inscribed some years later in the reign.

17. Arrian 1.17.10 and 18.2, along with a military procession.
18. Curtius 3.1.1; cf. 4.3.11 and Arrian 2.20.5.
19. Curtius 3.1.20.
20. Curtius 3.1.20.
21. Arrian 2.3.8.
22. Diodorus 17.31.6 ("magnificent gifts").
23. Arrian 2.5.8 and 2.6.4; Curtius 3.7.3–4.
24. Arrian 2.5.9, to Athena.
25. Arrian 2.5.9. The religious offerings honored the hero Amphilochus, who allegedly fought at Troy and founded Mallus: Strabo 14.5.16.
26. Prayers to the Nerieds, Nereus, and Poseidon, for whom a quadriga was cast into the sea: Papyrus Oxyrhynchus 1798, fragment 11.
27. Arrian 2.12.1; Diodorus 17.40.1. On the other hand, Curtius 3.12.14 calls the burials inexpensive cremations.
28. Plutarch, Alexander 21.4; Diodorus 17.38.1–2; Curtius 3.12.13–15 and 23; cf. Arrian 2.12.3–8.
29. Curtius 4.1.26.
30. Diodorus 17.54.7; Curtius 4.10.23 and 12.2; Plutarch, Alexander 30.1 and Moralia 338e; Justin 11.12.6. Dated by some to 331 BC, but she probably died in spring 332.
31. Arrian 2.18.4, 2.20.4, and 2.21.1.
32. Diodorus 17.46.6; Arrian 2.24.6. The dedications included a ship and siege engine.
33. Athenaeus 4.167d, from Duris.
34. Arrian 2.26.4.
35. Plutarch, Alexander 25.6–8 and SIG³ 1.252N.5ff.
36. Ibid. and Moralia 179e–f (frankincense and cassia); Pliny, Natural History 12.62. Shipped to Alexander's austere tutor, the frankincense weighed 500 talents (14.2 tons) and the myrrh 100 talents (2.8 tons).
37. Arrian 3.1.4.
38. Arrian 3.1.5.
39. Diodorus 17.52.1–7; Curtius 4.8.1–3; Arrian 3.1.5–2.2; Codex Sabbaiticum 29.
40. Arrian 3.1.5, including Isis.
41. Dieter Arnold, Temples of the Last Pharaohs (Oxford: Oxford University Press, 1999), 138.
42. Francisco Bosch-Puche, "L' 'Autel' du temple d'Alexandre le Grand à Bahariya retrouvé," Bulletin de l'Institut Français d'Archéologie Orientale 108 (2008): 29–44.
43. Diodorus 17.51.4; Curtius 4.7.28; Plutarch, Alexander 27.7.
44. Arrian 3.5.2.
45. Arrian 3.6.1.
46. Curtius 4.8.9, honoring a son of Parmenion who drowned in the Nile.

47. Curtius 4.8.13; cf. Arrian 2.1.5.
48. Arrian 3.6.2; Curtius 3.1.9 and 4.8.12. The king took no ransom, although he accepted two gold crowns (see appendix 2).
49. Plutarch, *Alexander* 29.1–4; Arrian 3.6.1; Curtius 4.8.16, mentioning gold offerings.
50. Plutarch, *Alexander* 29.5. Athenodorus was fined by Athens for breaking his promise to compete in the Dionysia in order to participate in Alexander's games at Tyre.
51. Plutarch, *Alexander* 29.6 and *Moralia* 334e. This and the previous incident may have occurred at Susa in 324 BC, where they also performed: Athenaeus 12.538e–f and 539a.
52. Plutarch, *Alexander* 31.1–5, citing Eratosthenes.
53. Arrian 3.7.1–2.
54. Arrian 3.7.6, to the Sun, Moon, and Earth.
55. Curtius 4.9.25; Plutarch, *Alexander* 39.2. The trophy head belonged to Satropates.
56. Plutarch, *Alexander* 34.1 ("wealth, estates, and provinces").
57. Plutarch, *Alexander* 34.2. This gesture repaid Plataea for its role in the Persian War some 150 years earlier.
58. Plutarch, *Alexander* 34.3, honoring a citizen-athlete who had fought in the Persian War. This gift may have been made earlier, after Granicus: Truesdell Brown, "Alexander and Greek Athletics, in Fact and Fiction," in *Greece and the Eastern Mediterranean in Ancient History and Prehistory*, ed. K. H. Kinzl (New York: Walter de Gruyter, 1977), 78–80.
59. Arrian 3.16.4–5 (see also 323 BC).
60. Diodorus 17.64.6; Curtius 5.1.45. See discussion in chapter 4.
61. Arrian 3.16.9.
62. Arrian 3.16.7–8, mentioning the famous statues of the tyrant slayers plundered by Xerxes.
63. Arrian 3.16.9–10; Diodorus 17.64.5; Curtius 5.1.43. The latter authors put this at Babylon.
64. Arrian 3.18.6 and 10.
65. Curtius 5.5.5–24; Diodorus 17.69.2–9; Justin 11.14.11–12. These 800 victims of Persian atrocities were each given 3,000 drachmas, a set of robes, 2 oxen, 50 sheep, grain, and exemptions from royal taxes.
66. Curtius 5.6.20; Diodorus 17.72.1.
67. Curtius 5.7.12; Diodorus 17.68.6.
68. Plutarch, *Alexander* 39.3. The man allegedly carried a mule's load of gold, upwards of 200 pounds (90.7 kilograms). That weight of gold would be worth about thirty-five talents of silver.
69. Plutarch, *Alexander* 39.10. Once owned by Bagoas, the house at Susa contained clothing that alone was worth a thousand talents.

70. Plutarch, *Alexander* 39.12.
71. Arrian 3.22.1; Diodorus 17.73.3; Plutarch, *Alexander* 43.7 and *Moralia* 343b. The place of burial is conjectural since no actual tomb has ever been identified conclusively: Pierre Briant, *Darius in the Shadow of Alexander*, trans. Jane Marie Todd (Cambridge, MA: Harvard University Press, 2015), 24–37 and 414–16.
72. Curtius 6.2.6–9. These numbered about 1,000.
73. Justin 12.1.1, for those lost during the pursuit of Darius.
74. In addition to all back pay plus costs of returning home, discharge bonuses to Greek allied troops: Arrian 3.19.5; Plutarch, *Alexander* 42.5; Curtius 6.2.10 and 17; Diodorus 17.74.3–5. The latter authors give the same amounts for cavalry (one talent each) and infantry (ten minae each); the former list cavalry only. Those staying with Alexander received a bonus of three talents each.
75. Curtius 6.2.10. Darius had escaped with about 7,000 or 8,000 talents: Arrian 3.19.5; Strabo 15.3.9.
76. Arrian 3.25.1.
77. Plutarch, *Alexander* 44.5.
78. Following the fictional meeting of Alexander and Thalestris: Diodorus 17.77.3, cf. *Alexander Romance* 253–54.
79. Diodorus 17.77.5, as part of Alexander's Orientalization of the court.
80. Diodorus 17.78.1; Curtius 6.6.11, to quiet opposition.
81. Curtius 6.6.18–19; cf. Arrian 3.25.4.
82. Curtius 6.6.34.
83. Strabo 11.8.9–10; Pliny, *Natural History* 6.61.
84. Curtius 7.3.3; Arrian 3.27.5; Diodorus 17.81.2.
85. Arrian 3.27.5, to Apollo.
86. Strabo 11.8.9; Pliny, *Natural History* 6.61.
87. Diodorus 17.81.2.
88. One named Alexandria in the Caucasus, the other perhaps Kartana: Arrian 3.28.4; Curtius 7.3.23; Diodorus 17.83.1–3; Pliny, *Natural History* 6.62.
89. Arrian 3.29.5; Curtius 7.5.27, giving the details of two talents per cavalryman and half a talent for each infantryman.
90. Diodorus 17.83.8–9; Curtius 7.5.43.
91. Arrian 4.1.3–4 and 4.4.1; Justin 12.5.12; Pliny, *Natural History* 6.49; *Marmor Parium* (*FGrH* 239 B7); Curtius 7.6.25–27, adding that Alexander paid owners for slaves selected to populate the city.
92. Curtius 7.9.21.
93. Arrian 4.4.1.
94. Arrian 4.4.3, presumably to the river itself.
95. Curtius 7.10.15; Pliny, *Natural History* 6.46–47.
96. Justin 12.5.13 (twelve cities); Strabo 11.11.4 (eight settlements); cf. Diodorus 17.83.2 ("other cities").

NOTES

97. Arrian 4.8.1–2, when Alexander neglected Dionysus and honored the Dioscuri instead.
98. Arrian 4.15.7–8, responding to the omen of a spring of oil.
99. Arrian 4.16.4–7, where the plunder changes hands several times.
100. Plutarch, *Moralia* 334f, a bronze statue featuring the brave musician holding a spear and kithara.
101. Curtius 8.5.9 (the proskynesis affair).
102. Curtius 7.11.7–19; Arrian 4.18.7 and 19.1–3. Both authors report a sliding scale of rewards, with Curtius giving a simple range of ten talents down to one (10 + 9 + 8 . . . +1 = 55). Arrian starts with a higher first prize of twelve talents but gives no specifics about second, third, and so forth and implies that every successful climber received at least 300 gold darics. Of about 300 volunteers, some 30 perished—numbers suspiciously formulaic and perhaps not to be entirely trusted. It has been argued, in fact, that Arrian's use of the term "darics" was itself a literary convention: A. B. Bosworth, *A Historical Commentary on Arrian's History of Alexander*, vol. 2 (Oxford: Clarendon, 1995), 129. According to Arrian, Alexander's payout was at least 362 talents.
103. Curtius 8.2.40.
104. Curtius 8.4.18. The losses were incurred by the army due to a blizzard.
105. Curtius 8.4.20.
106. Aelian, *Varia Historia* 9.30. Having burnt his own possessions to stay warm, Alexander sought refuge in Anaxarchus's tent and recompensed him accordingly.
107. Curtius 8.6.19. Alexander allegedly gave "50 sestertia" to each of the nine (conspiratorial) pages who stayed late at their posts.
108. Curtius 8.6.26: fifty talents plus the opulent estate of Tiridates.
109. Plutarch, *Alexander* 56.2.
110. Plutarch, *Alexander* 57.1–2; Polyaenus 4.3.10; Curtius 6.6.14–17.
111. Arrian 4.22.6, to Athena.
112. Arrian 4.24.6–7.
113. Curtius 8.10.13–18; Arrian 5.2.6.
114. Curtius 8.11.24; Arrian 4.30.4.
115. Curtius 8.11.3–4 and 25; Diodorus 17.85.5–6 and 86.1.
116. Arrian 4.30.9, to ferry troops downstream.
117. Arrian 4.28.5, 4.30.9, and 5.3.5, the work of Hephaestion and Perdiccas. A few more ships were also provided.
118. Arrian 5.3.6; Diodorus 17.86.3.
119. Arrian 5.8.2, after crossing the river safely.
120. Curtius 8.12.16–17 (plus vessels of precious metals, Persian robes, horses, trappings); Plutarch, *Alexander* 59.5.
121. Arrian 5.8.3, emphasizing that this was done *again* as earlier at the Indus.

NOTES

122. Bucephala and Nicaea: Plutarch, *Alexander* 61.2 and *Moralia* 328f; Arrian 5.19.4 and 20.2; Curtius 9.1.6 and 3.23; Diodorus 17.89.6 and 95.5.

123. Arrian 5.20.1; Diodorus 17.89.3.

124. Curtius 9.1.6; Diodorus 17.89.3. Each commander received 1,000 gold coins and a crown, while others got rewards commensurate with rank and service.

125. Arrian 5.24.4.

126. Arrian 5.24.6.

127. Arrian 5.28.4. These were unfavorable for the crossing, according to Ptolemy.

128. Arrian 5.29.1–2; Diodorus 17.95.1–2; Plutarch, *Alexander* 62.6–8; Curtius 9.3.19; Pliny, *Natural History* 6.62.

129. Diodorus 17.94.4; Justin 12.4.2–11.

130. Arrian 5.29.3; Curtius 9.8.8; Diodorus 17.102.4 (10,000 inhabitants).

131. Curtius 9.3.21–22 and 8.5.4; Diodorus 17.95.4. These 25,000 panoplies replaced old ones that were then destroyed.

132. Either worth, or weighing, 100 talents: Diodorus 17.95.4.

133. Arrian 5.29.5, before crossing the river.

134. Arrian 5.29.5.

135. Diodorus 17.89.4; Arrian 6.1.1, 6.2.4, and *Indika* 19.7; Curtius 9.1.3–4 and 3.21.

136. Arrian 6.2.1.

137. Arrian 6.3.1–2 and *Indika* 18.11–12.

138. Pollux, *Onamasticon* 5.42–43 (100 minas). In Alexander's youth, his horse Bucephalus had been purchased for the huge sum of thirteen talents: Plutarch, *Alexander* 6.1.

139. Plutarch, *Alexander* 65.1. *Metz Epitome* 84 rather comically reports that the gifts to these "naked philosophers" consisted of clothing (*vestimenta*).

140. Plutarch, *Moralia* 181b.

141. Arrian 6.5.4.

142. Arrian 6.15.1.

143. Curtius 9.7.15–22.

144. Arrian 6.15.2; Curtius 9.8.8; Diodorus 17.102.4.

145. Arrian 6.15.4.

146. Arrian 6.15.4.

147. Arrian 6.18.1–2 and 20.1; Curtius 9.10.3 ("founded several cities"); cf. Justin 12.10.6 (Barce).

148. Arrian 6.18.4–5 and 19.3. The king burned the boats that had been damaged: Diodorus 17.104.3; Curtius 9.10.4.

149. Arrian 6.20.5.

150. Pliny, *Natural History* 6.96; cf. Arrian, *Indika* 21.10.

151. Arrian 6.19.4.

152. Arrian 6.19.5 and *Indika* 20.10; Curtius 9.9.27; Diodorus 17.104.1; Plutarch, *Alexander* 66.2. Arrian makes explicit that these sacrifices were to different gods with a different ritual from those of the previous entry. The "sumptuous offerings" included bulls, a golden cup, and gold bowls.

153. Undertaken by Nearchus: Arrian, *Indika* 21.2.

154. Arrian, *Indika* 23.8, 5.1, and 33.9.

155. Built by Nearchus: Pliny, *Natural History* 6.96.

156. Arrian 6.21.5; Diodorus 17.104.8; Curtius 9.10.3 ("very many cities") and 9.10.7; Pliny, *Natural History* 6.97.

157. Curtius 9.10.12; Arrian 6.25.1–5; Strabo 15.2.5–6. All royal baggage was reportedly lost.

158. Arrian 6.27.3–5 and 29.4–9, and 30.1–2; Curtius 10.1.1–9 and 22–38; Diodorus 17.106.2–3; Strabo 15.3.7. These crimes by Alexander's own officials took place while the king was campaigning in the East; he made necessary repairs.

159. Plutarch, *Alexander* 68.7. It is alleged that when the king ordered provisions for his army, Abulites brought coins instead. Furious, Alexander tossed the money to the horses to show how useless it was in this situation. True or not, the king hardly needed to throw away the full 85.3 tons of coins to make his point.

160. Plutarch, *Alexander* 67.1–6; Diodorus 17.106.1; Curtius 9.10.24–30; but discredited by Arrian 6.28.1–2.

161. Arrian 6.28.3; Plutarch, *Alexander* 67.7–8; Diodorus 17.106.4; cf. Athenaeus 13.603a–b, celebrating the survival of the army.

162. Arrian, *Indika* 36.3, celebrating the survival of the fleet.

163. Arrian, *Indika* 36.9, another celebration hosted by Nearchus at the seacoast.

164. Curtius 10.1.19 (700 ships); Arrian 7.19.3–4; Plutarch, *Alexander* 68.2; Strabo 16.1.11. Many, but perhaps not all, of the ships were completed: Diodorus 18.4.4.

165. Diodorus 17.111.1.

166. Arrian 6.29.10. The work was undertaken by Aristobulus.

167. Following an old Persian royal custom, each woman was given one gold coin (and each pregnant woman, two): Plutarch, *Alexander* 69.1 and *Moralia* 246a–b; Justin 1.6.13; Polyaenus 7.45.2.

168. Arrian 7.3.1–6; Plutarch, *Alexander* 69.6–8; Diodorus 17.107.4–5; Strabo 15.1.65; Aelian, *Varia Historia* 5.6. As part of the obsequies, see the next entry.

169. Plutarch, *Alexander* 70.1–2; Athenaeus 437a–b; and Aelian, *Varia Historia* 2.41. The winner and forty-one other participants died.

170. Diodorus 17.108.4–8; Plutarch, *Moralia* 846a–c. Harpalus also took 6,000 mercenaries. See chapter 6.

171. Arrian 7.4.8; Athenaeus 538b–539a (citing Chares); Plutarch, *Alexander* 70.3; Aelian, *Varia Historia* 8.7; Diodorus 17.107.6.
172. Plutarch, *Alexander* 70.3; Curtius 10.2.9–11; Diodorus 17.109.2. Arrian 7.5.3 and Justin 12.11.3 give the figure as 20,000 talents. See discussion in chapters 1 and 6.
173. Arrian, *Indika* 42.6, hosted by Nearchus.
174. Arrian 7.5.4–6 and *Indika* 42.8–9 (cf. 23.6), including gold crowns for Peucestas, Nearchus, Onesicritus, Leonnatus, Hephaestion, and the remaining bodyguards.
175. Pliny, *Natural History* 6.138.
176. Arrian 7.11.8–9.
177. Arrian 7.12.1; Plutarch, *Alexander* 71.8; Diodorus 17.109.2. Each of 10,000 men was given a talent in addition to all back pay and money for the journey home. Although less than the two talents given the Thessalian cavalryman in Bactria, this bonus was twice that for an infantryman released at Bactria.
178. Arrian 7.12.2; Plutarch, *Alexander* 71.9; Justin 12.4.8–9; Diodorus 17.110.3 (claiming there were 10,000 children on the dole).
179. Arrian 7.13.1, thousands stolen by brigands.
180. Arrian 7.14.1; Plutarch, *Alexander* 72.1 (3,000 performers from Greece); Diodorus 17.110.7; Athenaeus 12.538a.
181. Diodorus 17.111.6.
182. Arrian 7.14.8 (10,000 or more talents); Plutarch, *Alexander* 72.5 (10,000); Diodorus 17.115.2–5 (12,000); Justin 12.12.12 (12,000). Diodorus 18.4.2 claims that some aspects of the project were never completed, so perhaps the lower figure is preferable. Aelian, *Varia Historia* 7.8 describes the precious metals and fine Persian clothing burned on the pyre.
183. Involving 3,000 performers and 10,000 animals: Diodorus 17.115.6; Arrian 7.14.6 and 10.
184. Arrian 7.16.1.
185. Diodorus 18.12.2. A huge convoy of 110 triremes carried this money from the royal treasury to Macedonia. Moving large amounts of money by sea entailed serious risks of loss, as we know from Plutarch, *Cato the Younger* 38.1, where Cato divided a cargo of about 7,000 talents into more than 3,000 separate chests, each attached to corks by long ropes. In the event of shipwreck, the corks would serve as locator buoys to salvage the sunken silver.
186. Arrian 7.17.1–4.
187. Arrian 7.14.6.
188. Arrian 7.19.2.
189. Arrian 7.19.5.
190. Arrian 7.19.4 and 21.1.

191. Arrian 7.21; Strabo 16.1.9–11.
192. Arrian 7.21.7.
193. Arrian 7.22.4–5, giving variations of the story.
194. Arrian 7.23.3–4.
195. Arrian 7.23.5 (crowns for victors).
196. Arrian 7.23.6–8.
197. Arrian 7.24.4; cf. Plutarch, *Alexander* 75.3–4 and Diodorus 17.116.1.
198. Arrian 7.25–7.26.3; Plutarch, *Alexander* 76.
199. Plutarch, *Moralia* 343d; Diodorus 18.4.4–5 (reporting that the project was cancelled after the king's death).
200. At the Isthmus of Corinth: Pausanias 2.1.5.
201. Strabo 9.2.18, relating a letter to Alexander from the engineer Crates about the project, suggesting that the king may have had a financial interest in the work.
202. Plutarch, *Alexander* 61.3.
203. Athenaeus 4.155d, from Agatharchides.
204. Athenaeus 4.146c–d; Plutarch, *Alexander* 23.10.
205. Athenaeus 12.537d, quoting Ephippus, and 12.539a, quoting Polycleitus.
206. Athenaeus 12.537e, quoting Ephippus.
207. Pliny, *Natural History* 35.92, for the Alexander Keraunophoros, discussed in Andrew Stewart, *Faces of Power: Alexander's Image and Hellenistic Politics* (Berkeley: University of California Press, 1993), 191–95. Stewart accepts the reading "twenty gold talents" rather than "twenty talents worth of silver (paid in gold)."
208. Sprinkled on the king's floor and burnt in his presence: Athenaeus 12.538a.
209. Plutarch, *Alexander* 39.6.
210. Plutarch, *Moralia* 331e, reporting the gift of 10,000 gold coins on the occasion of their first meeting; Sextus Empiricus, *Against Grammarians* 1.282, paid for a poem.
211. Alexander sent Xenocrates fifty talents, but only thirty minae were accepted: Cicero, *Tusculan Disputations* 5.91; Plutarch, *Alexander* 8.5; *Moralia* 331e and 333b; Themistius 21.252a. The thirty gold talents reported in *Suda* 42 is surely a confusion of the talents offered and the minae accepted.
212. Plutarch, *Moralia* 179f. This gift is sometimes conflated with the previous one to Xenocrates, but the amounts and circumstances are reported differently.
213. Athenaeus 9.398e, to support animal research.
214. Rewarded for flattery: Horace, *Epistles* 2.1.232.
215. Plutarch, *Moralia* 188c, *Alexander* 39.4, and *Phocion* 18.1; Aelian, *Varia Historia* 1.25 and 11.9. Aelian's reference to a city as one of the gifts

proffered to Phocion may lie behind the rebuke of Alexander in Seneca, *On Benefits* 2.16.

216. Plutarch, *Alexander* 39.5. The name Serapion is probably anachronistic.
217. Strabo 15.1.61.
218. Plutarch, *Moralia* 179c. Perilaus was content with ten talents, but Alexander insisted on fifty.
219. Ps.-Callisthenes, *Alexander Romance* (Armenian) 134.
220. Valerius Maximus 5.6, ext. 5, and Diogenes Laertius 5.4, although Plutarch, *Alexander* 7.3 seems to credit this restoration to Philip II, who had destroyed the city in 350 BC.

Appendix 4

1. Olga Palagia, "Hephaestion's Pyre and the Royal Hunt of Alexander," in *Alexander the Great in Fact and Fiction*, ed. A. B. Bosworth and Elizabeth Baynham (Oxford: Oxford University Press, 2000), 173.
2. For a partial list and interesting background discussion, consult John Cherry, "Blockbuster! Museum Responses to Alexander the Great," in *Responses to Oliver Stone's Alexander: Film, History, and Cultural Studies*, ed. Paul Cartledge and Fiona Greenland (Madison: University of Wisconsin Press, 2010), 305–36.
3. As happened recently at the University of Buffalo: ABC News, March 2015.
4. The coins were part of *IGCH* 777, from the village of Yasna Polyana some thirty kilometers (nineteen miles) southeast of Burgas. Meanwhile, at the other (western) end of Bulgaria, the Pernik Museum is trying to raise funds to exhibit its own treasure of Alexander coins, secreted in a vault since its discovery in 1968.
5. See, for example, *The Herald* (Everett, Washington), March 26, 2012, for a residential burglary. For major thefts, see Brian Haughton, *Ancient Treasures* (Pompton Plains, NJ: New Page, 2013), 59–67.
6. *The Washington Post* (Washington, DC), December 22, 2011. The problem is not entirely recent: Sharon Waxman, *Loot: The Battle over the Stolen Treasures of the Ancient World* (New York: Times Books, 2008), esp. 348–52.
7. Goldberg Auctioneers Sale 59 (May/June 2010), lots 2073–2099.
8. Goldberg Auctioneers Sale 62 (Jan./Feb. 2011), lots 3051–3062.
9. Edward Taylor, "Valuing the Numismatic Legacy of Alexander the Great," *The Celator* 22 (2008): 6.

SELECTED BIBLIOGRAPHY

Abbé de Mabry. *Observations sur les Grecs*. Geneva: Compagnie des Libraires, 1749.

Abbott, Jacob. *The History of Alexander the Great*. New York: Harper and Brothers, 1848.

Abd el-Raziq, Mahmud. *Die Darstellungen und Texte des Sanktuars Alexanders des Grossen im Tempel von Luxor*. Mainz am Rhein: Philipp von Zebern, 1984.

Adam, Adela. "Philip *Alias* Hitler." *Greece and Rome* 10 (1941): 105–13.

Adams, Lindsay. "In the Wake of Alexander the Great: The Impact of Conquest on the Aegean World." *Ancient World* 27 (1996): 29–37.

Adams, Lindsay. "The Games of Alexander the Great." In *Alexander's Empire: Formulation to Decay*, edited by Waldemar Heckel, Lawrence Tritle, and Pat Wheatley, 125–38. Claremont, CA: Regina Books, 2007.

Adcock, Frank. *The Greek and Macedonian Art of War*. Berkeley: University of California Press, 1957.

Akamatis, Ioannis. "Pella." In *Brill's Companion to Ancient Macedon*, edited by Robin Lane Fox, 393–408. Leiden: Brill, 2011.

Alram, Michael. "The Coinage of the Persian Empire." In *The Oxford Handbook of Greek and Roman Coinage*, edited by Willaim Metcalf, 61–87. Oxford: Oxford University Press, 2012.

Amitay, Ory. "Alexander in *Bavli Tamid*: In Search for a Meaning." In *The Alexander Romance in Persia and the East*, edited by Richard Stoneman, 349–65. Groningen: Barkhuis Publishing, 2012.

Andreades, Andreas. "Les Finances de guerre d'Alexandre le Grand." *Annales d'Histoire Économique et Sociale* 1 (1929): 321–34.

Andronikos, Manolis. "Regal Treasures from a Macedonian Tomb." *National Geographic*, July 1978, 54–77.

Andronikos, Manolis. *The Royal Graves at Vergina*. Athens: Archaeological Receipts Fund, 1980.

Andronikos, Manolis. *Vergina: The Royal Tombs*. Athens: Ekdotike Athenon, 1994.

Antela-Bernárdez, Borja. "La Campāna de Alejandro: Esclavismo y dependencia en el espacio de conquista." In *Los espacios de la esclavitud y la dependencia desde la antigüedad*, edited by Alejandro Beltrán, Inés Sastre, and Miriam Valdés, 281–96. Besançon: Presses Universitaires de Franche-Comté, 2015.

Antikas, Theodore, et al. "New Finds on the Skeletons in Tomb II at the Great Tumulus of Aegae: Morphological and Pathological Changes." Paper presented at the Archaeological Works in Macedonia and Thrace conference, Thessaloniki, March 13, 2014.

Aperghis, G. G. *The Seleukid Royal Economy: The Finances and Financial Administration of the Seleukid Empire*. Cambridge: Cambridge University Press, 2004.

Archibald, Zofia. *The Odrysian Kingdom of Thrace: Orpheus Unmasked*. Oxford: Clarendon Press, 1998.

Arena, Emiliano. "L'Introduzione della leggenda ΒΑΣΙΛΕΩΣ ΑΛΕΞΑΝΔΡΟΥ nella monetazione di Alessandro Magno." *Revue Belge de Numismatique et de Sigillographie* 157 (2011): 135–70.

Arnold, Dieter. *Temples of the Last Pharaohs*. Oxford: Oxford University Press, 1999.

Ashurst, David. "Alexander the Great." In *Heroes and Anti-Heroes in Medieval Romance*, edited by Neil Cartlidge, 27–42. Cambridge: DS Brewer, 2012.

Atkinson, J. E. *A Commentary on Q. Curtius Rufus' Historiae Alexandri Magni Books 5 to 7.2*. Amsterdam: Hakkert, 1994.

Austin, Michel. "Hellenistic Kings, War and the Economy." *Classical Quarterly* 36 (1986): 430–66.

Austin, Michel. "Alexander and the Macedonian Invasion of Asia: Aspects of the Historiography of War and Empire in Antiquity." In *War and Society in the Greek World*, edited by John Rich and Graham Shipley, 197–223. New York: Routledge, 1993.

Badian, Ernst. "The First Flight of Harpalus." *Historia* 9 (1960): 245–46.

Badian, Ernst. "The Administration of the Empire." *Greece and Rome* 12 (1965): 166–82.

Badian, Ernst. "Alexander in Iran." In *The Cambridge History of Iran*, vol. 7, edited by Ilya Gershevitch, 420–501. Cambridge: Cambridge University Press, 1985.

Badian, Ernst. *Collected Papers on Alexander the Great*. London: Routledge, 2012.

Barr-Sharrar, Beryl. "Macedonian Metal Vases in Perspective: Some Observations on Context and Tradition." In *Macedonia and Greece in Late Classical and*

Early Hellenistic Times, edited by Beryl Barr-Sharrar and Eugene Borza, 123–39. Washington, DC: National Gallery of Art, 1982.

Barr-Sharrar, Beryl. *The Derveni Krater: Masterpiece of Classical Greek Metalwork.* Princeton, NJ: American School of Classical Studies at Athens, 2008.

Bartsiokas, Antonis, et al. "The Lameness of King Philip and Royal Tomb I at Vergina, Macedonia." *Proceedings of the National Academy of Sciences* (2015): 1–5 (early electronic edition with appendix).

Baynham, Elizabeth. "The Ancient Evidence for Alexander the Great." In *Brill's Companion to Alexander the Great*, edited by Joseph Roisman, 3–29. Leiden: Brill, 2003.

Baynham, Elizabeth. *Alexander the Great: The Unique History of Quintus Curtius.* Ann Arbor: University of Michigan Press, 2004.

Baynham, Elizabeth. "Power, Passion, and Patrons: Alexander, Charles Le Brun, and Oliver Stone." In *Alexander the Great: A New History*, edited by Waldemar Heckel and Lawrence Tritle, 294–310. Malden, MA: Wiley-Blackwell, 2009.

Bellinger, Alfred. *Essays on the Coinage of Alexander the Great.* New York: American Numismatic Society, 1963.

Beloch, Julius. *Griechische Geschichte.* Berlin: Walter de Gruyter, 1925.

Bernard, Paul. "Nouvelle contribution de l'épigraphie cunéiforme à l'histoire hellénistique." *Bulletin de Correspondance Hellénique* 114 (1990): 513–41.

Bernhardt, Rainer. *Luxuskritik und Aufwandsbeschränkungen in der griechischen Welt.* Stuttgart: Franz Steiner, 2003.

Bernstein, Peter. *The Power of Gold: The History of an Obsession.* New York: Wiley, 2000.

Berry, Steve. *The Venetian Betrayal.* New York: Ballantine Books, 2007.

Berve, Helmut. *Das Alexanderreich auf prosopographischer Grundlage.* 1926. Reprint, Salem: Ayer, 1988.

Bevan, Wilson. *The World's Leading Conquerors.* New York: Henry Holt, 1913.

Billows, Richard. *Kings and Colonists: Aspects of Macedonian Imperialism.* Leiden: Brill, 1995.

Bing, J. D. "A Further Note on Cyinda/Kundi." *Historia* 22 (1973): 346–50.

Blackwell, Christopher. *In the Absence of Alexander: Harpalus and the Failure of Macedonian Authority.* New York: Peter Lang, 1999.

Bloedow, Edmund. "Diplomatic Negotiations between Darius and Alexander: Historical Implications of the First Phase at Marathus in Phoenicia in 333/332 B.C." *Ancient History Bulletin* 9 (1995): 93–110.

Bloedow, Edmund. "On the Crossing of Rivers: Alexander's διφθέραι." *Klio* 84 (2002): 57–75.

Bloedow, Edmund. "Why Did Philip and Alexander Launch a War Against the Persian Empire?" *L'Antiquité Classique* 72 (2003): 261–74.

Bloedow, Edmund, and Heather Loube. "Alexander the Great 'Under Fire' in Persepolis." *Klio* 79 (1997): 341–53.

Borza, Eugene. "Fire from Heaven: Alexander at Persepolis." *Classical Philology* 67 (1972): 233–45.

Borza, Eugene. *In the Shadow of Olympus: The Emergence of Macedon.* Princeton, NJ: Princeton University Press, 1990.

Borza, Eugene. "Alexander at Persepolis." In *The Landmark Arrian,* edited by James Romm, 367–70. New York: Pantheon Books, 2010.

Borza, Eugene, and Olga Palagia. "The Chronology of the Macedonian Royal Tombs at Vergina." *Jahrbuch des Deutschen Archäologischen Instituts* 122 (2007): 81–125.

Bosch-Puche, Francisco. "L' 'Autel' du temple d'Alexandre le Grand à Bahariya retrouvé." *Bulletin de l'Institut Français d'Archéologie Orientale* 108 (2008): 29–44.

Bosch-Puche, Francisco. "The Egyptian Royal Titulary of Alexander the Great, I: Horus, Two Ladies, Golden Horus, and Throne Names." *Journal of Egyptian Archaeology* 99 (2013): 131–54.

Bosch-Puche, Francisco. "Alexander the Great's Names in the Barque Shrine at Luxor Temple." In *Alexander the Great and Egypt: History, Art, Tradition,* edited by Volker Grieb, Krzysztof Nawotka, and Agnieszka Wojciechowska, 55–87. Wiesbaden: Harrassowitz, 2014.

Bose, Partha. *Alexander the Great's Art of Strategy: The Timeless Leadership Lessons of History's Greatest Empire Builder.* New York: Gotham Books, 2003.

Bosworth, A. B. *A Historical Commentary on Arrian's History of Alexander.* 2 vols. Oxford: Clarendon, 1980–1995.

Bosworth, A. B. "The Indian Satrapies under Alexander the Great." *Antichthon* 17 (1983): 37–46.

Bosworth, A. B. "Alexander the Great and the Decline of Macedon." *Journal of Hellenic Studies* 106 (1986): 1–12.

Bosworth, A. B. *Conquest and Empire: The Reign of Alexander the Great.* Cambridge: Cambridge University Press, 1988.

Bosworth, A. B. *From Arrian to Alexander: Studies in Historical Interpretation.* Oxford: Clarendon Press, 1988.

Bosworth, A. B. *Alexander and the East: The Tragedy of Triumph.* Oxford: Oxford University Press, 1996.

Bosworth, A. B. "A Tale of Two Empires: Hernán Cortés and Alexander the Great." In *Alexander the Great in Fact and Fiction,* edited by A. B. Bosworth and E. J. Baynham, 23–49. Oxford: Oxford University Press, 2000.

Bosworth, A. B. *The Legacy of Alexander: Politics, Warfare, and Propaganda under the Successors.* Oxford: Oxford University Press, 2002.

Bresson, Alain. "Coinage and Money Supply in the Hellenistic Age." In *Making, Moving and Managing: The New World of Ancient Economies, 323–31 BC,* edited by Zofia Archibald, John Davies, and Vincent Gabrielsen, 44–72. Oxford: Oxbow Books, 2005.

Briant, Pierre. *Histoire de l'empire perse de Cyrus à Alexandre*. 2 vols. Paris: Fayard, 1996.

Briant, Pierre. *From Cyrus to Alexander: A History of the Persian Empire*. Winona Lake, IN: Eisenbraums, 2003.

Briant, Pierre. "Alexander and the Persian Empire, between 'Decline' and 'Renovation.'" In *Alexander the Great: A New History*, edited by Waldemar Heckel and Lawrence Tritle, 171–88. Malden, MA: Wiley-Blackwell, 2009.

Briant, Pierre. *Darius in the Shadow of Alexander*. Translated by Jane Marie Todd. Cambridge, MA: Harvard University Press, 2015.

Brosius, Maria. "Alexander and the Persians." In *Brill's Companion to Alexander the Great*, edited by Joseph Roisman, 169–93. Leiden: Brill, 2003.

Brown, Truesdell. "Alexander and Greek Athletics, in Fact and Fiction." In *Greece and the Eastern Mediterranean in Ancient History and Prehistory*, edited by K. H. Kinzl, 76–88. New York: Walter de Gruyter, 1977.

Burrer, Friedrich, and Holger Müller, eds. *Kriegskosten und Kriegsfinanzierung in der Antike*. Darmstadt: WGB, 2008.

Burstein, Stanley. "Prelude to Alexander: The Reign of Khababash." *Ancient History Bulletin* 14 (2000): 149–54.

Burstein, Stanley. "Alexander's Administration of Egypt: A Note on the Career of Cleomenes of Naucratis." In *Macedonian Legacies: Studies in Ancient Macedonian History and Culture in Honor of Eugene N. Borza*, edited by Timothy Howe and Jean Reames, 183–94. Claremont, CA: Regina Books, 2008.

Buttrey, T. V. "Calculating Ancient Coin Production: Facts and Fantasies." *Numismatic Chronicle* 153 (1993): 335–51.

Buttrey, T. V. "Calculating Ancient Coin Production II: Why It Cannot Be Done." *Numismatic Chronicle* 154 (1994): 341–52.

Cahill, Nicholas. "The Treasury of Persepolis: Gift-Giving at the City of the Persians." *American Journal of Archaeology* 89 (1985): 373–89.

Carney, Elizabeth. *Women and Monarchy in Macedonia*. Norman: University of Oklahoma Press, 2000.

Cary, George. *The Medieval Alexander*. Cambridge: Cambridge University Press, 1956.

Cawkwell, George. *Philip of Macedon*. Boston: Faber and Faber, 1978.

Chaniotis, Angelos. *War in the Hellenistic World*. Oxford: Blackwell, 2005.

Chankowski, Véronique. "Richesse et patrimoine dans les cités grecques: De la thésaurisation à la croissance." In *Richesse et Sociétés*, edited by Catherine Baroin and Cécile Michel, 163–72. Paris: de Boccard, 2013.

Chardin, Jean. *Voyages du Chevalier de Chardin en Perse et autres lieux de l'Orient*. 2 vols. Amsterdam: La Compagnie, 1735.

Cherry, John. "Blockbuster! Museum Responses to Alexander the Great." In *Responses to Oliver Stone's Alexander: Film, History, and Cultural Studies*,

edited by Paul Cartledge and Fiona Greenland, 305–36. Madison: University of Wisconsin Press, 2010.

Clarke, Samuel. *The Life and Death of Alexander the Great*. London: Wm. Miller, 1665.

Cohen, Getzel. *The Hellenistic Settlements*. 3 vols. Berkeley: University of California Press, 2013.

Cousinéry, Esprit Marie. *Voyage dans la Macédoine*. Paris: Imprimerie Royale, 1831.

Curteis, Arthur. *Rise of the Macedonian Empire*. New York: Scribners, 1916.

Davies, J. K. "Cultural, Social and Economic Features of the Hellenistic World." In *The Cambridge Ancient History*, 2nd ed., vol. 7, part 1: *The Hellenistic World*, edited by Frank Walbank et al., 257–320. Cambridge: Cambridge University Press, 1984.

de Callataÿ, François. "La Date des premiers tétradrachmes de poids attique émis par Alexandre le Grand." *Revue Belge de Numismatique et de Sigillographie* 128 (1982): 5–25.

de Callataÿ, François. "Les Trésors achéménides et les monnayages d'Alexandre: Espèces immobilisées et espèces circulantes?" *Revue des Études Anciennes* 91 (1989): 259–74.

de Callataÿ, François. "The Graeco-Roman Economy in the Super Long-Run: Lead, Copper, and Shipwrecks." *Journal of Roman Archaeology* 18 (2005): 361–72.

de Callataÿ, François. "Le Transport des monnaies dans le monde grec." *Revue Belge de Numismatique et de Sigillographie* 152 (2006): 5–14.

de Callataÿ, François. "Armies Poorly Paid in Coins (the Anabasis of the Ten-Thousands) and Coins for Soldiers Poorly Transformed by the Markets (the Hellenistic Thasian-Type Tetradrachms) in Ancient Greece." *Revue Belge de Numismatique et de Sigillographie* 155 (2009): 51–70.

de Callataÿ, François. "Quantifying Monetary Production in Greco-Roman Times: A General Frame." *Pragmateiai* 19 (2011): 7–29.

de Callataÿ, François. "Royal Hellenistic Coinages: From Alexander to Mithradates." In *The Oxford Handbook of Greek and Roman Coinage*, edited by William Metcalf, 175–90. Oxford: Oxford University Press, 2012.

de Callataÿ, François. "Les statères de Pergame et les réquisitions d'Alexandre le Grand." *Revue Numismatique* 169 (2012): 179–96.

de Callataÿ, François. "The Fabulous Wealth of the Hellenistic Kings: Coinage and Weltmachtpolitik." In *Words and Coins from Ancient Greece to Byzantium*, edited by Vasiliki Penna, 91–101. Gent: MER, 2012.

de Sainte-Croix, Guillaume Emmanuel Joseph. *Examen critique des anciens historiens d'Alexandre le Grand*. 2nd ed. Paris: Delance et Lesueur, 1804.

Delev, Peter. "Lysimachus, the Getae, and Archaeology." *Classical Quarterly* 50 (2000): 384–401.

Drougou, Stella. "Vergina—The Ancient City of Aegae." In *Brill's Companion to Ancient Macedon: Studies in the Archaeology and History of Macedon, 650 BC-300 AD*, edited by Robin Lane Fox, 243–56. Leiden: Brill, 2011.

Drougou, Stella, and Chryssoula Saatsoglou-Paliadeli. *Vergina: The Land and its History*. Athens: Ephesus Publishing, 2005.

Droysen, J. G. *Geschichte des Hellenismus*. 3 vols. 1877. Reprint, Tübingen: Tübingen Wissenschaftliche Buchgemeinschaft, 1952.

Duncan-Jones, Richard. *Money and Government in the Roman Empire*. Cambridge: Cambridge University Press, 1994.

Duruy, Victor. *Histoire des Grecs*. 3 vols. 1889. Reprint, Graz: Akademische Druck, 1968.

Duyrat, Frédérique. "La circulation monétaire dans l'Orient séleucide (Syrie, Phénicie, Mésopotamie, Iran)." *Topoi* 6 (2004): 381–424.

Engels, Donald. *Alexander the Great and the Logistics of the Macedonian Army*. Berkeley: University of California Press, 1978.

Erskine, Andrew. "The View from the Old World: Contemporary Perspectives on Hellenistic Culture." In *Shifting Social Imaginaries in the Hellenistic Period*, ed. Eftychia Stavrianopoulou, 339–63. Leiden: Brill, 2013.

Faraguna, Michele. "Aspetti amministrativi e finanziari della monarchia macedone fra IV e III secolo a.C." *Athenaeum* 86 (1998): 349–95.

Fedak, Janos. *Monumental Tombs of the Hellenistic Age: A Study of Selected Tombs from the Pre-Classical to the Early Imperial Era*. Toronto: University of Toronto Press, 1990.

Finley, Moses. *The Ancient Economy*. London: Chatto and Windus, 1975.

Finley, Moses. *Ancient History: Evidence and Models*. New York: Viking Penguin, 1985.

Flower, Michael. "Alexander and Panhellenism." In *Alexander the Great in Fact and Fiction*, edited by A. B. Bosworth and E. J. Baynham, 96–135. Oxford: Oxford University Press, 2000.

Forbes, Steve, and John Prevas. *Power Ambition Glory: The Stunning Parallels between Great Leaders of the Ancient World and Today . . . and What Lessons You Can Learn*. New York: Three Rivers Press, 2009.

Franz, Daniel. "Kriegsfinanzierung Alexanders des Grossen." In *1001 & 1 Talente: Visualisierung antiker Kriegskosten*, edited by Holger Müller, 115–50. Gutenberg: Computus Druck Satz, 2009.

Fraser, P. M. *Cities of Alexander the Great*. Oxford: Clarendon Press, 1996.

Gabriel, Richard. "Alexander the Monster." *Quarterly Journal of Military History* 25 (2013): 38–45.

Gage, Nicholas. "Tomb of Philip of Macedon Found in Greece." *New York Times*, November 25, 1977.

Garnsey, Peter. *Famine and Food Supply in the Graeco-Roman World*. Cambridge: Cambridge University Press, 1988.

Gast, John. *The History of Greece, from the Accession of Alexander of Macedon, till Its Final Subjection to the Roman Power*. 8 vols. London: J. Murray, 1782.

Gill, David. "Inscribed Silver Plate from Tomb II at Vergina." *Hesperia* 77 (2008): 335–58.

Glotz, Gustave. *Ancient Greece at Work*. 1920. Reprint, New York: Norton, 1967.

Goldstein, Jonathan. "Demosthenes' Fine and Its Payment, 323–322 B.C." *Classical Journal* 67 (1971): 20–21.

Goron, Stan, and J. P. Goenka. *The Coins of the Indian Sultanates*. New Delhi: Munshiram Manoharlal Publishers, 2001.

Green, Peter. *Alexander to Actium: The Historical Evolution of the Hellenistic Age*. Berkeley: University of California Press, 1990.

Green, Peter. *Alexander of Macedon, 356–323 B.C*. Berkeley: University of California Press, 1991.

Griffith, G. T. "The Macedonian Background." *Greece and Rome* 12 (1965): 125–39.

Grote, George. *History of Greece*. 12 vols. London: John Murray, 1856.

Habicht, Christian. *Athens from Alexander to Antony*. Cambridge, MA: Harvard University Press, 1997.

Hamilton, Earl. "Imports of American Gold and Silver into Spain, 1503-1660." *Quarterly Journal of Economics* 43 (1929): 436–72.

Hamilton, Earl. "American Treasure and the Rise of Capitalism (1500-1700)." *Economica* 27 (1929): 338–57.

Hamilton, J. R. *Plutarch, Alexander: A Commentary*. Oxford: Clarendon Press, 1969.

Hammond, N. G. L. *Alexander the Great: King, Commander and Statesman*. Park Ridge, NJ: Noyes Press, 1980.

Hammond, N.G.L. *Three Historians of Alexander the Great*. Cambridge: Cambridge University Press, 1983.

Hammond, N. G. L. "An Unfulfilled Promise by Alexander the Great." In *Zu Alexander dem Grossen*, vol. 1, edited by Wolfgang Will and Johannes Heinrichs, 627–34. Amsterdam: Hakkert, 1987.

Hammond, N. G. L. "The King and the Land in the Macedonian Kingdom." *Classical Quarterly* 38 (1988): 382–91.

Hammond, N. G. L. "Casualties and Reinforcements of Citizen Soldiers in Greece and Macedonia." *Journal of Hellenic Studies* 109 (1989): 56–68.

Hammond, N. G. L. "The Archaeological and Literary Evidence for the Burning of Persepolis." *Classical Quarterly* 42 (1992): 358–64.

Hammond, N. G. L. *Sources for Alexander the Great: An Analysis of Plutarch's Life and Arrian's Anabasis Alexandrou*. Cambridge: Cambridge University Press, 1993.

Hammond, N. G. L. "Philip's Innovations in Macedonian Economy." *Symbolae Osloenses* 70 (1995): 22–29.

Hammond, N. G. L. "Cavalry Recruited in Macedonia Down to 322 B.C." *Historia* 47 (1998): 404–25.

Hammond, N. G. L. "Alexander's Newly-Founded Cities." *Greek, Roman and Byzantine Studies* 39 (1998): 243–69.

Hammond, N. G. L., and G. T. Griffith. *A History of Macedonia, vol. II: 550–336 B.C.* Oxford: Clarendon Press, 1979.

Harding, Brian. "The Use of Alexander the Great in Augustine's *City of God.*" *Augustinian Studies* 39 (2008): 113–28.

Hasnas, John. "Reflections on Corporate Moral Responsibility and the Problem Solving Technique of Alexander the Great." *Journal of Business Ethics* 107 (2012): 183–95.

Hatzopoulos, Miltiades. *Actes du ventes d'Amphipolis.* Athens: de Boccard, 1991.

Hatzopoulos, Miltiades. *Macedonian Institutions Under the Kings: A Historical and Epigraphic Study.* 2 vols. Athens: Research Centre for Greek and Roman Antiquity, 1995.

Hauben, Hans. "The Expansion of Macedonian Sea-Power under Alexander the Great." *Ancient Society* 7 (1976): 79–105.

Heckel, Waldemar. *The Marshals of Alexander's Empire.* London: Routledge, 1992.

Heckel, Waldemar. *Who's Who in the Age of Alexander the Great.* Malden, MA: Blackwell, 2006.

Heisserer, A. J. *Alexander the Great and the Greeks: The Epigraphic Evidence.* Norman: University of Oklahoma Press, 1980.

Herzfeld, Ernst. "Rapport sur l'état actuel des ruines de Persépolis et propositions pour leur conservation." *Archäologische Mitteilungen aus Iran* 1 (1929): 17–64.

Holt, Frank. *Alexander the Great and Bactria.* Leiden: Brill, 1988.

Holt, Frank. "Spitamenes against Alexander." *Historikogeographika* 4 (1994): 51–58.

Holt, Frank. "Alexander the Great and the Spoils of War." *Ancient Macedonia* 6 (1999): 499–506.

Holt, Frank. *Thundering Zeus: The Making of Hellenistic Bactria.* Berkeley: University of California Press, 1999.

Holt, Frank. "Alexander the Great Today: In the Interests of Historical Accuracy?" *Ancient History Bulletin* 13 (1999): 111–17.

Holt, Frank. "The Death of Coenus: Another Study in Method." *Ancient History Bulletin* 14 (2000): 49–55.

Holt, Frank. *Alexander the Great and the Mystery of the Elephant Medallions.* Berkeley: University of California Press, 2003.

Holt, Frank. *Into the Land of Bones.* 2nd ed. Berkeley: University of California Press, 2012.

Holt, Frank. "Alexander the Great at Bactra: A Burning Question." *Electrum* 22 (2015): 9–15.

Hong, Sungmin, Jean-Pierre Candelone, Clair Patterson, and Claude Boutron. "Greenland Ice Evidence of Hemispheric Lead Pollution Two Millennia Ago by Greek and Roman Civilizations." *Science* 265 (1994): 1841–43.

Howgego, Christopher. *Ancient History from Coins.* London: Routledge, 1995.

Hubbard, L. Ron. *Tomb of the Ten Thousand Dead.* Hollywood: Galaxy Press, 2008.

Jamzadeh, Parivash. *Alexander Histories and Iranian Reflections: Remnants of Propaganda and Resistance.* Leiden: Brill, 2012.

Jones, A. H. M. *Ancient Economic History: An Inaugural Lecture Delivered at University College, London.* London: H. K. Lewis, 1948.

Jouguet, Pierre. *Macedonian Imperialism and the Hellenization of the East.* London: Kegan Paul, 1928.

Jursa, Michael. "Florilegium babyloniacum: Neue Texte aus hellenistischer und spätachämenischer Zeit." In *Mining the Archives*, edited by Cornelia Wunsch, 107–30. Dresden: ISLET, 2002.

Keynes, John M. *A Treatise on Money.* 2 vols. New York: Harcourt, Brace and Company, 1930.

Kholod, Maxim. "On the Financial Relations of Alexander the Great and the Greek Cities in Asia Minor: The Case of *Syntaxis.*" In *Ruthenia Classica Aetatis Novae*, edited by Andreas Mehl, Alexander Makhlayuk, and Oleg Gabelko, 83–92. Stuttgart: Franz Steiner, 2013.

King Charls His Speech Made upon the Scaffold. London: Peter Cole, 1649.

Kingsley, Bonnie. "Harpalos in the Megarid (333–331 B.C.) and the Grain Shipments from Cyrene." *Zeitschrift für Papyrologie und Epigraphik* 66 (1986): 165–77.

Knapowski, Roch. "Die Finanzen Alexanders des Grossen." In *Geschichte Mittelasiens in Altertum*, edited by Franz Altheim and Ruth Stiehl, 235–47. Berlin: de Gruyter, 1970.

Kottaridi, Angeliki. "The Palace of Aegae." In *Brill's Companion to Ancient Macedon*, edited by Robin Lane Fox, 298–333. Leiden: Brill, 2011.

Kottaridi, Angeliki, and Susan Walker, eds. *Heracles to Alexander the Great: Treasures from the Royal Capital of Macedon, a Hellenic Kingdom in the Age of Democracy.* Oxford: Ashmolean Museum, 2011.

Kremydi-Sicilianou, Sophia. "The Financing of Alexander's Asian Campaign." *Nomismatika Chronika* 18 (1999): 61–68.

Kron, Geoffrey. "Anthropometry, Physical Anthropology, and the Reconstruction of Ancient Health, Nutrition, and Living Standards." *Historia* 54 (2005): 68–83.

Kron, Geoffrey. "Comparative Evidence and the Reconstruction of the Ancient Economy: Greco-Roman Housing and the Level and Distribution of Wealth and Income." In *Quantifying the Greco-Roman Economy and Beyond*, edited by François de Callataÿ, 123–46. Bari: Edipuglia, 2014.

Kwarteng, Kwasi. *War and Gold: A 500-Year History of Empires, Adventures, and Debt*. New York: Public Affairs, 2014.

Ladynin, Ivan. "The Argeadai Building Program in Egypt in the Framework of Dynasties' XXIX-XXX Temple Building." In *Alexander the Great and Egypt: History, Art, Tradition*, edited by Volker Grieb, Krzysztof Nawotka, and Agnieszka Wojciechowska, 55–87. Wiesbaden: Harrassowitz, 2014.

Ladynin, Ivan. "Ἀλέξανδρος – 'Defender of Egypt'? On the Semantics of Some Denotations of Alexander the Great on the Ancient Egyptian Monuments." *Vestnik Novosibirskogo Gosudarstvennogo Universiteta* 13 (2014): 14–20 (in Russian).

Lane Fox, Robin. *The Making of Alexander*. Oxford: R & L, 2004.

Lane Fox, Robin. "The First Hellenistic Man." In *Creating a Hellenistic World*, edited by Andrew Erskine and Lloyd Llewellyn-Jones, 1–29. Swansea: Classical Press of Wales, 2010.

Lane Fox, Robin. "Introduction: Dating the Royal Tombs at Vergina." In *Brill's Companion to Ancient Macedonia*, edited by Robin Lane Fox, 1–34. Leiden: Brill, 2011.

Lane Fox, Robin. "Philip's and Alexander's Macedon." In *Brill's Companion to Ancient Macedonia*, edited by Robin Lane Fox, 367–91. Leiden: Brill, 2011.

Lane Fox, Robin. "Aspects of Warfare: Alexander and the Early Successors." *Revue des Études Militaires Anciennes* 6 (2013): 127–34.

Lazarides, Demetrius, Katerina Romiopoulou, and Iannis Touratsaglou. *Ὁ Τύμβος τῆς Νικήσιανης*. Athens: Athenian Archaeological Service, 1992.

Lemaire, Andre. "Le monnayage de Tyr et celui dit d'Akko dans la deuxième moité du IVe siècle avant J.-C." *Revue Numismatique* 18 (1976): 11–24.

Lenfant, Dominique. "Greek Monographs on the Persian World." In *Between Thucydides and Polybius: The Golden Age of Greek Historiography*, edited by Giovanni Parmeggiani, 197–210. Washington, DC: Center for Hellenic Studies, 2014.

Leriche, Pierre. "Bactria, Land of a Thousand Cities." In *After Alexander: Central Asia before Islam*, edited by Joe Cribb and Georgina Herrmann, 121–53. Oxford: Oxford University Press, 2007.

Le Rider, Georges. *Le Monnayage d'argent et d'or de Philippe II*. Paris: Bourgey, 1977.

Le Rider, Georges. *Monnayage et finances de Philippe II: Un état de la question*. Paris: de Boccard, 1996.

Le Rider, Georges. *Alexander the Great: Coinage, Finances, and Policy*. Translated by W. E. Higgins. Philadelphia: American Philosophical Society, 2007.

Lichtheim, Miriam. *Ancient Egyptian Literature*, vol. III: *The Late Period*. Berkeley: University of California Press, 1980.

Llewellyn-Jones, Lloyd. "The Great Kings of the Fourth Century and the Greek Memory of the Persian Past." In *Greek Notions of the Past in the Archaic and*

Classical Eras, edited by John Marincola, Lloyd Llewellyn-Jones, and Calum Maciver, 317–46. Edinburgh: Edinburgh University Press, 2012.

Lloyd, Alan. "From Satrapy to Hellenistic Kingdom: The Case of Egypt." In *Creating a Hellenistic World*, edited by Andrew Erskine and Lloyd Llewellyn-Jones, 83–105. Swansea: Classical Press of Wales, 2010.

Loomis, William. *Wages, Welfare Costs and Inflation in Classical Athens*. Ann Arbor: University of Michigan Press, 1998.

Lorber, Catharine. "Weight Standards of Thracian Toreutics and Thraco-Macedonian Coinages." *Revue Belge de Numismatique et Sigillographie* 154 (2008): 1–29.

MacDowall, David. "Der Einfluss Alexanders des Grossen auf das Münzwesen Afghanistans und Nordwest-Indiens." In *Aus dem Osten des Alexanderreiches*, edited by Jakob Ozols and Volker Thewalt, 66–73. Cologne: Du Mont, 1984.

Mahaffy, John. *Alexander's Empire*. London: T. Fisher Unwin, 1887.

Marazov, Ivan. *The Rogozen Treasure*. Sofia: Svyat Publishers, 1989.

Markou, Evangeline. "Gold and Silver Weight Standards in Fourth-Century Cyprus: A Resume." In *Proceedings of the XIVth International Numismatic Congress*, edited by Nicholas Holmes, 280–84. Glasgow: International Numismatic Council, 2011.

Marsden, E. W. *The Campaign of Gaugamela*. Liverpool: Liverpool University Press, 1964.

Martin, Felix. *Money: The Unauthorized Biography*. New York: Knopf, 2014.

Martin, Thomas R. *Sovereignty and Coinage in Classical Greece*. Princeton, NJ: Princeton University Press, 1985.

Masroori, Cyrus. "Alexander in the City of the Excellent: A Persian Tradition of Utopia." *Utopian Studies* 24 (2013): 52–65.

McInerney, Jeremy. *The Cattle of the Sun: Cows and Culture in the World of the Ancient Greeks*. Princeton, NJ: Princeton University Press, 2010.

McIntosh, Jane. *Treasure Seekers: The World's Great Fortunes Lost and Found*. London: Carlton Books, 2000.

Mead, Joseph. *Alexander the Great, a Poem*. London: Elliot Stock, 1876.

Meadows, Andrew. "The Spread of Coins in the Hellenistic World." In *Explaining Monetary and Financial Innovation: A Historical Analysis*, edited by Peter Bernholz and Roland Vaubel, 169–94. New York: Springer International Publishing, 2014.

Meeus, Alexander. "Some Institutional Problems Concerning the Succession to Alexander the Great: *Prostasia* and Chiliarchy." *Historia* 58 (2009): 287–310.

Meyer, Michael. *The Alexander Complex: The Dreams That Drive the Great Businessmen*. New York: Times, 1989.

Miles, Margaret. *Art as Plunder*. Cambridge: Cambridge University Press, 2008.

Millett, Paul. "The Political Economy of Macedonia." In *A Companion to Ancient Macedonia*, edited by Joseph Roisman and Ian Worthington, 472–504. Malden, MA: Wiley-Blackwell, 2010.

Milns, R. D. "Army Pay and the Military Budget of Alexander the Great." In *Zu Alexander dem Grossen*, vol. 1, edited by Wolfgang Will and Johannes Heinrichs, 233–56. Amsterdam: Hakkert, 1987.

Mitchell, Lynette. *Greeks Bearing Gifts: The Public Use of Private Relationships in the Greek World, 435–323 BC.* Cambridge: Cambridge University Press, 1997.

Montgomery, Hugo. "The Economic Revolution of Philip II—Myth or Reality?" *Symbolae Osloenses* 60 (1985): 37–47.

Moreno, Paolo. *Apelles: The Alexander Mosaic.* Milan: Skira, 2001.

Morris, Ian. "Archaeology, Standards of Living, and Greek Economic History." In *The Ancient Economy: Evidence and Models*, edited by J. G. Manning and Ian Morris, 91–126. Stanford: Stanford University Press, 2005.

Morris, Ian. *War! What Is It Good For?* New York: Farrar, Straus and Giroux, 2014.

Morrison, Gary. "Alexander, Combat Psychology, and Persepolis." *Antichthon* 35 (2001): 30–44.

Mousavi, Ali. *Persepolis: Discovery and Afterlife of a World Wonder.* Berlin: de Gruyter, 2012.

Nadali, Davide, and Jordi Vidal, eds. *The Other Face of the Battle: The Impact of War on Civilians in the Ancient Near East.* Münster: Ugarit-Verlag, 2014.

Nagle, D. B. "The Cultural Context of Alexander's Speech at Opis." *Transactions of the American Philological Association* 126 (1996): 151–72.

Naveh, Joseph, and Shaul Shaked, eds. *Aramaic Documents from Ancient Bactria (Fourth century BCE.) from Khalili Collections.* London: Khalili Family Trust, 2012.

Nawotka, Krzysztof. "Alexander the Great in Persepolis." *Acta Antiqua Academiae Scientiarum Hungaricae* 43 (2003): 67–76.

Neujahr, Matthew. "When Darius Defeated Alexander: Composition and Redaction in the Dynastic Prophecy." *Journal of Near Eastern Studies* 64 (2005): 101–7.

Newell, Edward. *Reattribution of Certain Tetradrachms of Alexander the Great.* New York: American Numismatic Society, 1912.

Newell, Edward. *The Dated Alexander Coinage of Sidon and Ake.* New Haven, CT: Yale University Press, 1916.

Ng, Su Fang. "Pirating Paradise: Alexander the Great, the Dutch East Indies, and Satanic Empire in *Paradise Lost.*" *Milton Studies* 52 (2011): 59–91.

Niane, D. T., ed. *Sundiata: An Epic of Old Mali.* Harlow: Longman, 1965.

Nicolet-Pierre, Hélène. "Argent et or frappes en Babylone entre 331 et 311 ou de Mazdai à Séleucos." In *Travaux de numismatique grecque offerts à Georges Le Rider*, edited by Michel Amandry and Silvia Hurter, 285–305. London: Spink, 1999.

Ogden, Daniel. *Alexander the Great: Myth, Genesis and Sexuality.* Exeter: University of Exeter Press, 2011.

Ogden, Daniel. "Alexander in Africa (332–331 BC and Beyond): The Facts, the Traditions and the Problems." In *Alexander in Africa*, edited by Philip Bosman, 1–37. Pretoria: Classical Association of South Africa, 2014.

Olbrycht, Marek Jan. "Curtius Rufus, the Macedonian Mutiny at Opis and Alexander's Iranian Policy in 324 BC." In *The Children of Herodotus*, edited by Jakub Pigon, 231–52. Newcastle upon Tyne: Cambridge Scholars Publishing, 2008.

Olbrycht, Marek Jan. "Ethnicity of Settlers in the Colonies of Alexander the Great in Iran and Central Asia." *Bulletin of the International Institute of Central Asian Studies* 14 (2011): 22–35.

Olbrycht, Marek Jan. "'An Admirer of Persian Ways': Alexander the Great's Reforms in Parthia-Hyrcania and the Iranian Heritage." In *Excavating an Empire: Achaemenid Persia in Longue Durée*, edited by Touraj Daryaee, Ali Mousavi, and Khodadad Rezakhani, 37–62. Costa Mesa, CA: Mazda Publishers, 2015.

Overtoom, Nikolaus. "Six Polybian Themes Concerning Alexander the Great." *Classical World* 106 (2013): 571–93.

Palagia, Olga. "Hephaestion's Pyre and the Royal Hunt of Alexander." In *Alexander the Great in Fact and Fiction*, edited by A. B. Bosworth and Elizabeth Baynham, 167–206. Oxford: Oxford University Press, 2000.

Panagopoulou, Katerina. "Between Necessity and Extravagance: Silver as a Commodity in the Hellenistic Period." *Annual of the British School at Athens* 102 (2007): 315–43.

Pandermalis, Dimitrios. *Alexander the Great: Treasures from an Epic Era of Hellenism*. New York: Alexander S. Onassis Public Benefit Foundation, 2004.

Parke, H. W. *Greek Mercenary Soldiers from the Earliest Times to the Battle of Ipsus*. Oxford: Clarendon Press, 1933.

Pearson, Lionel. *The Lost Histories of Alexander the Great*. London: American Philological Association, 1960.

Perdu, Olivier. "Le monument de Samtoutefnakht à Naples." *Revue d'Égyptologie* 36 (1985): 99–113.

Pernot, Laurent. *Alexandre le Grand: Les risques du pouvoir, Textes philosophiques et rhétoriques*. Paris: Les Belles Lettres, 2013.

Posner, Donald. "Charles LeBrun's Triumphs of Alexander." *Art Bulletin* 41 (1959): 237–48.

Pouzadoux, Claude. "Un Béotien à Tarente?" In *Artisanats antiques d'Italie et de Gaule*, edited by Jean-Paul Brun, 256–63. Naples: Centre Jean Bérard, 2009.

Price, Martin J. "Alexander's Reform of the Macedonian Regal Coinage." *Numismatic Chronicle* (1982): 180–90.

Price, Martin J. *The Coinage in the Name of Alexander the Great and Philip Arrhidaeus*. 2 vols. London: British Museum, 1991.

Pritchett, W. K. *The Greek State at War, Part 5*. Berkeley: University of California Press, 1991.

Radt, Timm. "The Ruins on Mount Karasis in Cilicia." In *From Pella to Gandhara: Hybridisation and Identity in the Art and Architecture of the*

Hellenistic East, edited by Anna Kouremenos, Sujatha Chandrasekaran, and Roberto Rossi, 49–64. Oxford: Archaeopress, 2011.

Rawlings, Louis. "War and Warfare in Ancient Greece." In *The Oxford Handbook of Warfare in the Classical World*, edited by Brian Campbell and Lawrence Tritle, 3–28. Oxford: Oxford University Press, 2013.

Rebuffat, François. "Alexandre le Grand et les problèmes financiers au début de son régne." *Revue Numismatique* 25 (1983): 43–52.

Reddé, Michel, ed. *De l'or pour les braves! Soldes, armées et circulation monétaire dans le monde romain*. Bordeaux: Ausonius, 2014.

Reinhold, Meyer. *History of Purple as a Status Symbol in Antiquity*. Brussels: Latomus, 1970.

Rezaeian, Farzin. *Persepolis Revealed*. Toronto: Sunrise Visual Innovations, 2004.

Richardson, William. *Numbering and Measuring in the Classical World*. 2nd ed. Bristol: Bristol Phoenix Press, 2004.

Roberts, Keith. *The Origins of Business, Money, and Markets*. New York: Columbia University Press, 2011.

Roisman, Joseph. *Alexander's Veterans and the Early Wars of the Successors*. Austin: University of Texas Press, 2012.

Rollin, Charles. *The Life of Alexander the Great, King of Macedon*. Providence, RI: B. Wheeler, 1796.

Rostovtzeff, Michael. *The Social and Economic History of the Hellenistic World*. 3 vols. Oxford: Clarendon Press, 1941.

Rotroff, Susan. *The Missing Krater and the Hellenistic Symposium: Drinking in the Age of Alexander the Great*. Broadhead Classical Lecture, University of Canterbury, Christchurch, August 7, 1996.

Rubincam, Catherine. "Numbers in Greek Poetry and Historiography: Quantifying Fehling." *Classical Quarterly* 53 (2003): 448–63.

Rubincam, Catherine. "The 'Rationality' of Herodotus and Thucydides as Evidenced by Their Respective Use of Numbers." In *Thucydides and Herodotus: Connections, Divergences, and Later Reception*, edited by Edith Foster and Donald Lateiner, 97–122. Oxford: Oxford University Press, 2012.

Ruffin, J. R. "The Efficacy of Medicine during the Campaigns of Alexander the Great." *Military Medicine* 157 (1992): 467–75.

Rzepka, Jacek. "How Many Companions Did Philip II Have?" *Electrum* 19 (2012): 131–35.

Sancisi-Weerdenburg, Heleen. "Gifts in the Persian Empire." In *Le tribute dans l'Empire Perse*, edited by Pierre Briant and Clarisse Herrenschmidt, 129–46. Paris: Peeters, 1989.

Sancisi-Weerdenburg, Heleen. "Alexander and Persepolis." In *Alexander the Great: Reality and Myth*, edited by Jesper Carlsen et al., 177–88. Rome: "L'Erma" di Bretschneider, 1993.

Scheidel, Walter. "Finances, Figures and Fiction." *Classical Quarterly* 46 (1996): 222–38.

Schmidt, Erich. *The Treasury of Persepolis and Other Discoveries in the Homeland of the Achaemenians.* Chicago: University of Chicago Press, 1939.

Schmidt, Erich. *Persepolis II: Contents of the Treasury and Other Discoveries.* Chicago: University of Chicago Press, 1957.

Schuyler, Eugene. *Turkistan: Notes of a Journey in Russian Turkistan, Khokand, Bukhara, and Kuldja.* New York: Scribner, Armstrong and Company, 1876.

Scott-Kilvert, Ian, trans. *The Age of Alexander: Nine Greek Lives by Plutarch.* New York: Penguin, 1973.

Shahbazi, A. S. "Iranians and Alexander." *American Journal of Ancient History* 2 (2003): 5–38.

Shaked, Saul. *Le satrape de Bactriane et son gouverneur: Documents araméens du IVe s. avant notre ère provenant de Bactriane.* Paris: de Boccard, 2004.

Simpson, R. H. "A Note on Cyinda." *Historia* 6 (1957): 503–4.

Sinopoli, Carla. "The Archaeology of Empires." *Annual Review of Anthropology* 23 (1994): 159–80.

Smith, Wes. "Cleopatra's Tomb? A 'Snowball's Chance' in Egypt." *Chicago Tribune*, April 14, 1996.

Spencer, Janet. "Princes, Pirates, and Pigs: Criminalizing Wars of Conquest in Henry V." *Shakespeare Quarterly* 47 (1996): 160–77.

Stewart, Andrew. *Faces of Power: Alexander's Image and Hellenistic Politics.* Berkeley: University of California Press, 1993.

Stolper, Matthew. *Entrepreneurs and Empire: The Murasu Archive, the Murasu Firm, and Persian Rule in Babylonia.* Leiden: Nederlands Instituut voor het Nabije Oosten, 1985.

Strauss, Barry. "Alexander: The Military Campaign." In *Brill's Companion to Alexander the Great*, edited by Joseph Roisman, 133–57. Leiden: Brill, 2003.

Strootman, Rolf. "Alexander's Thessalian Cavalry." *TALANTA* 42/43 (2010–2011): 51–67.

Tarn, W. W. "Alexander: The Conquest of Persia." In *The Cambridge Ancient History VI*, edited by J. B. Bury et al., 352–86. Cambridge: Cambridge University Press, 1927.

Tarn, W. W. "Alexander the Great and the Unity of Mankind." *Proceedings of the British Academy* 19 (1933): 123–66.

Tarn, W. W. *Alexander the Great.* 2 vols. Cambridge: Cambridge University Press, 1948.

Taylor, Edward. "Valuing the Numismatic Legacy of Alexander the Great." *The Celator* 22 (2008): 6–27.

Thompson, Margaret. "The Coinage of Philip II and Alexander III." In *Macedonia and Greece in Late Classical and Early Hellenistic Times*, edited by Beryl Barr-Sharrar and Eugene Borza, 113–21. Washington, DC: National Gallery of Art, 1982.

Thompson, Margaret. *Alexander's Drachm Mints I: Sardes and Miletus.* New York: American Numismatic Society, 1983.

Thompson, Margaret. "Paying the Mercenaries." In *Studies in Honor of Leo Mildenberg*, edited by Arthur Houghton et al., 241–47. Wetteren: NR Editions, 1984.

Thompson, Margaret. *Alexander's Drachm Mints II: Lampsacus and Abydus.* New York: American Numismatic Society, 1991.

Thompson, Margaret, Otto Mørkholm, and Colin Kraay, eds. *An Inventory of Greek Coin Hoards.* New York: American Numismatic Society, 1973.

Tilly, Charles. "War Making and State Making as Organized Crime." In *Bringing the State Back In*, edited by Peter Evans, Dietrich Rueschemeyer, and Theda Skocpol, 169–91. Cambridge: Cambridge University Press, 1985.

Townsend, David. *The "Alexandreis" of Walter of Châtillon: A Twelfth-Century Epic.* Philadelphia: University of Pennsylvania Press, 1996.

Tritle, Lawrence. "Alexander and the Greeks: Artists and Soldiers, Friends and Enemies." In *Alexander the Great: A New History*, edited by Waldemar Heckel and Lawrence Tritle, 121–40. Malden, MA: Wiley-Blackwell, 2009.

Tronson, Adrian. "The 'Life of Alexander' and West Africa." *History Today* 32 (1982): 38–41.

Troxell, Hyla. *Studies in the Macedonian Coinage of Alexander the Great.* New York: American Numismatic Society, 1997.

Tsimbidou-Avloniti, Maria. *Μακεδονικοί τάφοι στον Φοίνικα και στον Άγιο Άθανάσιο Θεσσαλονίκης.* Athens: TAPA, 2005.

Tsingarida, Athena, and Didier Viviers, eds. *Pottery Markets in the Ancient Greek World.* Brussels: CReA-Patrimoine, 2013.

van der Spek, R. J. "The Astronomical Diaries as a Source for Achaemenid and Seleucid History." *Bibliotheca Orientalis* 50 (1993): 92–101.

van der Spek, R. J. "Palace, Temple and Market in Seleucid Babylonia." In *Le roi et l'économie*, edited by Véronique Chankowski and Frédérique Duyrat, 303–32. Paris: de Boccard, 2004.

van der Spek, R. J. "How to Measure Prosperity? The Case of Hellenistic Babylonia." In *Approches de l'économie hellénistique*, edited by Raymond Descat, 287–310. Paris: de Boccard, 2006.

van der Spek, R. J. "The 'Silverization' of the Economy of the Achaemenid and Seleukid Empires and Early Modern China." In *The Economies of Hellenistic Societies, Third to First Centuries*, edited by Zofia Archibald, John Davies, and Vincent Gabrielsen, 402–20. Oxford: Oxford University Press, 2011.

van der Spek, R. J., B. van Leeuwen, and J. L. van Zanden, eds. *A History of Market Performance from Ancient Babylonia to the Modern World.* New York: Routledge, 2015.

von Reden, Sitta. "Money in the Ancient Economy: A Survey of Recent Research." *Klio* 84 (2002): 141–74.

von Reden, Sitta. *Money in Ptolemaic Egypt.* Cambridge: Cambridge University Press, 2007.

von Reden, Sitta. *Money in Classical Antiquity.* Cambridge: Cambridge University Press, 2010.

Waterfield, Robin. *Dividing the Spoils: The War for Alexander the Great's Empire.* Oxford: Oxford University Press, 2011.

Waxman, Sharon. *Loot: The Battle over the Stolen Treasures of the Ancient World.* New York: Times Books, 2008.

Wheeler, Mortimer. *Flames over Persepolis: Turning Point in History.* New York: William Morrow, 1968.

Wilcken, Ulrich. *Alexander the Great.* 1931. Reprint, New York: Norton, 1967.

Williams, John. *The Life of Alexander the Great.* New York: A. L. Burt, 1902.

Wilson, Joseph. "The Cave That Never Was: Outsider Archaeology and Failed Collaboration in the USA." *Public Archaeology* 11 (2012): 73–95.

Worthington, Ian. "How 'Great' Was Alexander?" *Ancient History Bulletin* 13 (1999): 39–55.

Worthington, Ian. "Alexander and 'the Interests of Historical Accuracy': A Reply." *Ancient History Bulletin* 13 (1999): 136–40.

Worthington, Ian. *Alexander the Great: Man and God.* London: Pearson, 2004.

Worthington, Ian. "Alexander the Great and the Greeks in 336? Another Reading of IG ii² 329." *Zeitschrift für Papyrologie und Epigraphik* 147 (2004): 59–71.

Worthington, Ian. *Philip II of Macedonia.* New Haven, CT: Yale University Press, 2008.

Wüst, F. R. "Die Rede Alexanders des Grossen in Opis." *Historia* 2 (1953/1954): 177–88.

Zervos, Orestes. "Additions to the Demanhur Hoard of Alexander Tetradrachms." *Numismatic Chronicle* 140 (1980): 185–88.

Zournatzi, Antigoni. "The Processing of Gold and Silver Tax in the Achaemenid Empire: Herodotus 3.96.2 and the Archaeological Realities." *Studia Iranica* 29 (2000): 241–72.

INDEX

Abbott, Jacob, 150–51
Abdera, 47
Abisares, 92, 183
Abydus, 162
Acesines River, 14, 107, 183, 191
Achaea, 182
Achaemenids. *See also* Persian Empire
 Alexander's gifts to, 99
 Alexander's preservation of the
 administrative system of, 144, 164
 archaeological ruins from the dynasty
 of, 81–84
 misfortunes of, 68–69
 coins issued by, 140, 162, 164, 166, 168
 Egypt conquered by, 56
 Pasargadae treasures of, 88
 Persepolis palace of, 79–80
 tribute paid to, 153–54, 164–65
 wealth of, 91
Achilles, 31
Ada of Curia, 227n13
Adventure Story (Rattigan), 150
Aegae (modern Vergina), 34, 47, 188
Aegean Sea, 113
Aeolis, 53, 188
Afghanistan, 10, 110–11, 138
Agalasseis, 183
Aiani, 34

Ai Khanoum, 110–11
Ake. *See* Tyre
Albania, 1
Alcetas, 143
Alexander (film, 2004), 73
Alexander Entering Babylon (Le Brun), 72–73
Alexander II (uncle of Alexander
 the Great), 69
Alexander IV (son of Alexander
 the Great), 37, 69, 141
Alexander Romance, 102
Alexander the Great
 armies of, xiii, 13–15, 19, 40, 46–72,
 74–80, 83–92, 94, 106, 113–27,
 138–39, 143–44, 147–54, 157,
 175–76, 214n27
 ascension to the throne of, 24
 Asia Minor campaigns of, 46, 50–55
 athletic contests sponsored by, 102–3,
 188, 190–92
 Balkan campaigns of, 46–49
 banquets of, 105–6, 115, 188, 190, 193
 Battle of Issus and, 30–31
 burials accorded by, 16–17, 35–36, 38,
 96, 109, 113, 187–92
 cash flow problems of, 41–43, 175
 Cleomenes pardoned by, 136, 141
 Darius III compared to, 17, 27–29

Alexander the Great (*Cont.*)
 death of, 69, 118, 141
 early modern representations of, 149
 as "enlightened leader," 156–57
 entertainment for, 102–5, 119,
 188, 190–92
 generosity and, 40–41, 96–97, 99
 gifts from, 40, 51, 64, 89, 92, 95–99,
 101–2, 105, 114, 122, 187–93
 gifts to, 8–9, 45, 72, 75–76, 91–94, 227n13
 Greek interpretations of the career
 of, 147
 heirs of, 141
 Horus name of, 58
 "humble origins" story of, 23–28, 32,
 39, 43, 118
 Iliad copy of, 31, 177
 infrastructure spending by, 95–96,
 110–12, 177, 189–93
 inheritance from Philip of Macedonia
 to, 17, 23–27, 32, 34, 37, 39, 46, 67
 loans to, 40–41
 looting and plundering by the forces of,
 xiii–xiv, 15, 20–22, 35, 40–41, 44–46,
 48–51, 55–64, 66–72, 74–75, 77–81,
 83–90, 94, 98, 122, 126–27, 138–39,
 142–44, 146–54, 157, 165, 175–76,
 180–85, 205n85
 management record of, xiii, 118–27,
 131–41, 144–45, 154–56, 175–76
 military spending by, 96, 112–18, 120–21,
 124, 126, 142, 177, 188–89, 192
 military training of, 42
 as "modern CEO," 154–56,
 176–77, 241n48
 monetization and, 152–54, 157–69,
 171–73, 175, 177, 180
 Opis Address (324 BC) of, 24–27,
 33–34, 43, 109
 Persian dress and protocols of, 97–98, 114
 Persian Empire campaigns and
 conquests of, 1, 5–6, 26, 32–34, 39–41,
 46, 50–63, 68–72, 74–80, 83–91,
 93–94, 99, 114, 120–21, 124, 126–27,
 137–39, 144, 146, 148–50, 152–53,
 157, 162–63, 165–67, 171, 180

 purported graves of, 7
 razing of cities by the forces of,
 62–63, 65–66
 religious offerings and temples of,
 95–96, 107–10, 115, 117, 188–92
 rents and taxes canceled by,
 51–52, 54, 96
 slaughter of noncombatants by forces of,
 xiii, 62, 64, 151
 spending by, 95–96, 104–5, 107–21,
 124–26, 142, 177, 187–93
 statues of Asia Minor campaign
 casualties and, 51
 Susa debt payment (324 BC) by, 10, 15,
 27, 124–27, 192
 Thrace and Illyria campaigns of, 46–47
 Timoclea and, 49
 tribute payments to, 53–54, 60, 69, 71,
 118, 164
 wealth of, xiii–xiv, 6–9, 11, 14–15,
 18–24, 27, 32–34, 37, 39–41, 43–45,
 52, 67, 72–73, 85, 93–96, 101, 105–6,
 117–18, 137, 141, 144, 146, 150,
 152–53, 157, 174, 176–77, 180–85
"Alexander the Great: 2000 Years of
 Treasures" (Sydney, Australia
 exhibit), 7
"Alexander the Great and the Unity of
 Mankind" (Tarn), 22
"Alexander the Monster" (Gabriel), 22
Alexandria (Arachosia), 110
Alexandria (Aria), 110
Alexandria (Egypt), 108, 110, 134–36, 162
Alexandria (Susiana), 110
Alexandria (The Caucasus), 110
Alexandria Eschate (Sogdiana), 110–11
Alexandria-Nicaea, 110
Alexandria on the Acesines, 110
Alexandria on the Oxus, 110–11
Alexandria-Xylinepolis, 110
Alexandropolis, 46
Alexis of Tarentum, 103
Amathus, 162
The Americas, 5, 154, 157
Ammon, 58, 107, 109, 188
Amphipolis, 109, 162, 172, 174–75

Amphitrite, 107
Amyntas son of Antiochus, 55-56, 71, 142
Anaxarchus, 190, 193
Ancient Greek Military Practices
 (Pritchett), 44
Andreades, Andreas, 116
Andronikos, Manolis, 36–37
Antela-Bernárdez, Borja, xiv
Antigenes the One-Eyed, 126
Antigonus One-Eyed, 119, 142–45
Antimenes of Rhodes, 133–34,
 136–37, 156
Antiochus II, 171
Antipater, 41, 50, 52, 114, 188, 192
Antiphanes, 53
Antisthenes, 68
Aornus, 107, 190
Aperghis, G.G., 174
Aphrodite Pythionice temple
 (Babylon), 131
Apis, 107
Apollo, 48, 107, 159
Arachosia, 110, 122, 138–39, 190
Aradus, 162, 182
Araxes River, 112, 189
Arbela, 71, 75, 94, 182
Arbis, 191
Aria, 60, 110, 182, 189–90
Ariamazes, 182
Ariaspians, 101, 190
Arigaeum, 110, 190
Ariobarzanes, 79
Aristagoras, 77
Aristides, 48
Aristobulus, 10, 32–33
Aristocrates of Thebes, 103
Aristocritus, 104
Ariston, 104, 189
Aristonicus, 104, 109, 190
Aristonymus, 103
Aristophanes, 11
Aristotle, 20, 99, 105, 146, 158, 193
Arrhidaeus. See Philip III Arrhidaeus
Arrian of Nicomedia
 on Alexander's campaigns in Thrace and
 Illyria, 46–47

on Alexander's capture of Greek envoys
 to Persia, 102
on Alexander's construction of a
 navy, 112
on Alexander's correspondence with
 Darius III, 70
on Alexander's generosity, 97
on Alexander's payment of debts at
 Susa, 125
on Alexander's pillaging of Issus, 57
on Alexander's sack of Persepolis, 79–80
on Cleomenes, 134, 136
on Darius III's thoughts regarding
 Alexander and looting, 72
on the death of horses at battle of
 Gaugamela, 61
on Harpalus's extravagance at
 Babylon, 130
on the looting of Persepolis, 85
on Malli's gifts to Alexander, 92
on Opis speech of Alexander, 25, 33–34
on Persian mercenaries fighting for
 Macedonia, 115–16
quantifications in the work of, 11,
 14–15, 25, 76, 92, 202n40, 203n56,
 209n54, 225n113
on Susa's gifts to Alexander, 76, 90
Arsames, 54
Arsites, 52
Artacana, 189
Artaxerxes III Ochus, 68
Artaxerxes IV Arses, 68
Artaxerxes V (Bessus), 68
Artemis, 107–8
Asclepiodorus, 53, 75
Asclepius, 107
Asia Minor. See also specific locations
 Alexander's campaigns in, 46, 50–55
 minting of coins in, 162–63
 Persian military forces in, 54–55
 Philoxenus as financial overseer in, 133
Aspendus, 53–54, 182
Assyrian Empire, 1, 143
Atarrhias the One-Eyed, 126
Athena, 21, 51, 107–8, 161
Athenaeus, 11, 95

Athena on Gold Coin of Alexander
 (Münzkabinett, Staatliche Museen), 21
Athenodorus, 103–4, 189
Athens
 Alexander's campaigns and, 78–79
 Athenodorus fined by, 104
 coins issued by, 6
 food prices and shortages in, 135
 Harpalus's bribes in, 131–32
 loot returned to, 188–89
 Persian panoplies in the Parthenon at, 51
 Persians' destruction (5th century BC)
 of, 80, 84–85
 tombs in the culture of, 35
Athribis, 109, 188
Audran, Gérard, 72–73
Augustine, 22, 148
Augustus, 175
Austin, Michel, 155–56

Baal-Marduk temple (Babylon), 109
Babylon. *See also* Babylonia
 Alexander's campaigns and conquests
 in, 9, 23, 32, 64, 72–75, 77–79, 89–90,
 94, 120, 139
 Alexander's death in, 118
 Alexander's return from India to, 140
 Antigonus's looting at, 144
 Aphrodite Pythionice temple in, 131
 Baal-Marduk temple complex in, 109
 coins minted at, 9, 162, 172
 commodity prices in, 174
 Greek ambassadors' gifts to
 Alexander in, 93
 Hanging Gardens in, 72
 Harpalus in, 130–31, 138, 192
 looting of, 58, 72, 74, 89–90, 94, 182–83
 Persian mercenaries fighting for
 Macedonia in, 115–16
 Persian royal treasury in, 72, 74, 90, 129
 wealth of, 74
Babylonia. *See also* Babylon
 Alexander's campaigns and
 conquests in, 55
 Alexander's construction of harbors
 in, 112

 satraps of, 55, 75
 tribute collection in, 53, 134
Bactra
 Alexander's order to burn loot at, 92,
 122, 127, 140
 Spitamenes's plundering of, 190
Bactria
 Alexander's campaign and conquest in,
 63, 121, 130, 137–40
 Alexander's construction
 of settlements in, 190
 cattle raids against Alexander's
 forces in, 121
 coin hoards in, 171
 Darius III's flight toward, 14
 Greek resettlement following
 conquest of, 63
 inventories from, 10
 livestock requisitioned by Alexander's
 forces at, 61, 217n100
 local tribal leaders in, 53
 monetization in, 172
 Persian retreat toward, 55
 as Persian satrapy, 164
 razing by Alexander's forces of, 63
 Thessalian cavalry at, 120
Badian, Ernst, 26
Bagoas, 93
Bagophanes, 72
Bahariya Oasis, 58, 109, 188
Bajaur, 183
Balacrus, 162
The Balkans
 Alexander's infantry units from, 74–75
 bimetallic currency in, 159
 bullion from, 171–72
 looting in, 46–49
 slavery and, 66
Beas, 183
Begram (Afghanistan), 110
Beloch, Karl Julius, 116
Berry, Steve, 7
Bessus, 121, 138, 190
Boccaccio, Giovanni, 149
Boeotian League, 48
Bolon, 139

Borza, Eugene, 19
Bose, Partha, 156
Bosworth, A.B., 65, 151
Branchidae, 63, 182
British Museum Alexander coins, 172
Bucephala, 110
Bucephalus (Alexander the Great's horse),
 27, 61, 93, 189
Bulgaria, 47
Burning of Persepolis (Rochegrosse), 77–78
Bust of Alexander (Pella), 4
Byblus, 162

Calanus, 109, 192
Calas, 52–53
Callisthenes, 10, 104, 155
Caphisias, 103
Caria, 133, 182
Carmania, 122, 191–92
Carrhae, 172
Caspian Sea, 112
Cato the Younger, 259n185
Chaeronea, 13
Chardin, Jean, 150
Chares of Mitylene, 10, 18, 28, 103
Charicles, 131
Charidemus, 29–30
Charles I (king of England), 149
Chaucer, Geoffrey, 149
Choerilus, 193
Chrysopolis, 6, 188
Cicero, 21–22, 147–48, 151, 157, 238–39n4
Cilicia, 54, 64, 70, 143, 163
Citium, 162
Clarke, Samuel, 150
Cleitus, 106, 155
Cleomenes, 77, 134–37, 141, 156
Cleopatra (daughter of Philip II, 99
Cleopatra (queen of Egypt), 7
Cleopatra (wife of Philip II), 69
Clitomachus, 102
Coenus, 106, 109, 191
Coeranus, 133
coins
 Alexander's gifts of, 101–2
 atmospheric lead data and, 167–68

 burials with, 37–38
 Cyrus's traditional gift of, 101
 Darius Vase's depiction of, 12–13, 29
 durability of, 19
 hoards of, 168–73, 175
 images on, 159–62
 minting of, 9, 75, 89, 140,
 157–67, 171–72
 obverse dies for minting of, 164–65
 payment of debts in, 126
 from Persepolis, 83, 85–86, 88
 Persian Empire's issuing of, 140,
 162–64, 166, 168
 as source of information about
 Alexander's empire, xiv, 8–10, 19–20,
 140, 161, 163–74
 as spoils of war, 57, 70
 Susa's treasures seized by Alexander in,
 76–77, 85
Colophon, 162
Corinthian League, 46
Cossaea, 192
Craterus, 122, 143
Cratinus, 103
Croton, 101, 189
Curteis, Arthur, 153
Curtius
 on Alexander's burning of Persepolis, 80
 on Alexander's conquests and looting of
 Persia, 5, 60, 68–69, 80 85–86, 90
 on Alexander's gifts to soldiers at
 Ecbatana, 89–90
 on Alexander's payment of debts at
 Susa, 125
 on Alexander's rewards to soldiers, 74
 on Babylon's wealth, 74
 on corrupting influence of Persian
 culture on Macedonia, 105
 Damascus looting recounted by, 57
 Darius III depicted by, 29–30
 on Malli's gifts to Alexander, 93
 on mismanagement in Alexander's
 empire, 119
 on Opis speech of Alexander, 25, 33–34
 Persepolis looting recounted by, 60, 68,
 83–86, 90

Curtius (*Cont.*)
 on Philotas, 138–39
 quantifications in the work of, 11,
 14–15, 25, 76–77, 85, 89–90, 209n54,
 216n75, 225n113, 226n129
 on Susa's treasures seized by Alexander,
 76–77, 90
Cyinda, 70, 143
Cynnane, 69
Cyprus, 55, 162
Cyrene, 182
Cyril, 146
Cyrnus, 109
Cyropaedia (Xenophon), 44
Cyropolis, 62, 114
Cyrus (king of Persia), 14, 93, 101, 109, 192
Cyzicus, 50

Damanhur, 172
Damascus
 Darius's captured entourage at, 106
 looting by Alexander's forces at, 56–57,
 60, 70, 87, 94, 120, 128, 182
 minting of coins at, 162
 Parmenion's role in the conquest of,
 10, 57, 87
Dante Aligheri, 149
Danube River, 107, 187
darics (Persian coins), 159, 180
Darius I (king of Persia), 29, 82
Darius III (king of Persia)
 Alexander compared to, 17, 27–31, 43,
 105, 152
 Alexander's capture of family
 members of, 57
 Alexander's gifts to family
 members of, xiii, 99
 armies of, 29–30, 55
 Battle of Gaugamela and, 58, 166–67
 Battle of Issus and, 30–31, 51, 56, 70,
 128, 160
 burial of, 109, 189
 burials of family members of, 188–89
 coins issued by, 163
 death of, 68, 89
 Dionysodorus's appeal to, 102
 flight from Ecbatana by, 88
 flight from Media and, 89

flight toward Bactria by, 14
flight to Media by, 71
mutiny against, 55
Persepolis' fall and, 77–78
poverty after losses in battle of, 72
Susa lost by, 72
tribute payments to, 53
wealth of, 17, 28–31, 40, 70–71, 94,
 97, 105–6
Darius Vase, 12–13, 29
Davies, J.K., 168–71
debt
 Alexander's payment at Susa (324 BC)
 and, 10, 15, 27, 124–27, 192
 among Alexander's army, 124–27
 at Caria, 133
 gambling and, 127
 in Macedonia at Alexander's
 ascension, 25, 32
de Callataÿ, François, 6, 26, 164–67
Deipnosophistae (Athenaeus), 95
Delos, 109
Delphi, 109, 190, 224n90
Demaratus, 109, 190
Demosthenes, 34–35, 132, 134–35
Derveni, 34
Dicaearchus, 131
Diodorus of Sicily
 on Alexander's army size, 13–14
 on Alexander's conquest of
 Thebes, 5, 49
 on Alexander's gifts to soldiers at
 Ecbatana, 89–90
 on Alexander's payment of debts at
 Susa, 125
 on Alexander's Persianizing policies, 98
 on Alexander's rewards to soldiers, 74
 on Alexander's "unimaginable"
 wealth, xiv
 on Harpalus's extravagance at
 Babylon, 130
 Persepolis looting recounted by, 59, 80,
 85–86, 90
 on Philip II's extravagance, 25
 on Philip II's minting of coins, 180
 quantifications in the work of, 11,
 14–15, 75–76, 85–86, 89–90, 180,
 202n41, 213n24, 214n27, 225n113

on self-immolation of Sidonians,
216–17n88
on Susa's gifts to Alexander, 75–76, 90
on Susa's surrender to Alexander, 72
Diodotids, 171
Diomedes, 32, 157
Dion, 34, 109, 188
Dionides, 149
Dionysius, 103
Dionysodorus, 102, 134
Dionysus, 107
Diophantus, 103
Dioscuri, 107
Dioxippus, 104
Dodona, 109
Domenichino, 49
Drangiana, 122
Droysen, Johann Gustav, 152, 157,
165, 171–72
Duris, 32–33
Duruy, Victor, 152
"Dynastic Prophecy"
(Babylonian chronicle), 71

Ecbatana
Alexander's campaigns and conquests
at, 72, 78, 88–90, 94, 120
Alexander's order to bring plunder to,
87–88, 130, 137–40
Alexander's rewards to soldiers at,
114, 120
Antigonus's looting at, 144
athletic games at, 192
coins minted in, 89, 172
funerals at, 189
looting of, 78, 88–90, 94, 114,
182–83, 189
mass funeral at, 109
palace at, 89
Thessalian Cavalry discharged at, 61
wealth of, 89
Economics (treatise), 135, 158, 163
Egypt
Alexander's conquests in, 1, 58, 71,
94, 122
Alexander's settlements in, 111
Alexander's shrines and temples to
Greek gods in, 108–9, 135

Cleomenes as financial overseer
in, 134–36
coin hoards in, 168, 172
Greek mercenaries in, 53, 55
Hellenistic Age kingdom in, 5, 142
looting by Alexander's forces of, 55,
94, 128
minting of coins in, 162
Moses' exile from, 66
Persian rule of, 55–56
Roman conquests in, 5
satrapy of, 55, 71
Seleucus's flight to, 144
wealth of, 1
Elis, 182
Engels, Donald, 87
Ephesus, 53, 107–8, 188
Ephippus, 18, 107
Epidaurus, 107, 192
Epigoni, 14
Erasmus, Desiderius, 149
Erigyius, 109, 128, 190
Eugnostus, 53
Eumenes
Antigonus's war with, 143–44
disdain for entertainers by, 105
fortune hidden in the tent of, 41, 94,
105, 112
looting in India by, 65
as trierarch (naval builder), 112
Euphrates River, 112–13, 177, 189
Europa (half-sister of Alexander
the Great), 69
"Eurydice tomb" (Vergina), 37
Eurylochus, 190
Evagoras, 53, 231n92
Evius, 103, 105

Finley, Moses, 20
Flatterers of Alexander, 104
Forbes, Steve, 155
Franz, Daniel, xiv, 20
Fraser, P.M., 110

gambling, 127
Gast, John, 150
Gate of All Nations
(Persepolis), 82

Gaugamela
 Alexander's pardoning of soldiers
 at, 105
 Alexander's rewards to soldiers at, 114
 Alexander's victory at, 71–72, 166–67
 Darius III's order to burn areas near, 55
 death of horses at battle of, 61
 looting at, 51, 58–59, 71, 74, 94, 105,
 114, 120, 182
 size of Alexander's forces at, 75
 Thessalian cavalry at the battle of, 120
Gaza
 Alexander's gifts to his mother from, 98
 captives after the siege of, 57–58
 cost of siege at, 114
 looting of, 94, 182
 razing by Alexander's forces of, 62
 sacrifices at, 188
Gedrosian Desert, 64, 122–23, 140, 191
Gedrosians, 101, 190
Glaucus, 32, 157
Glycera, 131
Gobares, 88
Gold Larnax from Vergina, 38
Gordium, 70, 94, 182
Gower, John, 149
Granicus River
 Alexander's gifts to his mother
 following battle of, 98
 battle (334 BC) at, 50–52, 69
 looting near, 51, 69, 94, 182
 size of Alexander's army at, 14
 Thessalian cavalry at the battle of, 120
Great Tumulus tombs (Vergina), 36–39
Green, Peter, 129, 153
Griffith, G.T., 26
Grote, George, 86
Gryneium, 50, 181
Gymnosophists, 191

Hadish (Xerxes's residential palace), 84
Hagnon, 106
Hall of a Hundred Columns (Persepolis
 Palace), 82, 84
Hammond, Nicholas, 153
Hanging Gardens of Babylon, 72

Harpalus
 Alexander's boyhood friendship
 with, 128
 in Babylon, 130–31, 138, 192
 bribery by, 131–32
 Calas and, 52
 at Ecbatana, 138
 embezzlement by, 132–33, 136,
 140–41, 167
 extravagance of, 130–31
 Macedonian court connections
 of, 127–28
 murder of, 132
 Parmenion and, 237n102
 Pythionice and, 131
 sexual intrigues of, 130–31
 as treasurer of Alexander's empire, 52,
 127–33, 136–38, 140–41, 145, 156
Hatzopoulos, Miltiades, 41
Heckel, Waldemar, 129–30
Hector, 109–10, 189
Helios, 107
Hellespont, 107, 162, 188
Hephaestion, 107, 109, 136, 141, 192
Heraclitus, 103
Herakles (alleged son of Alexander the
 Great), 37, 69
Herakles (Greek mythology), 107,
 161–62, 189
Herishef, 56
Hermolaus, 138–39
Hermopolis, 109, 168
Herodotus, 11, 29, 31, 77, 202n41
Herzfeld, Ernst, 81
hetairoi (king's companions), 40–41, 52,
 97–98, 112, 188
Hindu Kush Mountains, 122–23, 140, 190
Holcias, 142–43
Homer
 gifts and camaraderie in the works
 of, 97–98
 Iliad of, 31–32, 157, 177
 quantifications in the work of, 11
 horses, death of, 61–62
Howgego, Christopher J., 154
Hubbard, L. Ron, 7

Hydaspes, 63, 107, 114, 183, 190–91
hypaspists (elite infantry force), 115
Hyperbolus, 103
Hyphasis River, 107, 191
Hyrcania, 189, 192

The Iliad (Homer), 31–32, 157, 177
Illyria, 46–47, 181
India
 Alexander's campaigns and conquests
 in, 1, 41, 63–66, 91–94, 113, 122–24,
 127, 130, 137, 140
 Alexander's construction in, 112
 Alexander's gift-giving in, 191
 Alexander's return from, 132, 136, 163
 Alexander's settlements in, 110–11
 armies raised by, 14
 coin hoards in, 171
 gifts to Alexander from, 91–93
 Hellenistic Age kingdoms in, 142
 looting in, 65, 94, 122
 monetization in, 171–72
 monsoons in, 114
 resistance to Macedonian
 forces in, 65
Indian Ocean, 112
Indus Valley. See also India
 Alexander's building along, 112
 Alexander's campaigns and conquests
 in, 65, 91, 93, 107, 113, 122, 140
 Alexander's settlements in, 110
 Alexander's spending in, 190–91
 animal sacrifices in, 107
The Inferno (Dante), 149
Inventory of Greek Coin Hoards
 database, 171
Ionia, 53, 188
Issus
 Alexander's victory over Darius III at,
 30–31, 51, 56, 70, 128, 160
 burials and sacrifices at, 188
 changes in allegiances after battle at, 55
 looting of, 51, 56–57, 70, 94, 182
 mass funeral at, 109
 Semtutefnakht at the battle of, 56
 Thessalian cavalry at the battle of, 120

Issus Mosaic (Pompeii), 61–62, 129
Isthmian Games at Corinth, 102

Jamzadeh, Parivash, 99
Jaxartes River, 107, 190
Jesus Christ, 173
John of Salisbury, 148
Jones, A.H.M., 7, 11
Judaism, 149
Julius Caesar, 22
Justin (Roman author)
 on Alexander's payment of debts at
 Susa, 125
 on Alexander's plunder in the Persian
 Empire, 40, 85
 on the looting of Persepolis, 85
 on Philip II's extravagance, 26
 Pompeius Trogus and, 11
 quantifications in the work of, 11,
 14–15, 76, 90
 on Susa's treasures seized by
 Alexander, 76

Kandahar (Afghanistan), 110
Keynes, John Maynard, 154
Kingsley, Bonnie, 129–30
Kremydi-Sicilianou, Sophia, 6
Kwarteng, Kwasi, xiv–xv
Kyme, 48

Lake Copais, 193
Lampsacus, 50, 53, 162
Langarus, 187
Laomedon, 128
Le Brun, Charles, 72–73, 77
Le Clerc, Sébastien, 73, 77
Leonidas, 58, 99, 107, 188
Le Rider, Georges, xiv, 116, 137–38, 140,
 163, 237n102
The Life of Alexander the Great (Rollin), 146
L'Incindie de Persépolis
 (Rochegrosse), 77–78
Louis XIV (king of France), 72
Lucan, 148
Lucas, George, 7
Luke, Gospel of, 1

Lukovit Treasure, 47
Lydgate, John, 149
Lydia, 53
Lykon, 102, 104, 189
Lysanias, 46
Lysimachus, 99, 109, 119, 168
Lysippus, 51, 188

Mably, Abbé, 150
Maccabees, Book of, 6
Macedonia
　Alexander's gift-giving in, 98–99
　Alexander's stewardship during Philip's
　　absence (340 BC) and, 46
　armies of, xiii, 13–15, 19, 26, 29–31, 40,
　　42–43, 46–72, 74–80, 83–92, 94, 106,
　　113–27, 138–39, 142–44, 147–54,
　　157, 175–76, 214n27
　ascendancy of, 23–24, 42
　coins minted in, 159–63, 166,
　　168, 171–72
　court luxury in, 101
　financial problems of, 25–27, 32
　Holcias's mutiny (319 BC) and, 142–43
　imperialism of, 152
　jealousy in, 97
　Persian soldiers fighting for, 115–16
　purple in the culture of, 98
　Roman conquests in, 5
　taxes in, 26
　tombs in the culture of, 34–36, 173
　trade in, 26
Machiavelli, Niccolò, 149–50
Maedi, 46
Magarsus, 188
Magnesia, 162
Mali Empire, 6
Malli, 92, 183, 191
Mallus, 54, 78, 107, 188
Maracanda, 190
Marc Antony, 7
"March to the Sea" (U.S. Civil War, 1864), 64
Mardians, 93, 182
Mardonius, 31
Margiana, 190
Maroneia, 47

Matthew, Gospel of, 150
Mazaces, 55–56, 71
Mazaeus, 72, 75
Meadows, Andrew, 20, 116–17
Mediterranean Sea, 112
Mediterranean world. *See also specific
　locations*
　food shortage (331-324 BC) in, 135
　gold and silver's impact on, 19
　trade in, 134–35
Meleager, 47, 92, 121–23, 141–42
Memnon, 50, 54
Memphis, 55, 71, 94, 163–64, 182, 188–89
Mesopotamia, 24, 72, 140, 144, 192. *See
　also* Babylon
Meyer, Michael, 154–55
Midas, 6, 70
Midianites, 66
Miletus, 53, 113, 162, 182
Milns, Robert, xiv, 117
Milton, John, 149
Mithrines, 69
Montesquieu, 152
Moralia (Plutarch), xv, 23, 32
Morris, Ian, xv–xvi
Moses, 66
Mubarak I (sultan of India), 6
Muses, 107
Musicanus, 65, 93, 183
Myriandrus, 162
Mytilene, 54, 103, 189

Nabarzanes, 182
Nearchus, 10, 113, 128, 191, 202n40
Nereids, 107
Nereus, 107
Nesaean Plain, 183, 192
New World. *See* The Americas
Nicaea, 190
Nicanor, 109, 189
Nike, 161
Nikias, 53, 69
Nile River, 112
Nizami, 149
numismatics. *See* coins
Nysa, 190

Olympias, 51, 69, 98–99, 105,
 188–89, 227n13
Olynthus, 42
Onesicritus, 10, 32–33, 65, 231n92
opheleia (Greek word for "profit" and
 "plunder"), 20–21
Ophellas, 136–37
Opis
 Alexander's address (324 BC) at, 24–27,
 33–34, 43, 109, 207n21
 banquet and bonus for veterans at, 192
Ora, 183
Oreitae, 183
Oriental Institute at the University of
 Chicago, 81
Orxines, 93, 183, 226n129
Oxus River, 110–11, 120, 123, 190
Oxycanus, 183

Pack'n Plunder (game), 7
Pakistan, 138
Pallacotta Canal, 192
Panagjurishte Treasure, 47
Paphos, 162
Paradise Lost (Milton), 149
Parmenion
 Damascus seized and looted by, 10,
 57, 60, 70
 death of, 155
 Gaugamela victory and, 71, 166
 Gift of estate for, 189
 Gryneium siege (335 BC) and, 50
 Harpalus and, 237n102
 loot at Ecbatana and, 87, 138
 sack of Persepolis and, 79–80
Parmeniscus, 134
Paropamisadae, 164, 171
Parysatis, 69
Pasargadae, 87–90, 94, 137, 182, 192
Patala, 191
Patali, 183
Pausanias, 69, 131
Pella, 4, 34–35, 48, 162.
Peloponnesus, 188
Perdiccas, 40, 142
Perilaus, 193

Peritas, 193
Persepolis
 Alexander's conquest of, 15, 48, 59–60,
 66, 68, 72, 77–81, 83–90, 94, 120,
 122, 130, 137–39, 148–49, 166–67,
 176, 180, 182, 223n65
 Alexander's forces looting of, 59–60,
 68, 77–80, 83–90, 94, 120, 130,
 137–38, 148–49, 166–67, 176, 180,
 182, 223n65
 Antigonus's looting of, 144
 apadana reliefs at, 82–84
 archaeological ruins and excavations at,
 81–84, 86
 burial of Darius III at, 189
 coins from, 83, 85–86, 88
 Gate of All Nations in, 82
 palace at, 79–85, 182
 ruins of, 81
 wealth of, 59, 68, 77, 79, 85–86, 180
Persian Empire
 Alexander's campaigns and conquests
 in, 1, 5–6, 26, 32–34, 39–41, 46,
 50–63, 68–72, 74–80, 83–91, 93–94,
 99, 114, 120–21, 124, 126–27,
 137–39, 144, 146, 148–50, 152–53,
 157, 162–63, 165–67, 171, 180
 Alexander's gift-giving practices in,
 99, 101
 Alexander's preservation of the
 administrative system of, 144, 164
 armies of, 29–31
 Asia Minor territories of, 50–55
 coins issued by, 140, 162–64, 166, 168
 Greek resettlement in conquered areas
 of, 62–63
 naval warfare against, 113
 Philip II's campaigns against, 24, 144
 satrapies in, 52–53, 55
 wealth of, 28–31, 59, 68–70, 77, 79,
 85–86, 106, 124, 146, 152–54, 157,
 163, 167, 171, 174, 180
Persian War (fifth century BC), 29
Persis, 79, 89, 93, 101
Petrarch, 149
Phegeus, 92, 183

Phila, 128
Philip (physician of Alexander the Great),
 99, 188
Philip (satrap of Sogdiana), 109–10, 190
Philip II (Philip of Macedonia)
 Alexander's boyhood friends banished
 by, 128
 Alexander's inheritance from, 17, 23–27,
 32, 34, 37, 39, 46, 67
 Alexander's military training and, 42
 Alexander's pyramid planned for, 117
 armies of, 13, 26, 42, 46–47, 50, 52
 Asia Minor campaigns of, 50, 52
 assassination of, 24, 35, 69
 burial of, 109
 cash flow problems of, 42
 coin hoards and, 168, 171
 extravagant spending by, 25–26
 gold and silver mining promoted by, 26
 looting and plunder by the forces of,
 46–47, 50, 70
 monetization and, 158–60, 163, 166,
 168, 171, 180
 Persia campaigns of, 24, 144
 possible graves of, 36–38
 Triballi attack on the forces of, 47
 wealth of, 42, 144
Philip III Arrhidaeus
 Babylon temple construction and, 109
 coin hoards and, 168, 171
 murder of, 69
 possible tomb of, 37
 succession of Alexander the Great
 and, 141
Philippeioi (Macedonian coins), 159
Philippi, 26, 34
Philistides, 103
Philonides, 104
Philotas, 46, 106, 138–39
Philoxenus, 133, 136–37, 156
Phocion, 193
Phoenicia, 75, 133, 163
Phormion, 104
phoros (tribute), 53–54
Phrasimelus, 104
Phrygia, 53, 70, 182

Phrynichus, 103
Phylarchus, 33
Pindar, 48, 95
Pizzaro, Francisco, 154
Plataea, Battle of (479 BC), 31
Plataeans, 189
Plato, 20
Plutarch of Chaeronea
 Alexander and Darius III comparison
 by, 17, 28, 30–31, 97
 on Alexander's campaigns in Babylon
 and Susa, 23, 32–34
 on Alexander's founding of cities, 110
 on Alexander's payment of debts at
 Susa, 125
 on Alexander's raising money from
 Eumenes, 41
 Alexander's virtues championed by, xv,
 17, 22–23, 32–33, 39, 43, 97, 105, 148,
 150–52, 157, 159–60
 baggage trains described in, 87
 Battle of Issus account of, 30–31
 on Harpalus's extravagance, 131
 on looting of Bactria and Sogdiana, 63
 on looting of Damascus, 57, 60
 on looting of Persepolis, 85–87
 quantifications in the work of, 11, 15,
 32, 51, 76, 85–87, 148, 209nn54–55,
 225n113
 sources of, 33, 209n54
 on Susa's treasures seized by
 Alexander, 76, 85
Pnytagoras, 188
Polybius, 11, 147, 202n41
Polycleitus, 18, 76, 180
Polytimetus River, 62, 109, 190
Pompeii, 61
Pompeius Trogus of Gaul, 11, 14–15, 85, 90.
 See also Justin
Pompey, 22
Porticanus, 183
Porus, xiii, 78–79, 183
Poseidon, 107, 191
Priam, 107
Price, Martin, 20, 165, 172
Priene, 53, 108, 188

Pritchett, W.K., 44
Proteas, 101, 193
Protesilaus, 107
Proverbs, Book of, 149
Ptolemaic Dynasty, 172
Ptolemy
 Alexander's boyhood friendship
 with, 128
 Alexander the Great described by, 10
 Cilica looted by, 64
 Cleomenes killed by, 134, 136
 minting of coins by, 162
 as source for Arrian, 33
 as source of information on Alexander's
 wealth, 33, 209n54
 as successor to Alexander the Great, 22
Punjab region (India), 64, 66
Pyrrhon, 102, 193
Pythian (Pindar), 95
Pythionice, 131

Quellenforschung (source criticism), 18–19
Quintus Curtius Rufus. *See* Curtius

Rattigan, Terence, 150
Rhambacia, 191
Rochegrosse, Georges-Antoine, 77
Rock of Ariamazes, 62–63
Rogozen Treasure, 47
Roisman, Joseph, 125
Rollin, Charles, 146, 152
Roman Empire, 5, 21–22, 72, 147
Rosselli, Bernardo, 99–100
Rostovtzeff, Michael, 153
Roxane, 69, 141
Royal Tombs at Vergina, 36–39, 173
Rubincam, Catherine, 13, 202n41

Sainte-Croix, Baron de, 155
Salamis, 162
Samantha Swift and the Golden Touch
 (video game), 7
Sambastae, 92, 183
Sambus, 183
Sangala, 78, 109, 183, 191
Sardis, 69, 108, 162, 182, 188

Sauaces, 55
Schmidt, Erich, 81
Scymnus, 103
Scythia, 182
Seleucia, 172
Seleucids, 171–72
Seleucus, 144, 162
Semtutefnakht, 56
Seneca, 22, 148
Serapion, 193
Shahbazi, Alireza, 84
Sherman, William T., 64
Sibians, 92, 183
Side, 162
Sidon, 162–63, 188, 216–17n88
Sinbad the Sailor (film), 7
Sinopoli, Carla, 176
Sippar, 59
Sisimithres, 183
Sisygambis, 98
Siwah, 107, 182, 188
slavery
 Alexander's imperial cities and, 110
 Balkan conquests and, 66
 Gryneium siege and, 50
 Illyria campaign and, 47
 Indian conquests and, 64–66
 insurance scheme and, 134
 Miletus siege and, 53
 Musicanus mutiny and, 65
 Persepolis siege and, 59
 Rock of Ariamazes siege and, 63
 Thebes siege and, 48–49, 66
 wealth and, 8, 21, 41, 45, 91, 94
 in world history, xv–xvi
Socrates, 20
Sogdiana
 bounty paid in, 190
 coin hoards in, 171
 Greek resettlement following
 conquest of, 63
 livestock requisitioned by Alexander's
 forces in, 61
 looting of, 94, 121, 182
 as Persian satrapy, 164
 razing of cities in, 62–63

Soli, 53–54, 78, 182
Sopeithes, 92, 183
source criticism (Quellenforschung), 18–19
Spain, 5, 154
Sparta, 31
Speculum Sapientiae (Cyril), 146
Spitamenes, 190
Stagira, 193
Stateira, 69, 109
Stewart, Andrew, 51
Stone, Oliver, 73
Strabo, 11, 65, 85, 89–90
Strauss, Barry, 202n41
Sudracae, 191
Sundiata Keita (founder of Mali Empire), 6
Susa
 Alexander's campaigns and conquests at, 23, 32, 72, 75–79, 87, 94
 Alexander's entourage at, 105
 Alexander's payment of debt (324 BC) at, 10, 15, 27, 124–27, 192
 Antigonus's looting at, 144
 athletic games at, 189
 coins minted in, 172
 Darius III's loss of, 72
 gifts to Alexander at the conquest of, 75–76, 85, 89–90, 166, 182–83
 looting of, 58, 94
 Persian boys travel to, 14
 purple cloth and dye from, 98
 treasure seized at, 17
 wealth of, 76–77, 85–86, 89, 137, 180
 weddings at, 18, 103, 114, 125, 192
Susiana, 110, 192
Sveshtari Treasure, 47
syntaxis (Greek contributions to Hellenic war effort), 53–54
Syria, xiii, 5, 56, 131, 171, 192

Tachara (residential palace of Darius I), 84
Tarn, William, 22–23
Tarsus, 54–55, 131, 162–63
Tauriscus, 128–30
Taxila, 91, 122, 183, 190
Taxiles, 91–92, 97, 107, 122, 141, 183, 190
Teos, 162

tetradrachmas, 159–61, 163, 168
Thebes (Greece)
 Alexander's army's size at, 13–14
 Alexander's conquests and looting (335 BC) in, 5, 48–49, 66, 78–79, 85, 94, 147, 176, 181
 Alexander's promise to rebuild, 102, 193
 captives after the siege of, 57
Thebes (Egypt), shrine to Ammon at, 108–9
Theocritus of Chios, 101
Theopompus, 25, 101, 131
Thespiae, 65–66
Thessalian cavalry
 Alexander's payments to, 89, 120–22, 124, 127
 Damascus looted by, 57, 60, 120
 discharging of members of, 61, 89, 123–24
Thessaloniki, 69
Thessalus, 104
Thrace, 46–48, 66, 181
Thucydides, 202n41
Tigris River, 107, 113, 177, 189, 192
Timocleia, xiii, 48–49
Timocleia before Alexander (Domenichino), 49
Timotheus, 103
Tiridates, 85
Tomb I (Vergina), 36–37, 210nn70–71
Tomb II (Vergina), 36–39, 173, 210nn70–71
Tomb III (Vergina), 37, 173
Tomb of the Ten Thousand Dead (Hubbard), 7
"Treasure of the Peacock's Eye" (Young Indiana Jones television episode), 7
Triballi, 47
Tribute Bearers at Persepolis (apadana relief at Persepolis Palace), 82–83
The Triumph of Alexander (Rosselli), 99–100
Trogus. See Pompeius Trogus of Gaul
Troy (Ilium)
 Alexander's symbolic visit (334 BC) to, 50, 188

INDEX

Alexander's temple at, 107, 109
Homer's account of, 32
wealth in, 1, 182
Tyre
Alexander's construction at, 112, 188
Alexander's looting and razing of,
78–79, 94, 114, 163, 182
Alexander's rewards to soldiers at, 114
captives after the siege of, 14, 57
cost of siege at, 114
mass funeral at, 109, 188
mint at, 162
release of prisoners at, 189

Uxians, 60, 182

van der Spek, Robert, 174
The Venetian Betrayal (Berry), 7
Vergina (ancient Aegae), 34–38, 173,
210nn70–71.
von Reden, Sitta, 6
Vorovo Treasure, 47

Walter of Châtillon, 30
War and Gold (Kwarteng), xiv–xv
War! What Is It Good For? (Morris), xv
Wauquelin, Jehan, 149
wealth
of Alexander the Great, xiii–xiv, 6–9,
11, 14–15, 18–24, 27, 32–34, 37,
39–41, 43–45, 52, 67, 72–73, 85,
93–96, 101, 105–6, 117–18, 137,
141, 144, 146, 150, 152–53, 157, 174,
176–77, 180–85

of Babylon, 74
of Darius III, 17, 28–31, 40, 70–71, 94,
97, 105–6
of Persepolis, 59, 68, 77, 79, 85–86, 180
of the Persian Empire, 28–31, 59, 68–70,
77, 79, 85–86, 106, 124, 146, 152–54,
157, 163, 167, 171, 174, 180
of Philip II, 42, 144
slavery as a source of, 8, 21, 41, 45, 91, 94
of Susa, 76–77, 85–86, 89, 137, 180
of Troy, 1, 182
Wheeler, Mortimer, 78
Wilcken, Ulrich, 153
World War I, 113
Worthington, Ian, 37–38

Xathrians, 191
Xenocrates, 193
Xenophon, 44, 168, 202n41
Xerxes, 51, 84–85
Xylinepolis, 191

Young Indiana Jones (television show), 7

Zadracarta, 189
Zagros Plateau, 87
Zeleia, 53
Zerafshan River, 7, 109, 182
Zeus
Alexander's offerings and temples to,
107, 191
Iliad and, 32
on Macedonian coins, 159, 161–62
Thespiae citizens' dedication to, 65–66